DISCARD

THE PARTHENON FRIEZE

The Parthenon frieze, one of Western civilization's major monuments, has been the subject of intense study for over two hundred years. Most scholarship has sought an overall interpretation of the monument's iconography and therefore neglects the visual language of the sculpture, an essential tool for a full understanding of the narrative. Dr. Jenifer Neils's study provides an in-depth examination of the frieze that decodes its visual language, but also analyzes its conception and design, style and content, and impact on the visual arts over time. Unique in its wide-ranging approach, *The Parthenon Frieze* also brings ethical reasoning to bear on the issues of repatriation as part of the ongoing debate on the Elgin Marbles.

This volume contains two innovative visual aids of the Parthenon frieze especially prepared for this book by Dr. Rachel Rosenzweig. The fold-out included at the back of the book is the first complete line drawing of the entire frieze incorporating the latest research on the disposition of the blocks. For computer viewing an accompanying CD-ROM contains two virtual reality movies of the relief based on casts in the Skulpturhalle Basel.

Dr. Jenifer Neils is Ruth Coutler Heede Professor of Art History at Case Western Reserve University, where she has taught since 1980. A scholar of Greek art and archaeology, she organized the exhibition "Goddess and Polis: The Panathenaic Festival in Ancient Athens" and edited the exhibition caralogue. Neils is also author of *The Youthful Deeds of Theseus* and the second *Corpus Vasorum Antiquorum* of the Cleveland Museum of Art.

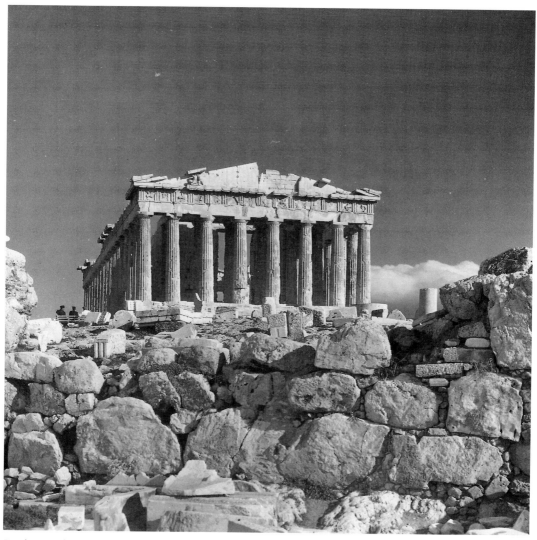

Parthenon from the west. Photo: Alison Frantz AT 5

THE PARTHENON FRIEZE

JENIFER NEILS

CAMBRIDGE
UNIVERSITY PRESS

PUBLISHED BY THE PRESS SYNDICATE OF THE UNIVERSITY OF CAMBRIDGE
The Pitt Building, Trumpington Street, Cambridge, United Kingdom

CAMBRIDGE UNIVERSITY PRESS
The Edinburgh Building, Cambridge, CB2 2RU, UK
40 West 20th Street, New York, NY 10011–4211, USA
10 Stamford Road, Oakleigh, Melbourne 3166, Australia
Ruiz de Alarcón 13, 28014 Madrid, Spain
Dock House, The Waterfront, Cape Town 8001, South Africa

http://www.cambridge.org

First published 2001

Printed in the United States of America

Typeface Adobe Garamond 11.5/14.5 pt. *System* QuarkXPress[R] [GH]

A catalogue record for this book is available from the British Library.

Library of Congress Cataloging-in-Publication Data

Neils, Jenifer, 1950–
The Parthenon frieze / Jenifer Neils.
p. cm.
Includes bibliographical references and index.
ISBN 0-521-64161-6
1. Friezes – Greece – Athens. 2. Parthenon (Athens, Greece) 3. Athens
(Greece) – Buildings, structures, etc. I. Title.
NA2965 .N45 2001
733′.3′09385 – dc21
00-065095

ISBN 0 521 64161 6 hardback

ἄπασι τοῖς Ἕλλησι φίλοις
εὐχαριστήριον

CONTENTS

LIST OF ILLUSTRATIONS

To study the Parthenon frieze properly one must spend time in London, Athens, and Basel. I have profited much from time spent in these cities and their fine museums, which have done so much to further Parthenon studies. For *xenia* at the British Museum I thank Dyfri Williams and especially Ian Jenkins, with whom I have had many stimulating discussions about the frieze. His book, along with those of Frank Brommer (1977) and Ernst Berger (1996), have been constantly at my side throughout my research and writing. All of us who work on the frieze owe these scholars a great debt of gratitude for their careful study and arrangement of the frieze blocks. In Athens my work on the Acropolis was facilitated by Ismene Triandi, Panos Valavanis, and Christina Vlassopoulou, who arranged for me to see the west frieze, which is now in conservation on the Acropolis. In Basel Tomas Lochman, director of the Skulpturhalle, graciously put the entire cast collection at my disposal. This book could not have been written without the generous leave offered to me by the former Dean of Arts and Sciences at Case Western Reserve University, John E. Bassett. Funds pertaining to the Ruth Coulter Heede Professorship provided for numerous trips abroad and other research expenses. For consultation about specific aspects of the Parthenon frieze I am indebted, as always, to Evelyn B. Harrison, Olga Palagia, Alan Shapiro, and Erika Simon, and I thank Anastasia Dinsmoor for allowing me to read William B. Dinsmoor's unpublished manuscript on the Parthenon frieze housed in the Archives of the American School of Classical Studies at Athens. I have also profited much from discussions regarding Athenian history, literature, and ideology with my colleague in classics, Angeliki Tzanetou.

The task of assembling the many illustrations was made easier by the unfailing assistance of the following: Jan Jordan and Craig Mauzy (Agora), Marie Mauzy (American School of Classical Studies), Michael Vickers (Ashmolean), Herbert Cahn (Basel), Angelos Delivorrias (Benaki), Ursula Kästner (Berlin), Keith Lowe (British Museum), Timothy Rub (Cincinnati), Rachel Rosenzweig (Cleveland), Peter Kayafas (Eakins Press Foundation), Amy Brauer and David Mitten (Harvard), Brigitte Tailliez (Louvre), Carlos Picon (New York), Leslie Hammond (Tampa), Sandra Knutsen (Toledo), Christina Risberg (Uppsala), Anna Maria Moretti (Villa Giulia), Francesco Buranelli (Vatican). Many other friends, including Jeffrey Hurwit, Margaret Miller, John Oakley, Olga Palagia, Peter Schultz, and Alan Shapiro, were most helpful to me in obtaining illustrations. I am especially thankful to Manolis Korres who granted permission for the use of his drawings, which elucidate so many aspects of the Parthenon. The library staff at Case West-

ern Reserve University, especially rare-book librarian Susie Hanson, and at the Cleveland Museum of Art, in particular, head librarian Ann Abid, were ever willing to track down an obscure book or article.

One of the challenges of teaching the Parthenon frieze is how to present it as a continuum with only slides at one's disposal. In searching for a better mechanism that did not disrupt the continuity of the procession I was most fortunate to secure the services of Dr. Rachel Rosenzweig. She brilliantly solved the problem by making a virtual reality movie of the frieze based on the casts in the Skulpturhalle Basel and incorporating Ian Jenkins's revised arrangement of the blocks. Since this format has proved ideal for teaching and lecturing, we decided to include a CD-ROM version with this volume. She is also responsible for the first complete drawing of the entire frieze based on this new arrangement and numbering system. Needless to say I am very much in her debt for her willingness to take on any task, no matter how challenging, and her many useful drawings and plans made especially for this book.

For a thorough and critical reading of the entire text I am most grateful to my first teacher of classical archaeology, Rhys Carpenter Professor Emerita of Bryn Mawr College, Brunilde Sismondo Ridgway. Involved in her own extensive publication program, she nonetheless took time out to review my manuscript and offer many cogent comments. I am also most appreciative of the support, enthusiasm, and expert guidance provided for this project by my editor, Beatrice Rehl. Finally, I thank my loyal friends Wendy, Anne, and Jess for many turns around the lake, and Jim and Jamie for their patience and good humor.

Cleveland, July 2000

ABBREVIATIONS

AA	*Archäologischer Anzeiger*
ABV	J. D. Beazley, *Attic Black-figure Vase-painters.* Oxford, 1956
AJA	*American Journal of Archaeology*
AM	*Mitteilungen des Deutschen Archäologischen Instituts, Athenische Abteilung*
AntK	*Antike Kunst*
ARV2	J. D. Beazley, *Attic Red-figure Vase-painters.* 2nd ed. Oxford, 1963
BaBesch	*Bulletin antieke Beschavung*
BCH	*Bulletin de correspondance hellénique*
BSA	*Annual of the British School at Athens*
CVA	*Corpus Vasorum Antiquorum*
FgrHist	F. Jacoby, *Fragmente der griechischen Historiker*
GRBS	*Greek, Roman and Byzantine Studies*
IG	*Inscriptiones Graecae*
JdI	*Jahrbuch des Deutschen Archäologischen Instituts*
JHS	*Journal of Hellenic Studies*
LIMC	*Lexicon Iconographicum Mythologiae Classicae* Vols. 1–8. Zurich, 1981–97

THE PARTHENON FRIEZE

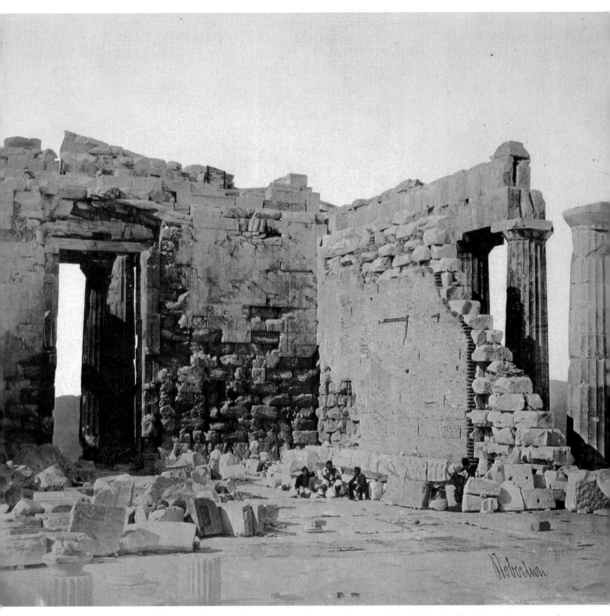

Figure 1. Interior of the Parthenon from the southeast showing frieze blocks lined up along modern brick wall. Albumen print by James Robertson, 1853–1854. Photo: Benaki Museum

INTRODUCTION

S mashed, fragmented, displaced, rearranged. The fate of one of the most unusual and sophisticated artistic creations of the classical period, the sculpted Ionic frieze of the Parthenon, is symbolized by a photograph (Fig. 1) taken in the mid–nineteenth century by the Scotsman James Robertson. Ten marble slabs, blasted from the building in 1687, subsequently buried, and then excavated in 1833, are here shown lined up along the base of a modern brick wall within the ruined Parthenon. Another portion of the frieze (not visible in the photograph) remained *in situ* above the intact west porch, a column of which is discernible just outside the doorway. Approximately half of the 160-meter expanse had been shipped far overseas to England fifty years earlier under the auspices of Thomas Bruce, seventh earl of Elgin. Many more pieces, especially from the ruined south side outside the photograph to the left, were irrevocably lost, and others had already gone the way of the lime kilns. These ten miraculously preserved slabs became fodder for early photographers attempting to capture the vanished glory of ancient Athens. In their reconfigured, alien setting and fragmentary state they represent the fate of this monument, which today can only be made whole photographically on paper or reconstituted in plaster casts.[1]

To study the Parthenon frieze is both frustrating and rewarding. Frustrating because of the wide geographical dispersion of a monument that was conceived and executed as a complex whole and once formed an integral part of the most important building in classical Athens. Today large portions of it reside in the British Museum in London and the Acropolis Museum in Athens, with smaller bits scattered throughout museums and storerooms from Paris to Palermo (see Fig. 174). Since 1993, when the west frieze was finally removed because of corrosive air pollution in modern Athens, none of the sculpted slabs remain on the building for which they were designed. Students of the frieze are often reduced to the perusal of old and inaccurate drawings, black-and white photographs, and lifeless plaster casts.

But there are also rewards: namely, the exceptional quality of the carving, which epitomizes the high Classical style; the complexity of the compo-

sition, which is without parallel in extant Greco-Roman art; and the subtlety of the iconography, which has resulted in a series of profound readings over the past two hundred years. The historiography of the frieze, which dates back to the Renaissance, is almost as intriguing as the frieze itself. Since the days of its initial design the frieze has inspired generations of artists, from contemporary vase painters in fifth-century Athens to twentieth-century sculptors in America. Today it serves another noteworthy role – as part of the "Elgin Marbles," one of the flagships charting the choppy waters of the cultural heritage and repatriation debate. Hence, there are a myriad of ways to approach the frieze and challenging issues to address in considering its role both in ancient and modern Greece.

The photographer Robertson was not the first western European to record this unique monument. That distinction falls to one Cyriacus of Ancona, an eccentric Italian antiquarian who visited Athens in 1436 and again in 1444. In his travel diary of 1436 he specifically mentioned the temple of the goddess "on the topmost citadel of the city . . . splendidly adorned with the noblest images [preclaris imaginibus] on all sides which you see superbly carved on both fronts, on the friezes on the walls, and on the epistyles [i.e. metopes]." A drawing after his original amateur sketch (Fig. 2) of the Parthenon's distinctive octastyle facade excludes the sculpted metopes but adds at the bottom under the designation Listae Parietum figures clearly derived from the frieze: two seated gods, standing draped men, cattle with their drivers, and horsemen. Cyriacus of Ancona's interpretation of the frieze as "the victories of Athens in the time of Pericles" will be discussed later, but here it is interesting to note that the frieze, then still in place on the wall and hence difficult to see, captured the scholar's interest more than the readily observable metopes.[2]

This, alas, was not the case with ancient viewers. Pausanias, who thirteen hundred years earlier also traveled throughout Greece recording his observations, was clearly distracted by all there was to see on the Acropolis in Roman imperial times (ca. A.D. 150) and mentioned only the Parthenon's pediments (1.24.5) and its colossal gold and ivory cult statue. The biographer Plutarch (Life of Perikles 13.4–9 and 31.2–5) informs us that Pheidias supervised the sculptural program of the Parthenon and its teams of artists, but the only work that he actually attributes to the sculptor's hand is the chryselephantine Athena Parthenos that dominated the cella. The fifth-century historian Thucydides eulogized Perikles' leadership but failed to mention any of the Classical buildings on the Acropolis, much less their decoration. Even Vitruvius, the first-century A.C. Roman architect, who might be expected to take an interest in the Parthenon, made only a fleeting reference and that to a treatise on the building rather than to the temple itself. Thus, we lack altogether early firsthand literary accounts of the sculpted

PARTHENON-ZEICHNUNG
DES CYRIACUS.

Figure 2. West facade of the Parthenon with sketched frieze figures below. Silverpoint and ink on parchment drawing by unknown artist after Cyriacus of Ancona, 1436 or 1444. Deutsche Staatsbibliothek, Berlin, Hamilton MS 254, fol. 85ᵛ. After *Archäologische Zeitung* 1882, pl. 16.

frieze, nor do any of the extant building accounts meticulously inscribed on marble stelae mention this part of the project.[3]

This dearth of written testimonia accounts in part for the frieze's obscurity, which is in turn compounded by the condition of the sculpture. Because of the temple's conversion into a Christian church around A.D. 600 and a mosque around A.D. 1460, the Parthenon frieze remained virtually intact for over two thousand years; only the construction of a semicircular apse and the insertion of six clerestory windows resulted in the removal of some small sections of the east, north, and south friezes.[4] The date September 26, 1687, marks the holocaust that destroyed forever the integrity of this building and its lavish sculptural decoration. While besieging the Acropolis, which served as the Ottoman stronghold, Venetian forces under the command of Francesco Morosini lobbed a cannon ball into the Turks' powder magazine, the cella of the temple. The Parthenon exploded, and marble fragments were sent flying all over the citadel (Fig. 3).[5] What remained *in situ* of the frieze after the bombardment was largely at the west end of the temple. Even before the devastating explosion it would appear that the frieze had sustained some damage, probably as a result of earthquakes: the lower corners of many of the blocks are broken off.[6] There may also have been some deliberate defacement of the heads of the figures by zealous Christians attempting to excise pagan idols.

Fortunately, some evidence exists for the appearance of the frieze before the explosion of 1687. In 1674 Jacques Carrey of Troyes, a Flemish artist in the entourage of the French ambassador Marquis de Nointel, made drawings of the Parthenon pediments, metopes, and parts of the north and south friezes, as well as all of the east (except the removed central section) and west friezes. Although inaccurate in many instances and distorting the length of their subject matter by about 30 percent, these drawings nonetheless constitute invaluable documentation for our understanding of the missing sections of the frieze. While drawings were also executed later by the British architect James Stuart (1751–53), the British traveler Richard Dalton (west frieze only, 1749), W. Pars in the employ of the Society of Dilettanti (1764–66), and Feodor Ivanovitsch working for Elgin's team (1800–1802), they tend to restore missing sections and so do not reflect as accurately as Carrey's the true condition of the relief. A comparison of the Carrey drawing of slab XII of the north frieze (Fig. 4), with the drawing by Stuart of 1751 (Fig. 5) and with the photograph of the actual block in the British Museum taken by Alison Frantz in 1958 (Fig. 6), shows that the earlier drawing is more faithful in many details, especially the chariot wheel, to the original.[7]

Another aid in our understanding of the frieze is the plaster cast. As early as 1802 Lord Elgin commissioned *formatori* to make molds of the parts of the west frieze that he was unable to remove from the Parthenon. Today, the

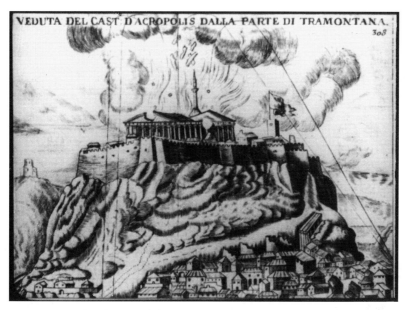

Figure 3. Bombardment of the Acropolis, September 26, 1687. Engraving. After Omont 1898, pl. XXXVI

plaster casts made from these and subsequent molds provide a record of the deteriorating condition of the west frieze. In addition, the piecemeal casting of the other parts of the frieze as they were found on the Acropolis and elsewhere documents the slow progress of Parthenon studies. Painstakingly and lovingly over the course of a century (1835–1939) a series of keepers at the British Museum pursued every last fragment of the Parthenon sculptures, commissioning their agents in Athens to have casts made and sent to London, where they were fitted onto the originals – pediments, metopes, and frieze. The keepers then had new molds of the original-*cum*-cast made and used them to supply casts to institutions all over Europe and America, thereby disseminating the latest reconstructions of this ever-expanding monument. The cast of North XII (Fig. 7) is a case in point. Most of the original slab, as seen in Figure 6, was sent to London by Lord Elgin, but the torso and helmeted head of the striding warrior at the upper right was clearly lost sometime between Carrey's drawing of 1674 (Fig. 4) and Stuart's of 1751–53 (Fig. 5). The torso fragment was discovered on the Acropolis in 1888–89, and shortly thereafter a cast of it was incorporated into slab XII in the British Museum. When the project was completed the frieze as displayed in London consisted of 60 percent original marble and 40 percent plaster cast and provided the most complete version of the frieze since the seventeenth century.

However, the laborious reconstruction was not to last. In 1929 when the art dealer Lord Duveen donated funds for a new gallery at the British Museum

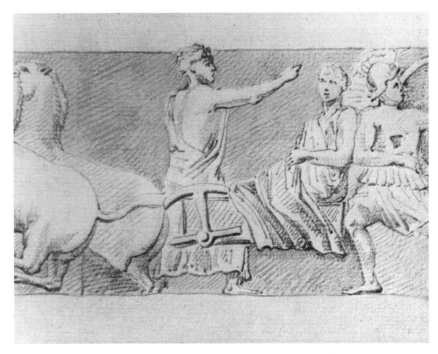

Figure 4. North XII *in situ.* Drawing by Jacques Carrey, 1674

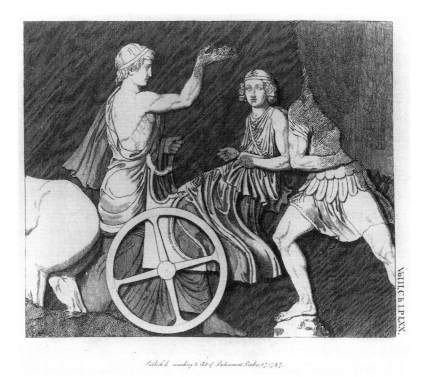

Figure 5. North XII *in situ.* Engraving by James Stuart, 1751–53

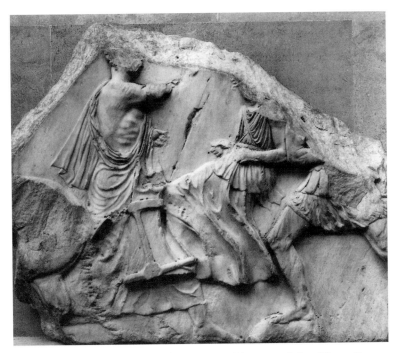

Figure 6. North XII in British Museum. Photograph by Alison Frantz, 1958. Photo: Alison Frantz EU 144

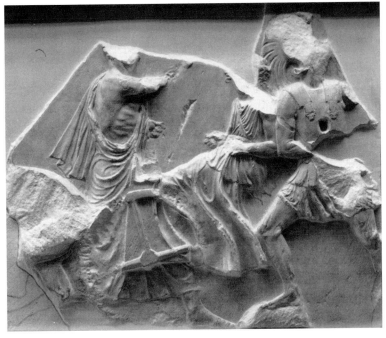

Figure 7. Cast of North XII composed of slab in London and fragment in Athens. Skupturhalle, Basel. Photo: D. Widmer SH 303

devoted exclusively to the Parthenon sculptures, a change in taste demanded a more purist display. When the gallery finally opened after the Second World War, the plaster additions had been removed and only the marble originals remained on view, as one sees them today in the Duveen Gallery of the British Museum (Fig. 172). To view the entire extant frieze in a plaster reconstruction one must visit the Skulpturhalle in Basel, Switzerland, which even today is commissioning casts of newly discovered fragments to be fitted into the ensemble.[8] And finally, it is planned that someday casts of the entire frieze will be put into place on the exterior cella wall of the poured concrete reproduction of the Parthenon in Nashville, so that it might be possible to recreate the experience of an ancient viewer, albeit in the light of Tennessee.[9]

Yet another book on the Parthenon frieze perhaps *needs* an excuse. Ever since the blocks plucked from the Parthenon by Lord Elgin entered the British Museum in 1816, the frieze has been the subject of numerous handbooks by sensitive curators and scholars from 1839 to the present.[10] In the past two dozen years no less than two two-volume monographs in German have dealt in detail with nearly every extant fragment of the frieze.[11] An authority on Greek art as renowned as Sir John Boardman has asserted: "The Parthenon Frieze, which sometimes seems to exercise an unhealthy dictatorship over our understanding of Classical art, is an uncharacteristic monument, and was the least conspicuous of the new sculpture on the Acropolis."[12] So why another book, and why now?

Scholars in the field might suspect that this book was motivated by the recent controversy over the subject of one small but important section of the frieze, spawned by Joan Connelly's theory that it represents not the highpoint of the festival held in honor of the city's patron deity, the Panathenaia, but rather a mythological human sacrifice.[13] Hers is by no means the first mythological interpretation of the frieze, and probably not the last. Refutation of any particular theory is not the purpose of this book, although I hope to prove at least indirectly that such a hypothesis is impossible on many counts. The wide publicity bestowed on Connelly's theory only highlights the necessity of again looking even more carefully at the composition of this relief sculpture and its details in order to obtain the most plausible reading of the narrative. It is my contention that one must first understand the visual language of the artist/designer(s) before reaching conclusions about the meaning of the whole.[14]

This book is a reconsideration of the Parthenon frieze from a variety of points of view – first and foremost that of an art historian – but also those of a fifth-century visitor to Athens, of a designer, of a sculptor, of a cultural his-

torian, and perhaps what might seem most remote, of an ethicist. Many of these approaches have been neglected in our preoccupation with finding one single overriding theme that manages to reconcile all the inconsistencies we suspect in the religious procession. Most scholars these days feel duty-bound to present an interpretation of the subject matter, admittedly an important aspect of the frieze, but without first coming to an understanding of the visual language of the whole. It is this artistic language that provides the visual clues for, first, a proper understanding of the individual elements of the frieze and, only then, a plausible reading of the content. The frieze is often presented in introductory art history classes as a masterpiece of relief sculpture and as the epitome of the Classical style without much of an explanation of what that actually means. Along with the other Parthenon marbles, the frieze figures prominently in the debate about the return of cultural property to its country of origin, and new arguments as well as new precedents are being brought forth for the repatriation of such monuments, which are seen to be synonymous with the cultural identity of a people. Many questions still need to be addressed concerning this complex work of art, and it is my hope that this study of the Parthenon frieze goes some way toward raising them, if not answering them. As one of the most ambitious artistic monuments of the Classical period, it merits consideration of all its manifold dimensions.

NOTES TO THE READER

The numbering of the frieze blocks (Roman numerals) and the individual human figures (Arabic numerals) here follows the new numbering sequence of Jenkins, 1994a. All previous scholarship on the frieze uses the older system established by Michaelis in 1871 and corrected by Dinsmoor in 1954. The new numbering affects only the latter halves of the north and south friezes: a concordance can be found on page 255. The individual human figures are numbered from left to right on each side. Text illustrations include both originals and casts; the latter are noted as such in the captions.

As for orthography I have tried insofar as possible to spell proper names as the Greeks would have, except in those instances (e.g. Thucydides) when such spellings might be unrecognizable by the general reader. For definitions of Greek terms in italics and their relationship to the frieze the reader is referred to the Glossary. *Classical,* upper-cased, refers to the phase of Greek art that falls between the Archaic and the Hellenistic, ca. 480–330; *classical,* lower-cased, refers to Greek and Roman art as a whole.

All three-digit dates are B.C. and all vases are Attic unless otherwise indicated.

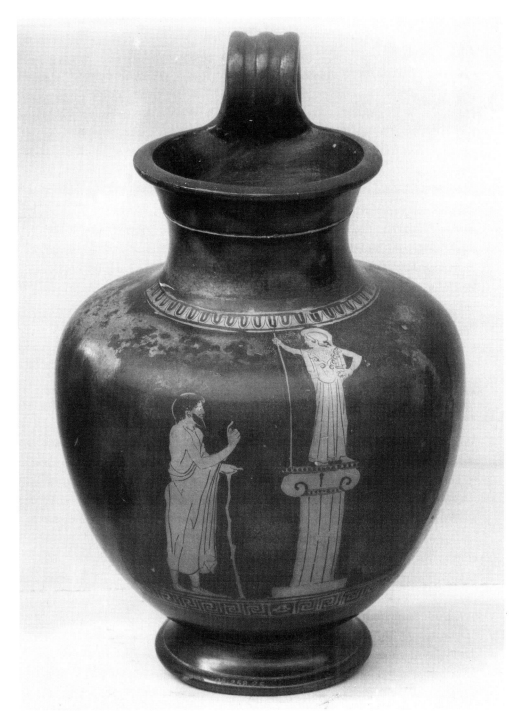

Figure 8. Worshipper before statue of Athena. Red-figure oinochoe, attributed to the Group of Berlin 2415, ca. 460. Metropolitan Museum of Art, New York, 08.258.25. Rogers Fund, 1908. Photo: museum

POLIS

THE FRAMEWORK OF RITUAL

As I said before, the Athenians are more
devout about religion than anyone else.
– Pausanias I.24.3

A pilgrim to Athens (as in Fig. 8) in the eighty-second Olympiad (452–49) would not have been overwhelmed by the sanctuary of the city's patron goddess, as the hordes of international tourists are today. Then the Acropolis consisted of a barren rock surrounded by hastily reconstructed defense walls; the goddess's shrine was a mere shed, possibly called the *opisthodomos,* housing an old but venerable olive-wood statue. (Cf. its appearance ca. 400, Fig. 9.) The grand sixth-century Temple of Athena Polias was demolished, its sculptural debris buried, with only the limestone foundations still visible. Gone were the numerous Archaic marble dedications – brightly painted *korai,* equestrian statues, votive columns – likewise long since broken and deposited in the Acropolis fill. The only gleaming white marble pieces were those blocks and unfluted column drums that lay abandoned from the never completed *hekatompedon* or 100-footer temple (hereafter called the pre-Parthenon) begun in joyful thanks after the miraculous victory at Marathon in 490. The pitiful state to which the Acropolis had been reduced was the result of the Persian incursion a generation earlier, during which "they stripped the temple of its treasures and destroyed the whole Acropolis by fire" according to the fifth-century historian Herodotos (8.53). Vowing before the battle of Plataia in 479 never to rebuild the temples that were destroyed and burned by the Persians but to allow them to remain "as a memorial to those who come after of the sacrilege of the barbarians" (Diodoros 11.29.2), the Athenians had dutifully left their lofty sanctuary in ruins.[1]

There were few tokens of hope after this massive destruction. One of the earliest was Athena's olive tree, her gift to the city, which miraculously

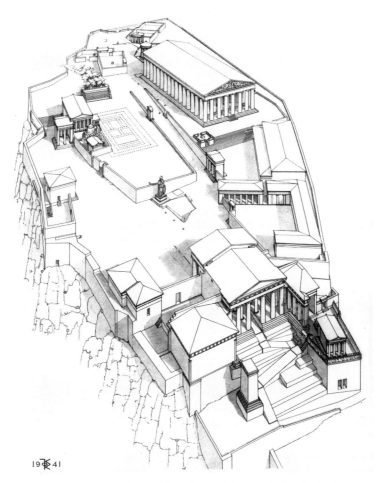

19☧41

Figure 9. Reconstruction of the classical Acropolis by G. P. Stevens. Photo: Agora Excavations, American School of Classical Studies at Athens

sprouted back to life in spite of its charred state (Figs. 10–11).[2] Herodotos (8.55) described the event as follows: "Now it happened that this olive tree was destroyed by fire together with the rest of the sanctuary; nevertheless on the very next day, when the Athenians . . . went up to that sacred place, they saw that a new shoot eighteen inches long had sprung from the stump."

Our hypothetical visitor might also have noticed a few small dedications made to the city's goddess in the second quarter of the fifth century. One of these was a marble statuette of Athena (Fig. 12) associated with an inscribed column base giving the name of the artist Euenor and the dedicator Angelitos. She wears her traditional attire and attributes: a belted Doric dress, the *peplos,* her protective aegis with gorgoneion, and a crested helmet

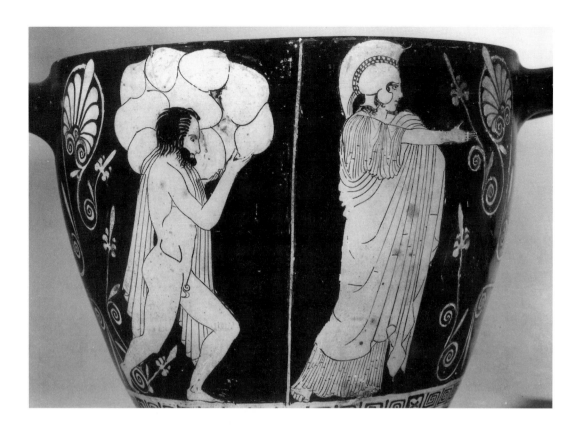

Figures 10–11. Athena and giant with boulder; citizens inspecting olive tree. Red-figure skyphos, attributed to the Penelope Painter, ca. 440. Musée du Louvre G 372. Photos: M. et P. Chuzeville

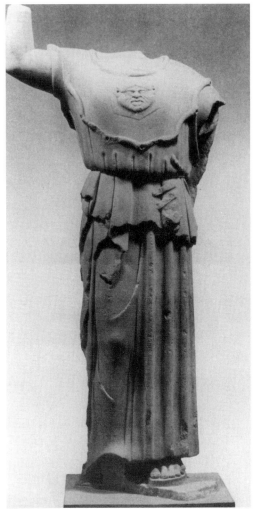

Figure 12. Marble Athena dedicated by Angelitos, ca. 470. Acropolis Museum 140. Photo: author

(evidenced by the end of the crest trailing down her back). Similarly dressed and posed with her hand on her hip is the so-called "Mourning" Athena carved in low relief on a small marble stele also dedicated on the Acropolis (Fig. 13). The goddess is, in fact, not mourning but is looking at what appears to be a turning post or pillar usually associated with the Greek palaistra. Hence, it has been argued that this relief commemorates an athletic victory won at the Panathenaic games held every four years in honor of Athena. These were modest private dedications, in no way as lavish or as numerous as those of the preceding century, but they attest to the piety of

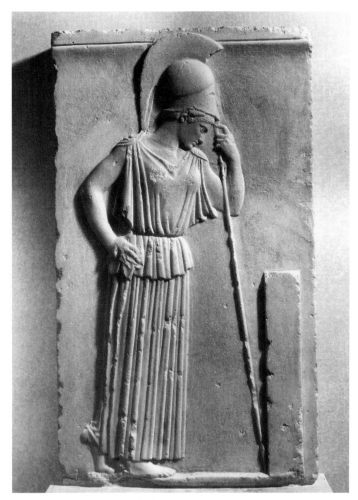

Figure 13. Marble relief of the so-called Mourning Athena, ca. 470. Acropolis Museum 695. Photo: Alison Frantz AT 337

the Athenians in the wake of their miraculous naval victory over the Persians at Salamis in 479.[3]

Somewhat more splendid were life-size group sculptures in bronze. One was the votive monument of Pronapes, once consisting of a four-horse chariot, charioteer, and groom mounted onto a stepped base of Pentelic marble (Fig. 14). The inscription indicates that Pronapes was a winner in the games at Nemea, Isthmia, and the Panathenaia, and the monument dates to ca. 460–50. Also dedicated around this time was a statuary group mentioned by Pausanias (1.24.1), and possibly by the sculptor Myron. It represented "Athena striking Marsyas the Silenos," who is about to pick up the musical instrument invented but then rejected by the goddess, the double pipe, or

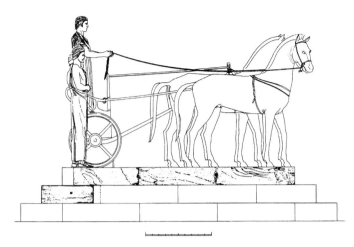

Figure 14. Reconstruction of the bronze votive chariot of Pronapes, ca. 460. Drawing: M. Korres, used by permission

Figure 15. Athena and Marsyas. Red-figure oinochoe, ca. 440. Antikensammlung, Berlin F 2418. Photo: Jutta Tietz-Glagow

Figure 16. Reconstruction of the bronze Athena Promachos by G. P. Stevens. Photo: Agora Excavations, American School of Classical Studies at Athens

instrument invented but then rejected by the goddess, the double pipe, or *aulos* (Fig. 15).[4]

However, the grandest sight on the Acropolis at this time was what was later to be called the Athena Promachos, a colossal bronze statue jointly fabricated by the Athenian sculptor Pheidias, the painter Parrhasios, and the metal engraver Mys (Fig. 16). It stood at the west end of the foundations of the Old Athena Temple, facing all who entered the Acropolis, and the tip of its spear and the crest of its helmet could even be seen from ships rounding Cape Sounion at the southern tip of Attica. The cuttings for its base indicate that it stood on a podium 5.5 meters square, and it is estimated that the statue rose 9 meters in height. Pausanias (1.28.2) later referred to the statue as a "tithe from the Medes who landed at Marathon," and the extant building accounts inscribed in stone and set up on the Acropolis make it clear that it was commissioned by the state and may have cost as much as eighty talents (the cost of an entire temple at Plataia). Spanking new in the 460s, this impressive statue would have been the brightest and most ostentatious in all of Greece at the time.[5]

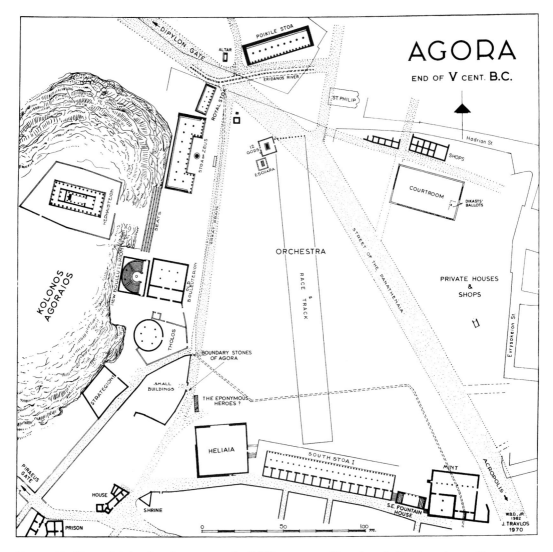

Figure 17. Plan of Athenian Agora at end of fifth century. Drawing: J. Travlos, Agora Excavations, American School of Classical Studies at Athens

In spite of these new dedications on the Acropolis our mid-fifth-century pilgrim would have been much more impressed with the lower city, the Agora, or public market place (Fig. 17), for here there were not only new monuments but also new buildings, and even landscaping. The statesman Kimon had enhanced this exposed area with shady plane trees, roofed stoas, and a terracotta pipeline to carry fresh water to the Academy. His family's most renowned embellishment was the Stoa Poikile, or Painted Stoa, so named because it showcased specially commissioned paintings, one of which

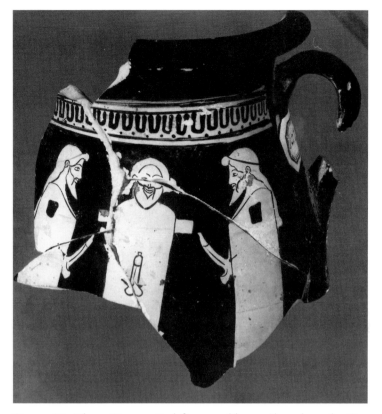

Figure 18. Three Herms. Red-figure pelike attributed to the Pan Painter, ca. 470. Musée du Louvre Cp 10793. Photo: museum

depicted the Athenians' victory at Marathon under the leadership of Kimon's father, the general Miltiades. Kimon's piety to gods and heroes is indicated by his founding of a shrine in honor of the local hero Theseus, whose bones he retrieved from the island of Skyros in 476–75, and the erection of herms, pillars surmounted by portraits of the god Hermes, at the northwest entrance to the Agora (Fig. 18). Farther along the Panathenaic Way, the broad route transecting the Agora, one of the bronze sculptures plundered by the Persians, namely, the double statue of the tyrannicides Harmodios and Aristogeiton by Antenor, had been replaced with a newer (477–76) version by the sculptors Kritios and Nesiotes (Fig. 19). Clearly this patriotic statue commemorating a recent historic event was essential to the image of the young democracy. Also probably erected in the 460s was a unique civic structure, the circular Tholos, which served as the headquarters of the *prytaneis,* the executive committee of the democratic assembly. Nicknamed *Skias,* or sun hat, because of its unusual conical roof, it was a promi-

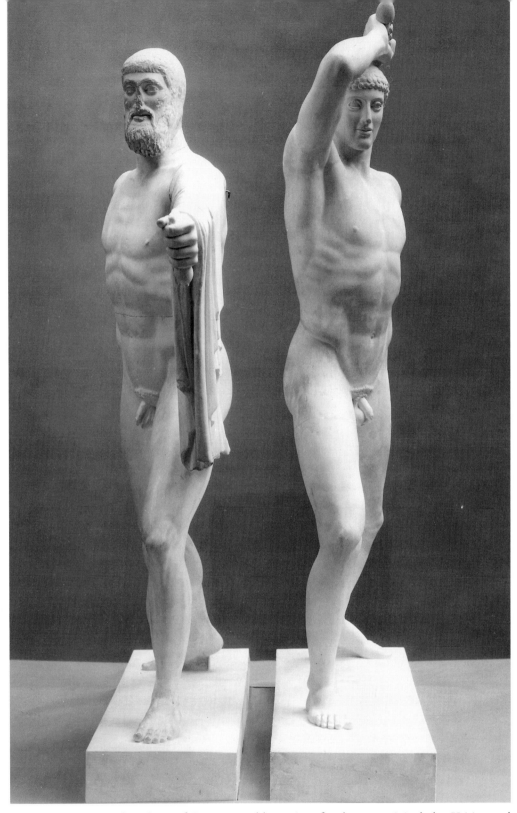

Figure 19. Tyrannicides. Casts of Roman marble copies after bronze originals by Kritios and Nesiotes, ca. 477–76. Photo: Metropolitan Museum of Art 94510

nent feature at the southwest corner of the Agora. Finally, construction had probably just begun on the large Doric temple of Athena and Hephaistos, known as the Hephaisteion, situated on the hill to the west of the Agora. Thus, since the Persian invasion the Agora had arisen from the ashes to become an attractive civic center of which the *demos* could be proud.[6]

In spite of their vastly different states of repair in the mid–fifth century, the Acropolis and Agora did share one important characteristic, namely, their function as sites of intense religious activity. In ancient Greece ritual took the form of contests and games, elaborate processions, sacrifices, and gift-giving. While altars and temples sufficed for the last two activities, larger open areas were needed for the first, and it seems that from early times the Athenian Agora served this function. In ancient sources this area is called the Orchestra because temporary wooden seating was erected here before a permanent theater and odeion or concert hall were constructed on the south slope of the Acropolis. By the fifth century, and possibly earlier if sixth-century inscriptions referring to a *dromos* apply, the Agora had a running track stretching north-south across it with starting gates adjacent to the Altar of the Twelve Gods. We also know from ancient sources that military drills were carried out here, particularly those of the Athenian cavalry. Finally, the street of the Panathenaia, the route for all religious processions from the city gates to the Acropolis, dominates the area and in fact dictated the location for most buildings and monuments throughout the Agora's long history.[7]

The most famous religious procession that followed this route and gave it its name was that of the Panathenaia, the annual festival honoring the city's patron deity. Celebrated since at least 566, it was conducted with special pomp every four years, in emulation of the games in honor of Zeus at Olympia. If our hypothetical pilgrim had arrived in Athens near the end of the summer month of Hekatombaion in the year 450, he could have witnessed one of these Greater Panathenaia, during which he would have been regaled with musical and dance competitions, athletic contests for boys and men, equestrian demonstrations and races, a regatta in the harbor, a kind of male beauty contest in *euandria* (manliness), and a tag-team torch race. While most competitions were open to any Greek speaker, these last three contests were exclusively for local citizens, as they involved teams chosen from the ten Athenian tribes. Unlike the victors at Olympia who were awarded olive wreaths, the leading Panathenaic competitors were given large quantities of Athena's sacred olive oil sealed in specially designed earthenware jars known as Panathenaic amphoras (Figs. 20–21). The black-figure designs on these vases were religiously prescribed and changed little over the years. On the main side is a striding, armed Athena with spear raised,

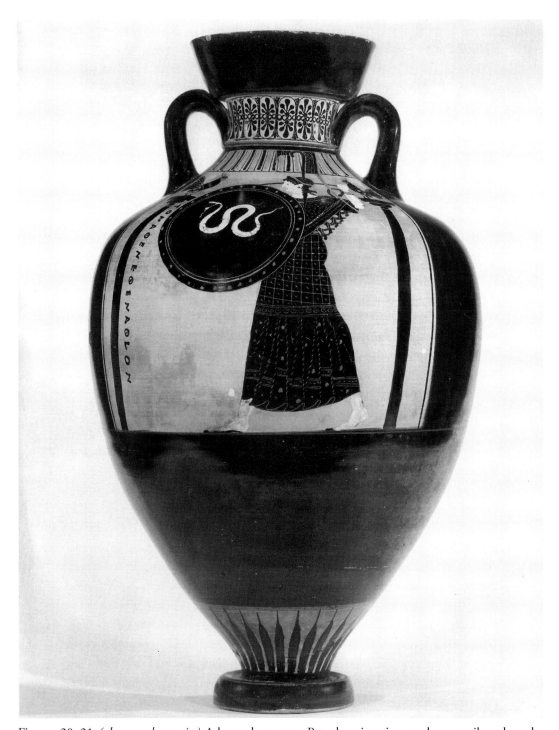

Figures 20–21 *(above and opposite)* Athena; horserace. Panathenaic prize-amphora attributed to the Eucharides Painter, ca. 490. Metropolitan Museum of Art, New York 1956.171.3. Fletcher Find, 1956. Photos: museum

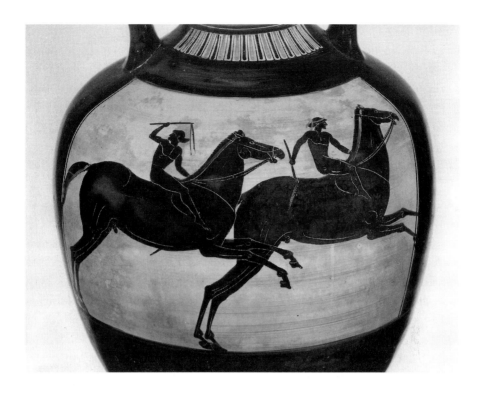

flanked by two columns surmounted by cocks, and the inscription ΤΟΝΑΘΕΝΕΘΕΝΑΘΛΟΝ ("from the games at Athens") along the left-hand column shaft. On the reverse is one of the athletic or equestrian events for which the oil served as a monetary prize.[8]

The festival culminated with a long procession from the Dipylon Gate to the Acropolis, a distance of over one kilometer. Essential to all ancient Greek religious processions were musicians, *kanephoroi* (basket-carriers), sacrificial victims (cattle, sheep, goats, or pigs), and someone qualified to perform the rites, namely, a priest or priestess. In the case of the Panathenaia we know that, in addition to animal sacrifice, a special gift, an elaborately woven robe known as the *peplos,* was prepared every four years for the goddess and carried in the procession to her temple. The high point of Athena's festival consisted of those momentous events that took place on the Acropolis: the presentation of the robe and the ritual slaughter of the *hecatomb* or one hundred heifers, whose flesh was later distributed to the populace in the Agora below for feasting. Thus, this festival excited and satisfied all the senses: music and the recitation of Homeric poetry for the ear, exhibitions of athletic and equestrian prowess to delight the eye, the scent of incense and

burning fat to please the nostrils, the savor of wine and freshly roasted red meat for the palate, and for the sense of touch the dressing up in richly woven, festal garments. Set against the backdrop of the rather drab Acropolis in the years before the great fifth-century building program, this colorful spectacle would have been especially impressive, as it constituted the finest display of Athenian piety, civic pride, and prosperity.[9]

This striking visual contrast between the Agora embellished by his one-time rival Kimon and the Acropolis may have been one of the factors prompting the *demos* and its leading statesman Perikles to turn attention toward the sanctuary of Athena at this time. Perikles initiated events by first inviting other Greeks to a pan-Hellenic congress to be held in Athens for the consideration of four issues: "the Greek temples which the barbarians burnt, the sacrifices which they vowed to the gods when they fought the barbarians but had not yet made, and the sea, that all might sail in security, and keep the peace" (Plutarch, *Perikles* 17.1). Although the Spartans declined to participate and so the congress never took place, Perikles' initiative was nevertheless a great propaganda coup for Athens. It not only advertised far and wide the Athenians' religious piety and concern for peace, but more concretely it allowed them to proceed with the refurbishment of the sanctuary of Athena on the Acropolis, since now there could be no objections from the allies or other Greek states.[10]

Two other important conditions paved the way for the Acropolis rebuilding program: peace and money. In 451 Athens signed a five-year truce with Sparta, and in 449 Perikles sent Kimon's brother-in-law Kallias to negotiate a peace treaty with the Persians on behalf of the Greeks. Although the authenticity of this latter treaty has been doubted, there appears to have been a cessation of operations against Persia at this time. Besides allowing the Athenians to devote their energies to non-war activities, the Peace of Kallias also effectively shelved the Oath of Plataia. The second crucial event was the transfer of the funds of the Delian League from Delos to Athens in 454. Shortly thereafter (449) a motion was carried in the assembly to allocate 5,000 talents of the treasury for the construction of new temples on the Acropolis, with an additional 200 talents to be transferred annually for the next fifteen years to finish the work. Thus, the Athenians had the leisure and the considerable resources, not to mention their great gratitude to Athena for their victories at Marathon and Salamis, to commence a major refurbishment of the Acropolis.[11]

In the later literature the statesman Perikles is credited with the refurbishment of the Acropolis, so that it is often referred to as the "Periclean" building program. Much of this assessment of Perikles' role comes from the biographer Plutarch, who wrote his *Life of Perikles* ca. A.D. 100, more than half a millennium after the life of his subject. Accustomed as he was to the lavish benefactions and public works of the Roman emperors, Plutarch may have given Perikles more credit than he actually deserved for the Acropolis buildings. Along with a tendency to ascribe great buildings to great leaders (as the Old Athena Temple, which is often called the Peisistratid Temple in spite of no evidence for such an attribution), there is also a tendency in biography to credit an individual with actions that may have been taken by the government, or in this case the *demos.* This reconsideration of Perikles' role is perhaps confirmed by arguments *ex silentio,* namely, earlier sources like Thucydides and Plato, who never mention Perikles' contributions to the rebuilding of the Acropolis. Plato (*Gorgias* 455E) quotes Sokrates as saying he himself heard Perikles propose the decree for the middle Long Wall to the Piraeus, and a number of sources credit him with the building of a secular structure, the odeion, or concert hall, on the south slope of the Acropolis. It seems strange that both of these lesser projects were the butts of jokes by the Attic comedian Kratinos, a contemporary of Perikles, but none referring to the much grander constructions on the Acropolis survives. His closest association with the Acropolis is a reference in the historian Diodoros (12.39.1) indicating that Perikles was on a board of commissioners, or *epistatai,* overseeing the accounts for the gold and ivory statue in the Parthenon. Strabo (9.1.12) states that Perikles superintended the work, but this is in contrast to Plutarch (*Perikles* 13.6), who claims that "the director and supervisor of the whole enterprise was Pheidias."[12]

In addition to the questionable authority of Plutarch in this regard and the lack of contemporary citations to Perikles' involvement on the Acropolis, there is some positive evidence regarding the authority for building programs in general and the Acropolis program in particular. In fifth-century Athens legislation for public expenditures was passed by the *demos,* or people. According to Isokrates (*Areopagiticus* 66): "Yes, and who of my generation does not remember that the democracy so adorned the city with temples and public buildings that even today visitors from other lands consider that she is worthy to rule not only over Hellas but over all the world." After approving the expenditures the *demos* then appointed a board of financial overseers *(epistatai)* to supervise individual projects and publish their accounts in the form of publicly accessible inscriptions on stone. The board

and the architects followed written descriptions of the building known as *syngraphai*, which had prior approval by the *demos*. The entire process seems to be committee and team work rather than the policy of a single individual.[13]

Naturally Perikles, like any other citizen, could have introduced to the assembly the legislation that resulted in the Acropolis building program, which later authors, with hindsight and seeing the results, may have deemed extraordinarily foresighted, and so anachronistically credited it to the most prominent political figure of the period. However, Greece had long been what has been called a "temple culture," and rather than inaugurating a new era of temple construction, the building begun in 447–46 was really business as usual for a wealthy Greek *polis*. Plans had been similarly drawn up after the battle at Marathon for a marble temple and a marble propylon, and it has not seemed necessary to ascribe these to any one individual. The major difference between the two projects was one of scale, but even this enlargement may not have yet been envisioned completely in the mid–fifth century. It is reasonable to ascribe the construction of the Parthenon and its new cult statue to the piety of the Athenians, at long last paying homage to their gods for the stunning victories at Marathon and Salamis.[14]

Surprisingly the program began not with the Temple of Athena Polias, which in fact was never rebuilt over its older foundations, but with a renewal of the later marble temple to the south. The site of the Parthenon does not seem to be one with as much cult association (or any that we know of), nor was it connected with any specific festival or traditional priesthood of the city. Why was it rebuilt before the Temple of Athena Polias? Religion would certainly have dictated an altar and a home, or *naos*, for the goddess Athena, but this obligation would presumably have been addressed after the return from Salamis, when the *opisthodomos* was erected for her cult statue. All traces of the altar of Athena are gone, but it can be presumed to have been located to the east of the Old Athena Temple. Political considerations may have played a part in the decision. Since the pre-Parthenon seems to have been a thank offering for Marathon and since concern had been expressed in the Congress Decree about vows made before battles but not yet fulfilled, this temple may have been given priority. This course was perhaps also taken for practical reasons, namely, that the building materials, such as marble blocks and pre-cut column drums, lay ready to hand. Also the large supporting platform, as much as twenty-two courses deep on the south side, which had been prepared for the earlier temple on this spot, provided a conveniently ample foundation for a splendid new temple.

Since so little of the pre-Parthenon is extant, it is difficult to assess its impact on its successor, but it is important to obtain an idea of its intended appearance, for it was the only large-scale marble predecessor to the Parthenon. In fact this building may have been the instigation for the opening in the early fifth century of the marble quarries on Mt. Pentelikon, 16 kilometers from Athens. Previously marble was used much more sparingly, for it had to be imported at considerable expense from the Cyclades. The pre-Parthenon's size has been calculated to be 66.9 by 23.5 meters (as compared to the Parthenon's 69.5 × 30.9 m), rather small for the size of the limestone podium (76.8 × 31.4 m). Since the three-stepped base and the lowermost drums of the columns were laid, it is possible to determine that the earlier temple employed the latest refinements, namely, curvature of the platform, inclination in the columns, and thickened corner columns. In plan (Fig. 22) the temple did not follow the canonical Doric as seen, for instance, in the nearby Hephaisteion. The cella seems to have had an additional room at the back, an opisthodomos with four columns (possibly Ionic), and the porches were designed with four prostyle columns, instead of the more normal two *in antis*. Deviations from canonical Doric also include the use of Ionic moldings. At the base of the wall ends *(antae)* was an Ionic molding that extended along the outer cella walls as well. Unfortunately we know nothing of the plans for the sculptural embellishment of this temple, although certainly carved metopes and pedimental sculpture would be expected. A sculpted frieze is not impossible given the Ionic moldings, and some miscellaneous fragments have been assigned to this building (see Chapter 2). In spite of this gap in our knowledge we can be fairly certain that the pre-Parthenon set a new standard for the use of marble and introduced Ionic elements into Doric architecture of mainland Greece. Its general plan, its use of refinements, and even much of its actual material were incorporated into the later Parthenon.[15]

However, from the beginning of the design process major alterations were made to the plan of the pre-Parthenon. A 6-by-16 Doric temple would have looked hopelessly old-fashioned at this date, for it was much too long in proportion to its width. A brilliant solution, which utilized the full width of the platform (with a slight extension to the north to accommodate an earlier shrine) but resulted in a much grander and aesthetically more pleasing building, was the unprecedented octastyle facade (Fig. 23). The result is not only a better proportioned building in plan (8 × 17 peristyle, 4:9 overall proportion) but also a much broader, lower facade in elevation. This new octastyle design in turn necessitated hexastyle porches, prostyle as in the pre-

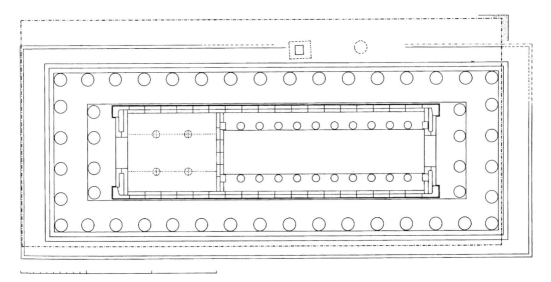

Figure 22. Plan of pre-Parthenon. Drawing: M. Korres, used by permission

Parthenon, which resulted in an extraordinarily wide (19 m) cella. Modifications were also made to the interior. The number of columns in the main cella was increased by three and configured into a U-shaped two-tiered colonnade. More than any previous temple the Parthenon displays an intimate relationship between the exterior and the interior of the building. The cella and its porches no longer "float" within the peristyle, which was usually deeper fore and aft than along the sides, but they are closer to and equidistant from the peristyle, on all sides.[16]

The increased width of the temple and the elaboration of the cella both suggest that the sculptor Pheidias had some say in their design. While the ancient sources attribute the plan of the Parthenon to the architects Iktinos and Kallikrates, the idea for a colossal cult statue must have dictated to some extent the enlarged cella. It would have been needed to accommodate the 26-cubit tall *Athena Parthenos,* which Pheidias was commissioned to execute in gold and ivory. Given all its gold (44 talents worth = 616 silver value) this statue was the symbolic, if not physical, embodiment of the Delian Treasury, and one wonders if its inspiration may not have been the colossal gilt Apollo made by the Archaic sculptors Tektaios and Angelion for the temple of the god on Delos. At any rate the success of Pheidias' earlier Athena Promachos was also certainly a factor in both the decision to commission a colossal statue and in the letting of the contract to Pheidias. Since he was already a well-respected sculptor in Athens, clearly winning the best commissions, his

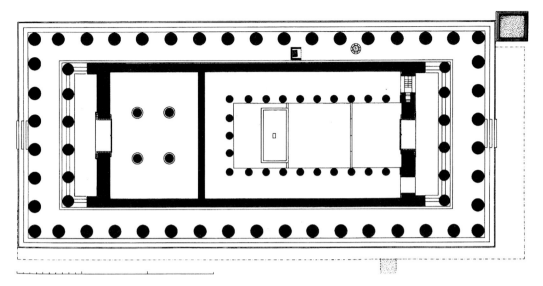

Figure 23. Plan of the Parthenon. Drawing: M. Korres, used by permission

opinions about the interior arrangements of the Parthenon would certainly have been taken into consideration by the architects.[17]

In ancient Greece, since the beginning of stone temple building ca. 600, architects and sculptors worked closely together, and in later times we know of architects who were also sculptors, like Skopas. The two, whether crafts-men or professionals, had similar training and skills, from the art of quarry-ing to the final surface treatment of the limestone or marble surface. They used similar tools and equipment, from the chisel to the hoist, and both hired painters to add chromatic effects to their stonework. Although Phei-dias is best known for his bronze and chryselephantine works, he, like most sculptors of his era, was undoubtedly familiar with marble carving. Likewise the elaborate armature erected for the interior support of the *Athena Parthenos* owed a great deal to architectural practices. We can thus envision Iktinos, Kallikrates, and Pheidias working in concert on the design of the Parthenon, its cult statue, and its sculptural program.

The sculptural program of the Parthenon is at once traditional, with its relief metopes, three-dimensional pedimental groups, and cult statue, but also radical. Ninety-two carved metopes are unprecedented for a Greek tem-ple and were never to occur again. Over-life-size pedimental statues were now the norm, but the number and complexity of the Parthenon pedimen-tal figures mark a dramatic departure from their immediate predecessors on the Temple of Zeus at Olympia. One need only compare the calm chariot

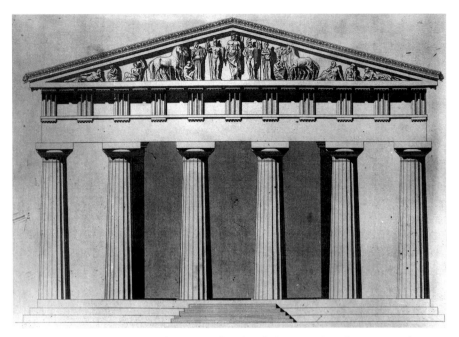

Figure 24. Reconstruction of the east facade of the Temple of Zeus at Olympia. Photo: DAI, Athens, Ol. 174

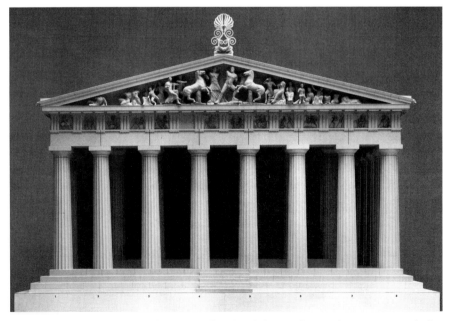

Figure 25. Reconstruction of the west facade of the Parthenon by E. Berger. Skulpturhalle, Basel. Photo: D. Widmer SH 278

horses of Pelops and Oinomaios (Fig. 24) with the rearing steeds of Athena and Poseidon (Fig. 25). Most extraordinary of all is the 160-meter, low-relief Ionic frieze encircling the cella and its porches. This sculpted band is unique and thus the most intriguing feature of the entire temple.[18]

The question which then looms is to what extent was the frieze an integral part of the original program. Did its conception play a role in the design of the Parthenon, as we assume the *Athena Parthenos* did, or is it simply an added frill to a Doric temple? This question will be addressed in the next chapter, which considers the design of the frieze.

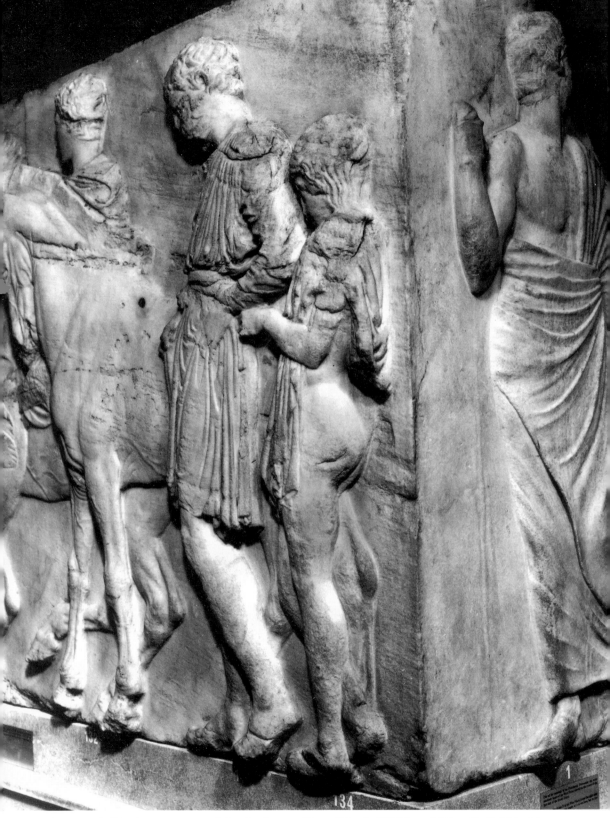

Figure 26. Northwest corner of the Parthenon frieze (North XLVII and West I). British Museum.
Photo: Alison Frantz EU 235.

PARADEIGMA

DESIGNING THE FRIEZE

The decision to have an Ionic frieze, and to
have it here, was an extraordinary one, and
induces the uneasy feeling that . . . it was
dictated by some kind of artistic *hubris.*
– Bernard Ashmole (1972, 116)

No classical relief carving before the Column of Trajan in Rome chal-
lenges the Parthenon frieze (Fig. 26) in terms of its extent or the mul-
tiplicity and variety of its figured narrative. It measures 160 meters (524
feet) in length and approximately one meter in height. With its some 378
dramatis personae, accompanied by 245 animals, it is a tour de force of plan-
ning and carving. Unlike the Parthenon's ninety-two carved metopes or its
fifty-some pedimental figures, the frieze is executed in extremely low relief,
never projecting more than 5.6 centimeters from the background of the
block. In spite of the fact that the carving is spread over 114 rectangular
blocks, the design presents to the viewer a seamless whole gliding effortlessly
and inexorably toward the east.[1]

The composition (Fig. 27) consists of two more or less parallel files of
figures who converge at the east. Commencing at the southwest corner
above the southernmost column of the west porch, the procession moves in
two directions: (1) the longer file moves northward along the west face and
then eastward along the north cella wall before turning the northeast corner
over the east porch, and (2) the shorter file moves eastward along the south
side until turning the corner and progressing northward. The two never
actually meet, but, as we shall see, there is contact between them on the east.
While the long north and south sides are similar in composition, with
streams of horsemen, chariots, older men, musicians, hydria-carriers, tray-
bearers, and sacrificial animals all moving toward the east, the west and east
friezes are entirely different in both content and execution. The west is
sparse, with figures widely spaced, and shows preliminaries, with a number

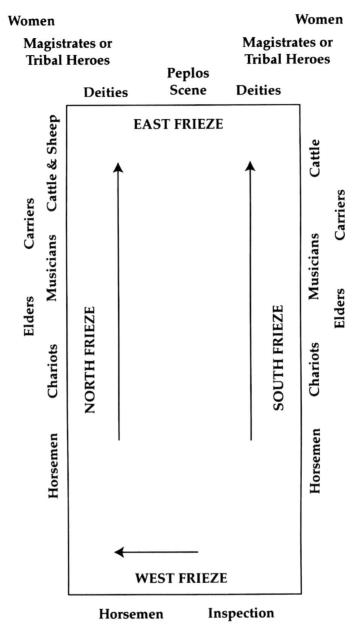

Figure 27. Plan of the Parthenon frieze. Drawing: R. Rosenzweig

of riders not yet dressed or mounted. On the east there are suddenly no animals, but crowds of richly draped women instead, standing men, and seated superhumans or gods flanking a central scene involving three women, a man, and a child. The east side clearly marks the culmination of the two processional streams, and the ambience here is solemn and stately. To put it

another way, the west frieze has thirty figures (not including horses) spaced over fourteen blocks and two short ends, while the east frieze presents sixty-three figures over the same expanse, but in this case consisting of only six, obviously much longer, blocks and two short ends. (The blocks numbered VII and VIII are in fact one very long slab.) Clearly the design of the frieze evolved as it went along, and in this chapter we will look at some of the artistic problems and challenges confronting its designer.

THE DESIGNER

In most handbooks of Greek art it is generally assumed that the designer of the Parthenon's entire sculptural program was the Athenian sculptor Pheidias. The only evidence for this assumption is the passage in Plutarch's *Life of Perikles* (13.4–9), which reads in part: "The man who directed all the projects and was the overseer *(episkopos)* for him [Perikles] was Pheidias. . . . Almost everything was under his supervision, and, as we have said, he was in charge, owing to his friendship with Perikles, of all the other artists." Although seemingly straightforward, upon closer examination this passage is problematic. The word *episkopos* (overseer) is not a technical term in Attic Greek or in Plutarch's vocabulary. In Attic inscriptions the term *architekton,* or master builder, was used to refer to the supervisor of a building project, and there is no category for any independent overseer for sculpture. It would appear that Plutarch was again being influenced by his own times, thinking perhaps of Trajan's close relationship with the architect Apollodorus and using it anachronistically as a model for Perikles and Pheidias. Given the similarities between the subsidiary relief decoration of the *Athena Parthenos,* which is without question attributed to Pheidias, and the architectural sculpture of the Parthenon, it seems likely that Pheidias was consulted for the latter and perhaps even drew up the original designs. For the purposes of this discussion we will assume that he was a sort of master designer who may or may not have executed any part of the actual frieze.[2]

Before the first chisel struck the marble, a number of major decisions had to be made by this master designer. First and foremost was the unprecedented decision to have an Ionic frieze on a Doric building. Once that radical determination was made, a subject (or subjects) that could be fit into a height of one meter by a length of 160 meters had to be devised. This subject then had to be accommodated to the four exterior sides of a rectangle consisting of two columnar porches and the two long blank walls of the cella. Since there was no precedent for a frieze of this magnitude,

what inspiration did the designer draw on to come up with his plan? Given the complexity of the frieze with over six hundred figures and animals, it goes without saying that considerable forethought went into its planning in the form of either detailed drawings or full-scale models. Even though we know little about the design of Greek sculpture, and so, much of what follows is speculative, it is nonetheless worthwhile to consider how the design came about and how it was adapted to the architecture of the Parthenon. Let us turn first to the unique concept of an Ionic frieze and how it might have been arrived at; like much in Greek art it is a combination of tradition and innovation.

DORIC VERSUS IONIC FRIEZE

The canon of Doric architecture dictates a triglyph-and-metope frieze over a Doric colonnade, as one sees on the exterior of the Parthenon. The epitome of Doric temple architecture, the Temple of Zeus at Olympia, thus carries Doric friezes over both its exterior colonnade and its inner porches. Atop each of its distyle-in-antis Doric porches, one encountered a frieze of seven triglyphs and six carved metopes, depicting the twelve labors of Herakles. The subject is so ideally suited to the space that one might think that the architecture was adapted for this specific purpose. The Parthenon with its hexastyle prostyle porches has five intercolumniations that would have normally called for ten metopes. Because the citizenry of Attica was divided into ten political divisions known as tribes (*phylai*), ten is a number that could have easily been used to fill two sets of metopes. (As we shall see, the number does play an important role in the design of the frieze.) Given that there are no iconographic problems, why substitute a long, continuous frieze for twenty carved plaques?

While artistic *hubris* may have been one factor, surely another was the presence of a proliferation of metopes on the exterior of the building (Fig. 28). No temple before or since had as many as ninety-two carved metopes. As the earliest sculptural decoration to be carved for the building, the metopal program was an ambitious undertaking, requiring considerable skill on the part of the designer(s) in order to avoid repetition and monotony, and taxing the variable abilities of the sculptors who were learning and developing a new style as they proceeded. In order to deal with the extensive metopal program, the designer chose a different subject for each side: centauromachy on the south, amazonomachy on the west, Trojan war on the

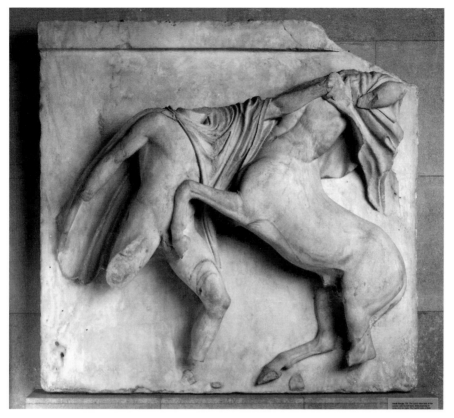

Figure 28. South metope 7 of the Parthenon. Photo: British Museum

north, and gigantomachy on the east. Even with four different narratives, he had to resort to what appears to be an extraneous subject for the middle metopes of the south side (nos. 13–21). It is also generally acknowledged that some metopes are much more sophisticated in terms of composition and execution than others; it was a considerable artistic challenge to vary what are essentially two-figure compositions. The prospect of carving even twenty more such metopes was probably not one that either the designer or the sculptors would have welcomed.[3]

Instead an imaginative and ambitious artist would have seen here an opportunity to accomplish something that is impossible with the staccato rhythm of the Doric frieze, namely, to provide a more unified smooth-flowing composition, such as one would have found in large mural paintings of this period. An Ionic frieze allows for more complex, multi-figured compositions in which a narrative can be played out across space and through time. Rather than illustrating separate episodes of a story as metopes do, the Ionic

frieze allows for a continuous spatial and temporal flow. The practical problems involve establishing a beginning and an end or climax without making the endpoints too artificial and abrupt.

The decision in favor of an Ionic over a Doric frieze could also have been inspired by the medium, namely, marble. While Doric architecture was developed in limestone, Ionic was, from its inception, an architecture of marble. This may explain the extensive use of Ionic elements in the Parthenon's design, as well as that of its marble predecessor, the pre-Parthenon. Marble sculptors were probably accustomed to carving figural friezes, and if some of them came to Athens from Ionia or the islands, as they did in the Archaic period, they may have suggested the innovation themselves. It is impossible to say if a frieze was planned for the immediate predecessor to the Parthenon, but as the first marble temple in mainland Greece, it may well have had more than the normal Doric sculptural embellishment.[4]

Whether chosen for variety, because of the medium, or by virtue of the origin of the sculptors, the choice was clearly the correct one aesthetically. Different in scale and degree of relief, the Ionic frieze adds to the sculptural program another dimension that yet more metopes could not have. While the figures in the pediments are carved fully in the round and the metopes are in very high relief (compared to their immediate predecessors at Olympia), the frieze is executed in the lowest possible relief. Given the diffused lighting conditions of the peristyle, this was probably a deliberate choice. Also, in terms of composition the frieze format offers another option from the isolated groups of the metopes and the centralized scenes of the pediments, namely, the opportunity for an extensive, uninterrupted narrative. In keeping with the lower relief and extended band, the designer chose a more passive and solemn tone in contrast to the excitement and dramatic conflict of the other sculptures.

That this decision was made somewhat belatedly is indicated by the top of the architrave blocks that lie beneath the frieze of the *pronaos* and *opisthodomos* (Fig. 29). They still carry the requisite regulae and guttae that are normally found just below the triglyphs of a Doric frieze. Also adjustments seem to have been made to the *pronaos* to allow for an Ionic frieze instead of the Doric one that may have originally been intended. Manolis Korres has written: "The alterations were dictated by consecutive decisions to enlarge and expand the sculptural programme." Before the positioning of the floor slabs (stylobate) of the east *pronaos* a decision was made to replace the Doric frieze with an Ionic one. After the positioning of the first column drums of the east portico it was decided that an Ionic frieze should be added

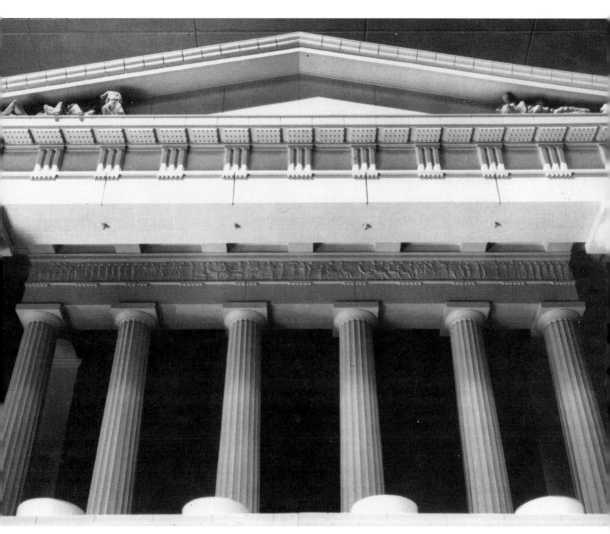

Figure 29. Cutaway model of Parthenon facade showing the regulae and guttae beneath Parthenon east frieze. Skulpturhalle, Basel. Photo: D. Widmer

to the interior of the *pronaos,* according to Korres. As a result the east wall was positioned farther to the west and the diameter of the columns was reduced. He concludes: "In general the erection of all the sides of the building was simultaneous, but nevertheless steadily behind the progress of the eastern side."[5] So it would seem that the Ionic frieze was not conceived from the beginning, but was deemed important enough to the entire sculptural program as it evolved to cause the architects to adapt the temple plan accordingly. We will consider the reasons for this drastic change in plans in a future chapter, but at present the precedents for such designs need to be considered.

SCULPTURAL PRECEDENTS

By and large continuous sculpted friezes are found predominantly on Ionic temples in Asia Minor, where they undoubtedly developed under Near Eastern inspiration. At present there is only one extant precedent for an Ionic frieze on a Doric temple and this, the architrave of the Temple of Athena at Assos, has little to do with the Parthenon in terms of material (andesite), date (third quarter of the sixth century), location (exterior architrave), or subject matter (two fights of Herakles, banqueters, and animal combat). Likewise the intriguing theory that the Parthenon frieze was directly inspired by the Persian reliefs of processioning tribute-bearers on the Palace of Darius at Persepolis seems misplaced since well-established precedents in Greek art are not lacking.[6]

Closer in medium and location to the Parthenon frieze, and visible to anyone visiting the sanctuary of Apollo at Delphi, was the frieze of the Siphnian Treasury, a small, all-marble Ionic treasury constructed ca. 525 by the newly rich islanders of Siphnos (Fig. 30). It appears to be the first sculpted architectural frieze in mainland Greece, and one of the most developed. The designer chose four different subjects for the four sides of this nearly square building, but with its proliferation of horses and its seated gods, it has some elements in common with the Parthenon frieze. Since Pheidias was commissioned by the Athenians to create a multi-figured dedication at Delphi commemorating their victory at Marathon, he presumably resided there in the 460s and would naturally have seen and studied this handsomely embellished building. He could not have helped noticing how effectively chariots and their dismounting riders fill a long frieze (west), or how gods can be depicted much larger than mortals by showing them seated (east). The lively interaction of these divinities with their excited speaking gestures, as well as the enthroned Zeus (Fig. 31), are details obviously noted by the designer of the Parthenon frieze. Likewise he would have observed the design problems inherent in two separate and awkwardly juxtaposed episodes for the east frieze, or the abrupt, anticlimactic end of the long, unidirectional gigantomachy on the north side. Another motif common to both the Siphnian Treasury and Parthenon friezes is the device of the single standing figure whose back is to the end of the block, acting like a visual caesura at the end of the line of figures.[7]

Even closer at hand, although it was destroyed by the Persians in 480 and so presumably no longer visible, was the sculpture of the Archaic temples of the Acropolis. It is possible that the Doric *Archaios Naos,* the Old Athena

Figure 30. Drawing of the Siphnian Treasury, Delphi, ca. 525. Photo: École française d'Athènes

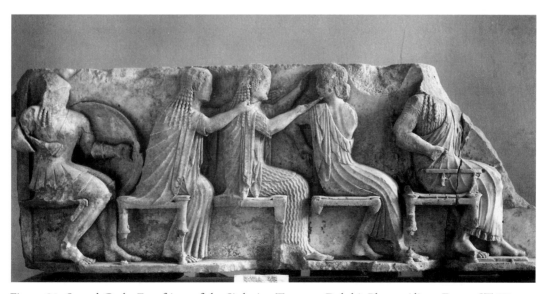

Figure 31. Seated Gods. East frieze of the Siphnian Treasury, Delphi. Photo: Alison Frantz ST 27

Temple, had some sort of Ionic frieze, since sculpted relief fragments found on the Acropolis have been assigned to this temple on the basis of the marble, type of clamps, style, and function. These fragments of a 1.21-meter-high relief band include a charioteer mounting a quadriga (Fig. 32), a male figure wearing a petasos, possibly the god Hermes, and a draped figure seated on a campstool. One fragment preserves the corner, indicating that the frieze extended over at least two sides. Given the fragmentary nature of this relief, it is impossible to say for certain that it belonged to a temple, as opposed to an altar, statue base, or parapet, but certainly the subject matter is suggestive, and at the very least provides a prototype for the religious procession.[8]

These earlier frieze compositions at Delphi and on the Acropolis suggest that the designer may have been influenced by marble precedents in his choice of motifs such as seated divinities and parades of chariots. What influenced the choice of a procession is more difficult to say. Votive reliefs with processions to deities, such as the Archaic example from the Acropolis dedicated to Athena (Fig. 33), were probably common, although this is the only one to survive from the Acropolis. Here a *kore*-like Athena wearing an Attic helmet welcomes a family of five (two boys, one of whom holds a phiale, man, girl, woman) who have come to offer a pig sacrifice. As is usually the case in votive reliefs the divinity is taller than the human worshippers, and somewhat aloof, as if she were a divine epiphany or cult statue. Her devotees are well dressed and certainly represent real individuals who may be celebrating the Apaturia, a rite in which citizen children were enrolled in their father's phratry, and in commemoration of which they dedicated this marble plaque on the Acropolis. Its relevance to the Parthenon frieze is the fact that actual Athenians are represented in a religious procession honoring their goddess on a monument set up in her sanctuary. It is worthwhile pointing out that no altar is present; given the sacrificial victim and the *phiale* (libation bowl) held by one of the boys, its presence is implied. In effect the relief commemorates the piety of the family toward Athena, as well as a specific ritual event.[9]

The similarity of such reliefs to the composition of the Parthenon frieze has suggested to some scholars that the frieze in effect was designed as one monumental votive offering. This view is supported on many counts: the scale of the deities in relation to the worshippers, the processional nature of the design in which a file (or files) of figures approach the deity (or deities), the inclusion of sacrificial animals and ritual equipment, and what might be called the dress-up nature of the occasion. Perhaps as influential in this regard as small votive reliefs were three-dimensional votive monuments, such as

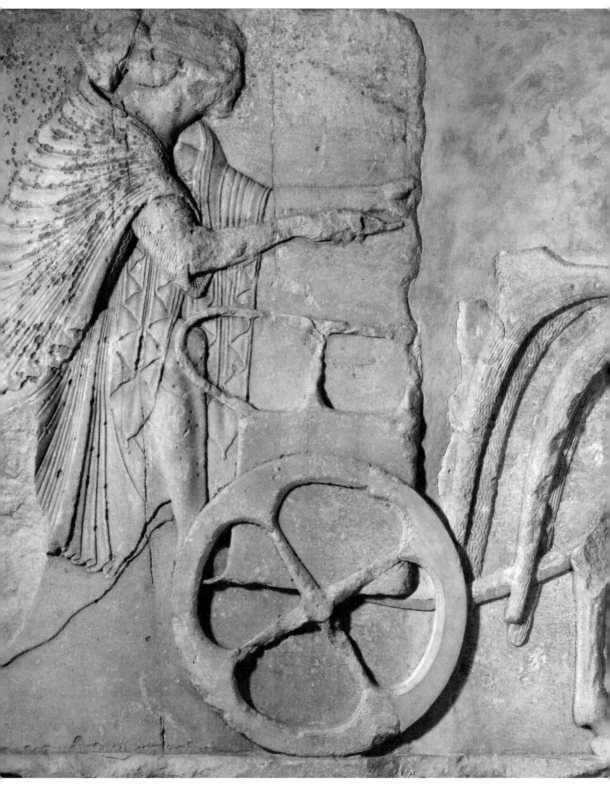

Figure 32. Marble relief of charioteer, ca. 500. Acropolis Museum 1342. Photo: Alison Frantz AT 575

Figure 33. Votive relief to Athena, ca. 490. Acropolis Museum 581.
Photo: DAI, Athens 69/1599

those dedicated at Delphi by the city states of Orneai, as described by Pausanias (10.18.5 θυσίαν τε καὶ πομπὴν χαλκᾶ ποιήματα "sacrifice and procession made of bronze"), and Pallene. Of the latter, two extant blocks (nearly 4 meters in total length) preserve cuttings for eleven life-size bronze figures, nine humans and two animals disposed in two rows, which are considered to be Archaic in date. As permanent stand-ins for the devout worshippers of Apollo, these monuments served, like votive reliefs, to immortalize the piety of their dedicators. Given the scale and cost of such dedications they cannot have failed to impress a visiting sculptor like Pheidias.[10]

Finally, mention should be made of a more modest type of sculptural dedication that may also have played a role in the design of the Parthenon frieze, namely, the statue base. One of the unique features of the Parthenon frieze is its unity of subject matter along the four distinct sides of the building. The norm for such four-sided friezes was four separate subjects, as on

Figure 34. Base of grave stele with four riders, ca. 550. Kerameikos Museum P 1001. Photo: DAI, Athens Ker 8052

the Siphnian Treasury or later on the Temple of Athena Nike on the Acropolis. In the case of Archaic statue bases with carved decoration, the front and occasionally the two lateral sides were decorated. The Riders' Base, which may have carried the grave stele of the famous *Diskophoros* (discus-holder) of ca. 550 shows four riders in low relief moving to the left (Fig. 34). There is a great variety in the depiction of the riders' age, hairstyle, dress, and position on their mounts, as well as in the stances of the horses. The bearded second rider, for instance, in a realistic touch is giving his mount more rein and pressing his bent leg to its flank in order to keep up with the prancing horse of the youthful leader. This funerary relief, and others like it with single riders, are clearly meant to honor the deceased in commemorating him permanently as an Athenian knight.[11]

Even more relevant to the frieze is the famous three-sided Hockey-Player Base, which was found embedded in the Themistoklean Wall erected in 478. It is named for the front panel, which depicts four athletes playing hockey in a very symmetrical composition. On each of the two shorter sides is an identical procession of a four-horse chariot driven by a long-robed charioteer accompanied by three hoplites, one of whom is stepping into the chariot box (Fig. 35). They form parallel processions, both moving toward the front, and in this scheme resemble the north and south friezes of the later Parthenon, where the two files converge at the center of the east. At a stretch one could also say there is unity of subject matter if the charioteers are meant to be converging on the athletic event.[12]

Figure 35. Hockey-Player Base, ca. 500. Athens National Museum 3477. Photo: Alison Frantz AT 88

RELATIONSHIP TO PAINTING

That these funerary monuments represent a long-standing tradition that existed also in other media is indicated by a series of painted tomb plaques attributed to the mid-sixth-century vase painter Exekias (Fig. 36). As recently reconstructed this large monument consisted of sixteen separate plaques around a rectangular structure approximately 3.70 by 2.70 meters. About half of the plaques represent riders and chariots in procession accompanied by female mourners; the remainder depict segregated processions of mourners, two scenes of mourning the deceased in the house, and the setting out of a cart. Except for the indoor scenes and a frontal chariot, all movement is to the right, and so this monument is not a forerunner of the frieze in that sense. However, in terms of the unity of subject matter over all four outer sides of the monument, it does serve as a precedent, and the emphasis on chariots and riders as well as the massing of marching figures, especially those shown in pairs, are also suggestive. Funerals, like festival processions, were clearly elaborate religious and social rituals that called for displaying one's finest possessions: dress in the case of women, horses in the case of men. Such painted processions were popular in Attic vase painting from the Geometric period on, and perhaps also existed in larger-scale wall painting.[13]

Nearly all early wall painting from ancient Greece is lost, so it is difficult to assess the influence of this medium on sculptors. However, in the case of Pheidias, we have some significant indications. For one, Pliny (*Natural His-*

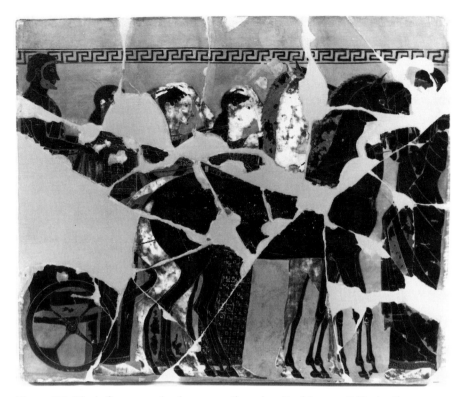

Figure 36. Black-figure tomb plaque, attributed to Exekias, ca. 540. Antikensamm-lung, Berlin F 1819. Photo: Ingrid Geske

tory 35.54) states that Pheidias began his career as a painter. Secondly, the famous painting of the Battle of Marathon, housed in the Stoa Poikile in the Agora, is attributed by both Pliny (*Natural History* 35.57) and Pausanias (5.11.16) to Pheidias' brother (or nephew) Panainos. The two also collaborated on the great *Zeus* at Olympia, which was completed after the *Athena Parthenos*. Thus, it seems that Pheidias had a close familiarity with monumental painting, a field in which some of the greatest artistic achievements of the early Classical period were realized, according to our sources.

The most famous of these was surely the painting of the Battle of Marathon, executed for the Stoa Poikile in the second quarter of the fifth century and now known only through the description by Pausanias (1.15.1). From his brief text it appears that the action moved from left to right, beginning with a battle between Greeks and Persians on equal terms, proceeding to a rout of the Persians, and finally a last-ditch fight at the Persian ships as the barbarians attempted to escape. The action thus moves both spatially and temporally across the picture plane. This sophisticated technique of a coterminous spatial and temporal progression is virtually unique in Greek narrative art as we know it; its only other occurrence is on the Parthenon

frieze, as we shall see. Because the art of wall painting was more developed at this time in terms of narrative, it most assuredly acted as an important influence on the design of the frieze, and its impact will be seen in the poses of several figures (Chapter 4). Before analyzing the time-space continuum of the frieze, however, it is important to consider some of the challenges facing a designer of a very long, relatively narrow frieze.[14]

DESIGN CHALLENGES

Variety was probably the biggest challenge facing the designer. How to fill a 160-meter frieze with a single subject and yet not bore the viewer? As we shall see in a later chapter, the procession does not represent every aspect of the Panathenaia, and so clearly the designer selected those elements that would best fill and yet give variation to this long expanse, such as racing chariots. In doing so, however, he met further challenges.

One important principle governing Greek relief sculpture to which the designer had to adjust his design was isocephaly. This tradition, whereby figures stand on a single groundline and their heads uniformly reach the top of the frieze, operated almost universally throughout architectural relief sculpture. Isocephaly is not a problem if all figures are at ground level and of equal stature. However, it poses challenges when some figures are mounted, either on horses or in chariots, or when some are divine and so of greater physical stature than mortals (e.g. Fig. 33). Part of the genius of the Parthenon frieze's design is the naturalistic and convincing manner in which the artist has coped with this challenge, so that the viewer is not aware of the fact that the horses are too small for the riders, or that the gods, by being seated, are one-third larger. A few subsidiary figures who are younger and so of smaller stature help to vary the otherwise monotonous composition of standing figures.

Another considerable design challenge was the avoidance of monotony; with so many figures moving across such a vast expanse, the repetition could become tedious (as it must, for instance, with the procession reliefs at Persepolis in Persia; see Fig. 134), and Greek art was never, or hardly ever, formulaic and repetitive. The designer did in fact adopt a formula, but it is so subtle that it is hardly noticed. For the long sides with endless files of quadrupeds, the simple a-b-a format consisted of varying the pace of the animals: walking, racing, walking. This is particularly evident in the case of the cattle who march slowly, become restive, and then calm down. But it is also applied to the chariots and the horsemen, albeit over a much broader expanse. While enabling scholars to reconstruct the frieze correctly, this rhythm also adds interest and variety to an otherwise pedestrian composition.[15]

The designer also introduced other subtle variations in the general movement from west to east. In particular, he used the sporadic figure of the marshal to act as a hiatus in the long forward movement occurring on the flanks of the building. The marshals often face in the opposite direction of the procession or stand frontally, a device that is known in art as "temporary retardation." According to one scholar this device works as "a strong incentive toward forward movement."[16] It is hardly used at all in the south frieze but is quite common on the north (e.g. N12, 45, 66, 72, 90). Likewise successive stages of a given action were employed in order to vary the rhythm of the procession. The best example occurs with the *hydriaphoroi* of the north frieze (Fig. 37). Like the three Magi adoring the Christ child in Italian Renaissance painting, each figure's action is a stage more advanced than the one behind. On the frieze the last youth (N19) is bent over and reaching down to pick up his water jar. The next (N18) stands and rests the jar on his shoulder, while his predecessor adjusts the position with his raised left hand. Only the first (N16) is marching forward, his head in complete profile. This phased action not only provides variety, but it also conveys a temporal progression, thus indicating movement in both space and time.

SPACE AND TIME

The format of the Parthenon frieze has never fit neatly into the categories of narrative devised by historians of Greek art. Both the setting and the time of the procession are at issue. Is there unity of time and space, i.e., do all parts of the procession take place in a single moment at one location as in most of monoscenic Greek art? Or are time and space more variable? Scholars who have studied the frieze have provided a variety of scenarios. One, for instance, argues for a single locale, the Dipylon Gate, and a single moment, the gathering for the procession (although why the gods would be sitting somewhere outside the city walls is never explained).[17] Others concur that we are seeing the procession at a single moment in time, that is *before* the procession begins (given the preparations in the west, the expectant attitude of the gods, etc.), but claim that the locale is different for each part (procession forming in the Agora while the gods and officials wait on the Acropolis). The frieze then shows "a highly selective panoramic overview of the moment before the great Panathenaic procession is to commence."[18] Reluctantly abrogating unity of time and place, many have tried to restrict time and movement, arguing that "the temporal progress is from preparation to an act early in the course of the procession (the reception of the *peplos*), and the spatial progress a fairly restricted one along the initial stretch of the

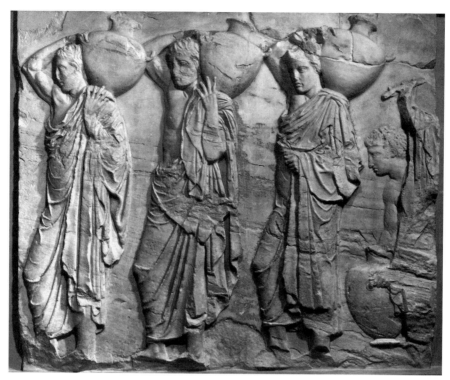

Figure 37. Hydria-bearers, N16–19. Acropolis Museum. Photo: Alison Frantz AT 161

Panathenaic Way into the Agora."[19] Most, however, view the procession as moving across space, and in doing so, an elapse of time is implicit.[20]

It is perhaps preferable to liken the narrative of the frieze to something slightly more ambitious, namely, the Marathon painting that preceded and surely influenced it. Hereby the frieze's narrative consists of an unusual (but not unprecedented) time-space continuum highlighting specific, select aspects of an event that took place over an expanse of distance and time. The designer had to cope with these discontinuities of time and space in order to produce what appears to be a seamless narrative moving inexorably toward and, as we shall see, eventually beyond, its conclusion. The restricting of the frieze to one time and/or one place necessarily results in a "downgrading" of the action to mere preparatory to-do instead of progress toward a conclusive action. The following scenario takes into account the action of the viewer who physically moves with the procession, a movement that inevitably involves lapsed time.

As has been noted, the west frieze, and in particular the southern part, shows some preliminaries to the procession. Nine of the twenty-three horses are unmounted (as opposed to only two horses on the north side). One of

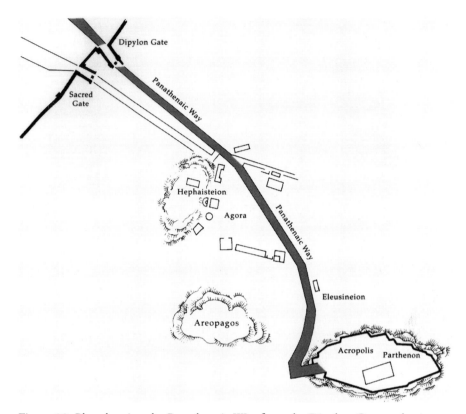

Figure 38. Plan showing the Panathenaic Way from the Dipylon Gate to the Acropolis. Drawing: R. Rosenzweig

these horses (W XIV, see Fig. 75) is even headed in the opposite direction, and it, along with the rearing horse on West VIII, are out of control. This (W XII–XVI), like the "equal" battle of the wall painting, is phase I of the event, and if it involves a procession to the Acropolis, it can be placed in the vicinity of the Dipylon Gate, outside the walls of the city. Phase II, on the west (north two-thirds), north, and south sides, shows the procession proper, moving along apace with no obvious interruptions.[21] Clearly here the procession is marching on a smooth, broad roadway, certainly the Panathenaic Way stretching from the Dipylon through the Agora and up to the Acropolis (Fig. 38).[22] Finally, in phase III (east frieze) the procession converges at an assembly of deities and a ritual event. The movement is more subdued and surely takes places on sacred ground, the *temenos* of Athena. The differences in temperament alone in these three sections suggest subtle changes in venue, and the striking contrast between the west and east friezes indicates a progression in time from beginning to end.

The designer has reinforced this progression visually by two key figures:

Figure 39. W30, cast. Skulpturhalle, Basel. Photo:
D. Widmer SH 637

the first (W30, Fig. 39) and the last (E34, Fig. 53). Both are posed frontally in
a similar stance with weight shifted onto their left legs. Both have their left
arms extended and their right bent at the elbow. And both are dealing with a
large piece of cloth. The youth at the beginning of the frieze, like many youths
shown in the palaistra (e.g. Fig. 40), is adjusting his *himation* before draping it
over his body. The older man, with the help of a child, is folding up an equally
large piece of drapery. The designer has ensured that these actions deliberately
echo one another, signaling on the one hand the preparations for and on the
other the denouement of the event – beginning and end.[23]

Thus, the narrative of the frieze, like its predecessor the Marathon painting,

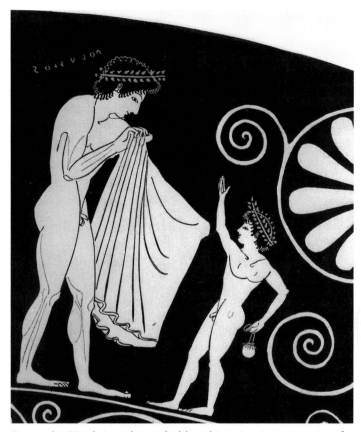

Figure 40. Youth in palaistra holding himation in preparation for dressing. Detail of red-figure calyx-krater, attributed to Euphronios, ca. 520. Antikensammlung, Berlin F 2180. After Furtwängler-Reichhold, pl. 157

illustrates a sophisticated narrative progression through space and over time. As the viewer moves from the west end of the temple to the east, he in effect recreates this movement, thereby enacting anew, and in a sense reliving, the religious procession. However, upon closer examination, the spatial construct of the frieze is even more developed, as we shall see, both on the flanks with the ranks of horsemen and on the east side with the seating plan of the gods.

THE RANKS OF THE HORSEMEN

The majority of the marching figures on the frieze proceed in single or double file without a great deal of overlapping. This is not the case, however, with the horsemen on the north and south sides, where the

designer has gone to the trouble to show as many as eight horses overlapping. This overlapping of horses represents serried ranks, or groups of horses, that are meant to be read as riding abreast, not in single file. The designer has provided subtle visual clues to indicate where one rank ends and another begins.

The groups on the south frieze are the most readily perceptible because the sixty horsemen are divided into ten ranks of six each, with individual ranks distinguished by costume. These divisions are the most obvious in terms of headgear: Thracian caps (the *alopekis*) for the first rank (S2–7); Attic helmets with cheek flaps raised for the seventh rank (S38–43); *petasoi* (or broad-brimmed hats) for the ninth rank (S50–55). Among the bare-headed groups, the second (S8–13) is distinctive in being the least dressed, only a *chlamys* over the otherwise nude body. The third rank (S14–19) wears merely a short tunic or *chitoniskos,* double-belted, while the fourth (S20–25) wears tunic and *chlamys.* The fifth (S26–31) and sixth (S32–37) wear contrasting body armor: metal cuirasses versus leather corselets with flaps. The footwear varies between sandals and *embades* (leather boots) but is fairly consistent within the individual groups.[24]

The riders, as noted above, are meant to be riding abreast in ten rows of six each. In order to indicate this on a flat relief without the devices of illusionism the designer was forced to spread them out like a hand of cards. The result is that the outermost rider, i.e., the one closest to the viewer of the procession, is at the end of the rank (just like cards splayed out to the left). These outside riders in fact are easy to pick out because the artist has ensured that there is blank space around their heads, and the full extent of their mounts is shown. This is particularly obvious in the case of the best preserved outside riders: S2, S8 (the only one of his group to wear a hat, which has been pushed back behind his head, see Fig. 69), and S26. There is also often a considerable gap between the groups of riders (especially between S43 and S44), as one would expect from serried ranks. Clearly these divisions were part of the original design of the frieze.

On the north side the situation is more complex, but nonetheless legible if one knows the visual clues to look for. There are again some sixty horsemen, but they are not divided into equal ranks. In fact, according to the Jenkins' plan it would appear that the number in each rank varies from as few as two (N81–82) to as many as eight. Jenkins and others, thus, obtain ten ranks of very unequal numbers. However, if one carefully reads the figures from the frieze itself, rather than the ground plan, it becomes evident that the artist designed not ten ranks, but eight, each of which includes

Figure 41. Plan of the horsemen of the north frieze (N75–135) with rank leaders indicated. Drawing: R. Rosenzweig after Collignon, pl. 75

seven to eight riders (Fig. 41). The rank leaders are conspicuous either by their pose of looking back, as noted by Beschi, and/or by their greater nudity, which makes them stand out from the other more fully garbed riders, as well as by the fact that they are often sharply reining in their mounts.[25]

To begin at the west end, two youths (N133 and 135) have not yet mounted and so seem more closely connected with the west frieze.[26] The eight horses in this group are less well ordered than in subsequent groups (see plan Fig. 41), as they have not yet assumed their rank positions. Their leader is probably the foregrounded and so dominant figure (N133), who is shown frontally and signals with his raised left hand. The next group of seven (N121–27) has nearly assumed a serried rank, and if one went by the rules of the south frieze the lead rider would be the one closest to the viewer, W127, who also raises his right hand to his head. The third group consisting of seven riders (N114–20) is in order and so its leader (N120, Fig. 42) does not need to look back, but simply signals with his raised right arm and reins in his mount. Note his conspicuously nude torso seen in back view. The next lead rider is clearly N113 (Fig. 43) who has all the requisite characteristics: looking back, nude torso, left free arm hanging over the rump of the horse.

The next groups are more complicated: there are either three very small sets (5,6, and 4 riders, respectively, according to Jenkins' plan), or we are dealing with two ranks that have collided and coalesced. That the latter scenario is more likely is indicated by N105 (Fig. 44), who, because of his pose, must be a leader (as opposed to N108 and N102, who according to the ground plan are the front riders). He, like the better preserved front riders N98 (Fig. 45) and N113 (Fig. 43), turns his upper body to the front, looks around behind, and has his free left arm dangling back over the haunch of his mount. The long, nude body of this figure from head to toe is also particularly distinctive. These arresting figures are so much alike and punctuate

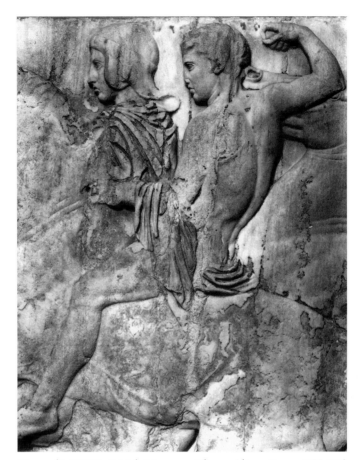

Figure 42. N120. British Museum. Photo: Alison Frantz EU 176

the frieze at such precise points that they all must perform the same role in the cavalcade, namely, as rank leaders, even if they are not in the foreground plane. Thus, the division between the fourth and fifth groups falls at the embedded figure N105 (Fig. 44) rather than at one, as we have come to expect, in the foreground plane. This pose appears once again with the leader of the next rank, N89 (Fig. 46).

In reference to this figure Jenkins has observed, "Such figures looking back over the shoulder serve at regular intervals to mark the passage of the ride-past. Almost invariably they mark the plane nearest to the viewer."27 However, the designer has subtly altered this scheme in the middle of the cavalcade to add even more interest and a touch of reality to an already varied composition. The fact that there are eight ranks of riders on the north side will become important when we consider the parallelism between the two branches of the procession.

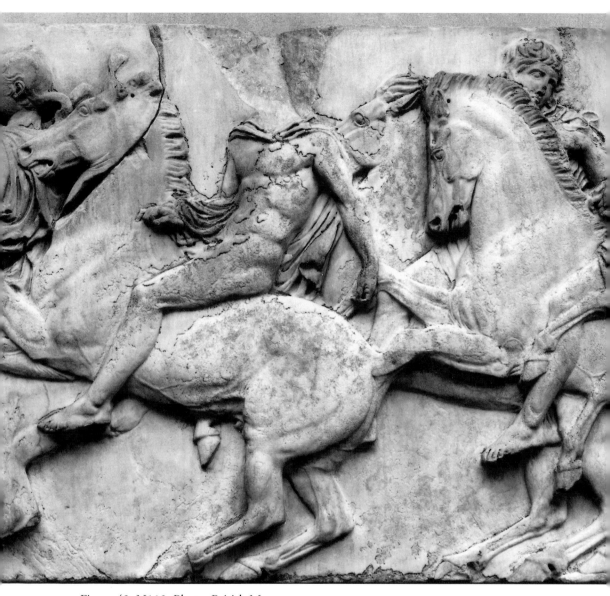

Figure 43. N113. Photo: British Museum

PARALLELISM OF NORTH AND SOUTH

In recent scholarship on the frieze it has become increasingly clear that
there is a strong parallelism in content between the north and south
friezes. Although some individual elements, such as sacrificial animals,
may vary – sheep on the north but not on the south – in general, the types
of participants and their ordering are exactly parallel. Victims followed by

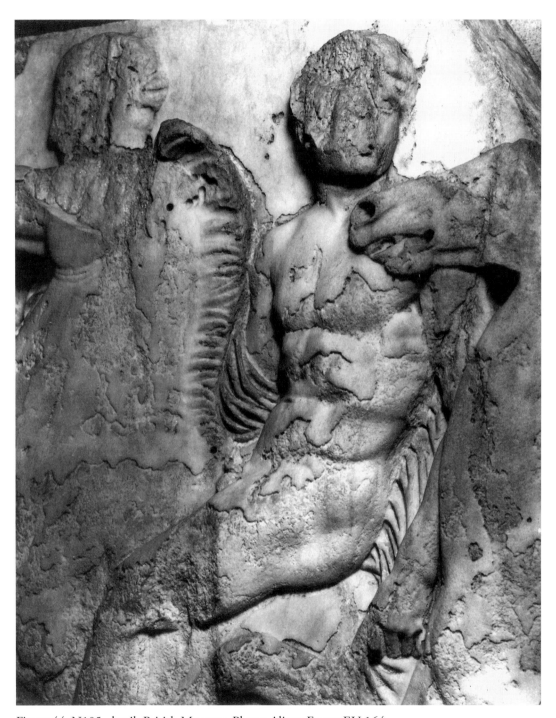

Figure 44. N105, detail. British Museum. Photo: Alison Frantz EU 164

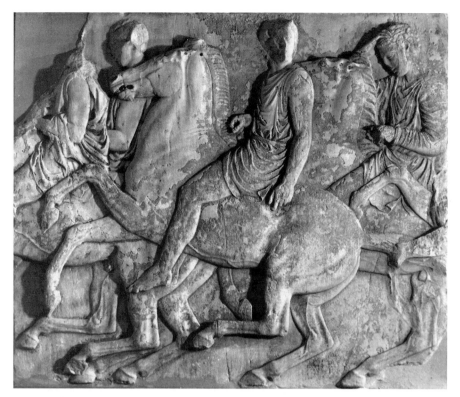

Figure 45. N98. Acropolis Museum. Photo: Alison Frantz AT 173

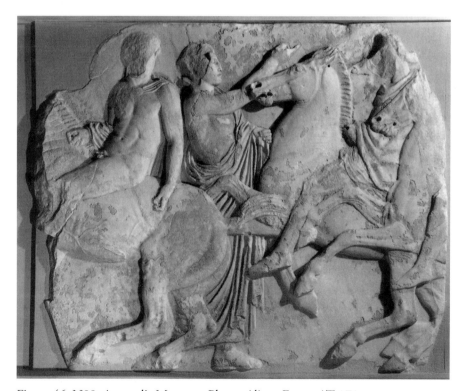

Figure 46. N89. Acropolis Museum. Photo: Alison Frantz AT 171

tray-bearers, *kithara*-players, and elders occur in both processions. Carrey's drawing of south figures 107–110 (Fig. 47) depicts them as *pinax*-(plaque-) bearers, but it is probable that he misinterpreted the surviving lower part of the *kithara*'s sound box. Although as yet no water-carriers or *aulos*-players survive from the south, given the conformity of the two processions, it is almost certain that they should be restored here in the missing sections.[28]

This congruence extends over to the east where the maidens and marshals form the culmination of each line of the procession. The question then remains of whether, and if so, how the west frieze plays into this scheme. In terms of direction the west frieze belongs with the north because the prevailing movement is to the left. West 2–11, consisting of eight horsemen, could be construed as a group, like those in the north cavalcade. Behind W11 stands a figure, facing right and tying his sandal; he clearly marks the beginning of the next rank, as the marshal facing right (N90) does on the north side. There follows a group of eight mounted men with a ninth (W15, see Fig. 85) dismounted. In the last third of the west frieze, again introduced by a standing figure facing right (W22, see Fig. 90), there are no mounted horsemen, although it is usually assumed that they are making preparations to mount. With six horses and nine men it is not entirely clear which horse belongs to whom, and it is possible that these horses should not even be considered eventual participants in the procession (see Chapter 5). It has been observed that the horse on slab XII (see Fig. 90), which is rubbing his nose along the cannon, has underdeveloped withers and very long legs. It is a filly, and so it is likely that the official standing before it (W22) may be rejecting it from the parade.[29] The horse on slab XIV (see Fig. 75) who is out of control and even facing the wrong direction, is also not a good candidate for a regimented procession. If one takes the first two groups of riders (W2–11 and W13–21) and adds them to the eight groups, as now correctly observed on the north, one ends up with the same number of ranks as the south side, namely, ten, although the total number of riders is obviously different (77 vs. 60). That the total numbers were less important than correspondence of groups is indicated by, for instance, the number of maidens in each file on the east side: sixteen in the southern procession and thirteen in the northern. Likewise the number of officials, sacrificial animals, etc., varies from north to south. This lack of symmetry in otherwise parallel streams adds interest and variety to the frieze in a way that a perfectly balanced composition might not. When one reaches the center of the east side the spatial arrangement becomes even more complex.

Figure 47. Carrey drawing of south frieze (S107–10)

THE SPACE OF THE GODS

The layout of the procession on the two flanks of the Parthenon demanded a destination or climax on the east. In fact the designer provided two in the form of two sets of seated divinities who receive the two files of the procession. As on the votive relief discussed earlier (Fig. 33), it was a common practice to increase the scale of the gods so they would be readily identifiable. Here this scale differential is achieved in a more naturalistic way by depicting the gods as seated; if they rose from their seats they would be one-third taller than the humans standing near them. In this way the isocephaly of the frieze is preserved, and the disparity in size is not readily apparent. The twelve gods are divided into two equal groups of six with one smaller (that is, younger) standing attendant in each grouping: Hermes, Dionysos, Demeter, Ares, Hera with winged attendant, and Zeus facing left (or south), and Athena, Hephaistos, Poseidon, Apollo, Artemis, and Aphrodite, with Eros facing right (or north). The groups are not strictly symmetrical, since Dionysos (E25) is seated facing the center, unlike all the other divinities, who are posed facing outwards.

A problem that has persistently confounded scholars is the fact that the

61

gods, with that one exception, have their backs to the central scene, the ceremony of the *peplos* and the highpoint of the festival in honor of Athena. As Jane E. Harrison once noted, "No artist in his senses would have so arranged the slabs that Athene should actually turn her back on the gift offered her."[30] Others have cited it as a design flaw. P. E. Corbett, for example, stated: "The composition has however a weakness, which may at first pass unnoticed in the general excellence of the execution; the gods turn their backs on the central group, and though Apollo, Hephaestus and Hera look around at their neighbours, and so toward the middle, the abruptness of the division cannot be ignored."[31] Various ingenious explanations have been offered as to why the gods are posed thus: the artist thus indicates their invisibility;[32] the designer has attempted to show that the ceremony of the *peplos* is taking place within the Parthenon, and so out of sight;[33] the central ceremony represents not the presentation of the *new peplos,* but simply the folding of the *old* one, and so is not worthy of special notice;[34] it is possible that the cloth is not a *peplos* at all but some other garment offered to the statue of Athena;[35] the gods are intentionally placed thus as it is unseemly for them to witness a human sacrifice.[36] All of these proposed solutions are awkward at best and generally cannot be reconciled with the overall high quality of the design of the frieze.

A new approach to the dilemma is clearly called for, one that addresses the issues of space and setting, rather than positing hypotheses based exclusively on iconography. It seems clear that the designer of the frieze was wrestling with a spatial conundrum; the viewer is presented with a solution, but what we need to determine is the design problem with which the artist was grappling. By looking at other frieze compositions with groups of deities, such as the east frieze of the Siphnian Treasury at Delphi (Fig. 31) or the east frieze of the so-called Hephaisteion in Athens of ca. 430 (Fig. 48), we also find two groupings of gods; however, they are confronting each other. On the Siphnian Treasury the gods are debating the outcome of a Trojan War battle depicted on the right half of the frieze. In the case of the Hephaisteion six gods, divided into two groups of three, are watching a battle taking place between them. In the first instance the gods are certainly meant to be on Mt. Olympos, and in the latter they are seated on rocks, probably in the Attic countryside. Hence, in respect to both arrangement and subject matter these scenes offer no exact parallel for the east frieze of the Parthenon.

If we imagine the gods of the Parthenon frieze as acknowledging the processions (as Aphrodite clearly does by pointing it out to Eros) *and* as witnessing the *peplos* ceremony as surely they must, then a seating plan must be

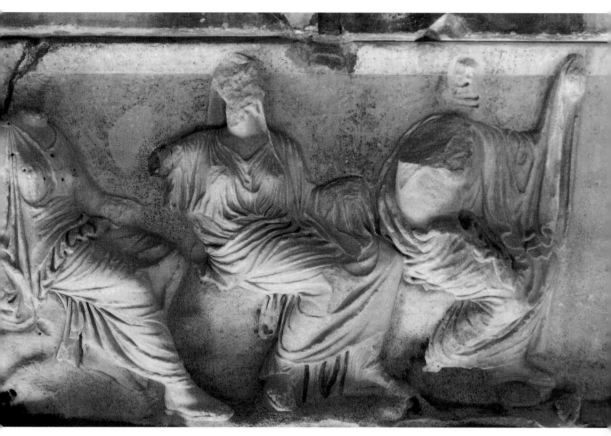

Figure 48. Three seated gods. Hephaisteion, east frieze. Photo: Agora Excavations, American School of Classical Studies at Athens

devised that takes into account these two events. An arrangement that acknowledges all three of these foci (two processions and *peplos* ceremony) is a semicircle. In 1892 A. H. Smith suggested that the *peplos* ceremony was meant to be taking place "in front of the two groups of gods, who sit in a continuous semicircle,"[37] but this idea has not been generally accepted by scholars even though it neatly solves the spatial problems and puts Athena and Zeus side by side, as one might expect to find them.[38] Where exactly might this semicircle be? Smith states, "These deities are supposed to be invisible, and doubtless, in a picture they would have been placed in the background, seated in a semicircle and looking inwards."[39] However, by placing the semicircle of seated gods in front of and facing the temple (which temple is still an issue), the *peplos* ceremony can be read as taking place in the center and the procession as arriving in two streams at the two ends of the arc of seated gods (Fig. 49). The north procession is received by Aphrodite and the south by Hermes, the two divinities closest to the

Figure 49. Reconstruction of gods on east frieze. Computer simulation: J. Delly

people.[40] This seating plan takes into account *both* the two files of the procession *and* the ceremony. If we project this arc convexly to the front of the Parthenon and then try to imagine how an artist would depict this spatial arrangement on a flat frieze without the devices of illusionism at his disposal, we arrive at precisely the solution he adopted. The designer in effect had to flatten the semicircle onto the low-relief band, leave space in the center for the *peplos* ceremony, and rotate the gods into profile positions for complete legibility. It is analogous to, but not precisely the same as, what he did with the ranks of horsemen who are splayed out to indicate spatial depth.[41]

A closer look at the poses of the gods lends support to this configuration. In many instances we see them deliberately turning to the front, unlike the Siphnian Treasury, for example, where they are in strict profile. Eight (Dionysos, Demeter, Hera, Zeus, Hephaistos, Apollo, Artemis, Aphrodite) of the twelve present their upper bodies to the viewer, as if it were a clue that one is meant to read these figures frontally. The persistent overlapping of these figures also suggests a three-dimensional as opposed to planar arrangement. In an earlier period vase painters may have been grappling with similar problems of trying to represent the gods in a semicircle, as for example the nine seated gods (including Herakles) on an amphora by Exekias (Fig. 50).[42] At first glance they appear to be placed helter-skelter, overlapping and facing one way or the other, in no apparent order, but if viewed as a concave semicircle with Zeus, Herakles, and Athena in the center, the arrangement is much more logical. Thus, the varied poses of the gods on the frieze, which seem at first glance to be natural and casual, almost anecdotal, are clues to the viewer of a spatially more complex composition.[43]

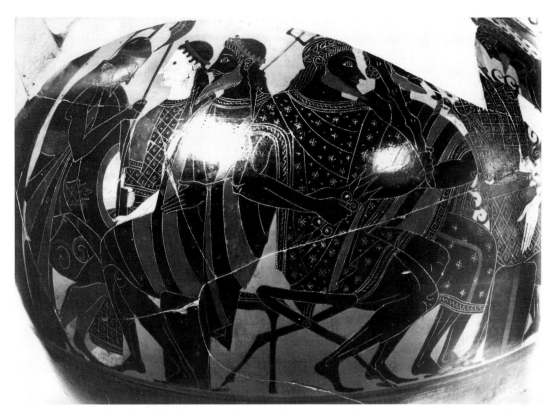

Figure 50. Seated gods. Black-figure amphora attributed to Exekias, ca. 530. Museo Faina, Orvieto 2748. Photo: DAI, Rome 61.1211

It is often claimed that Greek art, whether painting or relief sculpture, was purely two-dimensional, with no attempt to show depth other than via corporeal perspective. That Greek artists of the fifth century were entirely capable of designing in three-dimensional terms is indicated by vase paintings, like, for instance, that on the outside of a cup by Douris (Fig. 51).[44] This symposium scene shows banqueters reclining on three couches, two of which are shown in profile, the third depicted head on with the symposiast's back towards the viewer. Given the serving boy posed behind the table alongside the couch, this furniture is clearly meant to be projecting beyond the picture plane and into the viewer's space. This foreshortening was a popular device in Attic red-figure vase painting of the late sixth and fifth centuries and accurately reflects the actual space of the *andron* or men's dining room, where couches were arranged end-to-end along the four sides of the usually square room. Thus, it would not have been a radical departure for a Greek viewer to project the gods of the frieze out into his space as he viewed the facade of the temple.

Figure 51. Red-figure cup attributed to Douris, ca. 480. British Museum E 49. Photo: museum

Another element that supports this configuration of the frieze is the pivotal figure E47 (Fig. 52), who is taken to be a marshal. Although he is situated on the northern half of the east frieze just beyond the group of standing male figures (E43–46), he is shown raising his right hand to beckon to the first maiden at the head of the south procession (E17) who is three slabs away. Jenkins has written, "His gesture must be intended for the head of the procession on the south side of the east frieze. Here we have a subtle reminder that the two processions are in fact one."[45] The marshal's sight line in effect creates the cord of the semicircle by cutting across the gods, the *peplos* ceremony, and the two groups of standing male figures. His simple gesture across space serves to indicate that all of these figures are physically situated beyond, or in terms of the Acropolis topography to the east of, the heads of the two processions. He serves also to separate visually the human from the heroic/divine realm by creating a dividing line across the intervening space. As we shall see in the discussion of the iconography of the gods, this semicircular arrangement has resonance with certain aspects of Athenian cult practice.[46]

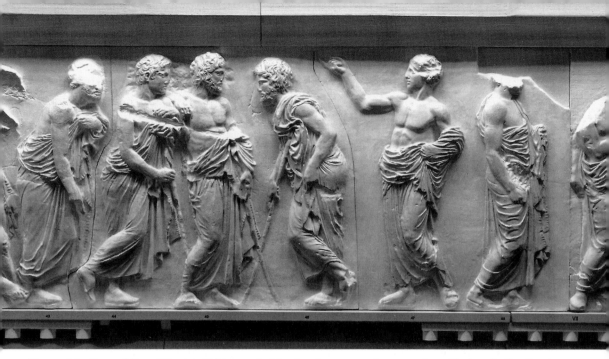

Figure 52. Cast of East VI with E47, marshal beckoning to south procession. Skulpturhalle, Basel. Photo: D. Widmer SH 341

TEMPORAL ASPECTS OF THE PEPLOS CEREMONY

As many scholars have noted, this scene over the east doorway to the temple is strangely anticlimactic, at least visually, and yet it was important enough to dictate the layout of the entire frieze into two processional files. It was here that the design must have begun and for which an exceptionally long block was ordered, quarried, and set into place. From this central point more-or-less symmetrical groups of figures, presumably decreasing in importance (gods, heroes, women, victims, carriers, *apobatai,* mounted cavalry, men and horses) fan out on both flanks, encircling the cella. What can we make of this unimpressive quintet? It consists of two unsymmetrical groups of three figures on the left and two on the right who seem to be enacting two unrelated rituals, since the main adult figures (E33 and E 34) have their backs to each other.[47] The ritual importance of this scene (which has always been difficult for us to understand in the absence of any related imagery) then must have over-ridden any ambition on the part of the designer to make it more exciting or dramatic in design terms. Its central position on a long block over the east entrance signals its importance, the significance of which will be discussed in Chapter 6.

However, its temporal relationship to the rest of the procession is important to consider even if absolute certainty over the meaning of the event

eludes us. It is clear from the way the cloth is being handled by the man and child (E34–35, Fig. 53) that the garment is being folded up, not unfolded. Evelyn Harrison has described the action as follows: "The man holds up the cloth in his two hands with the part of it flapped over, rotating it down until the thick fold is in line with the selvages below. The child is smoothing out the wrinkles and helping to bring the corners together. The artist has indicated the folds and single edges so precisely that we can tell the exact order of the folding."[48] Normally the folding up of an article of clothing would indicate that it is going to be put away for storage, and this would imply that the ceremony, whatever it was, is completed.

Why would the designer choose to depict the postlude rather than the presumably more momentous ritual event? In Greek ritual the actual moment of the religious act, whether it be sacrifice, augury, or gift-giving, is potentially unlucky because the rites could go awry. So, for instance, Greek art depicts either the time before the animal sacrifice (the procession) or its successful outcome (usually the meat cooking on the altar) but never the kill itself.[49] In a similar fashion the frieze shows the procession and the denouement but not the Greek equivalent of the consecration of the host. By choosing the moment *after* the presentation of the *peplos,* the well-being of the *polis* is assured, just as the meat burning on the altar demonstrates the successful outcome of a sacrifice.

This reading is perhaps confirmed by the other events depicted on the east end of the temple. Whereas at the west end, which the viewer encounters first, all is in a state of flux (ongoing contest of Athena and Poseidon in the pediment, undecided battle of Greeks and Amazons in the metopes, preparations for cavalcade on the frieze), by the time he reaches the east end all is satisfactorily concluded. The viewer is left in no doubt as to the outcome of any of the mythological events portrayed in the architectural sculpture or on the cult statue. In the east metopes the presence of the sun-god Helios at the far right indicates that the long night of fighting the giants is over. The tide has turned in favor of the gods and victory is assured. In the pediment above the sun rises as the moon (or night) sets, thereby providing the viewer not only with a locale (heaven) but a time (dawn) as well. As for the specific timing of the action, the full-length standing pose of Athena indicates that the birthing process from the head of Zeus is completed (this in contrast to the Archaic images that show her half-length and literally popping out of her father's skull). Going inside the temple to the base of the *Athena Parthenos* one sees that the action of creating Pandora has been finished and she is being adorned by Athena and Hephaistos. Thus, all these sculptures suggest a time after the main action or the successful outcome of a cataclysmic event. This timing contrasts markedly with the east pediment

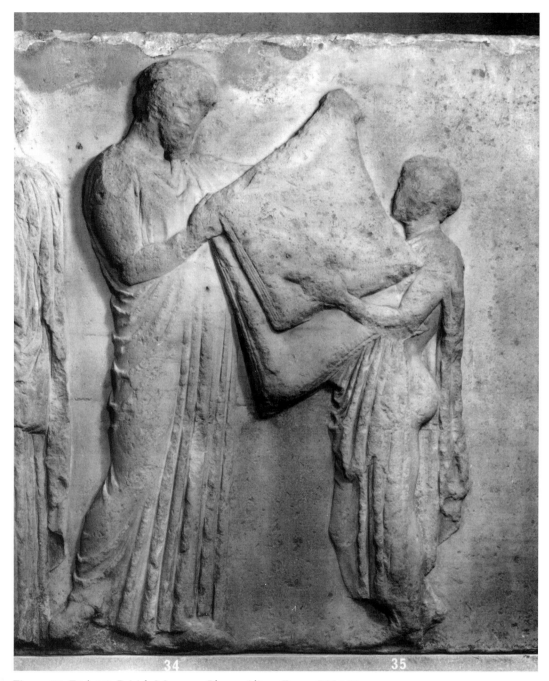

Figure 53. E34–35. British Museum. Photo: Alison Frantz EU 137

of the Temple of Zeus at Olympia (Fig. 24), where there is a strong feeling of foreboding and anticipation of events to come.

In one sense ritual is timeless, since by nature it occurs again and again. The designer of the frieze has captured this feeling of the endless repetition

Figure 54. View of central portion of east frieze between columns of peristyle. After Stillwell, 1969, pl. 63

of a ritual event in the low-key, calm, understated demeanor of his figures. There is no anxiety or foreboding here. Just as Nike (Victory) has alighted on the hand of the *Athena Parthenos,* so victory is assured by the yet again successful completion of an ageless ritual in honor of the city's patron deity. As if to capture this image for all time the designer has bracketed it with the two central columns of the eastern peristyle (Fig. 54); it is the only self-contained scene in the entire frieze that is framed so carefully for the viewer approaching the temple. In this way the ritual of the *peplos* is made static and eternalized.

POSTSCRIPT ON THE DESIGNER(S)

The foregoing discussion of the composition of the frieze indicates that the design is extremely sophisticated. It has also shown that many of the more progressive aspects occur on the east and the north, as opposed to the south and west. Other design differences could also be mentioned, such as the fact that the *apobatai* on the south either stand alongside or ride in their chariots but are not actively dismounting as on the north, or the greater nudity and frontality on the north frieze as opposed to the south. The north frieze has two kinds of sacrificial victims, sheep and cows, while the south has only cows. The massing of overlapping and interacting figures on the east side is completely different from the widely spaced and more isolated figures of the west frieze, as we have already mentioned.

While these differences may have iconographic significance, they might also indicate the possibility of *two* designers. After all, the Parthenon had two architects, Iktinos and Kallikrates. While at first the likelihood of two designers for what looks to be a very unified whole is dubious, when seen in the context of other Greek sculptural programs it is not improbable. We are certain on stylistic grounds that the Siphnian Treasury at Delphi was executed by two artists; the west and south friezes by a Master A, possibly Ionian, and the east and north by Master B, probably Athenian. The latter friezes are also more advanced in terms of composition, so besides collaboration there was also probably a degree of competition. Pausanias (5.10. 8) tells us that the pediment sculpture of the Temple of Zeus at Olympia was by two different artists: the East is ascribed to Paionios and the west to Alkamenes. While these specific attributions are contested, the point remains that the two pediments were believed to have been executed by two artists, in spite of their great similarity of style. Closer to home, there are numerous instances of collaboration, as for example the Tyrannicides by Kritios and Nesiotes (Fig. 19), not to mention the double signatures found on Attic pottery indicating the close collaboration of potter and painter. In the case of the Parthenon metopes, it has been suggested that the less progressive sculptors were relegated to the less important west facade and the less visible south side, and this may have applied to the designers as well.[50] This arrangement, if valid, would then provide a model for the frieze, which was carved immediately after the metopes. Early on in the process the designer of the west and south friezes might have sketched out his designs, and they, in turn, could have prompted a second designer to strive for improvements on the other two sides. This scenario, is, of course, not provable, but it does jibe with what seems to be a common practice in the execution of important artistic projects in ancient Greece. Collaboration and competition may well have been complementary spurs that impelled Greek art on its ever-changing progressive path.[51]

Figure 55. *Phidias showing the frieze of the Parthenon to his friends.* Oil on panel by Sir Lawrence Alma-Tadema, 1868. Birmingham Museums and Art Gallery. Photo: museum

TECHNE

CARVING OF THE FRIEZE

> With modern-day stone-cutting implements,
> construction of the Parthenon by the same
> stone masons and sculptors would require
> at least double the time, and the quality of
> the surfaces would not approach the level
> of perfection left by the ancient tools . . . it
> would be impossible today to complete
> construction in so perfect a manner in the
> astounding time of eight years.
> – Manolis Korres (1995, 7)

Once the complex design of the frieze had been conceived, drawn up, and accepted by the overseers of the temple, it became the task of a team of stonemasons, sculptors, metalsmiths, and painters to carry out the plan. First the requisite blocks had to be quarried from Mt. Pentelikon, transported the nineteen kilometers to the Acropolis, and finally hoisted into place atop the architrave of the porches and long walls of the cella. As the carving proceeded the sculptors refined their techniques and became capable of ever more impressive effects. Finishing touches in the form of color and metal attachments were added at the end (Fig. 55).

Given the different technical aspects of the work and the rapidity with which it was completed, a team of artisans versed in various media was necessary. Plutarch (*Perikles* 12.6) provides a detailed list of the kinds of materials and skilled workers required by a project the size and scope of the Parthenon, many of which were necessary for the frieze:

> The raw materials were stone, bronze, ivory, gold, ebony, cypress-wood, and to fashion and work them were the trades: carpenters, modelers, bronze-smiths, stone-workers, gilders, ivory-workers, painters, inlayers, workers in relief. Then there were the men engaged

in transport and carriage, merchants, sailors, helmsmen by sea, and on land wagon-makers, and cattlemen, and muleteers; rope-makers, flax-workers, leather-workers, road-makers, quarrymen and miners. And each craft, like a general with his own army, had its own crowd of unskilled hired laborers and individual craftsmen organized like an instrument and body for the service to be performed.

This wide variety of materials and artisans can also be found listed on the inscribed building accounts of the Parthenon, and demonstrates the complexity of skills demanded in temple building.[1]

In this chapter we will follow the evolution of the frieze from the quarry bedrock to the final painted and embellished product and consider some as-yet-unresolved issues, such as where – on the ground or *in situ* – the blocks were carved, how many sculptors were involved, and to what extent they followed preliminary plans or improvised as they went along.

THE RAW MATERIAL

In the late sixth and fifth centuries the marble of choice for sculpture came from the Cycladic island of Paros. Parian marble has a purity and transparency that make it ideal for sculpting the human figure, and for this reason it long continued to be the preferred material for figural sculpture, being especially popular for Roman imperial portraits. However, Parian marble has two major drawbacks: the nature of the bedding does not allow for the quarrying of very large blocks, and transporting it long distances was prohibitively expensive. For this reason the wealthy Sicilian temple-builders of the early fifth century used it sparingly, for instance, reserving it for the exposed parts of female flesh on the metopes of Temple E at Selinus. In Athens in the sixth century it had been used for the pedimental figures of the Old Athena Temple, as well as many of the dedications, particularly the *korai*. However, an entire temple of Parian marble would have been out of the question.

Fortunately, Athens is well supplied with its own marble. According to Xenophon (*Poroi* 1.4), "Athens has a plentiful supply of stone from which are made the fairest temples and altars, and the most beautiful statues for the gods." In the vicinity of the city there are two sources of sculpture-quality marble. From Mt. Hymettos, which forms the southeastern border of Athens, comes Hymettian marble, a bluish, fine-grained stone that became popular in the late fifth century. The other source, Mt. Pentelikon, is northeast of the city, and its quarries are situated halfway down the southern slope of the kilometer-high mountain. While not as fine or as white as

the marble from Naxos and Paros, which was used for much Archaic sculpture and smaller buildings like the Siphnian Treasury at Delphi, Pentelic marble had the distinct advantages for the Athenians of being relatively close and in plentiful supply. Being very hard, it does not take small details as well as other Greek marbles and turns a honey color with exposure.[2]

Pentelic marble had another distinct advantage over island marbles. The quarries on Mt. Pentelikon, unlike those of Paros, allow for the quarrying of very large blocks. It has been observed that when the nature of the quarry bedding enables the stone to be removed easily in large chunks, the architect or designer is inclined to use larger blocks in construction.[3] Large-scale quarrying only began on Mt. Pentelikon sometime after 490 when the pre-Parthenon, the first marble temple to be planned for the Acropolis, and the Older Propylon were begun. The scale of these buildings may in part have been determined by the availability of large marble blocks, but in any event this feature was certainly exploited for the later Parthenon by its architect Iktinos. The longest frieze block (East V), which lies directly over the east entrance to the cella, is an extraordinary 4.43 meters in length (the average frieze block being 1.22 m in length).

QUARRYING AND TRANSPORT

Although the raw material was free, its quarrying and especially its transport constituted one of the major costs of temple building in antiquity. One reason the exiled Athenian aristocrats' gift to Delphi in 513 of a marble facade for the Temple of Apollo was so extravagant was because the stone had to be shipped from the Cyclades and hauled up to the sanctuary (Herodotos 5.62.3). Because of these costs very precise measurements had to be provided by the architect beforehand, and as much as possible of the extraneous marble was removed at the quarry. Only about one-third of every block quarried was ultimately used in the actual building, so there is also a great deal of preliminary quarry work in this type of stone construction.

The decision to have an Ionic rather than a Doric frieze necessitated the quarrying of much larger blocks than would have been required by triglyphs and metopes. The average west frieze block is approximately 1.39 meters in length, with the end ones (W II and XV) being slightly longer (1.70 m). Those on the north and south sides are the most regular, being the same length as the standard wall blocks (1.22 m), again with some variation at the ends over the porches (1.38–1.705 m). The east frieze is the most irregular with each of the six blocks being a different length, and the range here is considerable (1.26–4.43 m).[4] The Parthenon metopes are a little over one meter

square, although their width varies with the widest (by as much as 10 cm) being in the center of the Doric frieze and the narrowest metopes toward the corners. Nonetheless, the quarry foreman could have received a bulk order for 92 metope slabs, as well as for the 90 frieze blocks on the long flanks and the 12 middle blocks of the west frieze. That leaves only eight blocks (two on the west and six on the east), all of which were exceptionally long (except East II), to be special orders. The depth of the frieze blocks is approximately 60 centimeters and the height is naturally consistent throughout (1.015 m).

The irregularity of the east frieze blocks indicates the extent to which this part of the building was given special consideration and suggests that its decoration was planned first. East V and VI are the nearly the same length as the architrave blocks (= interaxial spacing 4.185 m) upon which they rest, but the other east frieze blocks are not quite as long. While on the west the average length of the central frieze slabs is one-third of the interaxial spacing of the porch columns and on the long sides they match the wall blocks, on the east "the architecture is not in control."[5] It is clear that the blocks must have been cut to suit the composition, but the divisions do not occur in the obvious places, that is to say, in the natural divides between the various groups (processioning women, officials, gods, ritual group). Rather they appear where they are most inconspicuous, namely, between strongly vertical elements such as standing figures or flowing drapery. In other words the designer dictated the slab lengths on the east in order to mask the divisions as much as possible and to unify the entire composition even though it is composed of separate groups.

Once removed from the parent rock of Mt. Pentelikon, the blocks would be inspected for faults, squared, and left with a rough outer casing known as the quarry coat for safety in transportation down the mountain and overland to the Acropolis. Marble weighs approximately 2.75 tons per cubic meter. Thus, the average frieze block weighed 2 tons, while the largest block (East V) weighed nearly 8 tons. The blocks would have been dragged on sledges with ropes and winches up out of the quarry and then loaded onto heavy wooden wagons pulled by teams of mules (some of whom reveled in the task; see Epilogue). Once the carts reached the foot of the Acropolis, the difficult ascent was facilitated by means of a wide ramp and a traction system utilizing large pulleys.[6]

CARVING

In the latter half of the fifth century the Acropolis must have become a crowded, dusty, and noisy stone-working yard. Here, along with work on the other temple sculptures, the frieze blocks were trimmed to size and, like

any other block of the temple, provided with *anathyrosis* (Fig. 56). This labor-saving device involves recessing the vertical faces of the block ends with rough chisel work and leaving a smooth projecting band (11–13 cm wide) along the edge for close contact with the next block. The front faces of the blocks would have been given a smooth flat surface with the claw chisel before being hoisted into place above the architrave (see Fig. 60). Here the slabs were anchored to the blocks beneath by means of iron dowels seated with molten lead and attached to one another with iron double-t clamps encased in lead.[7] From the crowbar cuttings it can be determined that the corner slabs were laid first, usually followed by the central slabs, and the intermediate ones were laid last. A crown molding eventually decorated with a painted Lesbian leaf was set on top of the frieze with dowels; it is structurally part of the Doric ceiling bearer, which consists of a flat face, possibly painted with a complex meander, and a hawk's beak above (Fig. 57).

It has long been debated whether the frieze was carved on the ground and then hoisted into position, or carved *in situ*. Because the design respects the joints between blocks on the west and east friezes, many scholars have argued that at least these sections were carved in the workshop. A number of factors, however, make it clear that the entire frieze must have been carved after the blocks were in position. The first and most compelling of these is the existence on the top and bottom of every frieze block of a distinctive cutting: an exceedingly shallow and narrow recessed edge. At the bottom of the block it is 3.6 centimeters deep and only .8 centimeters high. At the top it is larger, measuring 5.6 centimeters in depth and 1.7 centimeters high. This cutting has been commonly termed a *scamillus,* although this term actually refers to a protective fillet, not a groove; it should more accurately be termed a guide strip. Whatever its proper name, the function of these cuttings was to provide the sculptor with guidance for the depth of relief and additional room for his chisel to finish the heads and feet of the figures (Fig. 58). If the blocks had been carved on the ground, such cuttings would not have been necessary. The guide strip is larger at the top, since heads are more rounded than the feet or hooves at the bottom.[8]

There are also some compelling practical reasons for carving the frieze *in situ*. An authority on stone-working, Peter Rockwell, has remarked: "It is always easier to move a carver than it is to move a carving. Human beings do not weigh 2.7 tons per cubic meter and can move by themselves; they are generally less fragile than finely carved details in stone."[9] We know that the frieze blocks were crowbarred into place and so even the slightest miscalculation of pressure would have chipped the sculpted edges. Just as columns are fluted after the drums are in place to ensure evenness from drum to drum, so it is easier to maintain a level background if the blocks are carved *in situ*.

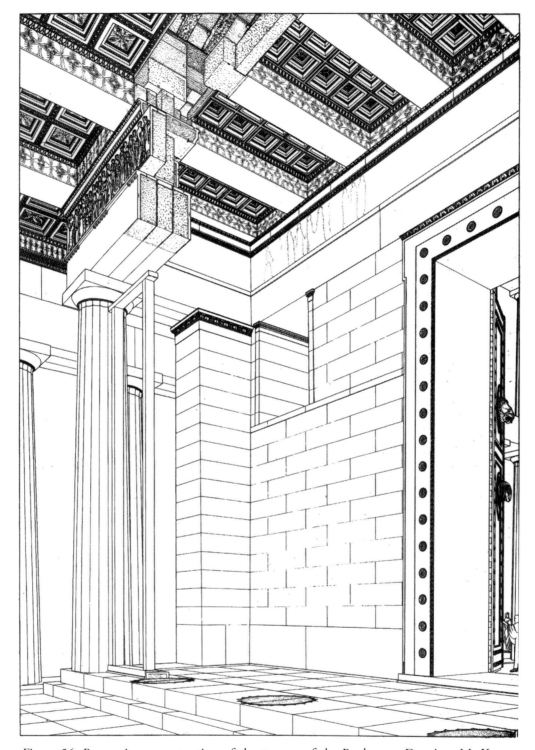

Figure 56. Perspective reconstruction of the *pronaos* of the Parthenon. Drawing: M. Korres, used by permission

Figure 57. Northeast corner of frieze with crown molding and Doric ceiling bearer. Drawing: M. Korres, used by permission

Figure 58. Three sculptors carving the frieze *in situ*. Drawing: M. Korres, used by permission

All in all the shallow relief of the frieze whose composition overlaps the joints between the blocks is more easily executed after placement. Also the erection of wooden scaffolding would not be an additional expense, since it was necessary for the final painting of the frieze, moldings, and ceiling coffers. Given the fact that a number of projects were being carried out simultaneously on the Acropolis, including the sculpting of both the metopes and the large pedimental figures, on-site space would be at a premium so that the carving of the frieze *in situ* was probably preferable in many respects to work on the ground.[10]

Once the blocks were set in position above the architrave and the cornice was in place, work could begin on the execution of the frieze. The faces of the blocks would have been carefully prepared with a claw chisel so that the surfaces were uniform and could receive the design. The project almost certainly commenced at the east and west sides, where the design tends to respect the limits of the blocks. Before carving began the main outlines of the design were sketched onto the smooth surface of the blocks (Fig. 59).[11] This preliminary sketching would have been particularly important on the north and south sides so that the designer could "proof" the drawing, so to speak, and correct any errors in the complex arrangement of overlapping horsemen. Further on in the chariot section it is clear that a compass was used to incise the outline of the chariot wheels; the central incised holes on the wheel hubs are still visible (see Fig. 6). Needless to say, all other signs of a preliminary sketch have been eradicated from the finished product.

After the sketch was applied to the blocks and the details were drawn in, it was up to the team of sculptors to carry out the carving. As the sculptors started in on the sketched design by establishing the outlines of the figures with a series of drill holes, they would have eradicated the individual features of the figures. However, they had some informal guidelines to keep the rows of figures in scale. This is particularly evident with the horsemen on the north frieze, as Jenkins has noted. By standing back from and looking at an angle along the frieze, one notices a series of horizontal lines serving as a sort of warp for the design (see Fig. 172). These consist, from the top down, of the heads of the riders, their hands clenched at the horses' withers, the curved legs of the riders and forelegs of the prancing horses, and finally the rear hooves of the horses planted on the groundline. These guidelines are by no means straight but flow up and down with the composition; they nonetheless could have served to keep the team of carvers on track.[12]

Given its highly finished state, the Parthenon frieze does not reveal much about the actual tools used in its carving or their stages of use. The standard practice in Greek sculpture was to eradicate as much as possible the

Figure 59. Artist sketching design onto frieze blocks. Drawing: M. Korres, used by permission

marks of the masons' tools, and so they are usually only visible in deep recesses. As in stone carving today, progressively finer techniques were applied to the stone until the final finish which ideally left the relief with no tool marks. The point and drill were used first for outlining the forms, followed by the flat and claw chisels for modeling and details like drapery, then rasps for smoothing, and finally abrasives, probably emery and pumice, to obliterate all signs of the rasp. Since the point was customarily used to cut figures free from the background, it was not utilized much for low relief, but was, for example, used extensively on the high-relief Parthenon metopes. However, in a least one instance the point was used to hollow out the deep areas within the chariot wheels (N XXIV).[13]

The claw chisel was also used, like the point, to remove unwanted stone by digging into the surface. Hence, it would have been used most extensively to create the flat background plane of the frieze (Fig. 60), but nearly all traces of its marks have been smoothed away. It also served to form the broad masses of stone for later work. It is clear from the way the marble is worked that from the beginning the sculptor conceived of the figures as three-dimensional; in order to achieve this desired effect he began by isolating completely the figure from the background. The flat chisel, on the other hand, was needed for more detailed work such as the veins, which are such a prominent feature of the horses (Fig. 61). This type of chisel could create "smooth contours and gentle modulations by removing a layer of stone per-

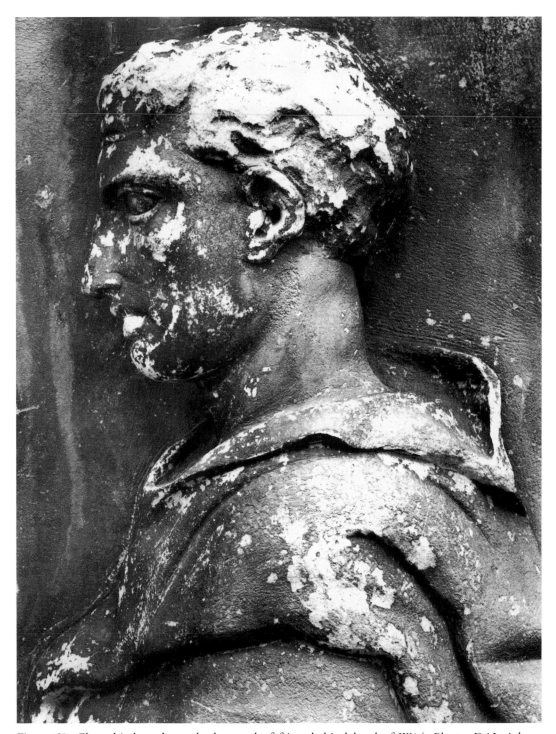

Figure 60. Claw chisel marks on background of frieze behind head of W14. Photo: DAI, Athens Hege 2544.

Figure 61. Detail of veins on horse's belly and rear leg (West V). Photo: DAI, Athens Hege 2342.

haps as fine as a skin."[14] It was used also to smooth the surface, taking away the rough surface left by the claw and point, thus preparing it for the finer rasp and abrasives. One area that preserves the marks of this tool is the back of Zeus' throne; the striated surface clearly shows the parallel strokes of the flat chisel.[15]

What particularly distinguishes the carving of the frieze, as well as other fine fifth-century low-relief works like the "Cat Stele" from Aegina (see Fig. 151), is the quantity and meticulousness of the drill work. Sheila Adam, an authority on Greek stone carving, has stated that "no other frieze shows such an abundance or variety of drill work."[16] The drill, operated by a bow and applied perpendicularly to the stone, was used in every stage from quarrying to fine details like the corners of the mouth. Since the drill provided better control and accuracy than the point and chisel, it was used extensively and in

a wide variety of ways and sizes. The most obvious drill holes are the large ones made for the attachment of additions in metal, such as horses' reins (see below). The most subtle are those rows of minute holes used to hollow out the channels along drapery folds, discussed later. Adam describes how in relief work the drill was used to establish the boundaries of a figure: "At a fairly early stage, perhaps immediately after drawing the outlines of their composition on the block, . . . a series of holes was drilled at right angles to the background around the outline of the figure. The areas between these perforated channels – the background – could be leveled off rapidly, and the individual figures left more or less clearly defined."[17] This outlining technique was used extensively on the frieze, and series of holes are still visible in places, for example, along the back of the rider N117.[18] The drill could also be used at an angle to the surface as a shortcut for outlining rounded forms; the back of the raised right arm of Hera (E29) is a clear-cut example of this technique. In cases where objects needed to be cut free from the background, like the now-missing part of the torch of Demeter, a drill would have been used to clear away the intervening stone. Likewise the drill was used to carve channels out between figures and their drapery or between figures and objects like the *hydriai* carried by youths on the north frieze (Fig. 37). The channels between fingers and toes were also hollowed out in this laborious way. One can clearly detect the eight drill holes serving to separate the ear from the hair of a bearded older man on the north (N41). Adam comments, "it was used on the Parthenon frieze for cutting every sort of channel, including many where sculptors of most periods would have employed only a chisel."[19] So the drill was one of the most used tools, from the initial outlining of the forms of the figures to the last facial details like the cavities of the ears and nostrils of the animals, and the corners of the human mouth.

Furthermore, the use of the drill was most fully developed and exploited in the fifth century for drapery, notably long vertical folds and the undercutting of drapery folds. Only where the outer parts of the drapery have broken or worn away can one detect the once-hidden series of small drill holes. Once drilled, these holes were transformed by means of a chisel into a continuous groove by the removal of the web of stone separating them. Adam has noted, "And after undercutting there was no need to remove the drill work which would be hidden quite satisfactorily behind the crisp outer edge of the overfold. Nevertheless, the Greek mason was such a perfectionist that very often these undercut areas have been cleared and smoothed quite thoroughly."[20] So, although not normally visible, rows of drill holes were used extensively all over the frieze. The most deeply cut drapery appears on the east frieze: ample folds enliven the laps of the seated gods, the *himatia* of the

conversing males next to the gods, and the robes of the women carrying ritual objects. Although shallow folds could have been cut with a chisel, the sculptors opted for deeply undercut garments and long parallel grooves.

After the drill and chisel work, the rasp was employed to smooth the surfaces of flesh as well as drapery. Rasp marks are visible within the drapery folds, and in one instance on the face of a figure, the cheek of Artemis (E40, Fig. 86). There is no indication that the rasp was meant to provide the surface with a rough texture for the application of paint.[21] Most rasp marks disappeared once the surface was given its final smoothing with abrasives.

Some elements of the composition could not be safely undercut and so were carved separately and attached via drill holes. This technique, known as piecing, was often used in Greek sculpture and is fairly common in the high reliefs of the Parthenon metopes, but is correspondingly rare on the frieze. One instance is a horse's jaw (N122) that overlaps a block; the lower part was added separately. The large mortise in the breastplate of N47 (Fig. 6) indicates that a heavy piece of carved marble, projecting beyond the original surface of the block (perhaps a gorgoneion?) was once tenoned into place here. On the east frieze it is clear from the prominent drill holes directly below and in line with the edges of the seats that the legs of the stools carried by the girls were added separately, presumably in marble, but another material is possible. Piecing could also make up for mistakes in the carving, but there is no evidence that this was necessary.[22]

To what extent the sculptors could diverge from the master design is not known. We know, for example, that one of the sculptors of the Erechtheion frieze changed the composition after it was already in place on the building by adding a stele.[23] Although the frieze seems to represent a faithful execution, there is at least one instance in which the actual carving seems to have varied from the original design. On North XLVI (Fig. 62), the original sketch must have depicted the head of the horse ridden by figure N129 thrust too farther forward for the proper equine proportions. After it was roughed out the sculptor corrected the position of the horse's head, carving it farther back, and then sculpted the drapery of rider N127 out of the former head. This scarcely discernible alteration in the design is nonetheless certain because the *chlamys* of N127 is too far forward from his chest.[24]

It is clear from some sections of the frieze, on the south side in particular, that the carving was not completed. The most conspicuous instances of this failure to complete the frieze are south slabs VI–X, where the manes of the horses are left as flat uncarved expanses. Also here many of the riders' heads and horses' forelocks have flat tops, indicating the sculptors' failure to eradicate the lower edge of the top guide strip.

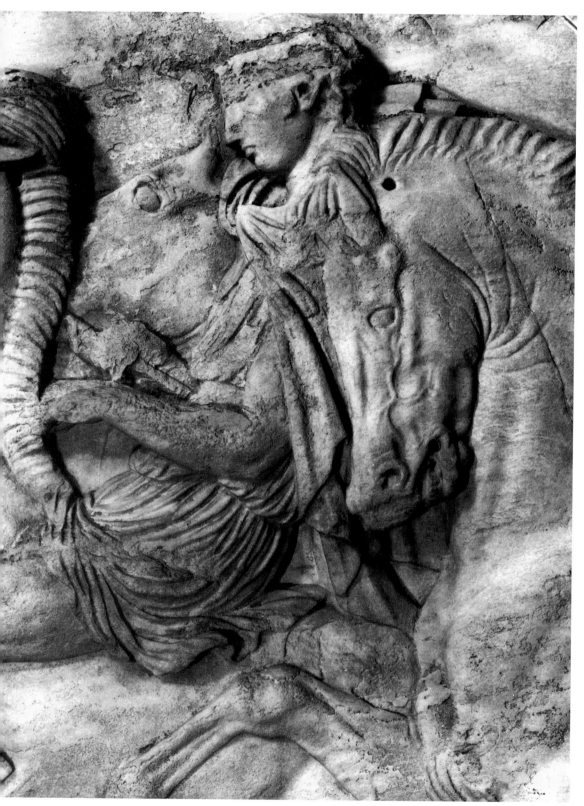

Figure 62. Detail of North XLVI. British Museum. Photo: Alison Frantz EU 183

In spite of these anomalies the carving of the frieze is overall of uniform excellent quality; it represents the work of a fully trained team who exploited their tools to the maximum to bring out the varied effects and rich elaboration of the original design. Now we must consider how many sculptors might have constituted this exceptional team.

NUMBER OF SCULPTORS

We know little or nothing of the workshop methods of Greek sculptors other than the fact that sons often followed their artisan fathers in the same trade. Many scholars have tried to estimate the number of sculptors on the basis of style, and results have ranged from three to eighty, as we shall see in the next chapter. Another method, based on information from external sources, might prove more workable for estimating the number of sculptors working on the frieze. It has been calculated that it took about five years (447–42) to carve the metopes and five more (442–37) to carve the frieze, which had to have been in place (although not necessarily completed) when the *Athena Parthenos* was dedicated at the Greater Panathenaia of 438. Given a total of ninety-two sculpted metopes, approximately eighteen were carved per year. Further, it can be estimated that one sculptor could probably complete two metopes in a year (since it takes approximately one year for a sculptor to carve a life-size human figure). Thus, if these calculations are correct, we are dealing with a team of about nine sculptors for the metopes. Applying a similar calculation to the frieze and with approximately five years to complete it, one can estimate that they must have carved about 32 meters (one-fifth of 160 m) per year. If there was the same team of nine sculptors, each one would have to carve 3.5 meters per year, a not unrealistic task.

Coincidentally nine is the very number of sculptors listed in the Erechtheion building accounts, which in addition provide a great deal of information about the social background of these workmen on the Acropolis. For instance, we learn that of these nine sculptors, three were citizens and five were metics (the ninth is unknown). Two of the metics lived in the deme of Alopeke, which is a suburb two miles east of the city, that is, on the way to Mt. Pentelikon, and two lived in Kollytos, just north of the Acropolis. They were paid sixty drachmas per figure, for small (60 cm tall) figures in high relief that were doweled onto dark Eleusinian limestone slabs. Since the standard wage for sculptors was one drachma per day (as also for hoplites), each figure presumably took two months to complete. It is clear that no one

accumulated much wealth in this profession, but one could subsist and perhaps even own a slave to help with the work.[25]

FINISHING

The finishing touches on any piece of ancient relief carving included additions in metal and the application of color (Fig. 63). The numerous drill holes on the frieze attest to the addition of metal accessories, and, while the polychromy is no longer extant, it can be deduced from other examples of marble relief work. The aim of these finishing touches was obviously to make the sculpture more realistic and, in some instances, to indicate objects or parts of objects that were too difficult to carve in such low relief. In addition color would serve to make the complex composition more legible from a distance. Both color and metal additions could also be used to distinguish important elements or sections of the frieze.[26]

In the eighteenth and nineteenth centuries an impassioned debate was waged in Europe regarding the use of color in Greek architecture, not only as an antiquarian problem but also in relation to the current practice of classical revival architecture. Eventually various discoveries, such as that in the 1830s of the polychromed remains of the Temple of Aphaia on Aegina, led to the conclusion that Greek sculpture and architecture were in fact painted. The question still remained, however, of to what extent. Given its long exposure to the elements and its extensive cleaning as a result of making casts in the British Museum, virtually nothing remains of the original polychromy of the frieze. Hence, it must be deduced from the incomplete areas of carving as well as comparanda from better preserved architectural sculptures.[27]

It is generally assumed that the background of the frieze was painted blue, on analogy with the blue background of other fifth-century relief sculptures, namely, grave stelae. Perhaps the closest comparison is with the Hephaisteion frieze, which according to several early travelers to Greece preserved traces of a blue background in addition to other paint. Since blue is the color of the sky it best represents the open air and so is appropriate for an outdoor procession or battle. The Eleusinian limestone used for the background of the Erechtheion frieze is also dark blue in color. Thus, we can safely assume that at least the background of the Parthenon frieze was more or less as the nineteenth-century Dutch painter Alma-Tadema depicted it (Fig. 55).

From another medium a close comparison can be found on a polychrome Boeotian vase that shows a rider, much like those on the frieze,

Figure 63. Boy painting the molding of a tomb. Etruscan red-figure hydria attributed to the Group of the Vatican Biga, ca. 400. Musei Vaticani Z 82. Photo: museum

against a blue background (Fig. 64). The horse is white, and the garments of the rider are red.[28] Red is a likely color for the drapery of the frieze figures, since it would have stood out well against the blue background. Also, from the time of Homer the color red was associated with the heroic, and in Archaic pedimental sculpture red lions bring down black bulls.[29] The bodies of the men may have been tinted a brownish color to distinguish sun-tanned men from white-skinned women. Likewise horses could range in color from black to chestnut to white and thereby be more decipherable within their complex overlappings. Such additions of color would have lent verisimilitude as well as clarity to the low relief of the frieze.

It has been suggested that the central section of slab V on the east, the

Figure 64. Rider against a blue background. Boeotian kantharos. Tübingen University S./10 1363. Drawing: after *CVA* Germany 36

so-called *peplos* ceremony, might have been divided off from the rest of the procession by vertical lines, "as if this central panel had a background of a different colour from the rest."[30] This observation, as many of the sightings of color on the frieze, is wishful thinking, in this case meant to support the contention that the *peplos* ceremony takes place inside the temple.[31]

In addition to the background, color served a number of other purposes on the frieze: to make the design more realistic, to complete portions that were too difficult to carve or to add in metal, to make the complex composition of the frieze more legible, and to distinguish important elements. The painted pupils of Apollo's eyes (Fig. 65), for instance, which are still clearly visible, add a touch of realism like the glass eyes inlaid in bronze statues. In the cases where figures seem to be clutching objects but there is nothing carved in their fists nor are there any drill holes, the objects must have been rendered in paint. Examples are the attributes of the gods: Poseidon's trident (E38), Apollo's laurel branch (E39), the end of Ares' spear. The older men on the north and south seem to be grasping objects in their raised fists, and it is thought that these possibly were painted olive twigs.

Often details were rendered in paint on undifferentiated masses. For instance, a number of the horses' tails are simply solid with no indication of hair, as West III, so presumably lines would have been painted on to suggest individual strands.[32] Another solid mass is the cloth being held up on East V, which is usually taken to be the *peplos*. It, like many depictions of special textiles in Greek vase painting, might have had rows of figures painted onto it. As already noted, the horses would almost certainly have been painted in

Figure 65. Head of Apollo (E39) with drill holes for
wreath and painted pupils. Photo: Alison Frantz AT 154

different colors to distinguish them from one another, especially on the
north and south friezes, where they overlap as much as eight times. In black-
figure vase painting of Corinth and Athens (see Fig. 36), quadriga teams are
regularly distinguished by color (black vs. added white).

As for metal attachments on the frieze, they also add a touch of realism,
especially for those objects that would have been metal in actuality. One
example is the wreath of Apollo: the series of holes (Fig. 65) encircling his
head probably once served to secure a gold (i.e. gilded bronze) laurel wreath
of the kind that was awarded to victorious musicians. Likewise for the head-
band of Hera (E29). Also some attributes partially carved in the marble were
then completed in metal. For instance, the two ends of the long object (pos-
sibly a caduceus or trumpet) cradled in the left arm of W23, and the upper
and lower ends of Athena's spear were added in metal, as indicated by the
drill holes. The upper parts of the objects (incense burners?) carried by two
pairs of girls on the east (E12–13 and E14–15) were no doubt too difficult

Figure 66. Cuttings for bridle of horse (West III). Photo: DAI, Athens Hege 1756

to carve over the girls' drapery and so were added in metal. The most common positions for these drill holes are at the jaw, ear, and withers of the horses (Fig. 66), and so the bridles and reins were certainly of bronze. Some holes, like the pair indicating the *antilabe* on the shield of S66, still retain the bronze end of the added shield handle. In this case and that of reins the bronze stood in for leather originals.

In some instances the addition of metal must have been used to distinguish certain objects or persons. A row of drill holes is preserved at the top of the right calf of the exceptional equestrian W15 (see Fig. 85), and so it is assumed that he was distinct from all the other riders by his golden sandal straps. One can perhaps also assume that the objects held by the marshals E49 and E52 were of metal because of the drill holes above their outstretched hands. If these were the sacred *kana,* or baskets, they would have stood out clearly against the colored background of the frieze.

Thus, paint and metal additions played an important role in the legibility of the frieze. The blue background would have made the figures appear much more three-dimensional, and the bright metallic objects would have added an eye-catching luster and richness to an already complex composition. The ultimate goal, however, was verisimilitude, as we shall discuss in the next chapter.

Figure 67. Detail of N133. British Museum. Photo: Alison Frantz EU 186

MIMESIS

THE HIGH CLASSICAL STYLE

It seems to me that it would not be beside the
point if one were to liken the rhetoric of
Isokrates to the art of Polykleitos and Pheidias
for its holiness, its grandeur, and its dignity.
– Dionysios of Halikarnassos (*De Isocrate,* 3)

. . . Greek sculpture entered its Classical stage.
As the blossom develops from the bud overnight,
so this stage was attained in the Parthenon
sculptures without any transition. . . . Everything
about them is entirely original, brilliant and
magnificent.
– Reinhard Lullies (1960, 35)

Today, stripped of its colorful paint and gleaming metal attachments, the
Parthenon frieze impresses by the uniform style of its carving, the virtu-
osity of its superimposed planes, and the naturalism and idealization of its
figures (Fig. 67). In these respects it is unique, and for many it represents the
epitome of the high Classical style as defined by modern taste and scholar-
ship. But what precisely is this style and how did it evolve? Does it represent
a new direction in the history of Greek art or is it a continuation of its pre-
decessors, the Archaic and early Classical? What are its defining characteris-
tics and who "invented" it? What role, if any, does the frieze play in the
style's subsequent development?[1]

In this chapter we will scrutinize more closely the individual figures of
the frieze, their poses, physiques, facial features, and drapery, and place them
in the context of the evolving Classical style. The history of Greek art is
often accused of Atheno-centrism, but in the case of architectural sculpture
it can safely be said that Athens led the way in the later half of the fifth cen-

tury. With its ambitious temple-building programs (the majority of which included sculpture) taking place on the Acropolis and throughout Attica, it attracted artisans from all over Greece, who, under the influence of a master designer, forged a new style. Here the conditions were ripe, as in Florence two millennia later, for the emergence of a radical new mode of expression; just as the Florentines rejected the *maniera* of Byzantine art, so the Athenians renounced the old-fashioned and stiff stylizations of the Archaic.[2]

This movement began following the Persian wars, the victories of which are often seen as a catalyst for a break in style. Such a scenario is not implausible, since Athens, rather than Sparta, led the Greek armies and navies to victory. However, a change in style is not simply inspired by political events, positive and energizing as they might be. Changes are often wrought by artistic geniuses working to solve aesthetic and compositional problems, often involving a major commission, as in the case of Giotto and the Arena Chapel in Padua. Large-scale artistic undertakings frequently involve rethinking modes of expression, and subtle changes often occur as the project evolves, as, for instance, the increasing size of the ceiling panels or the need to invent new poses for the series of Ignudi in the Sistine Chapel frescoes by Michelangelo. Such ambitious projects pose special challenges for artists, challenges that are often answered with the evolution of a new style.

POSES

We begin with how the figures are posed on the frieze. The choice of subject, a procession, naturally involved less active poses than the individual combats of the metopes or the dramatic actions of the pediments. Narrative art of the Classical period often shows a change in the time of the action: instead of the heat of the conflict, a quieter moment before or after is chosen. As a result, in both painting and sculpture, it is characteristic for figures to simply stand around, as the heroes do on the name-vase of the Niobid Painter in the Louvre (Fig. 68) or as they did in Polygnotos' famous mural painting *Troy Taken*. On the frieze the majority of figures are either seated relatively quietly on horseback (in spite of the galloping of their mounts) or walking calmly. There is little agitation, with the exceptions of the *apobatai* in their racing chariots, which occur in the middle of the north and south sides, and of the horse-tamers in the southern third of the west frieze.

Over 130 of the male figures on the frieze are mounted riders; most are shown in profile, legs dangling, with variety added by the tilt of the head and position of the arms. Some turn to present a frontal torso (W2; N89, 98,105,

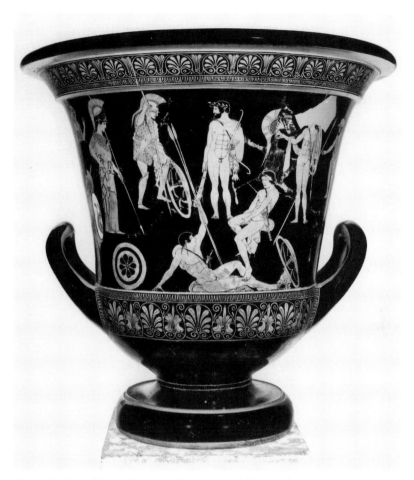

Figure 68. Herakles, Athena, and heroes. Red-figure calyx-krater attributed to the Niobid Painter, ca. 460–50. Musée du Louvre G 341. Photo: museum

113, 131), and we have recognized some of these as rank leaders. Rarer is the presentation of the back view (N120, Fig. 42), possibly because the back has less complex musculature and so less successfully engages the viewer.[3] Also seemingly unique is the rider S9 (Fig. 69) who bends sharply his right leg, breaking the rhythm of the concentric arcs of equine and human legs. It is somewhat surprising that the designer did not choose to add more variety to the positions of the riders' legs as he does with the horses', thus leading one to imagine that the leg of S9 was not originally intended to be bent but may be the sculptor's remedy for a problem with the stone. The back view and the bent leg seem to be experiments that were not repeated.

On the eastern third of the frieze, ahead of the *apobatai,* the processional figures stand calmly in profile with only an occasional figure turning to the

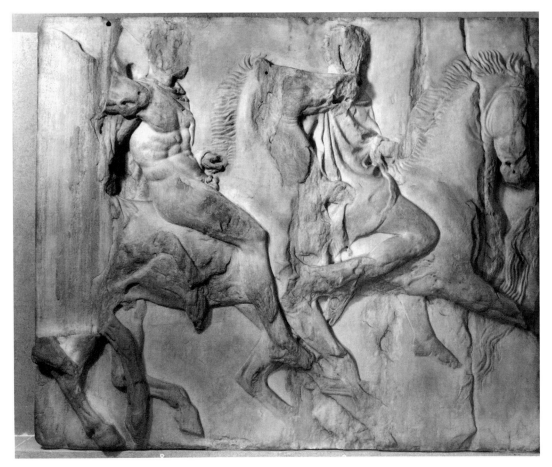

Figure 69. South III. British Museum. Photo: Alison Frantz EU 193

front or looking back for variety. They move the narrative more slowly toward the east, and in at least one instance four progressive phases of a single action are depicted. This innovative sequencing involves the *hydriaphoroi* (Fig. 37), the first of whom (N19) stoops down to pick his hydria up from the ground, the next (N18) places it on his left shoulder, the third (N17) grasps its foot with his left hand, while the last (N16) is posed in profile processioning to the left. This sequence of phased action, which was used frequently by Renaissance painters in their depictions of the three Magi, gives not only variety to the frieze but also moves it forward spatially and temporally.[4]

The greatest variety of poses appears in the west frieze, where we find incipient stages of the Classical pose par excellence: *contrapposto*. It is that of the standing male, exemplified by the *Doryphoros* (Fig. 70), whose complex ponderation involves all parts of the body: shoulders, arms, hips, legs. Known as the "Canon" of the Argive sculptor Polykleitos, it represented, even in antiquity, the perfect male body in a natural stance, with the weight

Figure 70. *Doryphoros.* Marble copy after the bronze original by Polykleitos, ca. 450–40. Minneapolis Institute of Arts 86.6. Photo: museum

Figure 71. Achilles. Red-figure amphora, name-vase of the Achilles Painter, ca. 450. Musei Vaticani 16571. Photo: museum

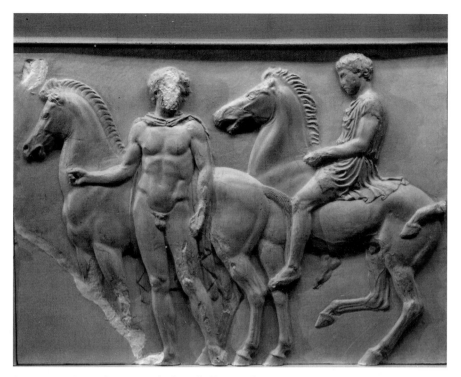

Figure 72. Cast of West V. Skulpturhalle, Basel. Photo: D. Widmer SH 626

shifted onto one leg with a corresponding dip in the shoulders. It is usually identified as Achilles, the ideal Greek warrior. This ponderated stance is also prevalent in vase paintings of the period, as, for example, the name-vase of the Achilles Painter (Fig. 71), where a warrior, the hero Achilles again, has shifted his weight to his left leg, in this case, and lifts his right foot off the ground. Although Polykleitos was an Argive sculptor, his work had a widespread influence, as evidenced by its impact on later sculptors. In particular, the standing males on the west frieze seem at first to reflect Polykleitan innovations, such that some scholars maintain that he actually worked on the Parthenon sculptures. In his frontal pose, near nudity and ponderated stance, W9 (Fig. 72) is closest to the Canon. Like the red-figure Achilles and the bronze *Doryphoros* his head turns and ever so slightly inclines, his abdomen is frontal with one hip shot out, and his free leg trails behind and to the side. Also characteristic of the high Classical style is the relative calm of his demeanor, and, as if to emphasize this *stasis,* he is depicted before one of the only quietly posed horses in the entire frieze. However, a glance at his shoulders shows that his posture is not as advanced at that of the *Doryphoros,* nor does the figure show chiastic balance. Therefore, it is unlikely that it shows the influence of the Argive sculpture.[5]

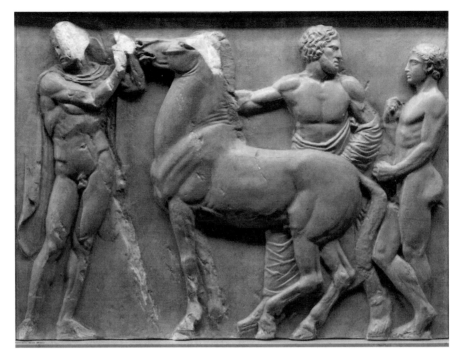

Figure 73. Cast of West III. Skulpturhalle, Basel. Photo: D. Widmer SH 624

A slightly more advanced pose is that of W4 (Fig. 73) who is usually interpreted as tying a fillet around his head – a *diadoumenos,* in short. With his left hip thrust far out to the right, his heavily muscled, almost frontal torso, and his right arm crossing over the front of his chest, he is a highly animated figure. In fact, the pose is probably adapted from that of an athlete *(apoxyomenos),* as seen on a Parian marble grave stele of ca. 470–460 found at Delphi (Fig. 74); here the figure also stands in three-quarter view to the right, with weight on the left leg, and the right arm across the chest, although the action is presumably different. In its pose and even in its proportions (nearly eight heads tall) this figure anticipates the famous *Apoxyomenos* of the late-fourth-century sculptor Lysippos. It is not improbable that Pheidias saw this stele while at Delphi, was impressed by it, and so incorporated the pose somewhat arbitrarily into the west frieze.[6]

Another pose on the west frieze may have been inspired by a famous sculpture nearer to hand. As he leans backs dramatically to the right, his right leg extended, his left leg bent and his right arm raised, W27 (Fig. 75) closely resembles the Marsyas of Myron (Fig. 15) which, as we have seen, was dedicated on the Acropolis sometime ca. 450, and so was certainly

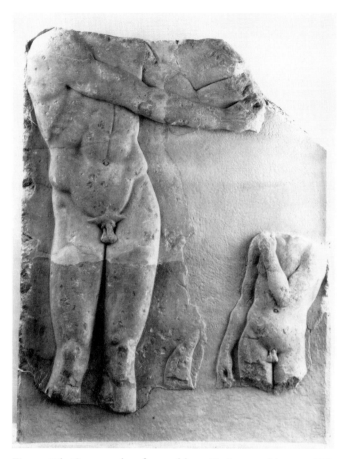

Figure 74. Grave stele of an athlete. Parian marble, ca. 450.
Delphi Museum 2161. Photo: École française d'Athènes

known to the designer of the frieze. Compositionally this group of a man
taming a rearing horse also recalls the pair of Lapith and centaur in south
metope 7 (Fig. 28), while the drapery serving as a backdrop is reminiscent of
south metope 27.[7] In contrast to Archaic schemata, these stances are not
only natural and pertinent to the job at hand but also serve to enhance the
meaning of the narrative or reveal something of the character of the person
depicted. This is especially true in the case of the most dramatic horse-tamer,
deliberately placed in the center of the west frieze, W15 (see Fig. 85). As one
of only two bearded riders on the frieze, he is clearly an important figure, as
we shall discuss in Chapter 5, and his dramatic pose, in contrast to most of
the calmer ones on the frieze, calls attention to itself.

Other innovative stances may possibly derive from wall painting, since

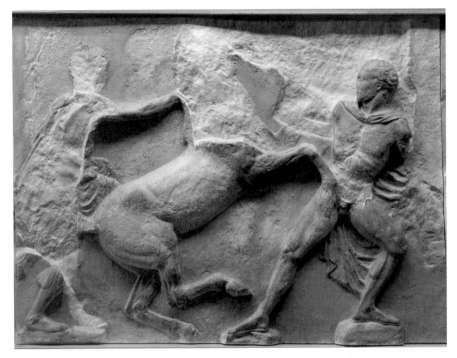

Figure 75. Cast of West XIV. Skulpturhalle, Basel. Photo: D. Widmer SH 635

many advances were being made in this medium in the early Classical period. One pose in particular that may reflect this influence is that of the sandal-binder, shown twice on the west (W12 and W29). These cloaked youths raise the left foot onto a rock and bend over to adjust the sandal lacings with both hands. Their pose is derived from earlier depictions of warriors donning greaves, as known from numerous vase paintings, and the action of the sandal-binder becomes quite popular in later sculpture – witness the famous Sandal-Binder of the Nike Parapet or the so-called Lysippean Jason (see Chapter 7). It may be seen in relief sculpture here for the first time, but is known from vases that reflect wall paintings (cf. the figure bending over to pick up his shield on the Niobid Painter's vase, Fig. 68) as well as a description of a figure who has one foot on a rock in Polygnotos' Underworld painting at Delphi (Pausanias 10.30.3). The frieze may well be the first instance in which this pose appears in relief sculpture.

It is only when we come to the clusters of men on the east frieze (Fig. 76) that the poses change to ones of lounging and relaxation as well as interaction. Exhibiting the same familiarity as the gods, these figures lean on one another (compare the male couple E44–45 with Hermes and Dionysos,

E24–25) and appear to be conversing familiarly, often in pairs like Apollo and Poseidon. They are distinguished in other ways from the procession, as we shall discuss below, but in terms of pose they are clearly distinct from the processional figures, all of whom are involved in performing specific tasks. One highly naturalistic stance is that of the figure who stands with one leg crossed over the other and the foot resting on its toes. It was used once on the west for a young boy (W6), and more frequently on the east among the groups of conversing men (E19, 22, 44, and 46). That it represents a very relaxed pose is indicated by the fact that the latter are leaning on their walking sticks. It is interesting to note that this pose was commonly employed for grave stelae, where it served to commemorate leisure-class men, often shown with their dogs and/or servants.[8] An even more relaxed pose and one that may have been invented for the frieze is the figure who leans *back* with his free leg extended in front. Both Eros (E42) and one of the conversing men (E21) are posed thus; Eros leans back onto Aphrodite, while the young man leans on his stick.[9]

For more dynamic poses one turns to those who are dealing with energized animals, namely, the horse-tamers (W27, Fig. 75, and W15, Fig. 85), cow-leader (S130, Fig. 115) and the *apobates* (N47, Figs. 6–7), who leaps on and off his chariot at break-neck speed. Here in the race the "heroic diagonal," so favored in later Classical friezes, is also put to good use for the outstretched left legs of the marshals (N44 and N65, Fig. 103) in front of the chariots. Like the sandal-binders, all these figures need rocks upon which to prop their flexed legs. Just as the calmly standing figures are next to calm animals, so the dynamic figures are juxtaposed with charging animals, as if to heighten or enhance the tension.

In deliberate contrast to the rest of the frieze, the gods are seated. They are also at ease, but each posture is unique. The specifics of their poses, along with their attributes, are clearly calculated to aid the viewer in identifying them (Fig. 77). Dionysos, the god of the symposium, lounges back against Hermes, whose left hand lies mysteriously hidden underneath his cloak. Demeter, her right hand to her chin, looks contemplative; it is often claimed that she is mourning her daughter in the underworld, but this gesture is found in contemporary Attic vase painting for figures who are simply waiting or expectant. Clasping his right knee in another pose used in vase painting (often for Odysseus on his mission to Achilles), Ares is also waiting but in a more restless mode. His left leg is entwined with his spear, as if temporarily, at least, immobilized. The winged attendant of Hera stands arranging her hair in a pose common to brides. She, like Eros, is so closely linked

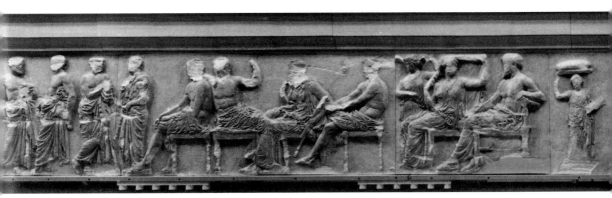

Figure 76. Cast of center of east frieze (East IV–VI, 20–46). Skulpturhalle, Basel. Photo: D. Widmer SH 347

to the seated figure in the foreplane, that they both in effect act like attributes of the adult deities. (Her identity will be discussed in Chapter 5.) Hera performs the traditional gesture of wives, the *anakalypsis,* or unveiling, as she turns around toward her husband. Zeus' pose, with his left arm resting on the back of the throne, is receptive and, in particular, open to sexual union.

On the other half of the east frieze Athena, like her father, leans slightly backward in a very relaxed manner. Her left leg, like Zeus', seems to deliberately fill the void under her partner's stool. Hephaistos, like Hera, turns to look back at his, unrequited in this case, beloved. The earth-shaker Poseidon is the only deity to let his arms hang toward the ground, also clearly off duty. Apollo, mirroring Hephaistos by looking back at Poseidon, is posed with his right thumb tucked into his mantle at the waist. This gesture, as Evelyn Harrison has so perceptively noted, refers to his incipient disrobing; as god of truth and light, he is one who "exhibits" himself to mortals.[10] The gesture of Artemis, adjusting her chiton, is difficult to explain, unless it is meant to feminize her in some way. Her left hand is entwined with the right arm of Aphrodite, who leans slightly into her lap – almost in a sense pinning her to her seat. The goddess of love points with her left hand to the procession while the standing child Eros lounges against her knees.

Although the gods are all seated, the subtle nuances in their positions are definite clues to their individual personae. In this way the Classical style uses pose and body language to reveal the character of the subject. Overall they are depicted in a very relaxed, familiar, and informal manner; there is none of the rancor or disagreement that one associates with these Olympian councils as described by Homer. This new, more humane approach to the gods is also more reminiscent of the art of the century to come than of the fifth century.

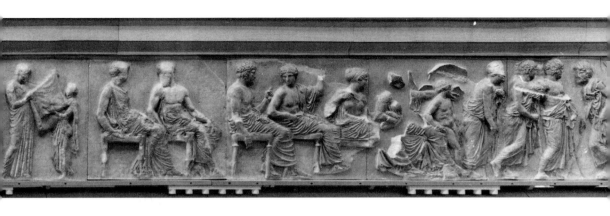

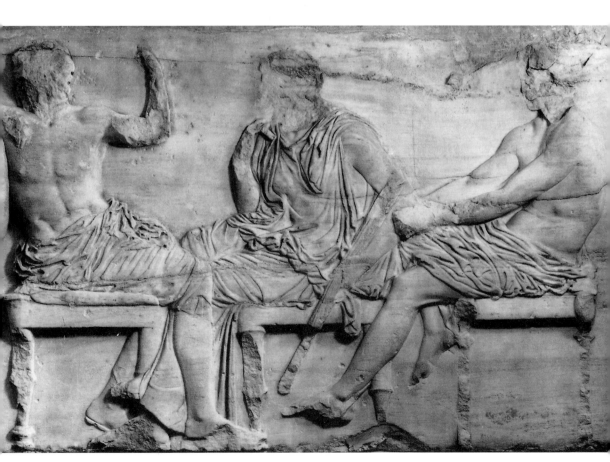

Figure 77. Dionysos, Demeter, and Ares (E25–27). British Museum. Photo: Alison Frantz EU 129

PHYSIQUES

Closely related to consideration of pose is the form of the human, i.e., male (since women were fully draped), body. In contrast to the *Doryphoros,* who is seven heads tall, the figures on the frieze are more elongated, being nearly eight heads in height. In the later Classical period there was a tendency for elongation, but here it may simply have served to make the figures more readable from a distance. The male figures are highly idealized with their perfectly proportioned anatomy, musculature, and bone structure. Only two figures on the frieze (W6, Fig. 73, and Eros, E42, Fig. 164) are completely nude, and they are both youths. Several horsemen, however, are nearly nude, since their *chlamydes* hang or flutter behind their frontal bodies (W2, W4, W9, W22, W27, S8, S79, N89, N133). These provide the best evidence for the treatment of musculature.

In comparing figures like W4 (Fig. 73) and W9 (Fig. 72) it is clear that the designer or individual sculptors treated the musculature differently depending on the age of the male. Both exhibit developed muscles in the torso, especially, pronounced pectorals and Iliac crests. However, in the younger figures, like W9, the transitions between the muscles are more fluid and somewhat muted. The older men have sharper divisions, deeply articulated serratus magnus muscles, and more pronounced bone structure, in particular, the sternum. Following this principle it is clear that the rank leaders among the horsemen (e.g. S8, Fig. 78) are depicted as somewhat older than their fellow cavalrymen. Likewise the marshals (cf. N44 and N45, Fig. 6) also have more mature bodies than the charioteers, *apobatai,* and riders that they direct. In describing the elders on the north frieze (N38 and N40, Fig. 105) Martin Robertson remarked that the ideal anatomy is subtly modified, "there is a distinct if muted suggestion of the heavier forms of age."[11]

As for anatomical details the figures of the frieze exhibit some innovations. The necks of figures, both male and female, show engraved so-called Venus rings, a feature that was limited to women in the sixth century and only became common with the Parthenon sculptures. Other traits of the Parthenon sculptures that become common later are the fold of skin just above the navel and the indentation over the nape of neck. These features are sometimes termed mannerisms, but in fact they are naturalistic features of human bodies and as such already appeared on some of the Olympia sculptures. Finally, there is the rendering of veins, seen especially clearly on the right hand of Poseidon in the well-preserved slab in Paris and the hands of the marshals (E49 and E52). Particular attention is paid to the fingers and toes; knuckles and nails are carefully rendered in spite of the fact that these

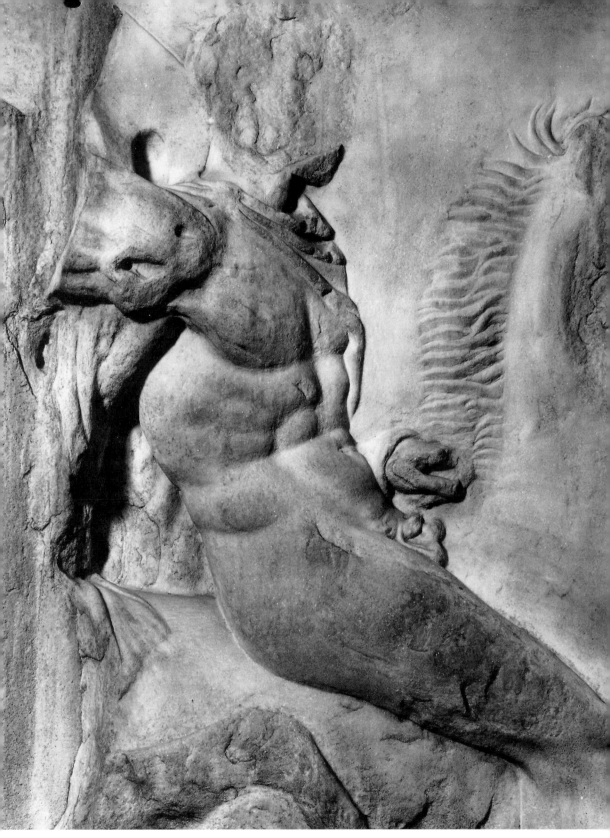

Figure 78. S8, detail. British Museum. Photo: Alison Frantz EU 195

could not be noticed from a distance. Some of these realistic details were already present on the sculptures of the Temple of Zeus at Olympia but are treated more realistically here.[12]

FACIAL FEATURES AND HAIRSTYLES

Many of the heads on the frieze are badly defaced or altogether missing. Nevertheless one can detect an amazing uniformity of facial type throughout the 160 meters of the relief. One is first struck by the lack of expression, or what might be better called a neutrality of expression. This is partly due to the participants' concentration on their mission, a religious procession, and to the mostly calm, serious nature of this task. A few are so serious that they have creases on their foreheads, like the riders (W2 and N99), the *hydriaphoros* (N18, Fig. 79), or Poseidon. In general, however, the youths' faces are blank, such that some scholars have claimed that they are incapable of thought.[13]

The facial features of N18 (Fig. 79; cf. also W2) are exceptionally finely carved, but since they are characteristic of most heads on the frieze they will serve for the whole. These Classical traits include broad and usually smooth forehead; heavily rimmed eyes with sharp brow lines; long, straight nose; "rosebud" mouth consisting of a strongly bowed upper lip and a fleshier, slightly pouting lower one; smooth cheeks; and prominent chin. Ears, when visible, are usually quite small. The older men and gods of the frieze are heavily bearded, as was the norm in ancient Greece, but beards are not so common as one might expect. The marshals, for instance, are not bearded, nor the musicians; the emphasis is definitely on youth.[14]

There is much greater variety in the hairstyles. Most of the men, young and old, wear their hair fashionably short. It lies fairly close to the head and is carved into thick undulating curls, often achieving a tousled effect. The youngest boys, i.e., attendants (W24, N136) and Eros, have considerably longer hair. That of the attendant W24 (see Fig. 90) is combed forward on top and knotted over the forehead, the hairstyle of an adolescent.[15] Eros' long hair flows back and is tied up with a fillet. Although it is now much effaced, a similar hairdo may have adorned the head of the child E35 (see Fig. 128). The oldest men also can have longer, straighter hair, and at least once it is braided in the fashion common in early Classical sculpture (N41). So hairstyle, like musculature, is used as an indicator of age.[16]

The most distinctive male hairdos are those of the clusters of men on the east frieze, E43–46. The cast of East VI (Fig. 52) shows them to have almost

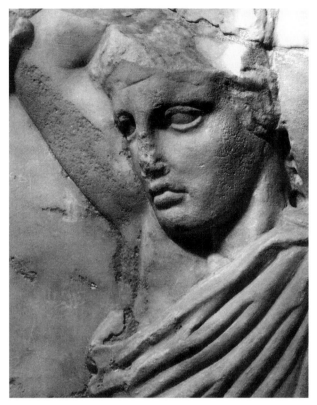

Figure 79. N18, detail. Acropolis Museum. Photo: Alison
Frantz AT 162

shaggy hair and beards. The incised lines within and parallel to the thick locks
constitute an extra-special elaboration of the hair that serves to designate these
men as particularly important figures, as will be discussed in the next chapter.

The hairstyles of the women frame their faces in thick wavy locks. At
the back the hair can either be bound up or tied into a long ponytail resting
along the neck. In general it seems that the younger women (based on dress;
see below) wear their hair in ponytails, while the older ones wear it tied up.
The goddesses Artemis and Aphrodite wear theirs tied up in a head scarf, or
kekryphalos.

DRAPERY AND FOOTWEAR

With the exception of Eros and one of the young male attendants
(W6), every figure on the frieze is clothed in some way or another.
While this is not surprising for women, it is unusual for men, who, since the

beginning of stone sculpture, are commonly shown in the nude.[17] There are surely iconographic reasons for this, as we shall discuss below, but here we will concentrate on the style of this ubiquitous drapery. As a point of departure we quote what Ridgway has to say in regard to Classical drapery: "For all its natural appearance, drapery is rational rather than realistic; it is not depicted per se but utilized and even exploited to express motion (motion lines) or to model the human figure that it is supposed to cover (modeling line)."[18]

Motion lines naturally appear in the highly animated figures. Cloaks that flutter out behind horsemen such as those of W2, W8 (Fig. 97), W14, W19, belong with some of the most spirited horses, i.e., those with all hooves or all but one off the ground. Even unmounted horsemen (W15, Fig. 85; N133, Fig. 67) have fluttering *chlamydes,* no doubt to accentuate the forward motion of their rearing mounts. On the north and south friezes there is little space for billowing cloaks and so it is not until we reach the *apobatai* that we again see motion lines in the drapery. The flaring skirts of N47 (Fig. 6), N64 (Fig. 103), N68, and N71 well convey the speed of their racing chariots. Thus, the motion lines relate not only to the figures wearing the drapery but to the action of their horses, as if, in effect, reinforcing their active forward pace.

As for modeling lines, these are ubiquitous. On the riders with short tunics, the concentric curves over their thighs give the cross-section of the form of the leg underneath. For the many men clad in *himatia,* the folds fork and loop across the calves and catch at the ankles, also suggesting the forms underneath. The women are so heavily draped that little of their physiques is visible. However, the V-folds on their chests do give a suggestion of the hollow between the breasts, and the blousoned overfolds at the hips accentuate their breadth (see Fig. 118). In contrast to the active motion lines of the men's drapery, the vertical channels of their robes project a solemn, stately, almost columnar effect to these figures. As for the seated gods, their *himatia* tend to lie in closely bunched folds over the lap (Fig. 77) and are more broadly stretched across the lower legs. In regard to the Parthenon frieze drapery, Sheila Adam has remarked: "though it seems natural and free when compared with the stiff lines of archaic drapery, [it] is nevertheless still designed in formal and symmetrical patterns, with parallel lines dominant even where the stuff appears to fall in natural curves."[19]

One distinctive aspect of Parthenon drapery that is realistic, and becomes almost a hallmark of Athenian mid-fifth-century sculpture is the fluted or so-called pie-crust edge (Fig. 80). It represents the selvage of a piece

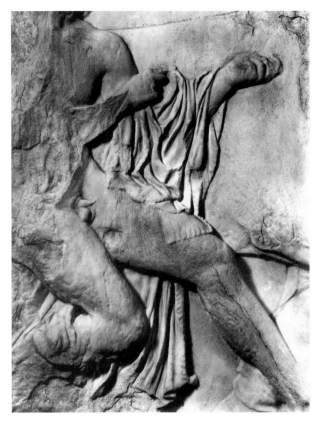

Figure 80. S130, detail. British Museum. Photo: Alison Frantz EU 225

of cloth woven on a warp-weighted loom and appears on most, but not all, *himatia* and *chlamydes*. It was certainly somewhat laborious to carve and would not have been all that visible from 40 feet below. However, like the later press folds, it is a realistic touch that makes the garments of these figures all the more credible.[20]

Another mannerism is the flipped-over hem of drapery that can be seen, for example, at the slit of the *chitoniskos* on N98 (Fig. 45), on the *chitoniskoi* of N47 (Fig. 6) and N95, but more often at the ankle along the hem of the *himation* (cf. N11–12; 40–42, Fig. 105). The double-girting of the *chitoniskos* of some of the riders creates interesting bunches of folds at the waist. Many of these garments also display a slit on the hem of the sleeve and/or skirt (e.g. W10, Fig. 72), a motif that reappears in copies after the frieze (see Fig. 150). Ribbon drapery is evident on a few of the figures, such as the *apobatai* N62 (who strikingly wears a long chiton) and N64. On this last figure

it looks as if one strap of his *chitoniskos* has come loose, so that the garment resembles an *exomis*. This occurs on other figures (N55; W8, Fig. 97; W15, Fig. 85) and so should probably not be taken as a special costume, but rather as the normal short chiton come undone.[21] Finally, a number of charioteers and riders (e.g. N99, Fig. 45), mostly on the north, have long sleeves, a form of dress usually considered Persian, but clearly adapted by both Athenian men and women in the fifth century.[22] These details of dress add infinite variety to the frieze and provide models for later sculptors, as we shall see in Chapter 7.

Just as there is a great variety of dress on the frieze, so there are many forms of footwear. Because most details of the upper parts of the footwear were rendered in paint, the strapwork of sandals and the lacings of boots are no longer visible. However, there is a readily detectable variation in the thickness of the soles of sandals that seems to break down into thick for women and thin for men. The processioning women on the east frieze wear fairly thick-soled sandals (see Fig. 118), as do Hera and Artemis. Males, including the gods Dionysos and Poseidon, wear thin-soled sandals, with the major exception of Zeus, whose are quite thick, and Hermes, who wears boots. It is interesting that Athena, well known for her male attributes, wears the thinner-soled version of the thonged sandal. The other common form of footwear is found on the riders (see Fig. 97); it consists of a high leather boot *(embades)*, secured just below the knee with a tight band. Overhanging flaps that flutter with the movement of the horses are either liners or the rough-trimmed tops of the boot. Although commonly worn by Greek cavalry according to Xenophon (*On Equitation* 12.10), they seem to be depicted first on the Parthenon frieze.[23]

LANDSCAPE

Another innovative aspect of the Parthenon frieze is its treatment of landscape elements. Previously trees and rocks appeared in Archaic and early Classical vase painting not as elements of setting per se but as props in the narrative. They often served to identify individuals (the vine of Dionysos, the pine tree of Sinis) or as indications of locale (the palm tree of Troy). Varying sizes and shapes of rocks were used to differentiate the deeds of Theseus on both vases and metopes: namely, the tall cliff of Skiron versus the low rocky bed of Prokrustes. Otherwise such landscape elements are exceedingly rare, particularly in relief sculpture.[24]

Thus, it is noteworthy that rocks appear fairly frequently in the

Parthenon sculptures, and especially on the frieze. There have been two important discussions of these rocks. The first, by Philipp Fehl, sees them as references to specific terrain between the outer Kerameikos and the summit of the Acropolis. The second, by G. B. Waywell, rejects this interpretation, and believes that rocks are used to support complex poses, in particular the sandal-binders and the animal-tamers, discussed above. While it is true that rocks generally appear when needed to support a particular pose (e.g., the cow-handler S130, Fig. 80; or horse-tamer W15, Fig. 85), this is not invariably the case (e.g. W26, who is standing on rocks but could just as well be on the ground). Hence a compromise between the two views is perhaps warranted: while some rocks are certainly props for the action, it was clearly the designer's intent to indicate a variety of types of rocky ground, and perhaps even a specific terrain. If one accepts Evelyn Harrison's reconstruction of the shield of the *Athena Parthenos* with its rocky cliffs and fortification walls, then specific elements of landscape were very much a part of mid-fifth-century narrative art.[25] Since this procession, like the Amazonomachy on the shield, was a localized Athenian event, it is not impossible that the artist was referencing landmarks in the Attic terrain.

However, Fehl probably goes too far in recognizing rocks under the feet of humans and horses when in some instances the sculptor of that section simply failed to chisel away the excess stone. Likewise his identification of supposed rocks under the feet of the gods as the rocky terrain of Mt. Olympos is problematic. If the designer had wanted to show the gods on Mt. Olympos, he would surely have given them rock seats, as was done for the seated deities in north metopes 31–32.[26]

HORSES

It has often been noted that there is a proportional discrepancy between the size of the horses and that of their riders, i.e., the riders are too large for their mounts, who thus resemble ponies. Are these horses rendered unrealistically in order to maintain the isocephalism of the frieze? An authority on horses in ancient Greece, J. K. Anderson, has written: "In the fifth century B.C. the Greek horse, as represented by painters and sculptors and described in literature, was a small animal, perhaps never exceeding, and seldom reaching, fifteen hands [60 inches], with a fine head and legs, high head carriage, and rather heavy body."[27] The high carriage of the head and neck is particularly characteristic of horses in Greek art and may represent an equine form of idealization. Xenophon (*On Equitation* 10.16) describes the

pose of a proud, well-trained horse: "He bears himself magnificently, with a haughty carriage, his front legs moving freely."

The pose most consistently used for the horses on the frieze is with one or both rear legs bent, bringing the buttocks to the ground, and the front legs lifted into the air. Like the famous "airs above the ground" of the Lippizaner stallions, this uplifted body is typical of parade horses who are trained to perform aerobic tricks like the levade, in which the haunches are deeply bent. As described by Xenophon (*On Equitation* 11.9): "a curvetting horse is a thing so admirable that it captures the eyes of all beholders, both young and old. At least no one stops watching or grows tired of the spectacle, as long as he continues to show off his brilliance." So, in spite of their realistic bodies, even to the carving of individual veins, these horses are mostly posed in an idealized parade stance, presenting what Xenophon terms " a worthy appearance." Like their riders who are not ordinary men, these horses are special, again in the words of Xenophon (11.1) "naturally endowed with great-heartedness of spirit and strength of body." Some of the horses are literally in mid-air with all four hooves off the ground; in these cases their riders (N117; W8, Fig. 97; W19) reach forward with their right hands to touch the top of the horses' heads, apparently in a effort to bring them back to the ground.

Some horses do stand quietly with all four hooves planted firmly on the ground. The stillness of these horses is echoed in the position of their tails, which fall vertically to the ground, in contrast to the tails of the galloping horses, which fly out almost horizontally behind them. So, like the drapery of the riders, even the tails of their horses consistently conform to the degree of motion in the composition.

ATTRIBUTION

The horses of the Parthenon frieze have played an important role in the vexed question of attribution. The individualized renderings of their cropped manes, for instance, have led certain scholars to make attributions based on stylistic traits. A case in point are the horses of South III–IV (Fig. 81) with their distinctive double-rowed, flame-like or flickering manes; they are attributed to the same hand as the chariot horses of South XXXI (Fig. 82), whose manes are similarly carved. At first this observation of the style of the manes seems like a reasonably objective approach to attribution, a Morellian technique used successfully in other areas of art history. However, in terms of the frieze, it soon becomes clear that it is not possible to assign any other slabs to this particular hand, except perhaps the half-hidden horse

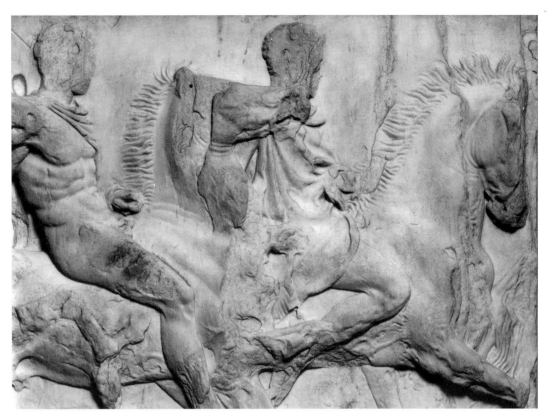

Figure 81. South III, detail. British Museum. Photo: museum

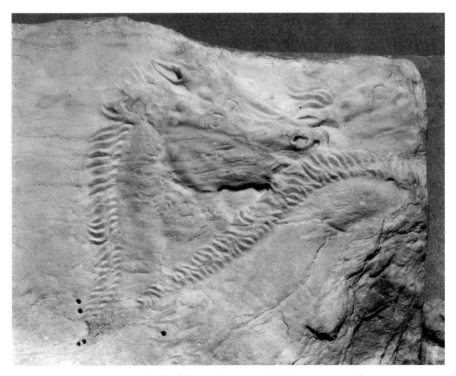

Figure 82. South XXXI, detail of horses' manes. British Museum. Photo: museum

of rider N134.[28] This method has led to some fairly improbable conclusions, namely, the detection of as many as seventy-nine hands at work on the frieze.[29]

In pursuit of the *Meisterfrage* issue, scholars have also tried to ascribe certain figures to masters responsible for other parts of the temple program. As one might expect, since both are relief sculptures, close correspondences between certain figures of the frieze and those of the Parthenon metopes have been detected. In terms of composition, south metope 5 could have been a prototype for the group of rearing horse and rider of West XIV. The cloak of the maiden on south metope 29, one of the most progressive of the metopes, has a pie-crust edge and the distinctively crinkled linen of her chiton closely resembles the *chitoniskos* of the *apobates* N47 (Fig. 6). The long curve of the horse's neck on West XII (Fig. 90) had led Brommer to believe that it was sculpted by the same person who carved the horse of Selene on north metope 29, although given the poor state of this metope it is hard to be convinced.[30] One might expect to find close similarities between the horses of the frieze and the centaurs of the south metopes. The centaurs, like the horses, all display prominent veins along their bellies, but in other respects they are less detailed and present an almost rubbery appearance compared to the rippling muscles of the horses on the frieze. The tail of the centaur on south metope 2 is like those of the chariot horses on frieze block North XXVI: in all cases they are smooth near the rump and incised beyond. Some of the more benign centaur heads, like that of south metope 4 (Fig. 83), recall the bearded men of the north frieze (Fig. 84). Although there are some points of resemblance, it is clear that the metopes were executed in an earlier phase of the Classical style, and while they paved the way in many respects for the frieze, the drapery, proportions, musculature, and poses of the frieze are more advanced.

There are also many points of comparison between the frieze and the pedimental figures, even though the latter are considerably larger in scale, carved fully in the round, and somewhat later in date. The similarity in the wide and deeply channeled drapery of the running goddess of the east pediment (G) to that of the charioteer of North XII (Fig. 6) is particularly striking and was noted long ago by Kjellberg.[31] Brommer compared the short chiton of Iris of the west pediment with that of the *apobates* N64 (Fig. 103); both have finely engraved folds within the larger folds of the cloth.[32] Ashmole believed that the rider W2 was carved by the same sculptor who was responsible for the figure of Poseidon in the west pediment; the head of Poseidon is no longer extant but is most likely reflected in the features of the Roman Triton from the Athenian Agora. The shape of the lips, the crease in the forehead, and the heavily rimmed eyes are apparent in both visages.[33]

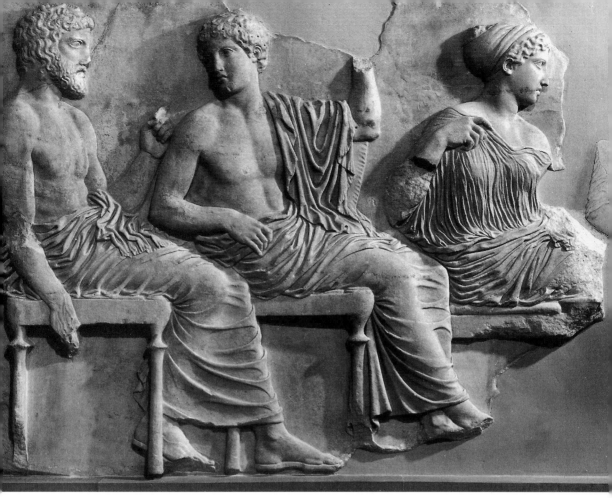

Figure 86. Poseidon, Apollo, and Artemis (E38–40). Acropolis Museum. Photo: Alison Frantz AT 152

quite matches the expert hand who is showing off here. Perhaps this block was carved as a model, a *paradeigma,* for the other sculptors to emulate, an inspiration for their own workmanship. If this is the case, then it may well have been the one (and perhaps only) block carved by Pheidias.

The other sculptor who is most often mentioned in relation to the carving of the frieze is Alkamenes, and some have seen in him the "Hauptmeister" of the entire relief. An Athenian and student of Pheidias, Alkamenes, like his teacher, is credited in the literature with statues of gods in bronze and gold-and-ivory. His style is considered to be quiet, solemn, and dignified; the frieze slab most consistently ascribed to him is East VI (Fig. 86). The heavy folds of the drapery, the serious expressions, the richly waved hair all seem to conform to the style of this sculptor as displayed in his one extant marble work, the Prokne and Itys from the Acropolis. If the Velletri Athena represents part of his cult statue group for the Hephaisteion, then one might see a simpler prototype in the marshal W1 (Fig. 87), who wears his *himation* around his waist, forming a long triangular apron

Figure 87. Marshal (W1). British Museum. Photo: Alison Frantz EU 188

who wears his *himation* around his waist, forming a long triangular apron in front.[36]

A number of other fifth-century sculptors, known mainly as names without extant works (Agorakritos, Kolotes, Kresilas), have been associated with specific slabs or individual figures of the frieze. In some instances the same relief is attributed to four possible sculptors by different scholars.[37] At this point it seems most reasonable to assume that there were approximately nine individual hands at work on the frieze under the supervision of two master designers. This scenario accounts for the different styles exhibited in the actual carving and the compositional differences between the north and south friezes. In the absence of signed originals by the great fifth-century sculptors, this large but still anonymous workforce may be the most practical solution for the age-old *Meisterfrage*.

Figure 88. Procession to Athena. Black-figure band cup, ca. 550. Niarchos collection, London. Photo: D. Widmer 837

ICONOGRAPHIA
IDENTIFYING THE PLAYERS

I have little doubt that the problems of the
Parthenon frieze – iconographic, religious,
artistic – will continue to be regarded as an
open sport for scholars until a fifth-century
text is discovered which tells us the truth.
– John Boardman (1984, 215)

The Parthenon frieze is a text. Some two and a half millennia after its
making the language can be at times obscure. However, if one makes
the attempt to learn its visual language, it is possible to come closer to an
understanding of its constituent parts and, in the end, closer to its true
meaning. Before grappling with the thorny issue of what the Parthenon
frieze actually means or what it meant to ancient Athenians, it is important
to identify as accurately as possible the various actors in its narrative. Today
we are in a good position to do precisely this. For one, the frieze is more
complete than it has been since the seventeenth century, so that, for
instance, when citing precise numbers of figures we are on much firmer
ground than scholars were even fifteen years ago. Also key fragments have
recently come to light, such as that found by Despinis in the storerooms of
the Athens National Museum, which shows how the goddesses Artemis and
Aphrodite are linked intimately arm in arm.[1] Secondly, there exists a great
deal of comparative data in other media, namely, vase painting and relief
sculpture, which can be pressed into service for a better understanding of the
frieze. A useful corpus is the abundant, but as yet largely untapped, imagery
to be found on red-figure amphoras of Panathenaic shape, much of which
relates to the Panathenaia and Greek religion in general.[2] Also in recent years
the study of classical iconography has progressed considerably, especially
with the publication of a voluminous iconographic lexicon devoted to classi-
cal antiquity.[3] Finally, the field of archaeology is always yielding new objects
through excavation and publication that can shed light on the problems of

the frieze. One important example is the Attic black-figure band cup in a private collection (Fig. 88) that provides rare evidence for the appearance of a procession in honor of Athena in the mid–sixth century.[4] Likewise we have a better grasp of religious rituals and their role in Greek society, due in large part to the publication of inscriptions dealing with cult.[5] By taking a comprehensive approach that tries to include all relevant data, it is possible to identify elements of the frieze more accurately than previously.

As successfully as they have been blended together, there is no denying that the frieze is made up of diverse groupings. Broadly speaking, there are riders (horse and chariot), bearers (of olive twigs, musical instruments, *hydriai,* baskets, animals, and sacrificial implements), and spectators (heroes or officials, and gods), all leading up to the central assembly of five, who perform or have performed some obscure (to us) ritual. Once these groups are analyzed in terms of age, dress, attributes, and activity, they can be related to Athenian ritual. Thus, the sections that follow will identify as accurately as possible the separate groupings of figures and their activities and then consider them in the context of Athenian society in the mid–fifth century as we know it.

PRELUDE (W22–30)

As we have demonstrated in Chapter 2, the southernmost third of the west frieze is not actually part of the procession proper. The six unmounted horses here represent the "rejects" so to speak; at least one (West XII, Fig. 90) is demonstrably too young and his mane is uncropped, and another seems to be so unruly that two men (W26–27, Fig. 75) cannot control him. Some of the human figures are also anomalous in various ways. Their oddities could be accounted for by the fact that this section was carved first and hence the canon was not yet established. Alternatively the designer could be indicating that these young men and their horses represent a prelude to the procession (just as on the east side there is a postlude; see Chapter 2).

The first figure (W30, Fig. 39) is a marshal – like other corner figures (W1, Fig. 87; S1; and E1) – but instead of directing the procession, he is still dressing.[6] His neighbor (W29) is also getting ready: his right foot is bare while he is tying a sandal on the other. The third figure (W28) is bridling a standing horse while another horse waits patiently behind. These calm horses contrast with the next two, who are rearing, back to back. One has in fact turned around in the opposite direction, facing right, and is being reined in by two actively posed men (W27 and W26, Fig. 75), the latter of whom has left his quiet horse to aid his companion.

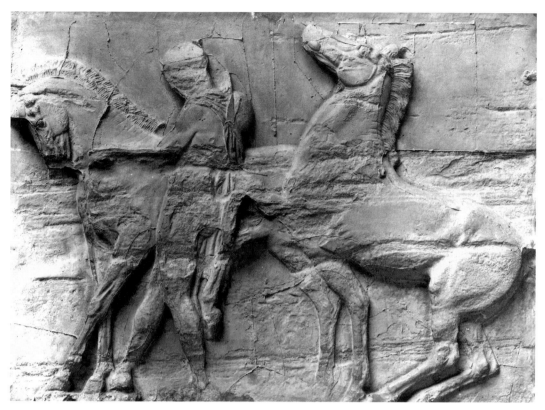

Figure 89. Cast of West XIII. Photo: British Museum

Next comes one of the most peculiarly posed figures on the entire frieze – W25 (Fig. 89). He is reining in his mount at the same time that he has placed his right foot on the far side of the horse's right forehoof. Both the youth and his horse are looking concentratedly down at the ground. The artist must have had something specific in mind, given this odd and exceedingly awkward pose. Via consultation with a horse trainer, I have been informed that this represents a common practice known as "parking up" the horse. The horse's legs are already splayed out in back and the youth is now attempting to do the same for the front legs. The result will be a horse leaning forward with a very stretched-out appearance. This is a classic pose commonly found in horse shows in halter class.[7] Once in this static position, the horse is presumably ready for inspection. This realistic element (among many others) indicates that we are witnessing a very specific event, a conclusion that is confirmed by the reading of the next block.

The last block in this section (Fig. 90) opens with a figure (W22), who looks down and is making a very precise gesture – his right index finger extended – toward the horse in front of him. Again an extremely specific

action is being enacted. Martin Robertson suggested that the man on the left "might be writing something down on a tablet, as in the *dokimasia* (inspection of young knights and their horses). Could he be booking the knight, whose gesture might be one of protest, for having his horse's mane wrongly dressed?"[8] If a tablet was once present, then the scene does resemble the *dokimasia,* or cavalry inspection, as depicted on late sixth- and early fifth-century vase paintings (Fig. 91).[9] Brommer contended that he could not be writing because his forefinger is extended and no tablet is visible, but it might easily have been rendered in paint or be hidden by the inspector's right forearm.[10] In relation to the cavalry the *Constitution of the Athenians* (49.1) states: "The council holds a scrutiny *(dokimasia)* of the cavalry's horses. . . . Horses which are unable to keep up, or are unwilling to stay in line and are unmanageable, are branded on the jaw with the sign of a wheel, and any horse which has been branded is rejected." At least two of the horses to the right of the inspector are depicted as unmanageable and unwilling to stay in line, and so should properly be rejected from the parade.

Recently Glenn Bugh has argued that these scenes on vases show not official enrollments of knights into the military, as described in the *Constitution of the Athenians,* but rather "simply the preliminaries to a procession or festival in which men or youths on horses participate."[11] That this interpretation is probably correct is supported by the fact that Attic vase paintings do not usually depict official actions of the Athenian state. Thus, both the frieze and these *dokimasia* vases show the same scene, one that must have been familiar to vase painters working in the vicinity of the Dipylon Gate, namely, the inspection of horses at the beginning of religious processions. At such times unfit horses would be eliminated by officials like W22, who, it should be noted, wears only an open *chlamys* and so is virtually nude as other important horsemen on the frieze (W2, W4, W9, N89, N105, N113, N120, N133 – the latter five all rank leaders).

That the inspection had special resonance for Athena and the Panathenaia is indicated by a red-figure amphora of Panathenaic shape in Munich (Fig. 92).[12] Here Athena herself is in the pose of the inspector – tablet and stylus in hand – while on the other side of the vase an athlete with a javelin, rather than a horse, stands at attention. The goddess is perhaps recording the name or score of the acontist at the Panathenaic games in her honor. The inspection and recording of participants appears to be an important part of the preliminaries to the festival.

The third and least important figure on this block (W24) seems to be a stable boy holding a lead to the horse. The boy has a cloak over his left shoulder like other attendant figures on the frieze. Surprisingly, the horse lacks any

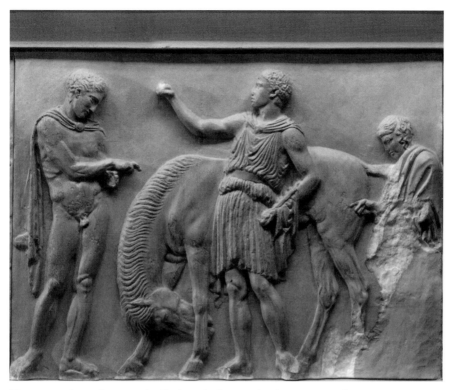

Figure 90. Cast of West XII. Skulpturhalle, Basel. Photo: D. Widmer SH 633

Figure 91. *Dokimasia.* Red-figure cup attributed to the Thalia Painter, ca. 490. Herbert Cahn collection, Basel 133. Photo: H.A.C.

drill holes along his head and so either the reins were painted or the horse is unbridled, in which case it might simply be hobbled. The horse is also in a noteworthy pose, rubbing his muzzle against his front leg. It appears very naturalistic, but could it be an sign of tiredness and defeat (at being hobbled) or a signal that he has been branded on the cheek, hence rejected?[13]

The question then remains, who is W23, prominently posed before the horse in the center of the composition? Although he could be the owner of the rejected horse, he lacks any affinity with the animal or with the inspector; rather he seems to be looking and gesturing far off into the distance. (In this respect he resembles E47, who was discussed earlier; see Chapter 2, Fig. 52.) In addition to his gesture, he holds a long object nestled in the crook of his left arm. Its length is indicated by the pairs of drill holes in the drapery below his left hand and along his forearm; these holes were clearly for the attachment of bronze extensions. Although this object could be a whip, it seems excessively large and so is perhaps better read as a *kerykeion* (herald's staff) or *salpinx* (trumpet-like instrument). With his right arm extended and his left at his hip, W23 in fact stands in the pose characteristic of the herald or *salpinx* player, as seen in Attic vase painting.[14] Although he is clearly not blowing a trumpet, the stance is close enough to recall the pose of this familiar figure. All this evidence – attribute, gesture, glance – support the identity of the man as a herald.

Both heralds and trumpeters performed important functions at Greek festivals.[15] The *keryx,* or herald, is specifically mentioned in texts dealing with the Panathenaia (e.g. Herodotos 6.111), and is represented on various vases, including Panathenaic prize-amphoras, proclaiming the victors in athletic contests.[16] The *salpinx,* however, is even more closely associated with the Panathenaia and the goddess Athena. A number of the reverses of Panathenaic prize-amphoras depict *salpinx*-players who are either calling for silence for the heralds or are themselves proclaiming the victors of athletic contests.[17] A trumpeter even appears in silhouette as the shield device of Athena on the obverse of a Panathenaic-shaped amphora fragment from the Acropolis (Fig. 93).[18] As a war trumpet, the *salpinx* is particularly appropriate to Athena, and she is shown holding one on a red-figure lekythos found in Athens.[19] Finally, the *salpinx*-player can appear in religious processions.[20]

A late Archaic red-figure cup in Florence (Figs. 94–95) in fact shows a scene that could be read as a harbinger of west frieze block XII.[21] On one side five nude youths are manhandling a sacrificial bull while the butcher stands waiting, sharpening his two long knives. Beyond the bull and facing the other side of the cup is a draped and wreathed youth holding up a folded writing tablet. He is clearly in some way connected with the four youths and

Figure 92. Athena as scribe. Red-figure amphora of Panathenaic shape attributed to the
Triptolemos Painter, ca. 480. Antikensammlung, Munich 2314. Photo: museum

Figure 93. *Salpinx*-player as shield device of Athena. Fragment of black-figure amphora of Panathenaic shape, ca. 480. Acropolis 1025. After Graef-Langlotz I, pl. 58

three horses (only one of whom is mounted) on side B. Standing in front of the horses is another nude youth, left hand at his waist, blowing a trumpet. Since the horses are not all mounted, this is clearly not a race and so perhaps it depicts preparations for the commencement of a religious *pompe,* which would go along well with the sacrifice on side A. So, then, another *dokimasia cum salpinx*-player, as on West XII. Whether the herald on the Parthenon frieze is about to sound his *salpinx* or is making an announcement, his position physically marks the starting point of the procession proper and his action proclaims its commencement. From this block on we are dealing with the procession proper, which continues all the way to the east to the figure E47 (Fig. 52), who, in a similar stance to the trumpeter, marks its end.

CAVALCADE (W1–21, N75–136, S1–61)

The ranks of horsemen constitute almost half (46 percent) of the entire frieze. As we have seen in Chapter 2, they are divided into two lines of ten ranks each – those ranks on the south being more obvious because of dress than those on the west and north. All of the riders are youths with the

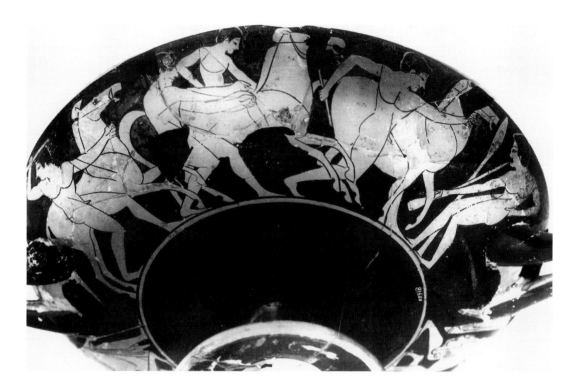

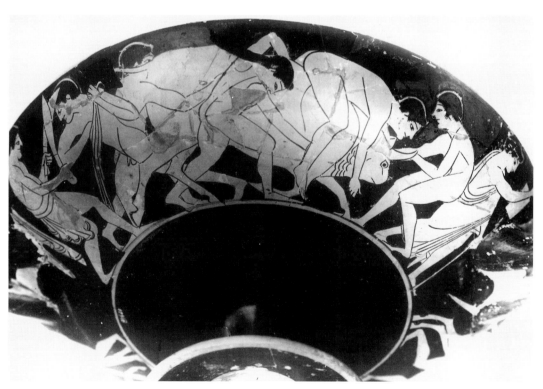

Figs. 94–95. *Dokimasia* with *salpinx*-player; youths bringing bull to sacrifice. Red-figure cup, ca. 500. Museo archeologico, Florence 81600. Photo: Soprintendenza Archeologica per la Toscana

exception of the two bearded men on the west (W8, Fig. 97, and W15, Fig. 85). In the entire cavalcade there are only three active marshals, recognizable by their long mantles, or *himatia* (W1, S1, N90; W30, if a marshal, is not yet active). No doubt they were less necessary in this part of the procession because each equestrian rank has its own leader, who, as we have seen, turns to signal or otherwise keep track of his rank's position in the cavalcade. These rank commanders are distinguished not only by pose and position, but in some cases also by more exposed flesh, as we have seen above (e.g. S8; N89, 105, 113, 120, 133).

On artistic grounds it is not surprising to see so much of the frieze devoted to horsemen; they offer variety to what would otherwise be a monotonous row of human figures. In terms of iconography a cavalcade also makes good sense, since equestrian parades were a regular sight in Classical Athens. Ancient testimonia (e.g. Demosthenes, Xenophon) often refer to cavalry processions in Athens, many of which took place in the Agora, and mention specifically the participation of the two senior officers, the hipparchs. Cavalry escorts accompanied holy processions to Eleusis and to Phaleron. While no specific reference to a cavalcade at the Panathenaia exists, it would be unusual, to say the least, if this important state festival did not include a public display of horsemanship in addition to the many equestrian contests.[22]

The cavalry was a relatively new phenomenon in the Athenian military, which was dominated by hoplites (foot soldiers) and thetes (rowers). In the period during which the Parthenon was built the Athenian cavalry apparently increased from 300 to 1,000 *hippeis,* or knights. It was organized by tribes *(phylai)* and commanded by ten secondary officers known as phylarchs. One such officer is depicted at the end of a rank of youthful riders on a fragmentary relief monument found in the Agora (Fig. 96). Dated to ca. 400, it commemorates the tribe's victory in an event known as the *anthippasia,* a mock cavalry battle held at the Panathenaia.[23] Such monuments were set up along the Panathenaic Way in the Agora along with memorials to individual cavalry commanders, the implication being that cavalcades traveled this route. Not only was the office of the cavalry commanders *(hipparcheion)* located at the northwest corner of the Agora in the area known as the Herms (Fig. 18), but the cavalry undoubtedly trained along the wide even surface of the Panathenaic Way. In his treatise on the cavalry commander (*Hipparchikos* 3.2) Xenophon actually recommends this practice: "As for processions, I think they would be most pleasing to both the gods and spectators if they included a gala ride in the Agora. The starting point would be the Herms; and the cavalcade would ride around saluting the gods at their shrines and statues. . . . When the circuit

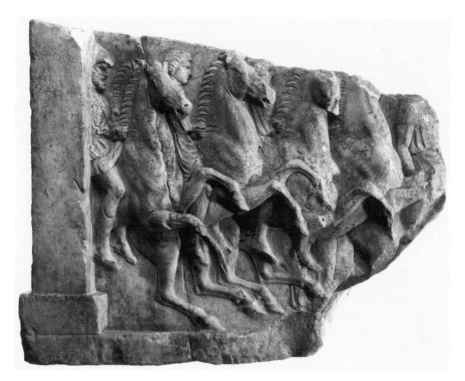

Figure 96. Commemorative marble relief of the tribe Leontis for victory in the *anthippasia,* ca. 400. Agora Museum I 7167. Photo: Agora Excavations, American School of Classical Studies at Athens

is completed and the cavalcade is again near the Herms, the next thing to do, I think, is to gallop at top speed by tribes to the Eleusineion." An equestrian parade by tribe thus seems to be an essential part of Athenian *pompai* (festal processions), especially in the glory days of the cavalry.

A number of scholars have called attention to the Thracian dress of some of the riders, in particular the two bearded men on the west (W8, Fig. 97, and W15, Fig. 85) and the first rank on the south side (S2–7). The costume consists of a distinctive fur cap with long ear and neck flaps *(alopekis),* a patterned cloak known as a *zeira,* and high leather boots with flaps *(embades).* It appears frequently in Attic vase painting, as on this red-figure cup by the Foundry Painter in Rome (Fig. 98).[24] Although Herodotos and Thucydides described the Thracians as an uncivilized war-like people, the Athenians had special connections with them. They used Thracian mercenaries in the army and attempted to colonize the gold-rich region of Mt. Pangaeum. A cult of the Thracian god Boreas was introduced during the Persian Wars as a result of the help provided to the Greek fleet by the north wind (Herodotos 7.189). It is clear from Attic vase paintings and the frieze that elite Athenian cavalrymen

adopted Thracian dress, and so it would have been acceptable (probably even chic) military attire in the mid–fifth century.[25]

As noted above, two of the horsemen on the west are bearded. W15 (Fig. 85) with his flying cloak is one of the most dynamic figures on the frieze, and his rearing mount is equally impressive; together they make up an entire frieze block (W VIII).[26] Unusually he stands beyond his steed, bracing his right foot on a rock as he restrains the horse, and so the viewer sees the entire extended flank of this powerful animal. Three pairs of horsemen are behind him and one pair precedes him. The other bearded equestrian (W8, Fig. 97) also appears in the midst of a rank of riders, but he is mounted. His cloak flutters behind and he presses his right hand to the top of his horse's mane, a gesture performed by two other horsemen (W19, N117). Since both of these horses have all their hooves off the ground, it must represent an attempt to control or calm the animal, as noted earlier.

Martin Robertson was the first to identify the two bearded "Thracians" on the west as the two Athenian cavalry commanders, the hipparchs, and he is surely correct.[27] According to Xenophon (*Hipparchikos* 3.1) the hipparch had specific religious duties in addition to his military ones: "First he must sacrifice to propitiate the gods on behalf of the cavalry; secondly, he must make the processions during the festivals worth seeing." The fact that the two hipparchs are featured at the west end, where the viewer first encounters the procession, acts as a signal that this procession is one worth seeing, i.e., an important state event. It also indicates a certain chronological terminus, since two hipparchs replaced the previous three when the cavalry increased in size in the second half of the fifth century.[28]

There are some other peculiarities of dress discernible among the horsemen. The rider W11, for instance, seems especially singled out from the other riders by his distinctive helmet and corslet: both have carved relief decoration. The helmet bears an eagle and the corslet a gorgoneion rather low over the abdomen (Fig. 99).[29] The latter detail would have been invisible from the ground, and one wonders if it might not have been some hidden sign of the artist, perhaps a signature of sorts. Two riders (W14, S44) wear fluttering animal skins instead of mantles over their *chitoniskoi*. As noted earlier (Chapter 4) a number of the riders on the north frieze (N99, Fig. 45; 101, 110, 123, 124, 135, Fig. 126) wear long-sleeved chitons. In the opinion of some scholars this sleeved chiton represents either an archaic form of dress or foreign attire, because it is often worn by Persians and Amazons in Attic vase painting, although usually accompanied by leggings. Like the Thracian garb, it is more likely to be simply a contemporary fashion, an alternative to the more common sleeveless chiton, especially as it is also worn by a number of the charioteers (N52, N59, S78).[30]

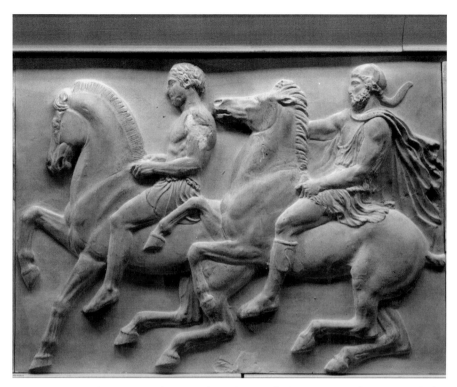

Figure 97. Cavalryman in Thracian dress: hipparch (W8). Cast of West IV. Skulpturhalle, Basel. Photo: D. Widmer SH 625

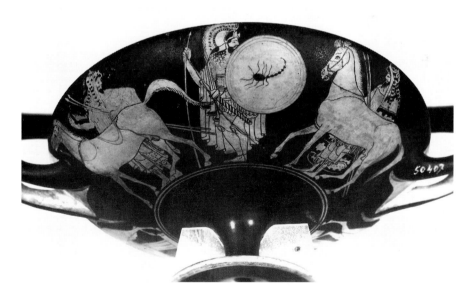

Figure 98. Cavalrymen in Thracian dress, possibly hipparchs. Red-figure cup attributed to the Foundry Painter, ca. 480. Villa Guilia, Rome 50407. Photo: Soprintendenza Archeologica per l'Etruria Meridionale

Figure 99. Detail of cast of W11 show-
ing gorgoneion on breastplate. Photo:
British Museum

CHARIOTS (N44–74, S62–88)

Ahead of the cavalcade one encounters a procession of four-horse chari-
ots or quadrigas, ten on the south and eleven on the north.[31] Each
chariot has a charioteer standing in the car and, as passenger, a warrior wear-
ing a plumed helmet and carrying a round shield (Fig. 100). This warrior
may be either in the car, in the act of stepping in or out, or standing along-
side on the ground. Most of the chariots are accompanied by a marshal and
at least one is held by a groom (N72).

Because of the warriors' actions of mounting and dismounting, this sec-
tion is usually taken to represent the *apobates* contest, a ceremonial race
known only in Attica and Boiotia.[32] Although details of the race are lacking,
it seems that armed men leapt from moving chariots and raced on foot to the
finish line. At least one Panathenaic prize-amphora (Fig. 101)[33] illustrates this
event, indicating that it took place at the Panathenaia, as does a commemora-
tive monument set up along the Panathenaic Way (Fig. 102).[34] Note how the
apobates' left leg can be seen through the chariot wheel, exactly analogously to
that on block XXIII of the north frieze (Fig. 103). The race apparently took
place in the Agora, as some late inscriptions refer to the *apobatai* descending
at the Eleusineion. This crowded public venue may account for the large
number of officials or marshals depicted on these sections of the frieze.

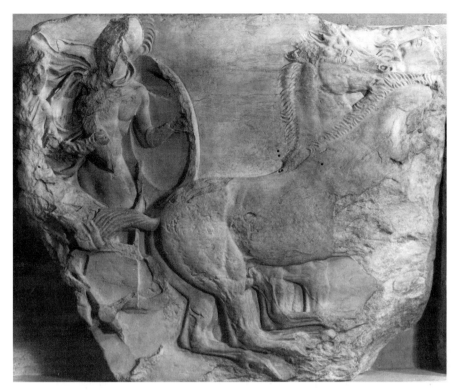

Figure 100. South XXXI. British Museum. Photo: Alison Frantz, EU 216

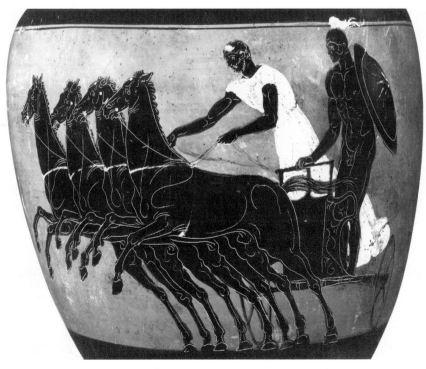

Figure 101. *Apobates.* Detail of Panathenaic prize-amphora attributed to the Marsyas Painter, 340–39. J. Paul Getty Museum, Malibu 79.AE.147. Photo: museum

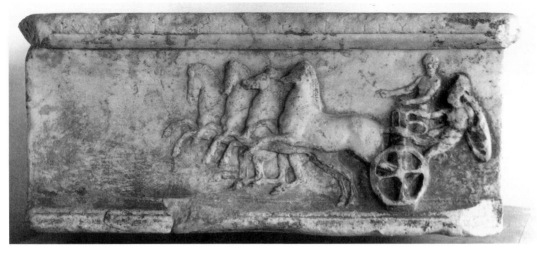

Figure 102. Marble base for a monument commemorating a victory in the *apobates,* fourth century. Agora Museum S 399. Photo: Agora Excavations, American School of Classical Studies at Athens

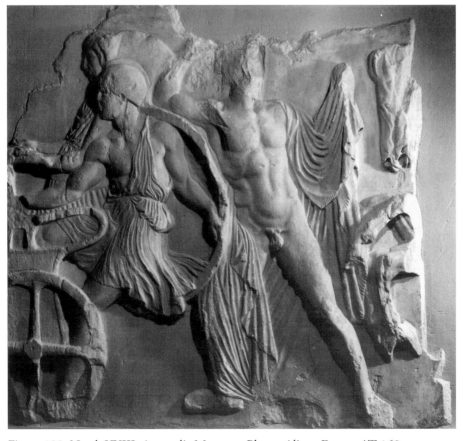

Figure 103. North XXIII. Acropolis Museum. Photo: Alison Frantz, AT 168

Although this is almost certainly a demonstration of skill on the part of the *apobatai* as opposed to an actual race, it does introduce the element of contest to the frieze as well as the only real military flavor, since the warriors all wear helmets and carry shields and at least two (N47, Fig. 7; N71) wear cuirasses. Some of the horse riders wear helmets (S38–43, N118, W11) with their body armor, but none carries a shield or any other type of weapon.[35] The display may have been intended to recall the legendary foundation of the Panathenaia at which the Athenian king Erichthonios appeared as a charioteer with an armed companion at his side.[36] On a black-figure vase in Copenhagen (Fig. 104) Athena is depicted like an *apobates* running alongside a racing chariot toward a goal post at the far right. It was clearly a distinctly Athenian event in which she, naturally given her association with horses in general and chariots in particular (see Chapter 6), took a special interest.

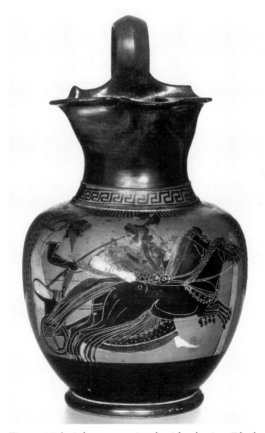

Figure 104. Athena running beside chariot. Black-figure oinochoe, ca. 510. Department of Classical and Near Eastern Antiquities, National Museum of Denmark, Copenhagen Chr. VIII.340. Photo: museum

ELDERS (N28–43, S89–106)

At this point there is a major change in format: the equestrian parade becomes a pedestrian one. The designer has nonetheless made a connection between the two by depicting the first two men on the north (N42, N43) looking back somewhat apprehensively at the chariot screeching to a halt behind them. (The comparable section on the south side is lost). The first part of this pedestrian procession consists of large clusters of standing, draped, bearded men. Again there is not complete parity between the two files, with sixteen men on the north (Fig. 105) and probably eighteen on the less-well-preserved south. Like the marshals, these men are dressed in voluminous *himatia,* draped around their lower bodies and up over their left shoulders, leaving the right arms and chests exposed. But unlike the marshals, some sport old-fashioned hairdos: long braids encircling their heads, a style popular for older men and gods in early Classical art.[37]

One distinctive feature of these groups is the fact that at least four of the men raise their right hands in a clenched fist. This pose has given rise to the idea that they might represent the *thallophoroi,* older men chosen for their beauty who carried *thalloi* (olive twigs) in the religious procession, according to Xenophon (*Symposium* 4.17).[38] Since there are no drill holes for attachments, either the twigs were painted or the clenched fists signify some other intent. Simon has suggested that this posture represents the attitude of worship, since it is shown as such on some votive reliefs.[39] It should be noted, however, that the Carrey drawing of N31, whose lower body is now missing, seems to show a short twig in the older man's lowered left hand, as the lines are much darker than the drapery folds.[40] Also many Attic vase paintings depicting processions show men carrying twigs, often directly behind musicians as on the frieze. One example is a red-figure amphora of Panathenaic shape in New York (Fig. 106), which shows on one side a youth carrying twigs in what must be a religious procession (cf. the other side, Fig.114).[41] The shape of this vase indicates that the context is the Panathenaia. In addition to the fist, the old-fashioned hairdo seems to be an important sign, namely, that these are very old men, and so the interpretation as *thallophoroi* still best fits the evidence. The large number of men is perhaps testimony to the large scale of the festival in which they are involved.[42]

MUSICIANS (S107–114, N20–28)

Ahead of the procession of elders march eight musicians: four *kithara* players and four *aulos* players. Although much is missing, these figures are

Figure 105. Elders. North X. Acropolis Museum. Photo: Alison Frantz AT 166

clear enough on the north side, thanks to Carrey's drawing (Fig. 107). However, the comparable section on the south side is more problematic, not only because Carrey's drawing stops at South XXXVIII but also because it shows four men cradling what appear to be square tablets in their left arms (Fig. 47). Brommer, following some suggestions by earlier scholars, took these to be large *pinakes,* or plaques. Although *pinax*-bearers are sometimes shown in Attic vase paintings of processions, on the vases these plaques are always small enough to be held in the hand. Hence, Simon has interpreted what look to be large plaques on the frieze as tablets and their carriers as *grammateis,* or secretaries responsible for the registration at the festival. Such tablet-bearers are unprecedented in depictions of religious processions, and so would be at odds with the rest of the iconography, which has precedents in Athenian art. Most scholars now agree that Carrey misunderstood the sound box of the *kithara* and that there should be restored here the same number of kitharists as on the north. If this is the case then the files are more or less comparable, as they are in most other respects.[43]

As further confirmation that the poorly preserved figure S107 is a kitharist is the fact that he appears to be holding something in his lowered right hand, mostly likely a plectrum for strumming the strings of the instrument. Also he is dressed like the kitharists on the north (N24–27, Fig. 108) in a long, sleeved, girt chiton with a diagonal mantle fastened on the shoul-

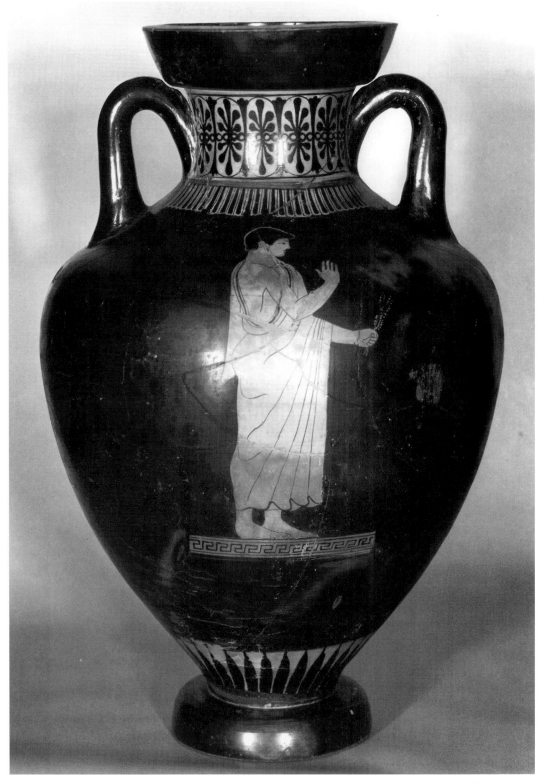

Figure 106. *Thallophoros.* Red-figure amphora of Panathenaic shape attributed to the Syleus Painter, ca. 470. Metropolitan Museum of Art, New York 20.244. Rogers Fund, 1920. Photo: museum

Figure 107. Carrey drawing of North VIII

Figure 108. North VIII. Acropolis Museum. Photo: Alison Frantz AT 165

der.[44] Comparanda for such elaborately garbed musicians are not hard to find. The obverse of the name-vase of the Painter of Berlin 1686 (Fig. 109) shows two such richly dressed kitharists in a religious procession to the altar of Athena on the obverse.[45] They are preceded by a pair of *aulos* players, just as is the kitharist on the band cup of similar date (Fig. 88).

On the frieze the kitharists are preceded by an equal number of *aulos* players. They are preserved not at all on the south, and on the north mostly in Carrey's drawing. All one cay say of them is that they were youths. In contrast with the kitharists who seem to be simply holding their instruments, the auletes are actually playing.

In addition to making solemn music for religious processions, musicians had another role in Classical Athens. Auletes and kitharists contested for lucrative prizes at the Greater Panathenaia. Long-robed kithara players are regularly depicted on red-figure amphoras of Panathenaic shape, and at least one shows the goddess herself playing the instrument next to her altar (Fig. 110).[46] She of course did not play the *aulos,* since the pipes disfigured her face (see Fig. 15, where she has cast them aside), but she is credited with its invention.[47] So these musicians, like the *apobatai,* have a double role on the frieze: as actual participants in the festival procession, and as referents to the *agones* that preceded it.

HYRIAPHOROI (N16–19, S115–118 CONJECTURED)

Ahead of the *aulos*-players on the north frieze come four *himation*-clad youths carrying water jars, or *hydriai* (Fig. 37). The first (N19) leans over to pick his jar up off the ground, while the other three support theirs on their left shoulders. It appears that the hydrias are heavy and so they are probably filled with water and were also certainly made of metal. Jenkins now reconstructs their counterparts on South XXXIX, although nothing remains of this entire slab.[48] Given the similarities between north and south, this hypothesis is probably correct.

These *hydriaphoroi* have presented a problem for scholars because the sources on the Panathenaia mention metic *girls* as the hydria-carriers. However, these sources are late (scholia and lexika) and so they perhaps do not pertain to the fifth-century version of the festival.[49] To circumvent this problem Simon has suggested that the hydrias represent the award given to the victors in the torch race held at the annual Panathenaia (there being four for the four years between Greater Panathenaias).[50] Since there are no other victory tokens on the frieze (such as Panathenaic amphoras) this theory, while suggestive, is prob-

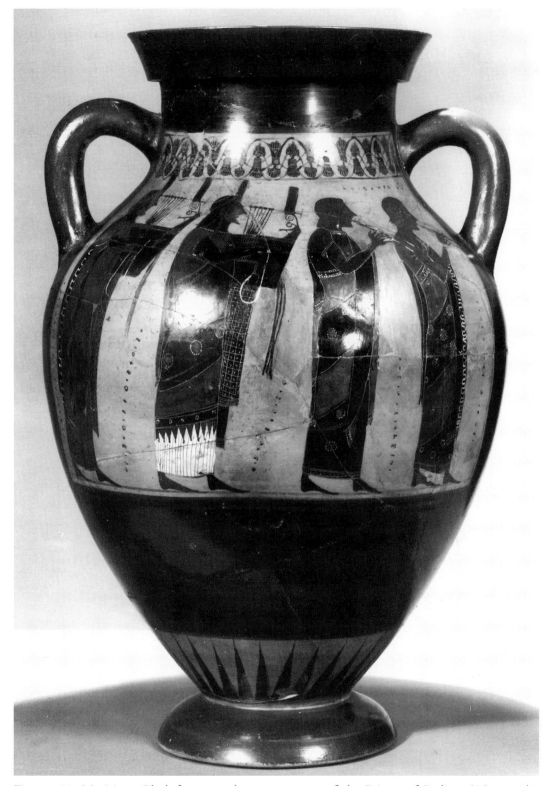

Figure 109. Musicians. Black-figure amphora, name-vase of the Painter of Berlin 1686, ca. 540. Antikensammlung, Berlin F 1686. Photo: museum

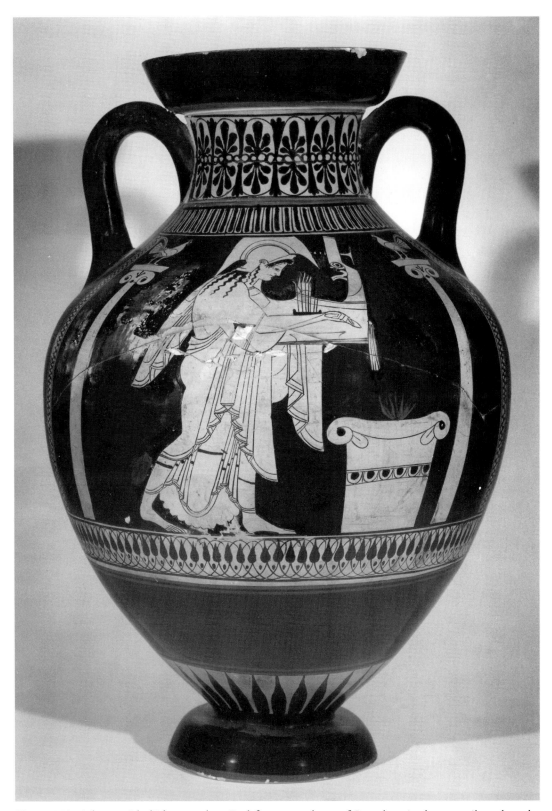

Figure 110. Athena with *kithara* at altar. Red-figure amphora of Panathenaic shape attributed to the Nikoxenos Painter, ca. 500. Antikensammlung, Berlin F 2161. Photo: Jutta Tietz-Glagow

ably not plausible, although the *hydriai* could possibly allude to the festival contests, as we shall see. Equally implausible is the suggestion that the *hydriai* were filled with imperial tribute paid to Athens by the allies and displayed annually on stage at the City Dionysia; surely money sacks would convey this idea better than water jars, which form a traditional part of Greek sacrifice.[51]

In fact there is vase painting evidence for male *hydiaphoroi* in religious processions in Athens. The fragmentary pelike by the Pan Painter that depicts the Herms on one side (Fig. 18) shows two processional figures on the other: a girl with an offering basket *(kanoun)* on her head and a youth bending over to pick up a hydria (Fig. 111). Since a *kanephoros* is a clear indicator of a religious rite, the male with the hydria must also be part of religious activity in the fifth century. Somewhat closer in date to the time of the Parthenon is a vase fragment in a private collection in Basel showing a wreathed youth performing the same action (Fig. 112). Water was used for purification during animal sacrifice in ancient Greece, and so like their predecessors (musicians, *thallophoroi*) and their successors (tray-bearers, sacrificial animals) the *hydriaphoroi* are an essential part of the religious ritual. In addition, numerous sil-

Figure 111. *Kanephoros* and male *hydriaphoros.* Red-figure pelike attributed to the Pan Painter, ca. 440. Musée du Louvre Cp 10793. Photo: museum.

Figure 112. Male *hydriaphoros.* Red-figure vase fragment attributed to the Dinos Painter, ca. 420. Herbert Cahn collection, Basel 23. Photo: H. A.C.

ver and gold *hydriai* are listed in the inventories of Parthenon along with other cult paraphernalia, including one hundred bronze *skaphai*.[52]

SKAPHEPHOROI (N13–15, S119–121)

Very little of the tray (or *skaphe)* bearers is actually preserved: on the south only one head (S120) and on the north one head (N15) and one nearly complete figure (N13, Fig. 113). All that one can deduce about these particular male participants is that they wear himations and are not bearded. The *skaphai,* which probably held honeycombs and cakes to attract the sacrificial victims to the altar, are carried on the left shoulder. Again according to late sources the tray-bearers were metics, richly dressed in purple gowns, and carrying gold trays. With no color preserved on the frieze it is impossible to determine if these accouterments were painted, but it seems likely.[53]

Besides a few scenes of harvest and the vintage, images of youths carrying troughs or baskets are not common in Greek art.[54] A red-figure amphora of Panathenaic shape shows draped youths in procession carrying religious paraphernalia, including a large *skaphe* on the left shoulder (Fig. 114).[55] A red-figure fragment of ca. 460–450 discovered in the dining debris of the Agora shows part of a procession including one youth with a tray on his shoulder, and another found in Cyprus and dated to the end of the fifth century shows a wreathed youth with *skaphe* at shoulder level.[56] Thus, it would appear from the vase-painting evidence that youths traditionally carried such trays in religious processions. Unlike the female basket-carrier, the *kanephoros,* whom we will encounter on the east frieze, these youths never seem to lead the procession.

SACRIFICIAL ANIMALS (N1–12, S122–149)

The north and south friezes part company when it comes to the sacrificial animals; there are ten cows on the south (Fig. 115), four cows and four sheep on the north (Fig. 116). All the animals have attendants in the form of youths draped in himations. Each horned sheep has one herdsman[57] and each cow has at least two, one on either side. On the south side the cows seem to have three herdsmen, and many of these youths are heavily muffled in their cloaks, with even their hands encased in the fabric (a posture that might affect one's handling of the animal). While most of the animals walk calmly with four feet stolidly on the ground, at least three are leaping or straining at their leads.

Figure 113. *Skaphephoros* (N13). British Museum. Photo: Alison Frantz EU 143

Figure 114. *Skaphephoros.* Red-figure amphora of Pana-
thenaic shape attributed to the Syleus Painter, ca. 470.
Metropolitan Museum of Art, New York 20.244. Rogers
Fund, 1920. Photo: museum

Animal sacrifice was the commonest ritual of Greek religion, for it not
only satisfied the gods but also offered the worshippers an opportunity to
consume red meat. The most expensive, and hence most pleasing to the
gods, of the sacrificial victims were bovine; sheep, being cheaper, were more
common. The female of the species tended to be sacrificed to female deities
and the male animals to male deities. The victim was decked out with gar-
lands or fillets called *stémmata,* attached to the horns, which in turn were
often gilded. (There appear to be no fillets or gilding on the frieze unless
rendered in paint.) In the best possible scenario the animal went willingly to
sacrifice or at least complaisantly.[58]

Clearly the frieze represents some anomalies in the standard representa-
tion of the Greek animal sacrifice that is so prevalent on votive reliefs.[59] Most
Classical reliefs show a group of worshippers leading one docile animal (or at

Figure 115. South XLIII. British Museum. Photo: Alison Frantz EU 223

Figure 116. North IV. Acropolis Museum. Photo: Alison Frantz AT 159

most three) to an altar. First, there is no altar present. Second, it is an extremely lavish and expensive offering. We know from ancient sources that a *hecatomb* (one hundred victims) was sacrificed to Athena at the annual Panathenaic festival. Since cows cost up to 100 drachmas apiece, this amounted to a very costly sacrifice.[60] The hecatomb is certainly represented by the ten cows of the south frieze, which would have been sacrificed at the large altar of Athena Polias. The group of four ewes and four cows on the north relates to an old Athenian law according to which a ewe was sacrificed to Pandrosos, the faithful daughter of one of the early kings of Athens who had a shrine on the Acropolis, whenever Athena received a cow.[61] This dual sacrifice is represented in shorthand on a black-figure hydria in Uppsala (Fig. 117), where the altar is clearly Athena's because of the owl, her symbol, perched upon it.[62]

It is also interesting to note that here on the frieze, in contrast to votive reliefs, some of the animals are quite restive: two cows on the south and one on the north are charging forward and so are being restrained by their herdsmen. Nikolaus Himmelmann has made the astute observation that these animals should not be considered stubborn or rebellious; one would expect to find such animals at the beginning of the procession, not in the middle or toward the end. Also they are not pulling back but rather rushing forward and so have to be restrained by their escorts, who even have to brace their feet against rocks. Rather than being recalcitrant they are eager to get to their destination, the altar. While this may seem contradictory to animal psychology, it is consistent with stories about "devout" animals who wished to be sacrificed for the gods. Aeschylus (*Agamemnon* 1297) refers to Kassandra walking to the altar "like a driven ox of god." Thus, the charging cow is not a genre motif or simply a diversion from the monotony of the procession, but a sign of religious devotion that will ensure an auspicious outcome for the sacrifice.[63]

WOMEN (E2–27, E50–51, E53–63)

Turning the corners from the files of animals, one meets for the first time female participants: sixteen on the left (south) and thirteen on the right (north, Fig. 118). These heavily draped and modestly down-looking females show much less interaction than the other, mostly male, figures of the frieze. They march solemnly and decorously forward to where they are met by marshals: the north file by E49 and E52, the south file by E48, who has turned to connect with the north file, and E47 (Fig. 52), who beckons to them from across the central part of the frieze.

The majority of these girls are carrying sacrificial paraphernalia. In each grouping the girls at the end carry *phialai* in their lowered right hands. The

Figure 117. Sheep and cow at altar of Athena. Black-figure hydria attributed to the Theseus Painter, ca. 500–490. Uppsala University 352. Photo: Bo Qyllander

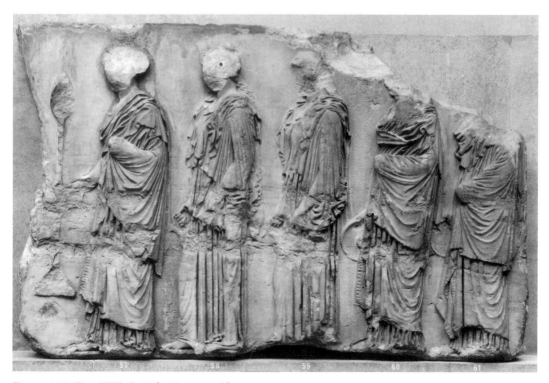

Figure 118. East VIII. British Museum. Photo: museum

Figure 119. Detail of oinochoe held by E7. Photo: Alison Frantz EU 123

Figure 120. Priestess at altar holding a *kanoun* and pouring a libation from an oinochoe; behind her a *thymiaterion.* Red-figure cup attributed to Makron, ca. 480. Toledo Museum of Art 72.55. Gift of Edward Drummond Libbey. Photo: museum

maidens in front of them carry wine jugs *(oinochoai)* likewise in their lowered right hands (Fig. 119). These are led by a pair (E56–57) or pairs (E12–13, E14–15) of girls carrying larger vertical objects. In the case of the object on the right (Fig. 118), which is silhouetted against the background, it is clearly a *thymiaterion,* or incense burner. On the left only the flaring base of the object is preserved and there are drill holes at the top. Most likely it was too difficult to carve these objects against the voluminous drapery of the girls and so the sculptor attached the upper portions separately.[64] Finally, the girls at the front of each procession (E16–17, E50–51, E53–54) are empty-handed. In the case of the pair E50–51, it is clear that they have handed over an object to the marshal E49, and in shape it resembles the offering basket, or *kanoun.* The next marshal E52 may have once held a similar object, since there is a drill hole near his extended finger. This suggests that at least one of the girls should be considered "fit to carry the basket" i.e., a *kanephoros.*[65] These various sacrificial objects can be seen in use by a priestess in the tondo of a red-figure cup by Makron (Fig. 120).[66]

The dress and hairdos of these women are quite specific and reinforce the identification of many of them as *kanephoroi*. Some wear the linen chiton with its crinkly folds visible at the bottom and a voluminous himation; they generally have their hair tied up in a scarf (E57, 60, 61). These appear mostly at the back of each group. The majority of girls wear the woolen *peplos* with a mantle draped over their shoulders, and their long hair streaming down their backs (cf. E58–59). (On the southern side they also wear chitons under their *peploi*.) This specially draped mantle has been termed a "festival-mantle" and serves, in this period, to identify the *kanephoros,* even if she is not carrying the requisite basket.[67]

Kanephoroi were special participants in the Panathenaia as well as other Attic cults. Vase paintings always show them in a place of honor in the procession, namely, at the front (cf. Fig. 88).[68] According to ancient sources they were virgins chosen from noble families and had to possess an unblemished reputation. They dressed in costly finery including gold and jewels, powdered their faces with white barley flour, and wore necklaces of figs. The *kana* they carried were reputedly of gold and silver and contained objects used in the ceremony, namely, the sacrificial knife and barley corn. The unprecedentedly large number of them on the frieze is undoubtedly due to the enormous size of the sacrifice and the consequent need for an extraordinary amount of cult paraphernalia.[69]

OFFICIALS AND EPONYMOUS HEROES (E18–23, E43–46)

The next group of figures is perhaps the most problematic of the entire frieze. It appears to consist of ten men, six on the left (Fig. 121) and four on the right (Fig. 52). Those at the left stand in three pairs facing one another. Those on the right are aligned quite differently: three clustered together facing right while the fourth stands apart staring at them. In their attire – *himation* and sandals (E45 is barefoot) – these men resemble marshals, but they, with the possible exception of E18, have an attribute the marshals lack, a walking stick. Some are bearded, and some not.[70]

Depending on how one wants to interpret these figures, the number and configuration can vary. For instance some scholars would exclude E18, claiming that he is the marshal leading the southern procession of maidens, thus making five rather than six on this side.[71] Others would include E47 and E48 in the group of four on the north side and exclude E18–19, identifying them both as marshals.[72] One writer has included all of the men

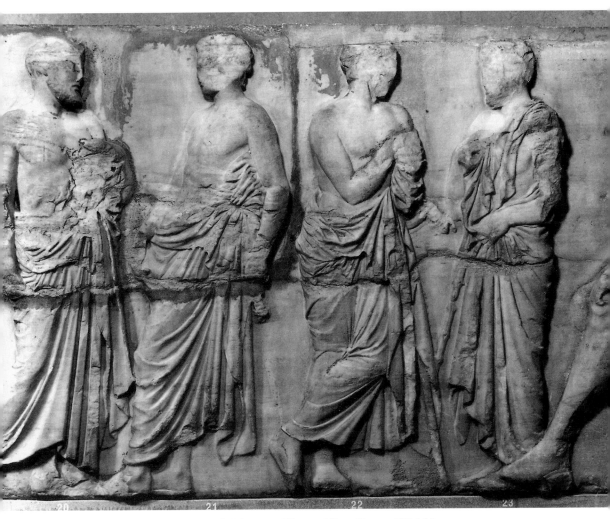

Figure 121. E20–23. British Museum. Photo: Alison Frantz EU 126

E18–23 and E43–48, making six per side for a total of twelve.[73] Finally, another commentator has removed both E18–19 and E47–48, leaving two groups of four flanking the gods.[74]

How to resolve this numerical problem? First, it should be noted that marshals *always* face or in some way acknowledge the procession. Or, as Evelyn Harrison has observed: "leading the procession is something these so-called marshals never do. They stay in their appointed places and give signals to those who move."[75] E18 is much more involved with E19 than with the procession, and this pairing exactly parallels the next two pairs, E20–21 and E22–23. The marshal directing the southern file of maids is E47, who, as we have seen earlier, beckons across space to his part of the procession. If he is a marshal, then

the youth behind him must be one too. He has turned to the other procession and, in so doing, acts as a pivot connecting the two parts of the frieze. These two (E47–48) then are the equivalent of E49 and E52, the two marshals who receive the north procession. Thus, there are four marshals at the head of the procession and all appear on the northern half of the east frieze. They are distinguished by the space around them from the closely set groups of men casually conversing with each other and leaning on their sticks.

Because of their proximity to the gods these men are considered to be either important officials of the state or heroes. It is sometimes claimed that they are also taller than the mortals on the frieze because many are leaning on their sticks and still reach the top of the slabs. However, at least three (E20, 23, 45) are not leaning and so are the same height as the rest of the standing men on the frieze.[76] On account of their number the most common identification of these ten men is the eponymous heroes after which were named the ten tribes of democratic Attica formed by Kleisthenes. While this theory goes back to 1906, it has been more forcefully argued of late by a number of scholars, who, however, cannot agree on the individual identifications.[77] The reasons for this are because the eponymous heroes lack specific iconography, and they are never depicted all together in extant Attic vase painting or sculpture. Take the hero Akamas, for instance, the son of Theseus, who fought at the Trojan War with his brother Demophon (who is not an eponymous hero) but otherwise has no major role in Attic mythology. He is depicted in Attic vase painting of this period as a bearded king, and yet many scholars identify the youth E44 as Akamas.[78] Those who would see these as *eponymoi* divide them into royal (E43–46) and non-royal (E18–23), but this is a somewhat artificial distinction that did not exist in antiquity. Although a fifth-century monument to the eponymous heroes that included statues of the ten existed in the Agora, little remains of it, nor is it datable.[79]

More recently there has been a trend to see these ten (or nine if E18 is removed) not as heroes, but as magistrates of the Athenian *polis*. It is explicitly stated in the *Constitution of the Athenians* (24.3) that the Athenian state had an enormous number (700) of *archai*, or magistrates. Most were chosen by lot or a show of hands, and at least nineteen boards of magistrates mentioned in the constitution consisted of ten members, one each from the ten tribes.[80] Examples include the *strategoi*, or generals in charge of both the army and navy; the nine archons and their secretary; the ten *athlothetai*, who oversaw the prizes in athletic contests. During the Panathenaia the last had additional specific duties ranging from the supervision of the *peplos* to financial arrangements, and so one scholar has argued persuasively that they must be represented here on the frieze.[81] However, there were other official groups who were also involved with the festival, for instance, the Βοῶναι, who were empowered to buy the sacrifi-

cial animals for the Panathenaia as well as other festivals. There are also the *hieropoioi* specifically assigned to the Panathenaia; they performed sacrifices, supervised the festival, and could impose minor fines. A strong case could be made for any one of these groups to be represented on the east frieze.

How then to decide who these men are – magistrates or heroes?[82] One clue that argues against their being magistrates is the fact that thirty was the normal age requirement for any male wishing to hold a magistracy at Athens. Four of these men (E19, 21, 22, 44) are beardless and so probably not likely to be thirty years old. Secondly, the heads, namely, those four on the north side (who are reminiscent of Nanni di Banco's *Quattro Coronati* in Florence), are highly individualized, almost suggesting portraiture. The designer has gone to considerable trouble here to alter the otherwise highly idealized, inexpressive Classical style (see Chapter 4), which is so pervasive on the frieze. The carving even seems more three-dimensional, if one compares the arm of E43 with that of the marshal E48. So the designer was clearly differentiating this group from others on the frieze. Also, if they are officials they would most certainly be depicted in the performance of their duties (like the marshals) or with attributes that indicated their status within the festival (like the inspector W22, or the *thallophoroi*). Rather than being active participants they are passive observers, clustered together conversing, not unlike the gods.[83] For all these reasons it seems likely that the viewer is meant to see these ten as a group apart, somewhere between gods and mortals. To date we do not know enough about the depiction of the eponymous heroes to identify any one precisely, but as a group they graphically embody the ten *phylai* of Attica.

GODS (E24–30, E36–42)

Because of their scale the twelve seated figures flanking the center of the east frieze are unanimously taken to be the Olympian gods. If they arose from their seats, they would be one-third taller than any of the other figures on the frieze. They are seated in two groups of six with one smaller, that is, younger, standing attendant in each grouping (Fig. 76). All sit on simple four-legged stools known as *diphroi,* except Zeus (E30), who sits on a throne. With the exception of E25 (who nonetheless turns around, Fig. 77) they are all facing the procession, and one goddess (E41, Aphrodite, Fig. 164) is actually pointing to it. The males are readily distinguished by the fact that their upper bodies are either nude or only partially draped. The boy E42 is one of only two completely nude figures on the entire frieze, the other being W6.

The most reliable clues to their identities are the carved attributes, such as the *petasos* (traveler's cap, Fig. 122) and boots of Hermes (E24), the torch of

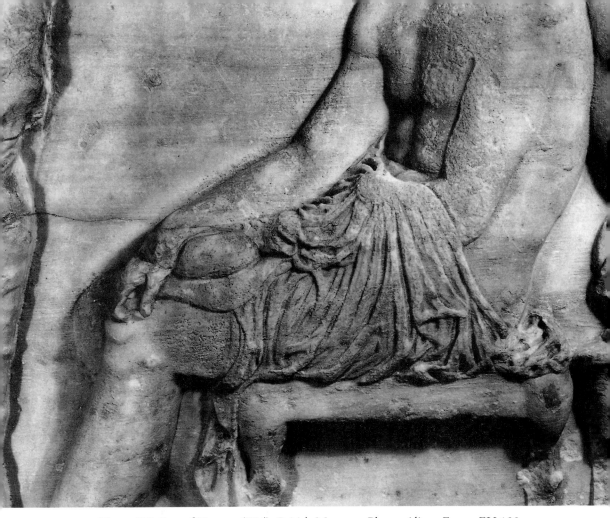

Figure 122. Lap of Hermes (E24). British Museum. Photo: Alison Frantz EU 130

Demeter (E26, Fig. 77), the throne of Zeus (E30, Fig. 124), the snaky aegis lying on the lap of Athena (E36, Fig. 123), and the crutch tucked under the arm of the smith god Hephaistos (E37, Fig. 123), a discreet allusion to his lameness. Drill holes around his head indicate that the youthful god E39 was wearing a headband (Fig. 65), and so he is certainly Apollo with his characteristic laurel wreath. Gestures, such as the brooding pose of Demeter mourning for her daughter Persephone (Fig. 77),[84] the *anakalypsis,* or unveiling of the perpetual bride Hera (E29, Fig. 124),[85] or the restless knee-grabbing pose of Ares (E27, Fig. 77) are also employed to characterize the individual deities. Even more subtle is the gesture of Apollo (Fig. 86), who has hooked his right thumb inside his cloak, an incipient act of revealing himself, a gesture suggestive of the god of truth, light, and prophetic revelations.[86]

Equally significant are the relationships of one god to another. The twelve are more or less configured into pairs. Hera, for instance, is not only seated beside her husband Zeus, but she turns her upper body toward him (Fig. 124). Hephaistos, the father of the earth-born king Erichthonios, turns to look at

Figure 123. Athena and Hephaistos (E36–37). British Museum. Photo: Alison Frantz EU 139

Figure 124. Cast of Hera, Zeus, and attendant (E28–30). Skulpturhalle, Basel. Photo: D. Widmer SH 337

Athena, who graciously raised the child on the Acropolis. The winged boy Eros (E42, Fig. 164) lounges in the lap of his mother Aphrodite (E41) and tucks his right hand under her outer garment. The youthful pair seated next to one another are the inseparable siblings Apollo and Artemis (E40, Fig. 86).

Of the fourteen figures this leaves two seated males (E25 and E38) and one standing female (E28, Fig. 124) unaccounted for. Although the twelve Olympians had not been codified as such at this date, one who was prominent among them and must have been on the frieze is the older sea-god Poseidon, and he is usually identified as the bearded male (E38, Fig. 86) conversing with Apollo. A painted trident can be supplied to his raised left hand. As for the other seated male (E25, Fig. 77), because of damage to the head it is not known whether he was bearded or not, but by a process of elimination he is taken to be Dionysos, although Herakles has been proposed.[87] The fact that he is seated on a cushion and leans back onto another god, unlike the other deities except Aphrodite, suggests the god of the symposium. His intimacy with Hermes refers not only to their relationship as stepbrothers but also to the care Hermes took of the baby Dionysos when he placed him under the protection of the Nymphs. The fact that the god of viticulture has his legs interlocked with those of another agrarian deity, Demeter, also might support this identification.[88]

Who then is the standing winged female (E28, Fig. 124)? She is posed directly beyond Hera, wears a long dress, and appears to be arranging her hair. Her left hand is raised to the back of her head, while her right hand seems to be adjusting the folds of her dress. Alternatively one could reconstruct her right hand with a *taenia,* or ribbon, once rendered in paint.[89] She is traditionally interpreted as Iris, the messenger goddess, but recently scholarly opinion has opted for Nike, the goddess of victory.[90] In Classical Greek art it is often difficult to differentiate these goddesses because both are usually depicted as winged and in flight or rapid movement, as Iris (N) in the west pediment.[91] They also can both be shown pouring libations from an *oinochoe,* or wine jug. Iris is most securely identified when she carries her *kerykeion,* or caduceus, or when she is shown in a short chiton and winged footgear; wings, apparently, are not essential to her identity.[92] Moreover Nike is more closely associated with Zeus and Athena than with Hera; a wingless Nike is thought to be Athena's charioteer in the west pediment, and she crowns Athena in east metope IV.[93]

Taking the clues of gesture and relationship into account, an earlier identification for this figure, namely Hebe, the daughter of Zeus and Hera, has been reargued recently.[94] Since she lacks any distinctive attribute other than an *oinochoe,* it is difficult to identify her in Greek art.[95] However, recent

Figure 125. Return of Hephaistos with Hera fanned by Hebe. Detail of red-figure skyphos attributed to the Curti Painter, ca. 420. Toledo Museum of Art 82.88. Gift of Edward Drummond Libbey. Photo: museum

studies of Hebe in fifth-century Athenian vase painting have stressed her intimate association with her mother Hera.[96] Hebe is so closely allied to Hera that she functions almost as an attribute of her mother, as Eros does for Aphrodite. Thus, we can identify Hera's young attendant on the large skyphos attributed to the Curti Painter in Toledo (Fig. 125) as Hebe; she is fanning her frustrated mother, who awaits the arrival of Hephaistos to liberate her from the magic throne.[97] Note especially how she is standing directly beyond her mother, their legs overlapping, indicative of their intimate, familial relationship. Family, whether of the gods (east pediment) or of ancestral Athenians (west pediment), is an important theme permeating the sculptural program of the Parthenon. In discussing this overriding theme, Ira Mark has written: "The assembly presents in one group the Olympians as protectors of the bearing and raising of children, and in the other, the Olympians as the model for and protectors of marriage."[98] Hebe, in one fig-

ure represents both offspring, as the child of Zeus and Hera, and marriage as the bride of Herakles.

Hebe's association with bridal imagery highlights her other major role in Greek mythology – the bride of Herakles. She can even stand alone in a bridal context, as on the Eretria Painter's red-figure *epinetron* (thigh guard) of ca. 425–420 (Fig. 126).[99] Here she plays an accessory role at the wedding of Harmonia, but her gesture of arranging her hair is identical to that of E28 on the frieze. In both instances she is making herself beautiful for the coming ceremony, and the action of binding one's hair is characteristic of brides in Attic red-figure vase painting of this period.[100] Thus, both gesture and position verify that this attendant figure is undoubtedly Hebe. The only problem with this identification is the wings, which are not her usual attribute, although they can occur.[101] One can posit good artistic reasons for the wings: they make it clear that Hebe and Eros are gods, differentiating them from the mortals who are the same height on the frieze.

The gods on the east frieze are particularly important because they represent the earliest extant depiction of what later became the canonical Twelve Gods of Greek and Roman art. These canonical twelve gods consisted of six males and six females; on the frieze Dionysos replaces Hestia, the goddess who stayed at home on Mt. Olympos to tend the hearth. Her absence supports the contention that the gods are not in the heavens but rather on earth. In the Agora there was, since Peisitratid times, an altar dedicated to the Twelve Gods, but exactly which ones were meant is never specified. In Attic vase painting of the sixth century the gods often convene for important events like the wedding of Peleus and Thetis (where incidently Hebe and Dionysos are prominently included), the birth of Athena, and the reception of Herakles into Olympos, but no vase shows the canonical Twelve.[102] Like many innovations of the Parthenon sculptural program, they appear here together for the first time.

THE PEPLOS CEREMONY (E31–35)

It is obvious from its position in the center of the east frieze that this ceremony involving five figures (Fig. 127) was the high point of the narrative. Visually it appears framed between the central columns of the temple facade (Fig. 54), and as we have seen, it is the focal point of the semicircle of gods. These standing figures are also markedly set off from the gods by the considerable empty space that surrounds them. Clearly this scene is the key to the interpretation of the entire narrative, but it strangely lacks a visual focus: two

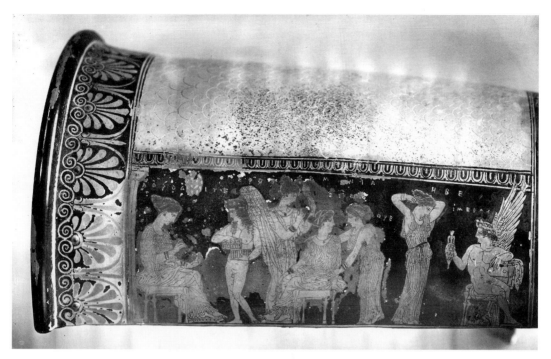

Figure 126. Hebe at wedding of Harmonia. Red-figure epinetron attributed to the Eretria painter, ca. 425–20. Athens National Museum 1629. Photo: DAI, Athens

adults are back to back interacting with smaller attendants while the fifth figure (E31) is literally in left field. She unlike the others is frontal and so one of her functions seems to be to attract the attention of the viewer, not unlike the frontal horsemen, or *thallophoros* (N38), on the north. The two activities to the right appear to be equally important, although the exact center of the frieze lies at the older woman's right elbow.

While the man and woman are almost universally seen to be a priest (on account of his unbelted, short-sleeved chiton) and a priestess, the roles of the younger figures are more difficult to understand. The somewhat shorter girl (E31) carries a stool with cushion on her head and a footstool cradled in her left arm; her partner carries only the stool with cushion.[103] A still unanswered question is the disposition of the stools. Are they for the unseated children of the gods (Hebe and Eros), for the priest and priestess, for the *peplos,* and if so, then why two?[104] Given the compact nature of this scene, which distances itself from the rest of the frieze, logic would suggest that the two stools were intended for the two important adults, the priestess and priest. Since one of the girls (E31) also carries a footstool, one should see a gender distinction in the destination of the stools. It is certainly for the

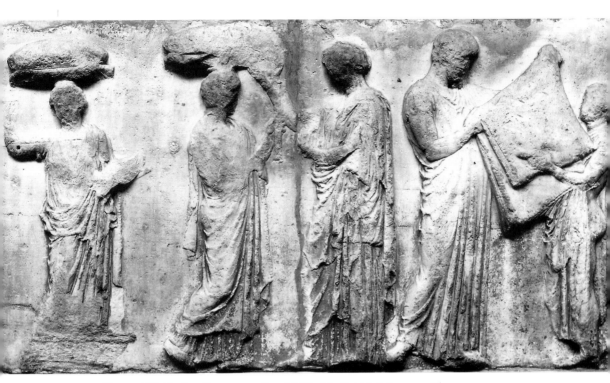

Figure 127. Peplos Ceremony: East V, 31–35. British Museum. Photo: museum

priestess, since women are regularly depicted with footstools on Attic grave stelae, whereas men usually have them only when enthroned.

It seems unlikely that these girls are simply *diphrophoroi,* that is, metic girls who carried stools for the noble *kanephoroi,* since they are not in any way associated with these women. Rather they must be more important figures, who played a key role in the cult of Athena. Ancient texts speak of two girls who interacted with the priestess of Athena and these are the *arrephoroi.*[105] The *arrephoroi* were ten-year-old girls who served the goddess for one year, during which time they lived on the Acropolis, presumably under the guidance of the priestess. They took office at the beginning of the year (1 Hekatombaion) and so appeared publically for the first time at the Panathenaia. Since it was deliberately mysterious, we know little of their role in the ritual *Arrephoria,* in which they carried secret things down from the Acropolis, but we do know that they began the weaving of the *peplos* – hence they are directly relevant to this scene. At the Chalkeia festival, nine months earlier, they helped warp the looms for the weaving of the goddess' *peplos,* the object highlighted in the adjacent grouping.[106]

As we have seen, the man and child are folding a large piece of cloth. That the bearded man must be a priest is indicated by his distinctive dress, a

Figure 128. Detail, E35. British Museum. Photo: museum

Figure 129. Detail of Attic grave stele of Polyxene. Athens National Museum 723. Photo: author

short-sleeved ankle-length ungirt chiton.[107] The gender and identification of his helper are more problematic. The identity of this *pais* has been based on various forms of evidence, anatomical, sartorial, and comparative, but the jury is still divided.[108] In 1787 when Stuart and Revett first published the frieze they identified the figure, now commonly known as E35, as a girl. However by 1871 the great authority on the Parthenon, Adolf Michaelis, had identified the figure as a "Knabe," and most subsequent scholars followed this identification, some specifying him as Erichthonios. Others have identified the child as a male slave, attending the priest. Whatever his specific identity, it was generally accepted that the child was male until 1975, when Martin Robertson revived the earliest identification.[109] His principal argument was anatomical, namely, that the child has Venus rings on its neck (Fig. 128) and so must be a girl. It has since been pointed out by a number of scholars that Venus rings can also appear on sculpted images of males, although they are much more prevalent on females.[110] A perusal of Attic grave stelae of the late fifth and fourth centuries demonstrates that the necks of male children are frequently carved with Venus rings (Fig. 129, see also Fig. 151).

In 1988 John Boardman extended the anatomical argument in favor of

a male child from consideration of the neck to the other exposed area, the dorsal region.[111] Using modern anatomical profile drawings of adults, he tried to demonstrate that the child manifests the more pronounced curvature of a mature female. However, one need only look at fifth-century Attic vase paintings of nude boys, such as Eros, to realize that such analyses are irrelevant in Greek art.[112] Anatomical accuracy was never the aim of Greek artists, but rather they sought to convey ideal forms, of which the male buttocks were a favored feature since the beginnings of figural representations in the Geometric period. It should also be noted that a backward-leaning pose actually serves to accentuate the inward curve above the buttocks of any human, male or female.

As for the sartorial arguments, many scholars have compared the child's dress with that of a young girl on the Parian marble grave stele in New York, and they have concluded that the *pais* is wearing female attire, an open-sided Doric chiton or peplos.[113] Jenkins suggested that the garment might be a *chlamys* on the basis of a Boiotian grave stele of a youth.[114] Recently Evelyn Harrison's detailed analysis of this garment has demonstrated that it is a *himation,* and since there is no undergarment, it can only be worn thus by a boy.[115] It seems that earlier scholars were misled by the drawing published by Stuart in 1787, which mistakenly showed a button on the child's shoulder. It should be noted that the other *peploi* represented on the frieze (i.e. those of Demeter, Hera, Athena, and many of the maidens) are both girt and sewn up at the sides. But the most important argument based on dress in favor of a male, and one that has not yet been taken into account in the considerable literature on this subject, is the length of the garment. Unlike the *peplos* worn by the girl on the stele in New York, this particular garment does not cover the child's feet but ends well above the ankles. One need only cast one's eyes along the bottom of Attic votive reliefs and grave stelae to determine the gender of the participants: women's ankles are *always* covered, men's rarely (unless they are priests or musicians in special garb). The same rule holds true throughout the east frieze, where all the women, including the goddesses, are modestly covering their ankles as well as much of their feet. Thus, there can be no doubt that the child is male based on the short length of his garment.

The traditional art historical method of comparative analysis has also yielded arguments in favor of a male *pais.* The most obvious point of comparison is the boy of like age at the western end of the north frieze (N134, Fig. 26); his size, stance, and bared buttocks in comparable profile, would certainly have reminded the viewer of the child on the east frieze. In other words the visual language of the frieze makes these two youths semantically interchangeable.[116] The comparison with the girl on the Parian stele noted

Figure 130. Sacrifice scene. Red-figure bell-krater attributed to the Hephaistos Painter, ca. 440. Museum für Vor- und Frühgeschichte, Frankfurt ß 413. Photo: museum

above is not as compelling, as Clairmont noted, because her dress is considerably less revealing.[117]

If this is a boy as seems to be the case, what role did a male child play in the cult of Athena other than the one depicted here? Late Antique sources speak of a temple boy who fed the sacred snake on the Acropolis, and there was a statue of a young boy in the area where the *arrephoroi* dwelled.[118] Attic vase paintings of cult scenes regularly show a boy (Fig. 130) assisting the priest at animal sacrifice. If we are correct about the temporal aspects of this scene (Chapter 2) and the *peplos* presentation is a fait accompli, then the boy will surely next assist the priest in the animal sacrifice. Such young assistants were important in cult because of their purity, and one can imagine only a very pure child handling the all-important gift for the goddess.

These then are the players on the frieze; all can be connected in one way or another to the festival of the Panathenaia. Next we will consider the meaning of the text.

Figure 131. *Skiaphoros* and *kanephoros*. Red-figure lekythos attributed to the Brygos Painter, ca. 480. Museo Archeologico, Paestum. Photo: Soprintendenza alle Antichità delle Province di Salerno, Avellino e Benevento

ICONOLOGIA

INTERPRETING THE FRIEZE

In a situation like this the obvious
explanations must be the right ones.
– John Boardman (1977, 41)

Cult? Myth? Symbol? History? Allegory? Drama? Symphony? Poem? Microcosm? All these models and more have been rallied to tease out the meaning and significance of the Parthenon frieze. Submitted to close scholarly scrutiny for over two hundred years, every detail of the frieze has served to support one viewpoint or another, every shred of literature probed to find an explanatory text, and many works of art in other media brought in to bolster a pet theory. How to sort through this morass of speculation is one of the challenges of this chapter; the other is to add to the edifice of learning yet another possible interpretation of this unique monument. As a result of changing audiences and changed historical circumstances, the reception and interpretation of the frieze have varied over time, and hence the historiography of the frieze is almost as interesting as the monument itself. Each generation presents its own viewpoints, and so we can expect ever new readings and new models in the new millennium.

The problem of what precisely the frieze represents has preoccupied scholars since its initial discussion in print. The first published interpretation was that of Cyriacus of Ancona (A.D. 1436), who called it "the victories of Athens in the time of Pericles," and as we shall see, this reading is precociously close to what could be considered the subtext of the frieze. Until fairly recently the generally accepted view of the frieze was that it represents the Greater Panathenaia, the principal festival of Athena, which was held with special pomp and competitions every four years and which culminated in the presentation of the *peplos* to the cult statue of the goddess housed in the Erechtheion. Stuart and Revett were the first to identify the procession as Panathenaic, and the majority of scholars have followed suit with some refinement of timing, purpose, and circumstances. These refinements largely

came about as a result of the prevailing opinion that Greek temple sculpture could not represent a contemporary event involving everyday mortals; rather, architectural sculpture should present mythological or historical narratives relevant to the deity worshipped in the building.[1] Thus, when Connelly published her view of the central scene of the frieze as a scene of human sacrifice from Athens' remote past, it seemed to satisfy many scholars who felt uneasy about a non-mythological theme on a sacred structure.[2] We shall review these various theories typologically before adding our own interpretation to the mix.

The other major problem that scholars have with the frieze as the Panathenaic procession is what to their minds are glaring omissions.[3] Among the most glaring seem to be the absences of Athenian armed hoplites; of representatives of the allied city-states of the Delian League, each of whom provided a panoply and cow to the Greater Panathenaia; and of *skiaphoroi,* or umbrella-bearers; and the change in gender of the *hydriaphoroi* from female to male. Some scholars cite the absence of the Panathenaic ship on whose yardarm was displayed the *peplos,* even though the first reference to this vessel is at the end of the fifth century and, in any event, it did not ascend to the Acropolis.[4] Some also miss the female *kanephoroi,* but as we have seen above (Chapter 5) the foremost women of the east frieze are empty-handed because the basket has already been relayed to the marshal. What we know about the Panathenaia derives mostly from much later sources, such as Roman and Byzantine lexical references, and so it is perhaps unrealistic to expect the procession of the mid–fifth century or earlier to exactly match the much later textual evidence.[5] In describing preparations for the Panathenaic procession of 514, Thucydides (6.58) does mention the fact that men customarily bore shields and spears, but he is speaking of a much earlier era. Religious festivals in ancient Greece were agglutinative, adding and changing elements over time, such that one should not expect the procession to include all aspects ever mentioned in the ancient texts, and it is quite possible that cavalrymen substituted for hoplites. Also the designer, of necessity, had to choose those elements he considered most important or those that could be best accommodated to a frieze composition. So, for example, large baskets carried on the heads or umbrellas perched over the heads of the *kanephoroi* would cause problems in terms of isocephaly, as one can see from this vase painting, which shows a miniaturized girl followed by her *skiaphoros* (Fig. 131). Nonetheless, the artist provided a unique solution to the absence of the *skiaphoroi;* he makes a direct allusion to them by means of the umbrella held by Eros (see Fig. 164).

Before launching into an overview of interpretations, it is worth remind-

ing the reader that the purpose of architectural sculpture was (presumably) to be understandable to the viewer and to promote some aspect of the site's patron deity. Recherché themes unrelated to the deity of the temple were not likely to be chosen. The sixth-century temple of Athena on the Acropolis had featured Athena prominently fighting the giants in one of its pediments. The pediments of the Parthenon also glorified the city's goddess: her birth from the head of Zeus in the east and her contest with Poseidon in the west. As a patron deity of heroes and of battle she is an appropriate overseer of the Trojan War, the Amazonomachy, and the centauromachy, all themes of the Parthenon's metopes. And in the fourth set of metopes on the east she is singled out from the other gods battling the giants as a fighter par excellence by receiving a crown from Nike. This emphasis on Athena is naturally appropriate in her temple and supersedes any political or historical message.[6] In summing up the purposes of such sculpture Brunilde Ridgway has recently written: "Greek architectural sculpture carried different meanings according to time and place, although its primary message, at all times, was religious, and any allegorical or historical allusion was entirely secondary, and left up to the (ancient) viewer's perception."[7]

THE HEROIC PAST?

What we call "myth" as opposed to history was the subject, as we have seen, of all the other sculptures of the Parthenon. It was also the subject of the embellishment of the *Athena Parthenos* in the cella: her shield was decorated with a painted gigantomachy on the interior and an Amazonomachy in relief on the exterior, her sandals bore the centauromachy, and the statue's base was filled with gods witnessing the appearance of the first woman Pandora.[8] So why not myth on the frieze?

Such was the contention of Chrysoula Kardara, when she argued that the frieze in fact depicted the first or inaugural Panathenaic procession during the reign of the legendary first king of Athens, Kekrops. Like Christian paintings of the Last Supper, it would represent the first instance of an event that became a recurring ritual within the cult. According to some sources the Panathenaia was founded by Erichthonios, the offspring of Hephaistos and Ge, following the smith god's unsuccessful sexual assault on Athena. Since Erichthonios is usually shown in Attic art as a child, Kardara identified E35 as the future king handing over the very first *peplos* to his predecessor Kekrops (E34, Fig. 127). The *diphrophoroi* E31–32 she identified as two of the daughters of Kekrops assisting the earth goddess Ge (E33), the "true"

Figure 132. Athena and Erichthonios. Red-figure cup fragments, ca. 460–50. Acropolis 396. After Graef-Langlotz, II, pl. 22

mother of Erichthonios. Other important mythical Athenians, such as Theseus with his father Aigeus, would be represented in the close-knit pair E44–45.[9]

As evidence in of support her identification of the young boy as Erichthonios she cited a fragmentary red-figure cup from the Acropolis (Fig. 132), which depicts Athena standing next to a boy drinking from a *phiale;* the olive branch with owl in the background indicates the Acropolis.[10] This

painting is a very convincing parallel for the child on the frieze, as the style of the boy's garment and its opening along the left flank, revealing his buttocks, are very similar. It is certainly true that there is an increased interest in Erichthonios in Attic vase painting of this period, and in particular his autochthonos birth (Fig. 133). But it can also be seen in these representations that Ge, with her streaming locks of hair, has a distinctive iconography not matched by E33 on the frieze and that in art Athena is always shown interacting with her foster-child.[11]

This mythological explanation also addressed the problem of some of the omissions in the frieze. For example, neither the ship nor the allies are appropriate if the central scene represents the first handing over of the *peplos* in mythical times. It also perhaps helped explain the preponderance of horsemen and chariots, since another mythical figure, often conflated with Erichthonios, king Erechtheus, was said to have invented the chariot and to have helped his countrymen control horses with the aid of the bit invented by Athena. These scenes of horsemen she believed to be not part of the procession proper, but rather the equestrian contests of the first Panathenaia, in spite of the fact that equestrian contests were probably not part of the Panathenaia before its reorganization by Peisistratos in 566.[12]

Useful as it is, there are some serious objections to this reading. The main one is that it involves a number of fairly obscure heroic figures who, lacking attributes, are not easily identified. Also certain key figures appear more than once; so, for instance W12 is also Aigeus, although here not bearded, and W22 (Fig. 90) is again Theseus. Hermes appears twice, as the herald (W23) and as one of the seated gods (E24), as does Poseidon, W27 (Fig. 75) and E38. While these identifications are not impossible it strains credulity to see the horseman W28 as Athena Hippia. It seems to be an unwritten law of the other Parthenon sculptures, namely, the metopes and pediments, that figures are never repeated, and so it is unlikely that these gods and Attic heroes would reappear in different parts of the frieze, and even more unlikely that they would be shown at different ages. Also in terms of strict chronology Theseus and Aigeus do not belong in primeval times with Kekrops and Erichthonios. As Boardman and others have concluded, Kardara "makes the whole more complicated and obscure than can be permissible in a public, classical monument."[13] It could also be said that these myths dealing with the early kings of Athens were more pertinent to the other new temple of Athena on the Acropolis, the Erechtheion, part of which stood over the reputed tomb of king Kekrops.[14] In addition, Kardara's reading took shape before intense study of the frieze had revealed that the riders are shown in their ten tribal ranks. Since the ten tribes were created at

the end of the sixth century, this date provides a *terminus post quem* for any historical reading of the frieze.

A more radical mythological interpretation is the one recently proposed by Joan Connelly, who, concentrating exclusively on the central scene of the east frieze, believes that it depicts the actions preliminary to a human sacrifice.[15] Here the viewer is presented with a royal family consisting of two sisters bearing stools; their mother, Praxithea; their father, King Erechtheus; and the youngest daughter, who is giving her life as required by an oracle for the salvation of the city in its war with Eumolpos and the Eleusinians. According to this reading, the father as priest is helping the sacrificial victim with her funeral shroud, and the two sisters, who will join in the sacrifice with their sister, are carrying their shrouds on stools. As affirmation of this reading the gods intentionally turn their backs on this scene "as it is unseemly for gods to watch mortals die."[16] This interpretation is based on Euripides' play *Erechtheus,* which was first presented in 422, nearly a generation after the planning of the Parthenon, and which only survives in fragments. Since the ending of the play establishes Praxithea as the priestess of Athena, the myth is seen as an *aition* for the Panathenaic festival.

This mythic reading raises more questions (thirty-four in the article alone) than it answers. The most obvious problem is the absence of either a knife or an altar, the sine qua non of sacrifice scenes in Greek art. In the few extant parallels for human sacrifice in Greek art an altar to which the victim is led and a weapon are always shown, since they serve to identify the action; even representations of lone priests show them equipped with a knife.[17] As we have tried to prove in earlier chapters, the child is almost certainly male, the drapery is being folded not unfolded, and the gods do not face away from the scene.[18] This identification of the central scene also leads to a temporal disjunction in relation to the rest of the frieze: the center has to be a "flashback" to an earlier time before the festival became a reality. While the Parthenon frieze does share elements of a motion picture, the idea of making the main action anterior to the rest is not only unprecedented but, being a dramatic and verbal technique, is unsuited to a visual composition; just because it can be done in words does not make it suitable for artistic expression. Equally problematic is the overriding mood of the frieze; it is not one of solemn self-sacrifice and impending death, but rather it is festive, and at times almost frivolous, as figures fuss with their clothes or casually chat with one another.[19] In a comprehensive study of animal versus human sacrifice in ancient Greece it has been demonstrated that scenes of human sacrifice have one element not found in scenes of animal sacrifice, namely, the complete absence of festive characteristics, such as crowns. In the opinion of the

Figure 133. Birth of Erechthonios. Red-figure squat lekythos attributed to the Meidias Painter, ca. 420–10. Cleveland Museum of Art 1982.142. Purchase, Leonard C. Hanna, Jr. Fund. Photo: museum

author "this confirms the role of anti-value that the Greeks gave to human sacrifice."[20] Whatever the merits of Connelly's arguments, a representation of human sacrifice on the facade of a Greek temple, even from the heroic past, is perhaps just too startling to be acceptable.[21]

One of the most ingenious readings of the Parthenon frieze is that of John Boardman, who has argued on the basis of numbers that the relief is a direct commemoration, in fact a heroization, of the *Marathonomachoi,* those Athenian hoplites who gave their lives at the Battle of Marathon in 490. Six weeks before the fatal encounter with the Persians these same Athenians could have taken part in the Greater Panathenaia of 28 Hekatombaion, and, according to Boardman's theory, it is this specific celebration of the festival that is immortalized in stone on the frieze. This interpretation can account neatly for the absence of the allies (the Delian League was not yet formed) as well as the missing hoplites; they have been heroized into knights on horseback or warriors riding in chariots. According to Boardman, these hoplites were the only "mortal Athenian citizens who, by their actions, had acquired the right to depiction on public buildings and in the company of the gods."[22] Since the Parthenon can be regarded in some respects as a thank offering to Athena for the victory at Marathon, this glorification of its heroes makes good Athenian propaganda. The clincher to this argument is found in numbers: Boardman adds up the riders (on horses and in chariots, but not the charioteers), the marshals, and the grooms and comes up with the exact body count recorded by Herodotos: 192 Athenian dead.

Critics, perhaps unfairly, have quibbled with the arithmetic, based as it is on an outdated and inaccurate reconstruction of the frieze. However, given the large lacunae in the north and south friezes, an exact sum may never be possible and the actual number of horsemen is close enough, approximately 190. In antiquity it would have been just as difficult as it is even today to recognize this total, but this is not to say that it wasn't in the designer's mind and plan. (Clearly he was concerned to demonstrate ten ranks of horseman in each file as we have seen in Chapter 2.) A more valid objection to this argument deals with exactly *who* is being counted – not the men on foot who carry cult equipment and lead the sacrificial animals, but the marshals who merely direct the cavalcade; not the experienced charioteers, but the young attendants who do nothing more than hold reins or fasten garments. Perhaps most problematic, at least to historians, is the fact that Marathon was a *hoplite* victory (no horses were involved on the Greek side), and of course these youthful riders look nothing like foot-soldiers. The majority do not even wear the armor or carry the weapons that one might reasonably expect in a commemoration of battle. Also we know that the

Athenians did commemorate Marathon in a very different manner, that is, in a wall painting that highlighted the *aristeiai* of specific individuals, not the company at large. When the subject was carved later on the south frieze of the Nike Temple, it likewise featured separate tableaux of the battle, presumably for easy recognition.[23] Given the rigid conformity of type in the faces of these "heroes" it is impossible to recognize any one individual, nor do they convey the aggressive vitality that one associates with the *Marathonomachoi,* as depicted elsewhere in Attic art. In a very general sense the frieze does celebrate the remarkable victory at Marathon (and those that followed, as we shall try to demonstrate), but it probably does not show those individuals who gave their lives on the battlefield, attractive as this theory might be.[24]

PERSIAN ALLUSIONS?

Building on the theory of Kardara, Ross Holloway accepted the identification of the boy as Erichthonios-Erechtheus, but rather than illustrating the first Panathenaia, he viewed the frieze as a triumphant renewal of the dedications of the archaic Acropolis destroyed by the Persians in 480. Just as the Parthenon itself is a re-creation on the same site of its unfinished predecessor, so the relief procession in effect restores the smashed marble *korai,* scribes, equestrian statues, animal votives, and athletic and musical victors' monuments that once adorned the pre-Persian Acropolis. The *peplos* scene is a symbolic re-creation, so the argument goes, of all the perished *peploi* of previous Panathenaic festivals, and even the *hydriai* carried by the youths are tokens of the lost metal vases once dedicated to Athena.[25]

While this interpretation has the restoration of the Tyrannicides statue group of 477 (Fig. 19), the original of which had been looted by the Persians, to recommend it, the substitution theory has not found many adherents. For one, there is not a close correspondence between archaic sculptures in the round from the Acropolis and the relief figures of the frieze. If the Persian destruction debris is any indication, the most prevalent dedication on the archaic Acropolis was the *kore,* of which over seventy-five are extant, rather than horsemen, of which there are only ten.[26] The archaic *korai,* unlike most of the maidens of the east frieze, wore chitons and held offerings, and the smaller sacrificial animals, as far as we know, were carried, on the back, as in the case of the Moscophoros. Even the shape of the hydria, known as the *kalpis,* is a form that did not become common until after the Persian Wars. More importantly, there is no literary evidence for nostalgia on

the part of the Athenians for their lost votives, and in fact crowded sanctuaries regularly buried outdated offerings to make way for new ones. All in all, it is difficult to credit this interpretation, but it did pave the way for readings even more closely related to the Athenians' role in the Persian Wars.

The most momentous event in Athens' recent past was the war with Persia (490–479), in which the Athenians and their allies fended off the most powerful empire in the western world on both land and sea. Following these stunning victories Athens became head of a defense league of equal partners committed to keeping the Persians at bay, but by the 440s the city had assumed the role of an imperial power receiving tribute from its subject city-states. In this sense it was not unlike the very enemy that it sought to destroy. Some scholars have seen a striking resemblance between the low-relief files of processioning figures on the frieze and those representing tribute-bearers on the grand staircase of the Apadana at the Persian capital of Persepolis (Fig. 134). A. W. Lawrence, the first to articulate this similarity, believed that the Athenians were deliberately quoting the Persian prototype as a way of accentuating their ideological differences: Greek democracy versus Persian despotism. In order to make this point the Greek copy had to mimic the eastern original as closely as possible, hence the anomalous subject on a Greek temple.[27]

The opposite point of view was taken by Margaret Cool Root, who assessed this programmatic relationship as one of conscious emulation on the part of the now-imperial Athenians. Just as the Ionic elements of the architecture of the Parthenon have been taken as a deliberate reference to the Delian confederacy,[28] so the Persian style of the frieze could reference Athens' domineering policies or Perikles' quasi-monarchical rule. Both Apadana and Parthenon friezes are designed as a two-pronged convergence toward a central scene, both work with the architecture to draw the viewer along, and both could be said to present "a vision of harmonious, hierarchically defined relationships within a society."[29] Given the architectural setting and the length of the compositions, these similarities are perhaps not surprising: one could cite the Ara Pacis as another example of the same principles, which are almost commonsensical in this type of monument.

Ideologically it is difficult to accept the proposition that the Athenians would consciously imitate the artistry of their barbarian foes, with whom their most hated tyrant, Hippias, found refuge. Admittedly in their private lives they copied the dress and some of the dining habits of easterners, but a wholesale adaptation of imperial-style propaganda is unlikely.[30] The most compelling evidence against this theory is the fact that no representatives of the allied city-states appear anywhere on the frieze. Surely if the Athenians

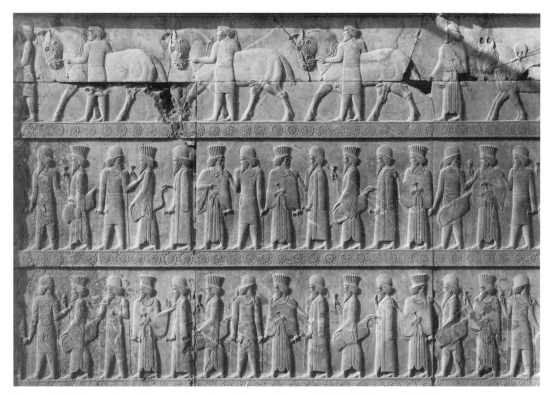

Figure 134. Processional Figures. Apadana, Persepolis, ca. 500–490. Photo: O.I.C.

wished to vaunt their imperial power, they need only line up the tribute-paying allies with their panoplies and cows. If the frieze does carry a message of imperialism, it is way too subtle for recognition; more easily recognizable are allusions to democratic Athens.

THE PERFECT (OR IMPERFECT) PRESENT?

The zeitgeist theory of the Parthenon frieze interprets it as a direct byproduct of an extremely confident and idealistic period of Greek history. These anonymous but perfect faces portray idealized Athenians who have achieved a kind of apotheosis and so can be depicted in the company of the gods. J. J. Pollitt has best articulated this concept: "If in the Parthenon frieze the Athenians have in fact inserted a picture of themselves into a context normally reserved for gods and demi-gods, the innovation is only explicable in the light of the humanistic idealism and confidence of Periclean Athens."[31] In recent literature there is an interesting split in the scholarship:

more conservative scholars view the frieze as the incarnation of *democratic* Athens, while more Marxist-oriented revisionist ones see it as the embodiment of *aristocratic* Athens.

The Panathenaia itself is usually regarded as a "populist" festival on account of its name, which at some point changed from Athenaia to *Panathenia* ("all Athenians"); its promotion by the tyrant Peisistratos, who was allied with the people against the aristocracy; and its elaboration under Perikles.[32] It was a time when people from all over Attica came into the city to watch the athletic competitions and observe the *pompe,* and it was often a time of civil disobedience. For instance, at the Panathenaia of 514, Harmodios and Aristogeiton, taking advantage of the mass of people, staged their assassination of the tyrant's brother Hipparchos, a move that quickly led to the foundation of democracy in Athens.

The subject or subjects of the frieze have been found to resonate with the "spirit of the age," as expressed in such rhetoric as Perikles' funerary oration (Thucydides 2.35–46). Pollitt has posited a close relationship between the frieze and Periclean ideology in what he sees as the three distinct cultural institutions singled out for glorification in the relief: contests *(agones),* sacrifices *(thusiai),* and military training *(polemikai meletai).* The contests are represented by the *apobatai,* the sacrifices by the religious procession, and military training by the cavalcade. This seems to neatly sum up all components of the frieze, but Perikles does not limit his encomium of Athens to these three items, nor does he particularly emphasize them. He also speaks glowingly of good taste, trade in foreign goods, educational systems, the navy, love of beauty, political participation, friendship to others, etc. The argument is therefore forced and somewhat circular, plucking those elements from Thucydides that best suit the components of the frieze.[33]

Pollitt has further argued that the frieze has little or nothing to do with the *procession* of the Panathenaia (although it may relate to the festival) because of the preponderance of horsemen not mentioned in any literary or epigraphic source. However, as *strategos* in the 440s when the Athenian cavalry increased in size from 300 to 1,000 strong, Perikles might have required Pheidias to feature it somewhere on the new temple then being planned. The *apobates* contests, Pollitt goes on to argue, were held at other times and places beside the Panathenaia, and the sacrificial procession is so generic that it could depict *any* religious ritual. All the gods, not just Athena, greet the procession, and the *peplos* scene he reads as "an isolated semantic unit" and not part of the processional scheme. He does accept the fact, however, that it "alludes to one of the culminating rites of the Panathenaic procession."[34] This being the case, it seems perverse to disassociate the other elements of

the frieze, all of which can plausibly be related to the Panathenaic procession as we know it from literature and vase painting (cf. Fig. 88).[35]

Pollitt is not the only scholar to take this "pastiche" approach to the frieze.[36] Burkhardt Wesenberg also tried to resolve some of the anomalies of the narrative by positing a full agenda of diverse activities: the south riders symbolize pre-Kleisthenic Athens, north and west riders represent democratic Athens (with W12, who has a sword at his waist as the phylarch in spite of his youth), the *hydriaphoroi* are carrying the tribute of the Delian League, and the foot procession and contests represented by the *apobatai* are simply generic activities of any festival. Most significantly, he divides the central scene on the east frieze into two separate cult activities; the priestess and her two attendants constitute the Arrephoria (a secret, nocturnal rite in which girls carried unknown objects on their heads to a precinct below the Acropolis), while the man and youth are engaged in the presentation of the Panathenaic *peplos*.[37] This interpretation necessitates changing the stools carried by the girls into trays, a lamp, and a torch, a reading that is difficult to accept.[38] It also demands a temporal disjunction, since the Arrephoria took place annually in the month of Skiraphorion, while the presentation of the *peplos* was celebrated every four years on the twenty-eighth of Hekatombaion, a month later. The problem with this type of analysis is that it goes against the stylistic and aesthetic unity of the frieze. If the designer had wanted to represent a synopsis of diverse rituals, he would have made the divisions more obvious, rather than making figures actually turn and signal, thereby unifying the four sides and different parts of the procession. Also the depiction of a panorama of Athenian religious life goes against the grain of classical Greek narrative, which avoids the juxtaposition of disparate events that take place in widely varying times and places.

An ideological approach of a different bent is currently fashionable among younger historians of ancient Athens. In their view the Panathenaia is envisioned not only as the democratic, populist event that its name implies, but also as "a site of political contestation between elites and nonelites."[39] It is argued that since this traditional and presumably religiously sanctioned festival began well before the foundation of democracy it may reflect conservative aristocratic values rather than the newer democratic ones. In the words of Robin Osborne: "The Parthenon frieze presents neither a record of some reality nor the creation of some remote ideal; it presents the very aristocratic image of Athenian democracy at its most elitist. Where all citizens are not just soldiers, but the quintessential soldier, the young man in the cavalry whom public inspection requires to be a model of physical fitness. In presenting this image the frieze also promotes it. . . ."[40]

Support for this interpretation comes from the absence of certain figures, such as metic women carrying umbrellas and stools for the elite *kanephoroi,* chosen from the upper classes. The absence of hoplites, thetes, and slaves is seen as privileging the aristocratic at the expense of the democratic. In Lisa Maurizio's study, which focuses on the procession rather than the festival at large, the abundance of horsemen on the frieze, and even their supposed nudity, are evidence of elitism, since horses were the privilege of the aristocracy and nudity can be related to the divine.[41] After comparing what one might expect in a procession *proper* with what is actually depicted on the Parthenon, she concludes that "only Athenians, and perhaps only elite Athenians, are present on the frieze."[42]

This argument tends to ignore the "democratic," by which I mean tribal, elements of the Panathenaia and their evocation on the frieze. In fact, the relief specifically references the Attic tribes at a number of points (ten divisions of the cavalcade; ten sacrificial cows; ten officials, or *eponymoi*). The inclusion of *skaphephoroi,* or metics dressed in expensive purple robes and carrying golden trays, indicates the participation even of non-citizens.[43] We have noted above (Chapter 4) the surprising lack of nudity on the Parthenon frieze. However, if the Panathenaic procession as depicted on the frieze accentuates the aristocracy, it should come as no surprise. One of the ways in which the new democracy succeeded was in allowing aristocratic families to retain their hereditary priesthoods; thus, it should not be considered "undemocratic" to see more elites than non-elites in a religious context. Just as civic parades today feature young men in their prime (football players or astronauts), beautiful girls (cheerleaders or pom-pom girls), and distinguished older leaders (statesmen and politicians), so in ancient art religious processions always present something of an ideal in their accentuation of youth, beauty, and wisdom. To "miss" the portrayal of the disenfranchised, the poor, or the enslaved is to miss the point.

LAND AND SEA

As noted above, the first writer to address the subject of the Parthenon sculptures was Cyriacus of Ancona, who called them "the victories of Athens in the time of Perikles." This idea, first expressed five and a half centuries ago, is echoed by modern scholars such as Ridgway: "The main themes in the Parthenon sculptural program could then be seen to carry a *generic* message of Athenian victories, both in allusion and in actual content."[44] In a search for a universal meaning informing the entire frieze it is

useful to return to the original intent of the temple built in this particular location. It is generally accepted that a pre-Parthenon was begun in the 480s as a thank offering for the victory at Marathon.[45] That temple, to the extent that it was constructed, was mostly destroyed in the Persian sack of 480, with parts of it prominently displayed in the north wall of the Acropolis. It is reasonable to assume that its successor, the replacement temple begun some forty years later in 447, was also a thank offering for military victory, but no longer simply for Marathon. Athenians would now naturally wish to commemorate all the successful battles against the Persians: Marathon, Salamis, Plataia, Mykale, Eurymedon. While Boardman argued (see earlier) that the Ionic frieze was a specific commemoration of the *Marathonomachoi,* it is more likely that the Parthenon refers to every military victory over the barbarian on both land and sea, not just the land victory at Marathon.

This reading can possibly be reinforced by a new consideration of the groupings of gods on the east frieze.[46] Since 1829 there has been a general trend to interpret the gods in terms of their cults, and more specifically in terms of cult location or topography.[47] Thus, in 1919 Carl Robert stated that seven of the twelve gods were chosen in reference to specific cult sites "on or near" the Acropolis; so, for example, Hephaistos and Poseidon sit next to one another because they had nearby cults in the Erechtheion.[48] This design principle of cult identity led George Elderkin in 1936 to misidentify Poseidon and Apollo as Butes and Erechtheus and Artemis as Pandrosos because of their shrines in or near the Erechtheion.[49] These scholars and others believed that Attic cults dictated the selection of the twelve divinities for the frieze, and that one could correlate their positions on the frieze, north versus south, to their primary cult locations in the city. In an important article published in 1976, Elizabeth Pemberton advanced the system of identification further by making the claim that the gods were represented in cult guise, that is, they were portrayed in such a way as to recall specific aspects of one of their cults.[50] This idea has been developed by other scholars,[51] but it has resulted in considerable disagreement over what particular cult epithet should be attached to any one deity. So, for instance, Apollo is said to portray Apollo Hypoakraios (North Slope), Apollo Patroos (Agora), Apollo Pythios (Ilissos), Apollo Delphinios (Ionia), and Delian Apollo (Delos).

Relating the locations of the gods on the frieze to their topographical associations within Attica is an interesting methodological gambit, but one that has no foundation in antiquity. While we have the benefit of accurate topographical maps on which to plot cult locations, the ancient Athenian pedestrian certainly related to the landscape in a different and more intimate way, via landmarks, boundary stones, and the roads and paths that led from

one area to another. It is anachronistic to impose our aerial vantage point on a population that saw the terrain from a very different perspective. Nor does it make sense that the ancient Athenian would want to identify a *specific* cult with the gods on the frieze; rather logic dictates that the Athenians in general and the designer in particular would seek to universalize the twelve gods, rather than tie them to particular cult places in Attica. In fact, there is evidence to suggest that the Athenians viewed cult in more general terms. Dedicatory inscriptions to Athena found on the Acropolis rarely use cult epithets; in the archaic and Classical periods nearly two-thirds of the inscriptions address the city goddess simply as "Athena" or "the goddess," not as Athena Polias, Athena Parthenos, or Athena Ergane.[52] The topographical or cult guise scheme is one that simply does not work for the frieze, and so we should seek another rationale for the arrangement of these important figures.

Erika Simon has demonstrated that four of the gods in the right half of the assembly (Poseidon, Apollo, Artemis, and Aphrodite) all relate to the Attic hero Theseus, and in particular his voyage overseas to slay the Minotaur.[53] More generally they are all divinities related to the sea and as such were worshipped in Attic ports; for instance, Apollo at Porto Raphti and later Phaleron; Poseidon at Sounion; and Artemis at Aulis, Brauron, and Mounychia in the Piraeus. The divine twins were born and worshipped in sea-girt Delos. Aphrodite was literally born from the sea and, in addition, she was invoked by sailors as Aphrodite *Euploia* ("Of the Safe Voyage").[54] The corresponding four gods on the other side (Hermes, Dionysos, Demeter, Ares) all have strong associations with the land. Dionysos as god of viticulture and Demeter as goddess of agriculture are firmly rooted to the soil, and especially to Attic soil as at Ikaria, Eleutherai, and Eleusis.[55] Hermes is both a god of herdsmen and a god of the crossroads. Closely connected with land travel, he was worshipped at herm shrines throughout the Attic countryside. Finally, Ares is the god par excellence of bloody hoplite battle; he had no temple in the city but was worshipped in rural Acharnai. The point here is not to highlight any specific cult locale of the individual gods, but rather their general associations with either sea or land.

The eight gods arranged thus in two groups referencing land and sea reflect not only Athens' past glories in the wars against the Persians but also its present power as realized in its preeminent position as head of the Delian League. In this way the gods' arrangement echoes contemporary policies as articulated in the famous Funeral Oration. Perikles twice referred to Athenian military action on land and sea: "As a matter of fact none of our enemies has yet been confronted with our total strength, because we have to divide

our attention between our navy and the many missions on which our troops are sent on land" (Thucydides 2.39); "For our adventurous spirit has forced an entry into every sea and into every land and everywhere we have left behind us everlasting memorials of good done to our friends or suffering inflicted on our enemies" (2.41).

One can find even closer links between the Olympian divinities and Athenian battles against the Persians. The nuptials of Hera and Zeus, for instance, were celebrated in an annual festival in their sanctuary at Plataia, the site of the Greeks' decisive land battle against Xerxes in 479. Artemis was worshipped at the Euboian promontory of Cape Artemision, where the Persian fleet was routed in 480. At the festival honoring Artemis Mounychia, one of the most important festivals held in Attica, Athenians also commemorated the anniversary of their naval victory at Salamis, since "on that day the goddess shone with a full moon upon the Greeks as they were conquering at Salamis" (Plutarch, *Moralia* 349f).[56] One could amplify these examples, but the point is not to indicate that specific deities were associated with specific battles, but simply that the Athenians accorded the Olympian gods the credit for their defeat of the Persians and so felt thankful to each and every one of them. The Parthenon frieze, as also the east metopes where the gods individually battle the giants and the east pediment where they witness the birth of Athena, pay homage to this collectivity of gods without whom victory was impossible.

Finally, a specific feature of the design supports this reading of victory on land and sea. On either side just after the divine couples (Hera-Zeus, Athena-Hephaistos) and at a slight distance beginning on a new block are Ares and Poseidon, gods respectively of land and sea battle. Just as the divine couples represent a kind of antithetic responsion, so do Ares and Poseidon; in other words they are deliberately placed at the heads of each second rank of gods to reinforce the message of the frieze: commemoration of "the victories of Athens" on land and sea. Their placement is hardly coincidental and for the ancient viewer would perhaps signal a strong message about Athens' military might both now and in the recent past.[57]

POSEIDON AND ATHENA

The land-and-sea scheme can find resonance in other parts of the temple, especially the west pediment. Here according to Pausanias (I.24.5) is the contest between the two gods for the patronship of Athens in which

Poseidon with a stroke of his trident brought forth a saltwater spring, while Athena produced an olive tree (Fig. 25). Although the contest may have been one of priority (i.e. who got there first) rather than one of quality (i.e. which gift is more useful), it nonetheless effectively betokens the duality of land (olive) and sea (salt spring).[58] Equally significant for an understanding of the Parthenon's sculptural program is the fact that this entirely new subject, never before represented, was chosen for the west pediment – a subject that features Poseidon, whose worship on the Acropolis only began after the battle of Salamis.[59] Even though Poseidon was bested in this contest, he is featured more prominently than Athena in the center of the pediment because of his newly important role in Athenian military policy. As Aristides (*Panathenaicus* 39) writes: "Poseidon withdrew; he did not, however, end his loving care. His and her subsequent behavior afforded no less evidence of the attention and honor which the Athenians enjoyed from both. For she granted to the city superiority in wisdom, while he granted superiority in naval battles . . . indeed I think beyond any who at any time have fought and won battles at sea." Both indeed are important patron deities of the Classical city.

Another even closer point of association between Athena and Poseidon is their mutual interest in horses and horsemanship, as indicated in their shared epithet: Athena *Hippia* and Poseidon *Hippios*.[60] These cult identifications are no doubt referred to in the two prominent chariots that flank these deities in the west pediment and, by extension, the entire western half of the temple, whose upper walls and porch are decorated with prancing horses and dashing chariots. Athena is credited with the invention of the bit, and her foster-son Erichthonios reputedly initiated the chariot race. In Attic vase painting Athena is frequently shown with horses and chariots (Fig. 104), often driving the latter herself. She is said to have taught the Athenians horsemanship and to have helped the Greeks build the Trojan horse. Equestrian events were a major part of her festival, and the largest number (140) of oil-filled Panathenaic amphoras (Figs. 20–21) went to the winners of the chariot race in her honor. Marble horses and equestrian statues, although comparatively rare in archaic Greece, were a common sight on the sixth-century Acropolis and seem to have made a more appropriate offering than the ubiquitous *kouroi*.[61]

Likewise Poseidon Hippios, worshipped as a god of horsemanship, received sacrifices of oxen from the Athenian knights at his shrine at Kolonos. Poseidon, "Lord of Horses" is invoked by the knights in Aristophanes' play (*Knights* 551), and it is clear that they considered him their

patron deity. Even more to our point, horsemanship and seamanship are equated in the realm of Poseidon. In the parabasis of *Knights* (551–67) and in a choral ode praising Athens from Sophocles' *Oedipus at Colonus* (707–19) horsemen and rowers are equated, as are the bit and the oar.[62] Poseidon is the giver of horsepower *(euhippon)* and sea power *(euthalasson)*:

> And I can utter another word of praise for this my
> mother city, a gift of the great god, a pride of the land
> supreme, the might of horses, the might of colts, the might
> of the sea. Son of Kronos, it was you who enthroned the
> city in this pride, lord Poseidon, creating first in these roads
> the bridle that tames horses. And the skillfully plied oar flies
> splendidly along . . .
>
> *– Oedipus at Colonus* 707–718
> (trans. H. Lloyd-Jones)

Poseidon is the only Olympian god shown mounted on horseback. On a South Italian pelike Athena and Poseidon are united as gods of horsemanship with Athena in a chariot on one side and Poseidon on horseback on the other.[63] Although this scene has been related to the contest depicted in the west pediment, it also can be related to the frieze where horses and chariots abound but are restricted to the west half of the building. This theme of Athena Hippia and Poseidon Hippios reverberates also in the west metopes, where half of the Amazons fight from horseback, as well as in the west frieze, where even a "good colt" is present.[64]

ATHENA AND ZEUS

If the west half of the Parthenon can be seen as a glorification of Athena and Poseidon, now prominently featured as a result of the naval successes at Salamis and elsewhere, what of the east half? Here Zeus reigns supreme in the center of the east pediment, where he has miraculously given birth to Athena, and in the central east metope (8), where he fights a giant. In the middle of the west frieze he is seated on an elaborate throne, as we have seen, next to Athena. While one might expect the goddess herself to be highlighted here on the main facade of her own temple, it is her relationship to the king of the gods that is clearly most important.

The father-daughter relationship of Zeus and Athena is an extraordinar-

ily strong one and is reflected in many areas: literature, cult, and art.[65] She, in effect, acts and is treated more like a beloved son than a typical daughter. In the *Iliad* (5.880) Ares complains that Zeus lets Athena do as she pleases, and later (8.360–72) she states that her patronage of Zeus' son Herakles was commanded by Zeus and carried out to please him. In the archaic period Athens claims that the city will never be destroyed by Zeus, "such is she, who, great hearted, mightily *fathered,* protects us, Pallas Athena, whose hands are stretched out over our heads" (Solon fr. 3.1–4). In Aeschylus' *Eumenides* (738) she announces that she is "very much of the father," meaning she always takes his lead and is a faithful follower, and later (827–28) claims that she is the only god who has access to the locked place where Zeus keeps his thunderbolts. Zeus not only grants her weaponry and armor, in particular his aegis, but also intelligence: "Zeus gave me *phronos* not to be despised" (850). Finally, at the end of the play the chorus reiterates a familiar refrain in stating that the city's citizens enjoy proximity to the throne of Zeus, are beloved by the maiden he loves, and are sheltered under Athena's wings (998–1002). The citizens of Athens clearly believed that their protection by Athena derived a special potency from her close relationship with Zeus.

This intimacy and like-mindedness of Athena and Zeus are also indicated in the large number of common cult epithets and instances of joint worship, especially in the state cults of Athens. Not surprisingly many of their shared epithets have civic or political overtones. As tutelary gods of the city itself, they are invoked on the Acropolis as Athena Polias and Zeus Polieus. In fact Zeus was the only male deity to have his own shrine on the Acropolis; it lay at the summit of the outcrop just to the east of the Temple of Athena Polias. Like the Panathenaia, his festival, the Dipolieia, began early in Athenian history, and its main rite, the *bouphonia,* is even said in one source to be Athena's festival.[66] Given their strong associations with the land and agriculture, it is not surprising that they both protected the sacred olive trees, the Moriai, under the combined epithets Athena Moria and Zeus Morios.[67] It was these very trees that provided the oil for the Panathenaic amphoras that served as prizes in the competitions held at the goddess' major festival.

Finally, in art Zeus and Athena are constantly paired, particularly in the gigantomachy, the introduction of Herakles into Olympos, and naturally her birth. But Zeus also appears in scenes where in truth he does not belong, like the birth of Erichthonios, usurping the place of the rightful father Hephaistos.[68] They share the *promachos,* or fighting pose (also with Poseidon),

striding into battle with weapon raised overhead. In Athenian art they make up a kind of invincible team on account of their superior fighting skills as well as their wisdom. It has been suggested that Zeus' active participation in the gigantomachy in vase paintings of the years 480–60 may have had a special significance for Athenians, as reflected in Aeschylus' *Persians* (532–34), where the defeat of the barbarians is credited to him.[69] So, he too partakes directly in the "victories of the Athenians."

How does Athena's intimate relationship with her father relate to the frieze? The eastern half of the cella walls and east porch is devoted to the religious procession; it is a visual embodiment of piety and *sophrosyne*. It represents the citizenry in their most religious demeanor, dressed to the nines, bearing expensive offerings, parading their virtuous women, and paying homage to all the gods, but to Zeus and Athena in particular. The destination of this procession is the Acropolis, home to the "city" cults of Zeus and Athena. This part of the frieze resembles a votive relief writ large, with the assembled Olympians as the goal and the *peplos* as the ultimate offering. These are people who, in the words of Aristophanes (*Knights* 566–68), are "worthy of the land and the *peplos,* who in infantry battles and naval expeditions were always victorious everywhere and adorned our city."

ATHENA AND THE PANATHENAIA

If the eastern half of the frieze is the essence of *pompe,* what particular *pompe* is it? Most would agree that it is the Panathenaia, because this was by far the most important state festival held in the ancient city, but how can we be certain? The most obvious answer is the *peplos* itself and its prominent position in the center of the east frieze.[70] There exists no precedent in Greek art for the central scene on the east frieze, although depictions of men handling large rectangles of cloth, usually in the palaistra and often with the assistance of young boys (Fig. 40), are fairly common and may have served as models for this unique scene.[71] However, there are numerous subtle clues in the frieze to the nature of the Panathenaia, whose ultimate goal was to provide a new robe for the cult statue.

First, there are allusions throughout the frieze to dressing-up by figures who fuss with or adjust their garments and foot and head gear.[72] As we have noted earlier, the narrative begins with an act of dressing (W30, Fig. 39) in a figure whose pose is closely echoed by that of the priest. On the west we also

encounter other preparations such as sandal binding (W12, W29) and fillet tying (W4, Fig. 73). On the north frieze an unmounted rider is having his belt clasped by an attendant (N134–36, Fig. 135), and one of the *thallophoroi* is adjusting his wreath in a fully frontal pose that calls attention to the action (N38, Fig. 105). A marshal on the south side (S82) is pulling up his himation, while another (S138) rearranges his wreath. Such gestures are even more concentrated among the gods: Hebe (E28) ties up her hair, while Hera (E29) holds forth her veil; Apollo (E39) has his thumb hooked into his himation, while his sister (E40) pulls up her slipping chiton. Athena (E36) has removed her aegis, as if in anticipation of the gift of a new robe.[73] These allusions to dressing, subtle as they may be, would not have been lost on an Athenian audience, which itself had just put on its Sunday-best for the festival in honor of their goddess. On the basis of an Attic vase painting in New York that represents the personification of religious procession (Fig. 136), one could conclude that festivals are all about dressing: here *Pompe* is shown in the act of fastening her dress. Before her rests the holy sacrificial basket, the *kanoun,* and just beyond Eros is tying his sandal, yet another allusion to dressing.

This theme of dressing in general, and the *peplos* in particular, is not restricted to the frieze alone; it occurs in much of the sculpture at the east end of the temple. On the base of the *Athena Parthenos* inside was depicted the birth of Pandora, in which Athena and Hephaistos are adorning the newborn goddess, if vase paintings and the text of Hesiod (*Works and Days* 72) are any indication. The gigantomachy of the east metopes is the same theme woven into the *peplos* presented to Athena. Although the birth scene above in the pediment may not allude to dressing, it would have shown Athena garbed in the protective armor of her father, the aegis, and possibly being crowned by Nike. Thus, this theme, like others, by being reiterated throughout the sculptural program reinforces its message.[74]

While all religious processions involve dressing up, one can also find in the frieze subtle allusions to the Panathenaic festival in particular. For instance, the umbrella held by Eros could be a reference to the missing *skiaphoroi.* The *keryx* on the west (W23) is probably the herald of the festival. The richly draped musicians recall the festival's many contests in music reinstituted by Perikles. The four *hydriai* carried by the four youths may allude secondarily to the bronze water-jars awarded as prizes in the annual Panathenaic torch-race. If Boardman is correct in identifying the ambiguous objects carried by pairs of girls on the east frieze (E12–15) as the legs of a portable loom (rather than thymiateria),[75] then the referencing of the Panathenaia and its *peplos* is really not all that subtle. Likewise,

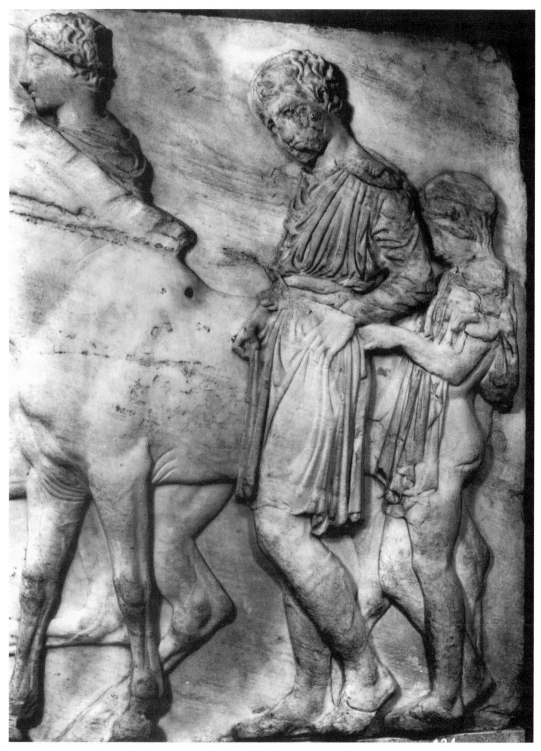

Figure 135. N134–36. British Museum. Photo: Alison Frantz EU 240.

Figure 136. Eros, Pompe, and Dionysos. Red-figure oinochoe attributed to the Pompe Painter, ca. 350. Metropolitan Museum of Art, New York 25.190. Rogers Fund. Photo: museum

the inclusion of the specific contest of the *apobates,* as opposed to chariot racing in general, can be taken as a direct signpost of the goddess' festival, since this race took place in the Agora and is so strongly associated with the Panathenaia. Hence, subtle and not-so-subtle indicators assure viewers that they are witnessing the most important festival of Athena held in ancient Athens.

THE FRIEZE AS DOCUMENTARY

A further claim can possibly be made about this representation of the Panathenaia, namely, that the designer was attempting to show the

Figure 137. Sacrificial procession. Red-figure loutrophoros related to Phintias, ca. 500. Athens National Museum 636. Drawing after Graef-Langlotz, pl. 50

real event, not some idealized construct. What evidence is there for a documentary type of narrative as opposed to a generic one? Some features of the frieze are so specific – the man who parks his horse, the *dokimasia,* the *keryx,* the cavalcade in its ten tribal divisions with its two hipparchs, the *realia* carried by the youths and girls (much of it listed in the actual Parthenon inventories) – that we can only imagine a real procession before the designer's eyes. Although one cannot go so far as to claim that these are specific individuals, we know that Athenians were used to seeing themselves in other depictions of such processions, especially on Attic vases. A red-figure loutrophoros from the Acropolis (Fig. 137), and so most likely dedicated to Athena, shows men and women carrying branches led by a flute-player named Lykos. A much later Panathenaic-shaped amphora from the Agora shows a similar procession, where the flute-player is probably the contemporary Athenian Chrysogonos.[76] That this vase represents the Panathenaic procession is indicated by the prize-amphora carried on the shoulder of one of the processioning youths and the olive tree in the background. If there was no artistic *hubris* involved in showing specific individuals worshipping Athena on vases associated with her festival, then

why not show contemporary Athenian types, with whom ancient viewers would strongly identify, on the frieze?

While at first the presence of the gods might seem to contradict this conclusion, their seating arrangement on stools in front of the temple might actually support it. There was a long tradition of placing out stools or couches for the gods in a ceremony known as *theoxenia,* defined by Hesychios as a common entertainment for all of the gods (Fig. 138). Recently Michael Jameson has shown that this ritual was much more common than previously recognized.[77] He describes it as "a type of ritual in which the Greeks explicitly honored supernatural figures by using the conventions of entertaining guests: they issued an invitation, they set out a couch on which they laid out coverings and put beside it a table which they adorned with, among other things, dishes containing food and drink."[78] One of the fullest accounts describing such a ritual is the law pertaining to the festival of Zeus Sosipolis and the Twelve Gods at Magnesia on the Meander; it involved a large procession, the carrying of the statues of the Twelve Gods dressed in the most beautiful clothes possible, the pitching of a *tholos* (presumably a temporary circular structure), the spreading of three of the most beautiful couches possible, music, and animal sacrifice to specific deities.[79] The gods are not imagined as coming to partake in their own animal sacrifice but are conceived of as guests enjoying the honors accorded to the patron deities of the city. The deities of the Parthenon frieze can be interpreted in this collective sense as well, as a *theoxenia,* sitting on specially prepared seats (stools given the presence of female gods, as women do not recline in Greek society), and witnessing the specific rites held in honor of one of their members, Athena.

As early as 1937, Lily Ross Taylor proposed that the religious ceremony on the east frieze might relate to the Roman ritual of the *sellisternium,* which was based on Greek cult practice.[80] At Roman festivals and spectacles, stools, thrones, and chairs, often richly draped and cushioned, were set out for the gods in order to secure their presence and goodwill for the ceremonies. She specifically noted the elaborate draping of the stool of Aphrodite, which resembles the draped stool depicted on Flavian coins. That such a rite may be connected with the Parthenon is indicated by the temple treasuries that list "seven Chian couches, ten Milesian couches, six thrones, four *diphroi* (regular stools) and nine folding stools" for the year 434/33.[81] One could well imagine this furniture being placed out for the gods on the Acropolis during the Panathenaia so that they could watch the procession's arrival at the east end of the Acropolis culminating with the presentation of the *peplos*

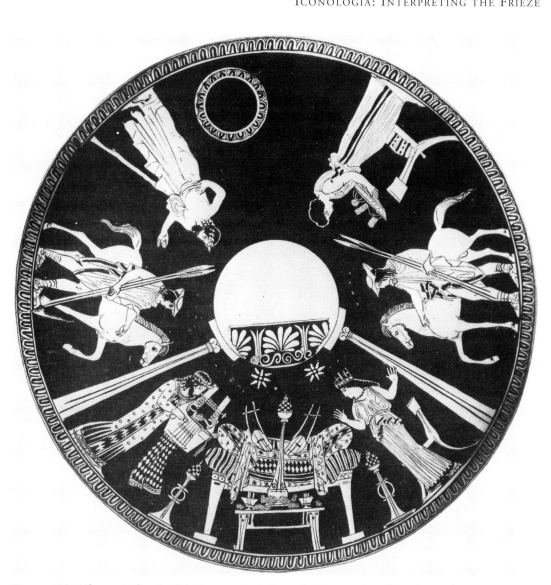

Figure 138. *Theoxenia* for the Dioskouroi. Red-figure hydria attributed to the Kadmos Painter, ca. 420. Regional Museum of Archaeology, Plovdiv. Drawing after van Hoorn, 1951, fig. 241

and the hecatomb sacrifice to Athena at the altar in front of her temple. Although some scholars have suggested that the gods are on Mt. Olympos or in the Agora,[82] in most scenes of sacrificial processions in Greek vase painting, the deity stands beyond the altar, and so we should imagine the Olympians situated similarly.[83] What we then see depicted on the frieze is the epiphany of the twelve gods, who have literally and in an ideal sense

accepted the invitation of the Athenians to the *theoxenia* in honor of the city's chief deity, have descended to the Acropolis, and have taken their respective seats.

The mingling of gods and mortals, so unrealistic to our eyes, was becoming a common practice in Greek art of the Classical period. Gods hovered above the battle of Marathon in the wall painting in the Stoa Poikile, Eros regularly flutters around brides, and Nike brings victory tokens to winning contestants on vases. Votive reliefs show normal citizens approaching what look to be epiphanies, not statues, of their patron deities. In their stunning victories against the Persians the Athenians felt a new closeness to the gods, and especially to Poseidon, Athena, and Zeus. This familiarity is admirably conveyed by the composition of the frieze, in which the gods literally and figuratively come to Athens to receive the city's thanks.

ETERNAL SPRING

If the Parthenon frieze looks back to and celebrates the "victories of the Athenians," it also looks forward. This prospective agenda is most evident in the theme of youth pervading the frieze's imagery from the vigorous riders at the rear of the procession to the nubile maidens who lead it. Evelyn Harrison has summed up this pervasive quality as follows: "The great majority of the participants are very young, because in each age the young represent the purest potential, and the success of the state depends on the use it makes of this potential."[84] The girls of marriageable age, the *kanephoroi* and other maidens of the east frieze, represent the future mothers of Athenian citizens, while the youthful riders are among the city's newest citizens and its future fathers. By their legitimate (in terms of Perikles' restrictive citizenship decree passed in 451/50) and fruitful unions they will produce future citizens and defenders of the state.

As the personification of youth, the goddess Hebe (Fig. 124) is particularly appropriate to this theme.[85] In Euripides' *Herakleidai* (850–58), produced ca. 430, she is called upon to restore Iolaus' youth so he can succeed in his duel against the king of Argos. She, too, is a bride, offered to the hero Herakles as a reward for his *arete,* but on the frieze she is still the dutiful daughter standing at the side of her mother, the goddess of marriage. So her presence resonates with both the mass of young women and the men of the cavalry for whom youth *(hebe)* and fitness are all-important.

This "youthening," which is characteristic of most Classical art and is so

evident on the frieze in particular, has recalled to many scholars the words of the funeral oration presumably delivered by Perikles after the siege of Samos in 439: a city without its youth is like a year without spring.[86] By capturing the city's *jeunesse dorée* permanently in marble, the Parthenon in essence immortalizes not only the glorious past but also the future hopes and dreams of Athens.[87]

Figure 139. *Taking Measurements: The artist copying a cast in the hall of the National Gallery of Ireland.* Oil on canvas by Richard Thomas Moynan, 1887. National Gallery of Ireland, Dublin 4562. Photo: museum

KLEOS

THE IMPACT OF THE FRIEZE

The legacy of Greece to Western art is Western art.
– Adapted from Bernard Williams as quoted
in Taplin, 1989, 170

From Roman imperial reliefs to Victorian wallpaper the Parthenon frieze has made an impact well beyond the confines of the Acropolis where it was originally created. In spite of its unlit and faraway position up under the ceiling blocks of the Parthenon's peristyle, the frieze nonetheless made an immediate impression on contemporary artists in fifth-century Athens. This influence continued well into Roman times and possibly even into the Italian Renaissance of the fifteenth-century or as long as the building stood relatively intact. After most of the complete slabs were removed from the Acropolis and put on permanent display in the British Museum (1817), the frieze became more readily accessible to the general public as well as to artists. In Bloomsbury it performed a major role in the promulgation of the neo-classical style then in its heyday. As a result of the worldwide proliferation of casts (Fig. 139) and photographs this impact continues up to the present day. This chapter will not attempt to cover in detail all instances of quotation of the frieze in later art, but will present a selective sampling of how this influence developed over time and by what means.

Given how much is lost from Greek antiquity, one problem with positing the influence of the frieze on later classical art is that one can never be certain that any extant monument was *the* prototype. As has already been observed, a number of Parthenon frieze motifs, such as the sandal-binder, probably were derived from now-lost monumental wall painting, which we know influenced Attic vase painting. Thus, any reflection of a motif that seems to us to be quintessentially Parthenonian could in fact derive from artworks in other media. This said, it is also the case that the innovative designers of the Parthenon frieze invented new compositional formats, styles of drapery, poses, spatial configurations, and even methods of carving that surely impressed the artists and travelers who saw the work both in progress and as a fait accompli.

LATE FIFTH-CENTURY ATHENIAN
VASE PAINTING

Those most likely to adopt the Parthenonian style and subject matter at first were vase painters who could quickly translate the new forms into their relatively rapidly made pottery. It is evident that certain Classical vase painters knew the Parthenon frieze, or at least parts of it, well enough to excerpt them as red-figure designs for their vases. There is some variety in their choice of subject as also in the quality of the rendering; as Brian Sparkes has remarked: "The more imaginative painters adapt freely, the poorer craftsmen copy more painstakingly."[1] In this context it is interesting to note that the vase paintings that most resemble the frieze tend to cluster around 430, while those that seem to quote the pediments appear in the later fifth century, thus reinforcing the relative dating of these two portions of the sculptural program. The vase painters whose work seems closest in style to the frieze are Polygnotos I (ca. 450–420); the Peleus Painter, a member of the Polygnotan Group; the Kleophon Painter, a younger member of this same group; and the Achilles Painter (Fig. 71). These painters were all active in the 440s to 430s, when the Parthenon sculptural program was nearing completion.

As might be expected given the Greek penchant for horses, a favorite motif derived from the frieze is a single horseman or pair of horsemen. Because riders on vases are conventionally shown moving to the right, one cannot automatically assume that they all depend on the south frieze. A case in point is the stamnos in Oxford attributed to Polygnotos that shows two horsemen with *petasoi* over their backs (labeled as the Dioskouroi) riding to the right (Fig. 140).[2] The group of horsemen on the south frieze with *petasoi* (S50–55) all seem to be wearing their hats on their heads and so are not models for the vase painter, whereas one figure from the north side (N131) has his slung over his back. The hats, however, could have been added by the painter, just as he added the spears in the riders' right hands. Other aspects of these figures that recall the frieze are the flying *chlamys* of the foremost rider, the downward glance and windblown hair of the second, and the poses of the horses with all four hooves off the ground (in this case they are flying over the sea). This is an example of a competent vase painter, not a slavish copier, who has excerpted two riders from the frieze, made additions, and adapted the Athenian knights into images of Kastor and Polydeukes.[3]

Single horsemen are more appropriate for smaller vases such as pelikai. The south frieze was certainly the inspiration for a vase like that shown in Figure 141.[4] In fact, the rider with his *chlamys* flowing down over the horse's flank

Figure 140. Two horsemen: Dioskouroi. Red-figure stamnos attributed to Polgnotos I, ca. 440. Ashmolean Museum, Oxford 1916.68. Photo: museum

and his *petasos* closely resembles S50 (whose head is missing but who would have been wearing a *petasos* like the others in his tribal unit, Fig. 142). The riders' right arms are in exactly the same position and the stance of their mounts is similar. It is clear why this particular rider was selected by a vase painter: he is more isolated from other horsemen and so could more easily be observed from a distance and copied. Later artists, such as the painter who decorated this cup, now in Cincinnati (Fig. 143), adapt more freely, bending the front legs of the horse to fit the tondo and treating the hair and drapery more loosely.[5] However, in certain details, such as the horse's mane, the depiction of the far foot of the rider (cf. Fig. 61), his right arm flung back, and the weighted corners of the *chlamys,* this rendering is actually closer to the frieze. These vase paintings demonstrate the range of adaptation of a single motif and may even reveal something about how paint was used on the frieze, that is, the border stripe of the rider's cloak, which shows up in most vase paintings.

Figure 141. Horseman. Red-figure pelike attributed to the Westreenan Painter, ca. 430. Tampa Museum of Art 86.64. Joseph Veach Noble Collection. Photo: museum

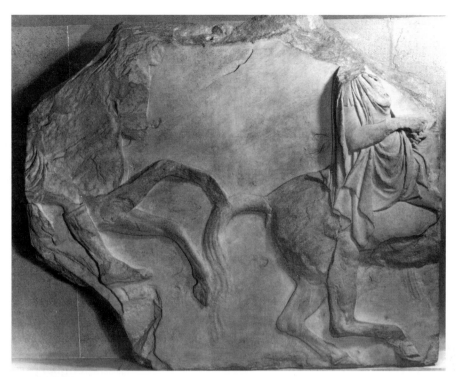

Figure 142. South XIX (S49–50). British Museum. Photo: Alison Frantz EU 210.

Figure 143. Horseman. Red-figure kylix in the manner of the Bull Painter, ca. 410. Cincinnati Art Museum 1884.231. Gift of the Women's Art Museum Association. Photo: museum

The most often cited and closest vase painting parallel for the frieze appears on a red-figure pelike in Berlin (Fig. 144).[6] This carefully, but somewhat painstakingly drawn youth, with *petasos* and *chlamys* over his back, is curbing his horse in exactly the same manner as W25 (Fig. 89). The painter had to invent the rear portion of the horse, which on the frieze was concealed by another horse, and his inadequacies as a draftsman emerge here as well as in an obvious problem with the baseline. Nonetheless he has conveyed with some precision the specific action of "parking up" the horse: the youth's right foot is clearly placed beyond the right forehoof of his mount. It has been suggested that this motif originated in wall painting because it also appears on a Roman late Republican relief, the so-called Altar of Domitius Ahenobarbus, at the far right end of the sacrificial procession.[7] In this instance it is difficult to judge the source, but the exactitude with which the vase painter has copied every detail certainly indicates that he at least knew the west frieze.

A number of scholars, noting some discrepancies between the vase painting and the relief (such as the difference in the ground line, or the position of the horse's head), believed that the painter must have been copying, not the frieze itself, but a model or sketch. This raises the interesting issue of whether the frieze could be seen well enough from the ground to enable an artist to re-create so accurately an excerpt from the composition, or whether vase painters and others might have had access to the scaffolding that the sculptors and marble painters were using to carry out their work on the frieze. Or were the copiers working from preliminary designs or sketches made for the sculptors? Perhaps the vase painters simply omitted those details that were either not of interest or not part of their painting tradition, as we see again below.

The equally dramatic scenes of the *apobates* also seem to have inspired vase painters, for this particular contest had not appeared on vases since the beginning of the fifth century (if then), and a spate of them suddenly occurs in the later fifth and into the fourth centuries in Attica.[8] As these often include Nike, Hermes, or Athena, they are not directly derived from the frieze, but their new popularity was probably prompted by it. Likewise the Panathenaic prize-amphora of 340–39 now in the Getty Museum (Fig. 101) shows the *apobates* contest for what appears to be the first time on an official prize-vase.[9] Unlike the contestants on the frieze, this warrior is nude, but he stands still holding the chariot rail with his foreshortened shield over his shoulder like those *apobatai* on the south side.

Another section of the frieze that proved popular for excerpting was the animal procession on the south side. The chous at Harvard University

Figure 144. Youth with horse. Red-figure pelike in the manner of the Washing Painter, ca. 430. Antikensammlung, Berlin F 2357. After Furtwängler-Reichhold, pl.171, 2

(Fig. 145) attributed to the Dinos Painter, on which two draped boys lead a bull to sacrifice, as indicated by the *stemma* or garland draped over its horns, echoes on a small scale south frieze block XLI (Fig. 146).[10] The garland on the horns of the bull that appears in other related paintings derived from the frieze suggests that such *stemmata* may originally have been painted on the marble relief.[11] Creative recycling of distinctive figures from the frieze was another route taken by Classical vase painters, as we have already seen above. The restive bull and restraining tamer of south frieze block XLIII (Fig. 115) are reconfigured for painted scenes of Theseus and the Marathonian bull, as for example on a bell-krater in the manner of the Dinos Painter (Fig. 147).[12] The rock is missing but implied in the painted version, and the animal-tamer has been given a club, but the pose of man and bull are immediately recognizable as those from the south frieze.

Athenian vase painters, like Attic comedians, were also capable of parodying religious processions. Since the old *kithara*-playing satyrs on a bell-krater in New York (Fig. 148) are labeled "singers at the Panathenaia," they could represent a parody of the frieze as well as the Panathenaic procession

Figure 145. Two youths leading a bull to sacrifice. Red-figure oinochoe attributed to the Dinos Painter, ca. 420. Arthur M. Sackler Museum, Harvard University Art Museums 1959.129. Bequest of David M. Robinson. Photo: museum

itself.[13] On the frieze a flute-player stands at the head of the kitharodes, and so it is possible that the scene is meant to spoof the more dignified relief. In addition these old musicians have adopted the scheme of sequential action that appears with the *hydriaphoroi* on the north frieze (Fig. 37): the first at the far left adjusts the position of his *kithara,* the second is strumming, and the third has just completed his plucking of the strings. This portion of the south frieze is almost completely missing, but the Carrey drawings, which indicate similar arm positions for the musicians (Fig. 47), could be used to support this relationship.

More dignified processions are the specialty of the Kleophon Painter, who perhaps comes closest to the mood of the frieze in his scenes of religious procession. In speaking of his great masterpiece, a volute-krater from Spina

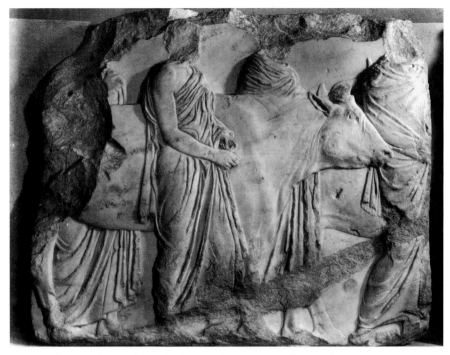

Figure 146. South XLI (S123–24). British Museum. Photo: Alison Frantz EU 227

Figure 147. Theseus and the Marathonian Bull. Red-figure bell-krater in the manner of the Dinos Painter, ca. 420. Diefenthal collection, Metairie. Photo: New Orleans Museum of Art

Figure 148. Singers at the Panathenaia. Red-figure bell-krater attributed to Polion, ca. 420. Metropolitan Museum of Art, New York 25.78.66. Fletcher Fund, 1925. Photo: museum

(Fig. 149),[14] Martin Robertson has remarked, "the artist has looked at and appreciated the frieze of the Parthenon in his own city, with its procession in honour of Athena."[15] In its solemn dignity, its absence of expression, and its richly draped young devotees, the procession to Apollo on the upper register of the obverse eloquently simulates the mood and style of the Athenian relief. More specifically, the draped youths walking beside their sacrificial bulls, the *kanephoros* with her festival mantle, and the half-draped god at ease with his arm on the back of his throne recall similar elements of the frieze. The figure standing just behind the *thymiaterion* is nearly a dead-ringer for the youth E48 (Fig. 52). Although a free adaptation, this exceptional vase painting captures better than any other vase the spirit of the Parthenon frieze.[16]

By the end of the fifth century Attic vase painting was on the wane and so there are few further reflections of the frieze, although some of its forms lived on in South Italian vase painting.

Figure 149. Sacrificial procession to Apollo. Red-figure volute-krater attributed to the Kleophon Painter, ca. 440–30. Museo Nazionale di Spina, Ferrara T57, C VP. Photo: Hirmer

FIFTH- AND FOURTH-CENTURY ATHENIAN RELIEF SCULPTURE

The first noticeable impact of the Parthenon frieze in sculpture naturally occurs on sculptural friezes carved in Athens in the latter half of the fifth century. Such influence can be detected in format, subject matter, style, and manner of carving. It is often claimed that the two friezes over the porches of the so-called Hephaisteion, the Doric temple on the hill overlooking the Agora, were inspired by the example of the Parthenon in their placement and perhaps also in the imagery of the seated gods. The Nike Temple parapet, although not a temple frieze, provides an illustration of how the Parthenon frieze shaped new types of monuments. Rhys Carpenter has written: "It is very apparent that the whole compositional scheme echoes the frieze of the Parthenon. The short east spur by the stairway is purely episodic in character, like the west flank of the Parthenon frieze; north and south are exact counterparts, moving symmetrically parallel toward the fourth side, which is exactly balanced on its central axis of composition and culminates in a ritual act in divine presence."[17] The distinctive motif of the restraining of a bull being led to sacrifice with the aid of a foot propped against a conveniently placed rock (S130, see Fig. 115) shows up twice on the Nike Temple parapet.[18] The famous Sandal-binder echoes the two youths on the west frieze (W12, W29) who lean over to tie their sandals, as does another Nike with her foot upon a boulder.[19] The head of the Sandal-binder, which was originally posed fully frontal, recalls the distinctive rank-leader on the north side of the frieze (N98, Fig. 45). In terms of style the drapery of the Nike Temple parapet is much more advanced, i.e., more transparent, but certain Parthenonian traits like the crimped selvage make an appearance on the *himatia* of some of the Nikai. The manner of carving with extensive use of the drill is also apparently a further development of the Parthenon method. If the parapet were better preserved, one might find even more correspondences between it and the Parthenon frieze, but what does remain demonstrates how influential the frieze was and indicates that some of the same sculptors probably worked on both.[20]

As has often been observed, once the Acropolis building program came to an end the various sculptors took up private commissions, by which we mean funerary stelae and votive reliefs. Naturally the style of the low-relief carving of the frieze would be reflected in these similarly low-relief monuments, and many parallels have been cited. One example is the *apobates* relief from the Agora discussed earlier (Fig. 102), where the warrior's leg is overlapped by the chariot wheel. Another is the fragmentary Boiotian relief,

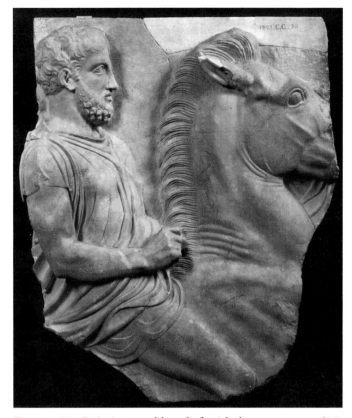

Figure 150. Boiotian marble relief with horsemen, ca. 430. Musei Vaticani 1684. Photo: museum

possibly from a large funerary stele, that the Venetian general Morosini brought to Italy after his siege of the Acropolis in 1687 (Fig. 150).[21] It depicts at least two horsemen (the second's cloak can be seen beyond the horse's jaw), and some of the mannerisms, like the split in the sleeve and skirt of the short chiton, are derived directly from the frieze. Unfortunately many of these reliefs, including also the so-called document reliefs, do not always rise to the quality of the frieze.

One grave stele, however, is exceptional in many ways and is particularly close to the frieze, such that George Hanfmann said of it: "One of the Parthenon sculptors strives to fit the young *polis* hero into the frame of domestic intimacy required for a family memorial."[22] The so-called Cat Stele (Fig. 151) from Aegina is dated slightly later than the frieze, ca. 420, and is in higher relief.[23] The deceased youth standing almost frontally at the right wears his himation around the waist and over the left shoulder in the manner of many males on the frieze, and its sharply tooled pie-crust edge is very

much in evidence. His head with its large eyes and rose-bud mouth, tousled hair, and finely carved ear resembles those of the youthful cattle-drivers. The close parallels in this stele's manner of carving to the techniques used in the frieze, particularly the extensive use of the drill, have been well documented and serve to reinforce Hanfmann's comment.[24] Even the composition, pairing a young man with his longer-haired attendant or slave (a theme that becomes ubiquitous in funerary art), makes one think of the youth (N135) having his belt tightened by a younger boy (N136, Fig. 26).

However, this particular youth N135 finds a much closer parallel in the figure of Hermes on one of four so-called Three-Figure reliefs, which exist now only in Roman copies (Fig. 152). His stance with one leg drawn back, his dress (double-belted *chitoniskos*), and particularly the manner in which his hand seems to grasp a clump of folds are exactly paralleled in the figure of Hermes at the left of the relief panel. Even closer in style to this Hermes is the warrior (S66) standing beside the still chariot on South XXVI (Fig. 153), so that some have suggested that the same artist carved both.[25] A further comparison involves another Three-Figure relief, namely, that of Theseus in the Underworld (Fig. 154). Standing at the right, his stance and drapery are comparable to the *skaphephoros* N13 (Fig. 113).[26] Perhaps an even closer comparison is the drapery crossing the lap of Peirithoos; it recalls that of the male gods, such as Dionysos (E25, Fig. 155). These reliefs, whatever their original purpose, come very close in style and in their subdued mood to the Parthenon frieze and are undoubtedly later works by the same sculptors.

Standing midway between the frieze and the Three-Figure reliefs are a series of high-relief figures found piecemeal over an extended time in the excavations of the Athenian Agora.[27] Their original location and purpose are still not established, although they seem to have been designed for a high position and possibly depicted the birth of Pandora with a large number of attendant deities.[28] Harrison has noted the striking resemblance of these figures to the frieze, especially in terms of "the carving of the thin chitons and delicate himatia, in the free rendering of the hair, in the shaping of the eyes, ears and mouths, and in a certain combination of gravity and charm in the expression of the youthful faces."[29] While the overall composition will remain unknown until more of the relief is found, in style the relief is clearly a somewhat later manifestation of the east frieze, and like other reliefs in Athens, executed by some of the same hands who worked on the temple program.

These examples serve to demonstrate the range of new types of relief sculpture that blossomed in Athens after the completion of the frieze. It and its corps of sculptors clearly spawned a fashion for sculpted friezes above and beyond those expected in the epistyles of Ionic temples.

Figure 151. Marble grave stele ("Cat Stele") from Aegina, ca. 420. Athens National Museum 715. Photo: Hirmer

Figure 152. Hermes, Eurydike, and Orpheus. Three-figure relief, Roman copy of late fifth-century Attic original. Musée du Louvre MA 854. Photo: M. et P. Chuzeville

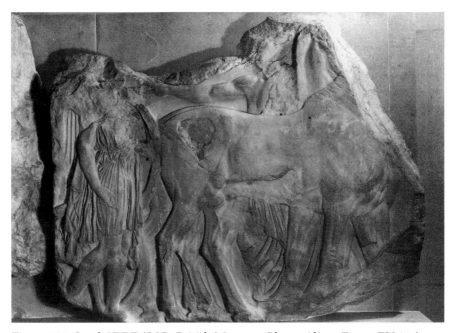

Figure 153. South XXVI (S66). British Museum. Photo: Alison Frantz EU 214

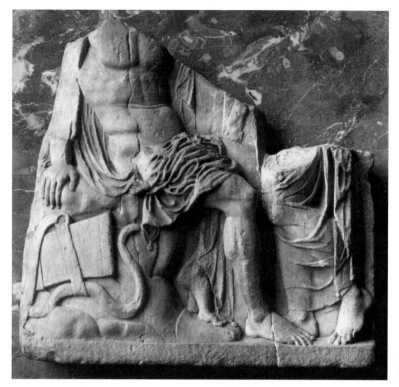

Figure 154. Peirithoos and Theseus in the Underworld. Three-figure relief, Roman copy of late fifth-century Attic original. Musée du Louvre MA 960. Photo: museum

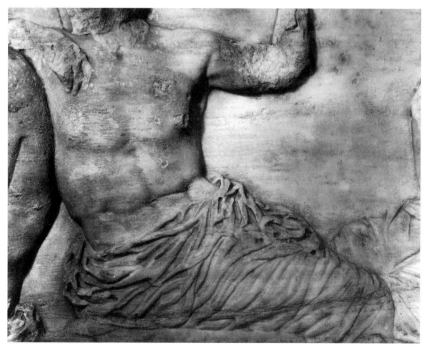

Figure 155. Detail of drapery of Dionysos (E25). British Museum. Photo: Alison Frantz EU 131

LATER NON-ATTIC ART

It is interesting to note how quickly and widely the influence of the frieze was diffused in the century after its execution. Two examples – one Lycian, one Scythian – will suffice to demonstrate this far-flung dispersion.

Found in the Royal Necropolis at Sidon in Phoenicia, the so-called Lycian sarcophagus (Fig. 156) of ca. 400–375 with its distinctively curved gable roof is frequently cited for the Parthenonian inspiration of its relief sculptures.[30] The dashing quadrigas in general and the smooth, expressionless faces of the hunters in particular recall the Parthenon frieze. In fact, these Lycian chariot groups are so close in their mode of carving to the frieze that Adam claimed it "was surely made by a man trained in Attica, and probably one who had worked on the Parthenon."[31] Although the heads of the horses are in higher relief and not strictly in profile, and hence more reminiscent of the Parthenon's pedimental horses, the fact that the prey is almost incidental indicates that the designer adapted his design from a non-hunting scene, no doubt the *apobatai* of the frieze (or some closely related monument). The panels on the short sides of the sarcophagus with their battles of centaurs and Lapiths are modeled after the Parthenon metopes in style and composition, and so inspiration from the frieze for the long sides is also highly probable.

Another, more remote echo of the frieze appears in Scythian goldwork. The elaborate *gorytos* (Fig. 157), or bow case, that exists in four replicas shows a double register of seated figures witnessing some sort of dramatic action.[32] Individually they recall related figures from the frieze, as do many of their seats; for instance, the bearded, half-draped man (king?) with his arm on the back of his throne in the center of the lower register reminds one of Zeus (E30) even down to the tiny sphinx that supports the arm of the chair. The larger seated woman to the left is reminiscent of Demeter (E26) in her drapery, of Dionysos (E25) in her pose with her left arm propped on a younger figure, and of Aphrodite (E41) with her right hand extended out at shoulder level. So, while the gold *gorytos* is not an imitation of the frieze in any sense, it, like the Kleophon Painter's krater, retains the spirit of its prototype.

Just as the frieze came to influence art in other media, so it also had an impact on other forms of sculpture besides relief. Ridgway has noted the influence of the frieze on later sculpture in the round: "drapery fashions that occur there for the first time find wide application in *free-standing statues;* the same is true for some three-dimensional poses."[33] An obvious example is the fourth-century statue known as the *Ares Ludovisi* (Fig. 158), which echoes remarkably faithfully the leg-holding pose of Ares (E27) on the

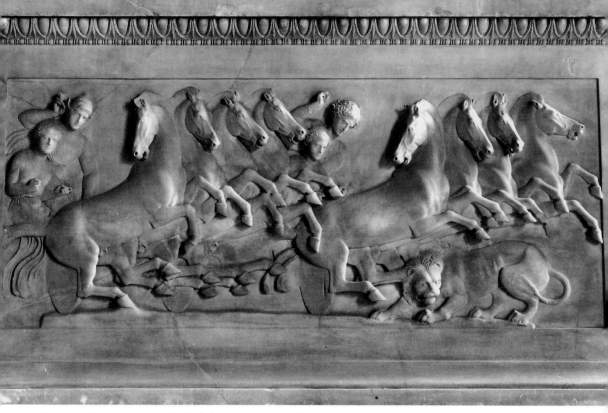

Figure 156. Lion hunt relief of the Lycian sarcophagus, ca. 400. Archaeological Museum, Istanbul 63. Photo: Hirmer

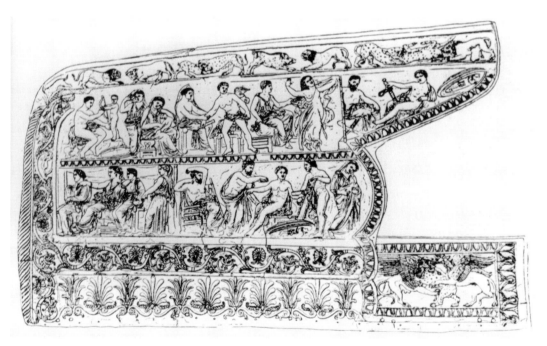

Figure 157. Scythian gold *gorytos,* fourth century. Hermitage, St. Petersburg. Drawing after Rousskia Frevnosti, 1889, fig. 121

Figure 158. *Ares Ludovisi.* Museo Nazionale Romano, Rome 8602. Photo: Alinari

frieze.[34] The male sandal-binder figure becomes Hermes on later coins and gems, and eventually finds expression in free-standing figures, such as the so-called Lysippean Jason and the Alexander Rondanini.[35] Even the backward-leaning figure of one of the eponymous heroes (E21) has been cited as a predecessor for the cult statue of Aphrodite in the Gardens and for a statue as removed in style from the frieze as the Farnese "Weary" Herakles.[36]

ART OF ROME

After the Hellenistic period the best known examples of the frieze's influence on relief sculpture come from the Augustan era, a period in which the style of fifth-century Greek art was deliberately revived. Decorative arts, such as the terracotta Campana reliefs, often carry motifs, like the *apobates,* which can be traced back to the Parthenon frieze.[37] A small bronze plaque found at Templemars in France and dated to the Augustan period, bears an exact copy of the cow-tamer from the south frieze.[38] In monumental art, the two processions of draped figures on the *Ara Pacis Augustae* (Fig. 159) consciously copy the standing draped men and women of the east frieze, who also approach from two directions.[39] Such a bifurcated procession, as well as the classicizing drapery (some *himatia* are worn in the Greek rather than the Roman manner), would remind all viewers in antiquity of the Parthenon frieze, as it does today. But less often cited in this context is the panel showing the Italic goddess of fertility, Tellus (Fig. 160).[40] In her seated pose with right leg extended, her attention to her offspring, her veiled head, and even to the buttoned sleeve descending to her right elbow, she closely resembles Aphrodite on the Parthenon frieze, enough to suggest that the Roman artist adapted the figure for Tellus simply by adding a second child. Since Venus Genetrix was the ancestor of the Julian family, this allusion to Aphrodite is all the more relevant on Augustus' altar and would perhaps have been recognized by contemporary viewers.

Another Julio-Claudian monument that bears echoes of the Parthenon frieze is the *Gemma Augustea* (Fig. 161).[41] In the center a relaxed half-draped Augustus sits enthroned to the left, a *lituus,* or augur's staff, in his right hand, and his left arm resting on the back of his throne. Although lacking a beard, he closely resembles Zeus on the Parthenon frieze, and the eagle under his seat is a direct allusion to Jupiter. His companion Roma, seated at his right side, look backs toward Augustus just as Hera turns toward her husband. The youth standing beyond Roma recalls Hebe in his close juxtaposition, so that the three can be read as a triad, like Zeus, Hera,

Figure 159. Procession relief. *Ara Pacis Augustae,* Rome. Roman, Augustan, 13–9 B.C. Photo: SEF/Art Resource, NY

and their daughter. The somewhat awkward composition in which the figures to the right of Augustus are seated with their backs to him also reminds one of the arrangement of the gods on the frieze. Perhaps we are meant to interpret the seated figures on the *Gemma Augustea* in a similar fashion, that is, as arranged in an arc awaiting the arrival of Tiberius. While the figure of Tellus here does not copy the Aphrodite of the frieze, her child who tucks his right hand into his mother's drapery may be a direct echo of the pose of Eros. Extending the analogy even further, it is possible to see the lower register of the *Gemma Augustea* as analogous to the *peplos* ceremony, that is, as an event taking place in front of the assembled mortals and divinities in the upper register. With the trophy being erected and the enemy captured, it is a scene that also suggests the idea that victory has been attained. While in Roman terms it undoubtedly represents a specific rather than a timeless event, in temporal terms it conveys the same message as the Parthenon frieze.

These comparisons suggest not only that the Parthenon east frieze was

Figure 160. Tellus panel. *Ara Pacis Augustae,* Rome. Roman, Augustan, 13–9 B.C. Photo: Alinari/Art Resource NY

Figure 161. *Gemma Augustea.* Roman, Julio-Claudian. Kunsthistorisches Museum, Vienna AS IX 79. Photo: museum

visible but that it exerted an influence on later, particularly Augustan, art. That this prototype was deliberately chosen is indicated by the fact that the Greek and the Roman reliefs have similar political agendas. The very fact that the Romans chose the frieze as a prototype might indicate that they viewed these citizens in procession as individual Athenians, rather than ideal types. In the case of Aphrodite and Tellus, the message is one of fecundity and future prosperity. In the triads Zeus/Hera/Hebe and Augustus/Roma/Germanicus there is a similar emphasis on progeny and dynastic succession. At the right beyond the throne of Augustus one sees the two gods Oikoumene and Neptune, personifying respectively the cities of the empire and the ocean that surrounded the world. Thus, the land-and-sea duality that we have observed in the arrangement of gods on the Parthenon frieze may be alluded to here in a Roman cameo carved some five hundred years later.[42] In spite of distance and time the Romans well understood the ideology of Athenian imperial art and incorporated it into their own artistic masterpieces.[43]

In the Hadrianic period (A.D. 117–138), which was equally if not more classicizing than the Augustan, it is not surprising to find works of art that closely copy those in Athens. Hadrian himself was a great Hellenophile who made numerous benefactions to the Greek city and had many Greek monuments duplicated for his villa at Tivoli. A relief (Fig. 162), found there in 1770 by the Scottish antiquities dealer Gavin Hamilton, is immediately recognizable as a subtle reworking of slab VIII of the west frieze (Fig. 85). No doubt adapting the composition to Hadrian's personal taste, the copyist has added an ill-fitting dog to suggest a hunting scene, has brought the horseman to the front side of his horse in order to display fully his nude body, and has transformed the bearded *hipparch* into a slenderer, clean-shaven youth. His balletic pose, awkward torso, flattened and decorative cloak, and non-Greek hairstyle all betray the relief's Roman execution. Writing of such neo-Attic reliefs Susan Walker has concluded: "Stylistic fidelity was often sacrificed in the cause of greater decorative appeal even to the point of combining elements from different sources and periods. The narrow-waisted man and his fine-ankled animal are slimmed down from the Classical canon almost to the point of effeteness."[44]

The Hadrianic period marks the highpoint of Roman interest in Athens and its antiquities. After the edicts of Theodosius II in A.D. 438, which effectively closed pagan temples, the Parthenon no longer functioned as the Temple of Athena Parthenos. Not long thereafter it was converted into a Christian church dedicated to the Virgin Mary. At this point all apparent interest in its pagan sculpture ceases for nearly one thousand years.

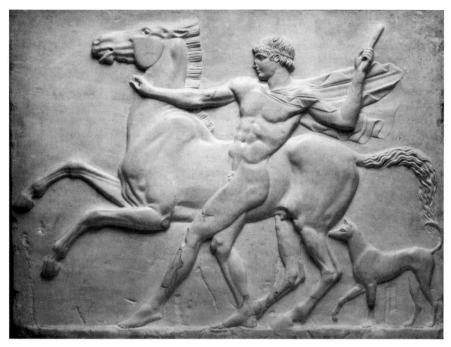

Figure 162. Roman marble relief from Hadrian's Villa. Hadrianic, ca. A.D. 120. British Museum 2206. Photo: museum

ITALIAN RENAISSANCE

Early Greek sculpture made no impact on Europe until the importation of the Elgin Marbles." So said Michael Greenhalgh in his important book, *The Classical Tradition in Art*.[45] However, this statement may have to be revised in light of what we know about the relationship of Athens and Italy in the fifteenth century. Florentine dukes ruled Athens from 1388 until 1458, when the city fell to the Ottomans. It was during this period that Cyriacus of Ancona made his two important visits to the city and, in addition to other monuments, sketched the west facade of the Parthenon and parts of its east and north frieze (Fig. 2). Recently it has been suggested that he made a drawing of the Propylaea, which is now lost but which originally would have shown the gateway as it had been transformed into the palace of the Acciaiuoli dukes. Given the close resemblance between the two buildings, it has been proposed that this drawing in turn influenced the architect Giuliano da Sangallo's design for the Medici villa at Poggio a Caiano. More relevant to our concern than the architecture is the decorative terracotta frieze that once embellished the entablature of the villa's portico facade. Here

one finds standing figures in military garb, cattle (attached to a plough), and two racing chariots that recall motifs from the frieze. Since we know that Cyriacus sketched at least part of the frieze and that Sangallo copied his sketches, it is not impossible that these figures are ultimately derived from the Parthenon frieze, as Tassos Tanoulas has recently suggested. He concludes: "The poised classical feeling emanating from the frieze at Poggio a Caiano, the manner in which the figures are disposed uncrowded, the dignity, the clarity of the contours, the restrained and, at the same time ample, forms, all reflect a desire for a classical style of a very particular quality: the Greek classical style."[46]

This desire for a specifically Greek classical style may have prompted other, more famous Italian artists to look to Greece for models. In writing of the sixteenth-century painter Raphael, Vasari states: "Such was Raphael's stature that he had draughtsmen working for him throughout all Italy, at

Figure 163. *Venus and Amor.* Fresco by Raphael (1483–1520) in the Farnesina, Rome. Photo: Alinari/Art Resource NY

Figure 164. Cast of Aphrodite and Eros (E41–42). Photo: British Museum

Pozzuolo and even in Greece; and he was always looking for good designs which he could use in his work."[47] Thus, it is not impossible that a sketch of Aphrodite and Eros from the east frieze could have influenced his design for one of the pendentives of the Loggia of Psyche in the Villa Farnesina in Rome, executed in 1517 (Fig. 163). Here Venus is pointing out to Cupid the lovely Psyche; her gesture and the fact that they are looking down below vaguely recall Aphrodite and her son on the east frieze (Fig. 164). While other intermediaries, such as the decorative arts, are possible, the close physical contact between Aphrodite and Eros seems to begin with their representation on the Parthenon frieze.[48]

Although Italian Renaissance connections with Athenian classical monuments may seem tenuous at best, with new discoveries and further research it may be possible to establish further links. In the case of the early nineteenth century there is no doubt about the source of classically inspired works of art.

THE "ELGIN" MARBLES

Lord Elgin's loot from Athens made its London debut in a garden shed in Park Lane in 1807. It was here that the frieze was sketched for the first time since it was removed from the building. In a drawing dated February 1807, Charles R. Cockerell, the British architect responsible for unearthing the frieze of the Temple of Apollo at Bassae, rendered a straightforwardly accurate visual record of north frieze block XXXVII as it was then constituted.[49] Because of their fragmentary state and damaged surfaces the marbles left some contemporary British connoisseurs "cold," while others, such as the painter Benjamin Robert Haydon, championed them and believed they would arouse European art from "its slumber in the darkness."[50] Rather than inspiring new, more naturalistic forms in sculpture and painting, it seems that it was the decorative potential of the frieze that was first seized upon by British artists. The Greek Revival architect Decimus Burton commissioned the Scottish sculptor and modeler John Henning to decorate two of his buildings, the Hyde Park Corner Arch (1825) and the Athenaeum Club (1827–30, Fig. 165) with reproductions of the Parthenon frieze. Eventually painted with a blue background, the individual figures are quite legible from a distance, and their decorative quality was subsequently seized upon by manufacturers of Victorian wallpaper, but with the male genitals prudishly concealed with bits of drapery.[51]

The first public display of the marbles, after their acquisition by the British Museum in 1816, inspired more imaginative recreations of the ensemble. In January 1817, the frieze, along with the other marbles, was installed in another temporary shed-like compartment that had originally been built to house the Bassae frieze. An imaginary and highly glamorized recreation of this gallery can be seen in the watercolor of 1833 by James Stephanoff (Fig. 166). A lone figure, presumably the "virtuoso" of the title, sits before a table on which rest busts of Perikles and Homer and before which is propped north frieze slab XLIII. Even though they were never displayed in this gallery, a few of Lord Hamilton's most famous vases are scattered in for good measure. The rest of the frieze lines the walls, just below the metopes (which have multiplied from the fifteen on display), as it did in the Temporary Elgin Room, as it came to be called. This idealized *Wunderkammer* populated by a single privileged connoisseur was a far cry from the reality of the wooden shed with its vast number of visitors from all classes of English society.[52]

In 1832 the Parthenon marbles were finally displayed in their own permanent home, "The Elgin Saloon." From this point on they continued to exert a determining influence on the course of British art up until the con-

Figure 165. Parthenon frieze reproduced in Wedgwood Blue and White. Atheneum Club, London, 1827–30. Photo: Crown.copyright.NMR

servative Victorian classicist Edward Poynter resigned as president of the Royal Academy in 1918. In fact, they are sometimes held responsible for the ossification of English art, which had a difficult time moving beyond classical idealism.[53] Even in contemporary British art the impact of the Parthenon marbles, especially the east pediment with its reclining figures, is still discernible, as for instance in the recumbant nudes of the twentieth-century sculptor Henry Moore.

The neo-classical style inspired by Greek art was also strongly favored in nineteenth-century Germany. The most famous example is a painting by the architect Karl Friederich Schinkel, which places the frieze into an idyllic landscape as part of a classical building under construction (Fig. 167). This painting glorifies the artisans responsible for the sculpture as well as the soldiers in the background returning from war. The latter are referred to in the inscription on the temple wall that quotes Aristotle's hymn to *arete* and the virtues of valor and death on the battlefield. It is clear that Schinkel has both taken liberties with the frieze and based his design, not on the actual remains

Figure 166. *The Virtuoso.* Watercolor by James Stephanoff, 1833. British Museum. Photo: museum

but on Stuart and Revett's restored figures. Note in particular the inclusion of part of the Nike parapet and the reversal of direction on the slab with Zeus and Hera. More than drawings, though, it was casts of the frieze that were to exert an even more widespread influence.

THE IMPACT OF THE CASTS

As soon as the Parthenon marbles were put on display, requests came in for casts, and so the Trustees of the British Museum commissioned the neo-classical sculptor Richard Westmacott to make molds and deliver plaster casts as required. By 1838 a second set of molds was created to meet the increasing demand for casts on the part of art schools and museums throughout Europe and America.[54] In the nineteenth century German universities and French academies had extensive cast collections that were used in the teaching of art history and classical archaeology.[55] After the establish-

ment of modern Greece as an independent state in 1830, the British Museum presented a full set of cement casts of the Parthenon sculptures to the King of Greece. When these arrived at the port of Piraeus in 1846, they were greeted with an enthusiastic reception and were promptly put on display by the Archaeological Society.[56] Although the display of casts is currently out of fashion in most museums and art schools, the maintenance of study centers equipped with complete sets of life-size casts in Athens and Basel has been a great boon to Parthenon studies.[57]

The influence of these casts of the frieze is best seen in artists' studies after the casts, often student exercises. Sculptors in particular, ranging from Horatio Greenough to Auguste Rodin, are known to have made drawings of figures from the frieze.[58] In the case of the American neo-classical sculptor Greenhough, who is best known for his portrait statue of a half-draped George Washington in the guise of the Phidian Zeus at Olympia, his drawings done at the French Academy in Rome resulted in a sculpture inspired by the frieze. His relief of Castor and Pollux of ca. 1847 (Fig. 168) shows the heroes overlapping and riding in opposite directions. The foreground rider seems to be a synthesis of riders from the west frieze: W2 for the revealed body, W8 for the pose of horse and rider, and perhaps also W10 for the foot seen in the background plane.[59]

Figure 167. *A Glance at the Golden Age of Greece.* Copy of a painting by Karl Frederich Schinkel, 1825. (Original destroyed in 1945; copy by Wilhelm Ahlborn, 1836). Alte Nationalgalerie, Berlin. Photo: Foto Marburg/Art Resource, NY

Figure 168. *Castor and Pollux.* Marble relief by Horatio Greenough, ca. 1847. Museum of Fine Arts, Boston 92.2642. Bequest of Mrs. Horatio Greenough, 1892. Photo: museum

Most French nineteenth-century artists encountered casts of the frieze in their student days at the École des Beaux Arts, and so there are no doubt thousands of sketches of those parts of the frieze that were available through casts. One of the more sensitive drawings is a graphite sketch by Edgar Degas of west frieze block XV (Fig. 169), one of the few that shows a fully preserved horse without a rider interrupting its contours. Degas' interest in equine anatomy that comes to the fore in his later paintings and plaster statuettes of race horses is already evident in this early stage of his artistic career.[60]

While it is not surprising to find a neo-classical sculptor and a French art student inspired by the frieze, it is certainly more unusual to encounter an American realist painter evincing an interest in classical subjects. Thomas Eakins had a brief but interesting Grecian phase during which he made a small oil study of an open landscape in which the figure of Pheidias is pointing out a pair of horsemen to two companions (Fig. 170). The two horsemen are no doubt derived from a west frieze slab (probably IX), casts of

Figure 169. *Sheet of Studies*. Graphite drawing by Edgar Degas, 1855–56. Musée du Louvre RF.15529. Photo: R.M.N.

Figure 170. *Phidias Studying for the Frieze of the Parthenon*. Oil on wood by Thomas Eakins, ca. 1890. Eakins Press Foundation, New York. Photo: E.P.F.

Figure 171. *L'Appel.* Oil on canvas signed by Paul Gauguin, 1902. Cleveland Museum of Art 43.392. Gift of the Hanna Fund. Photo: museum

which were certainly available to artists in Philadelphia. This imaginative re-creation of a moment in the life of the Greek sculptor is unusual and suggests that the painter was attempting to show how Greek art is based on nature, rather than abstract or ideal forms.[61] His painting is the embodiment of the evaluation of the Select Committee of the House of Commons, which was appointed in 1816 to inquire whether it was expedient for the British Government to purchase Lord Elgin's collection: "It is surprising to observe in the best of these marbles in how great a degree the close imitation of nature is combined with grandeur of style."[62]

Our last reprise of the frieze takes us into the twentieth century and a long way visually from the classical era. At first glance one might well wonder what a painting by Paul Gauguin of Tahitian women (Fig. 171) has to do with the Parthenon frieze. If it had not been for a black-and-white photograph left in the artist's South Seas hut we might never have suspected the source of the pose of the half-draped girl on the right. She is the mirror image of the important pivotal figure on the east frieze, E47 (Fig. 52), the marshal who beckons to the other side and so brings the two files together. It would appear that Gauguin understood the meaning of the marshal's gesture, because his painting is entitled *L'Appel* (The Call). For an artist who claimed "La grosse erreur, c'est l'art grec," it is a surprising source to say the least.[63]

L'Appel illustrates well how far the influence of the Parthenon frieze can travel in time and space – showing up two and a half millennia later on the other side of the globe in a different medium based on a photograph. It also well represents the universality of the frieze as a work of art that in this sense belongs to everyone. In this regard it has played a leading role in the cultural heritage debate that we shall consider in the next chapter.

Figure 172. Interior of the Duveen Gallery, British Museum. Photo: museum

THAUMA

WHOSE HERITAGE?

In civilized countries no sanctuary exists to
equal it. May its construction remain eternal
until the completion of time. Amen.
– Evliya Chelebi 1667

The controversy over whether these magnificent
stones should remain in London or be returned
to the Acropolis burns as consistently as any
political issue of modern times.
– Thomas Hoving 1997

On July 31, 1801, a motley crew consisting of an Italian landscape
painter, a Tartar figure painter from central Asia, and a hunchback
draftsman from Naples, all under the direction of the Reverend Philip Hunt,
a thirty-year-old English clergyman, began the systematic removal from the
Parthenon of its sculptural adornment – works of art that had remained for
over two thousand years in the position for which they were carved. This
team was carrying out its operations with the direct permission of the Sultan
of Turkey, Selim III, in the form of a *firman* (edict) obtained by and on
behalf of the British ambassador to the Sublime Port, Thomas Bruce, sev-
enth Earl of Elgin. In addition to the fifteen metopes from the south side
and all but two of the remaining pedimental figures (which were believed
incorrectly to be Roman), they took down approximately one-third of the
north and south friezes. In order to lessen the excessive weight of these frieze
blocks for ease in transport, their back halves were sawed off. Having sur-
vived the 1687 explosion relatively intact, the western end of the temple still
retained its superstructure and so made removal of the west frieze too diffi-
cult; most of it remained in place until 1993, when it was finally removed
because of the devastating air pollution in modern Athens.[1]

The story of Lord Elgin and the Marbles has been told and retold;

books on the subject have been published, updated, and reprinted. For two hundred years his actions have been debated as to their legal and ethical propriety, and still the debate continues. The French, no doubt envious that they did not secure for themselves more of the sculptures of the Parthenon, coined the term *elginisme* to describe the plunder of cultural treasures in general. Beginning at least as early 1898, the Greek claims for repatriation have continued to this day with increasing support from international organizations like UNESCO and ICOM. Today this controversial case has become the symbolic flagship charting the choppy waters of repatriation.

Given the facts that there is today a growing movement favoring the restitution of cultural property via legal, political, and institutional channels, that the debate regarding nationalism versus universalism of cultural treasures is waged weekly in the press, and that moralities in this area are changing just as they have in other areas of human conduct, it seems reasonable to review the case of the Parthenon marbles, particularly in light of the frieze, which, even more than the metopes and pediments, was created as a narrative and stylistic unity. Or as one legal scholar has said, "the Elgin marbles, on which everyone has an opinion, provide a convenient and glamorous context for a reasoned discussion of the repatriation issue."[2]

THE LEGAL ISSUES

The legal issues are perhaps moot, since the disputed events took place almost two hundred years ago, and no documents, in particular the various *firmans,* exist in the original. The British, having investigated the issue of ownership at the time of purchase (1816), claimed legal title to the marbles then as they do today. In response to a request made by the Greek minister of culture Melina Mercouri in 1983 to return the architectural sculptures to Greece, the House of Commons declined, stating: "The collection secured by Lord Elgin, as a result of transactions conducted with the recognised legitimate authorities of the time, was subsequently purchased from him and vested by an Act of Parliament in the trustees of the British museum 'in perpetuity.'" As recently as February 17, 1996, a government spokesman in the House of Lords stated the British position as follows: "[The] Parthenon sculptures . . . were legally exported from their country of origin. . . . The title of the British Museum to the Marbles is unimpeachable."[3]

The legal case for British ownership has been argued at length by an eloquent spokesperson, John Merryman, professor of law at Stanford University, who makes the case that Lord Elgin had legal title to the marbles and so could legally transfer ownership to the Crown. The question of Elgin's own-

ership hinges on whether the removal of the marbles was authorized by the legal authority in Greece at the time, the Ottomans. Unfortunately the official *firman,* the formal written instrument, exists only in an Italian translation that does not specifically grant authority to remove the superstructure of the temple, but rather to "carry away some pieces of stone with inscriptions and figures" (presumably those lying around the Acropolis after the explosion of 1687). It seems clear that Elgin and his henchmen did exceed the authority granted him by the Turks who then occupied Greece, but no one at the time challenged their actions. The generous bribes to Turkish officials, quite customary throughout the Ottoman Empire, allowed Lord Elgin's agents virtual carte blanche on the Acropolis and they duly took advantage of the political situation, which at the time favored Britain over France, to obtain as much as physically possible. Clearly the Turkish rulers had been sufficiently bribed and at any rate did not care enough to enforce the, admittedly vague, letter of the law as indicated by the Sultan.

While admitting that the removal may have been illegal, Merryman argues that the Ottomans subsequently legitimized Elgin's actions by allowing the shipments of the marbles to embark from the Piraeus harbor for England. In essence Merryman argues for a *post facto* legality, but the fact is that, once the Turkish authorities in Athens had allowed the removal of the marbles, to block their export would have shown up their earlier carelessness. Just like the British Parliament in 1816, the Turkish officials were faced with a fait accompli and had to make the best of a bad situation. To call this an "act of ratification" gives their laissez-faire actions a legal dignity they perhaps do not merit.[4]

Another argument used by legal experts is the statute of limitations (in spite of the fact that this is not applicable in international law). Between the last shipment of the marbles from Greece (1816) and the first official request for their return (1983) over 160 years have elapsed. Given that the Acropolis was not surrendered by the Turks until 1833 and that the Greeks then spent decades cleaning up and excavating the Acropolis (1835–89), reconstructing ancient monuments, demolishing medieval buildings, constructing an Acropolis museum (1865–74), repairing damage from an earthquake in 1894, and replacing earlier restorations, it could be construed as a responsible action on the part of Greece that it did not request the return of the marbles until ready and able to preserve and exhibit them properly. Arguably a statute of limitations is a mere technicality and should not be applied to important cultural property; in the recent case of the Lydian silver hoard illegally exported from Turkey, such a motion filed by the buyers, the Metropolitan Museum of Art, was denied. Likewise such a statute is not applied today in the cases of restitution of artworks looted a half century ago during the Second World War.

While legal scholars would like to apply modern instruments, like the statute of limitations, to the issue of repatriation, they find the application of other modern international laws, such as the Hague Convention of 1954, to be inadmissible. According to this treaty parties to the convention are to "refrain from requisitioning movable cultural property" located in the territory of another party. By this line of reasoning it would have been illegal for the Ottomans to allow the removal of antiquities from Greece, thus negating Elgin's title to the material. Although this particular convention was not law in the nineteenth century, there in fact was a common practice of returning art objects to the country of origin when hostilities ceased, as for example the return of art treasures to Italy after the downfall of Napoleon.

As stated at the beginning, the legal issues are clouded by time, distance, and a lack of documentation. Nevertheless legal scholars continue to try out legal arguments but are inconsistent in their application of modern laws and conventions. More relevant in the current political climate are the stances taken by major international organizations that have tackled the issue of cultural property and heritage head on.

CULTURAL HERITAGE ISSUES

The 1970 UNESCO Convention defines cultural property as "property which, on religious or secular grounds, is specifically designated by each State as being of importance for archaeology, prehistory, history, literature, art or science," including the following category: "elements of artistic or historical monuments or archaeological sites which have been dismembered." This all-inclusive definition certainly encompasses any and all classical architectural sculpture removed from a temple. Today most countries have laws restricting the export of their cultural property as a means of preserving their heritage and, in the case of antiquity, protecting archaeological contexts. Because of a seemingly unquenchable appetite for ancient artifacts on the part of museums and wealthy collectors worldwide, the looting of archaeological sites and even local museums is of serious international concern. Hence, organizations like UNESCO and ICOM are committed both to the prevention of art theft and to the repatriation of cultural property, including the Acropolis marbles.

As often in the case of cultural heritage issues, there are two sides to the question. On the one hand the Greeks legitimately feel that the monuments of the Acropolis are symbolic of their civilization; these, more than any other document, building, or work of art, epitomize their highest artistic and cultural achievements. Often this position is expressed in more emotional,

nationalistic terms, as in the words of Melina Mercouri: "they are the symbol and blood and the soul of the Greek people . . . we have fought and died for the Parthenon and the Acropolis." The British, more restrained, as one might expect, also have a legitimate claim on the "Elgin" marbles as part of their cultural heritage. The sculptures have been on display in the British Museum since 1817, influencing generations of artists, poets, and architects. As recently as May 1997, the Heritage Secretary stated that "it was not a feasible or sensible option" to return the marbles to Greece, as they form "an integral part of the museum's collection." What this official failed to acknowledge, by taking such a short, nationalistic view of history, is that they were an integral part of the buildings on the Acropolis for even longer. How does one weigh two centuries of ownership against twenty-two?

If we grant that both sides have legitimate heritage claims on the marbles, how can the issue be resolved fairly? Proponents of the British side have often cited the principle of repose, whereby an object should remain where it is unless some compelling reason for relocating it arises. This principle is naturally invoked by those who own someone else's cultural property, namely, museums and collectors, and wish to maintain the status quo. Although this principle seems especially apt in the case of fragile art objects for which excessive movement is potentially dangerous, art museum professionals who organize international blockbuster exhibitions and yet advocate this concept for their own collections are being inconsistent. The principle of repose would perhaps have been better applied in 1801, thus avoiding the irreparable damage to the Parthenon caused by the removal of its sculpture.

The most compelling argument on behalf of institutions like the British Museum, whose mission is to collect and display the art and artifacts of the world's civilizations throughout history, is that of cultural internationalism. This raises the debate to a higher plane; it is not a matter of parochial Greek versus British interests, but concerns the cultural heritage of all mankind. In this sense it has been said that "we are all Greeks," since all of the inhabitants of the contemporary world are equally inheritors of the culture of the ancient Hellenes. Wherever they are located, the sculptures of the Parthenon are heritage to be enjoyed and appreciated by all as opposed to the property of a single state.

The question then is where best would they fulfill this noble mission, in a gallery in London (Fig. 172) in proximity to some of the finest artistic creations of the ancient civilizations of Egypt, Mesopotamia, and Greece, or in a new specially designed museum in Athens in proximity to the sanctuary which they once adorned? This question brings us to the real crux of the problem, which can only be argued on ethical grounds.

ETHICAL CONSIDERATIONS

One avenue to a moral decision is via consideration of the "greater good." Who benefits most by the possession of the Parthenon marbles? Are there potentially negative results when cultural heritage is returned to its original owner? One frequently expressed concern is that the return of the marbles would result in the impoverishment of a great institution, the British Museum, and lead to the future depletion of museum collections, so feared by curators, keepers, and directors. In 1986 the director of the British Museum likened the return of the marbles to cultural fascism. "It's nationalism and it's cultural danger, enormous cultural danger. If you start to destroy great intellectual institutions, you are culturally fascist." This extremist view does not address the real issue, which is one of enhancing one great collection, in this case the Acropolis Museum, at the expense of another. Are there moral reasons for doing this? Granted the British Museum would be losing one of the "jewels in its crown," but this is not the same as England losing its crown jewels, which are essentially to that country what the marbles are to Greece. Cultural heritage, whether the crown jewels or the Parthenon marbles, are "objects charged with cultural significance, the loss of which deprives a culture of one of its dimensions." As we have noted earlier, the cultural identities of both Britain and Greece are embedded in the marbles, but in the balance Greece's claim is much greater; hence a greater good accrues to Greece by their return.

As for a return of the sculptures causing a massive hemorrhaging of western museums, this is a much overstated case. Most art that is displayed in museums today is portable; it was made for the trade and/or for individual ownership, to be bought and sold on the open market. Those objects that were made for a specific context and affixed permanently, like mosaics, wall paintings, and architectural sculpture, should not be purchased in the first place, because such collecting causes irreparable damage to the artistic integrity of the monument. This concept of fixed property is well understood by the British, for they invoked it in the controversial case of the *Three Graces*. This neo-classical marble statue was commissioned from Canova in 1814 by the Duke of Bedford for his country home, Woburn Abbey, where a special octagonal room was added to the sculptural gallery for its enshrinement (Fig. 173). In 1968 this area was changed into a restaurant and the statue was sold to a private investment company in 1985. Then the J. Paul Getty Museum, bought it for 7.6 million pounds, but was refused an export permit by the British government's review committee. The head of the Heritage Division within the Department of the Environment determined that because the statue's plinth was bolted to the floor, the sculpture should be considered a fixture. This ruling was eventually overturned, but then the gov-

Figure 173. Interior of the Temple of the Three Graces, Woburn Abbey. Photo: Crown.copyright.NMR

ernment deemed the statue to be of such aesthetic and art historical importance and so closely connected with British history that its export would adversely affect the cultural heritage of Britain.[5] It is ironic, to say the least, that Britain insists on its heritage rights to a portable statue by an Italian artist but fails to recognize the claim of the Greeks to fixed artistic property made by Greek artisans for a temple in a Greek sanctuary. Each case must be decided on its own merits, and the reason the Elgin Marble debate is in the forefront is precisely because it has such strong merits on the Greek side.

An important issue regarding the Parthenon marbles that has recently come to the fore is that of stewardship. Where are the Parthenon marbles better off? Who is better equipped to care for and display them? One need only look at the slabs of the west frieze, which as of 1993 have been housed in the Acropolis Museum, to realize that the frieze blocks in London are in better condition than those which remained on the temple and suffered from the last few decades of air pollution in Athens. But rarely is the case made that the atmosphere in Victorian London was so bad that there was discussion about exhibiting the important art collections outside the city. As St. Clair has recently remarked: "The fact that the Elgin Marbles were indoors gave them some protection, but nineteenth-century London, with its rapidly changing weather, its rain and humidity, and the carbon dioxide and sulphur smoke and soot belched from factories, steam engines, and millions of domestic coal fires, was probably the most damaging environment that had ever existed anywhere in the world."[6] The blackening of the marble caused by soot is very evident today on some of the less well-preserved frieze blocks, which, because of their friable surface, were not cleaned before installation in the Duveen Gallery (Fig. 172).

The most recent controversy involves this special, unauthorized cleaning prior to installation of the marbles in the new gallery financed by the art dealer Sir Joseph Duveen in 1937–38, and its coverup by the authorities of the British Museum. Clinging to the old-fashioned notion that classical marbles were pure white, Duveen used his agents to bribe the museums' workmen to clean the sooty surfaces with more than water, in fact, with metal chisels and harsh abrasives. It was not until a keeper from another department alerted the director to the "somewhat raw" appearance of parts of the Parthenon frieze that the disastrous cleaning was brought to a halt. The incident was never officially investigated and reported to the public; an international colloquium held at the museum in the fall of 1999 addressed the results of this controversial cleaning.[7]

If, as they now admit, the British Museum authorities failed in their stewardship of the Parthenon marbles, would they have been better off in Greece? Atmospheric conditions were certainly no better there, and until recently there was no museum adequate for their display. However, a new Acropolis Museum is about to be constructed on the level ground to the

Figure 174. Right lower leg and foot of Artemis (E40). Museo archeologico, Palermo 781. Photo: Alison Frantz SC 42.

south of the Acropolis, which, when completed, will be a more state-of-the-art environment than the Duveen Gallery. One could argue that it is preferable to see the marbles in the strong light of Greece than in the dark, northern atmosphere of England. It would also be an improvement in our understanding of this monument to see it facing out as it was carved, rather than "outside-in" as it is presently displayed.

In opposition to these negative arguments, there are a number of positive moral reasons for repatriation. The most compelling is both a moral and an art historical argument, namely, that the Parthenon along with its sculptures was designed as an integral whole. Although the majority of the frieze is in the British Museum, some of the key slabs – that with Poseidon, Apollo, and Artemis (Fig. 86), for instance – as well as nearly all the west frieze are in Athens. In terms of more or less complete slabs the tally is London 52, Athens 39, Paris 1. Many of the smaller fragments, found over the years on the Acropolis, are meaningless unless joined to the larger pieces to which they belong. Likewise the fragment with two heads of *thallophoroi* in Vienna (Fig. 84) or the foot of Artemis in Palermo (Fig. 174) are simply trophies that make little sense aesthetically or intellectually in isolation. In the common union that is now Europe these far-flung *membra disjecta* should be reunited. Where?

The logical place is Athens, the city that still houses the temple for which these sculptures were carved. There is no question of restoring these pieces to the actual building that already carries replacement casts of the sculptures that remained, but displaying them together for the first time in two hundred years will enable lovers of art, art historians, archaeologists, and the museum-going public to experience the ensemble as it was intended. Such a display can only enhance our readings of this inestimable monument and reveal to generations to come the "beauty and majesty" of the Parthenon marbles.

EPILOGUE

This book ends with two fables – one modern, one ancient – which speak for themselves. The first concerns a colossal marble caryatid from the shrine of Demeter at Eleusis, given to the Fitzwilliam Museum in Cambridge by the collector and traveler Edward Daniel Clarke, who acquired it in 1801. According to the museum's catalogue:

> This battered and worn caryatid bust, from the sanctuary at Eleusis near Athens, was mistakenly revered for centuries as the corn goddess Demeter herself. . . . The fallen architectural sculpture was first described by a traveller in 1676, and in 1801, despite its continued veneration by the locals who piled it around with manure, E. D. Clarke purchased it from the local governor and brought it by ship to England. Almost as if by divine retribution, the *Princessa* was wrecked off Beachy Head, but the sculpture was recovered. Eleusis was to turn into an industrial wasteland.[1]

The transaction is described in Clarke's own words:

> I found the goddess in a dunghill buried to her ears. The Eleusinian peasants, at the very mention of moving it, regarded me as one who would bring the moon from her orbit. What would become of their corn, they said if the old lady with her basket was removed? I went to Athens and made application to the Pacha, aiding my request by letting an English telescope glide between his fingers. The business was done.[2]

The Eleusinians protested in vain against the removal of their goddess, and as if in confirmation of their intense feelings, an ox broke loose from its yoke and butted violently with its horns at the statue. It then ran amok over the plains of Eleusis, bellowing loudly.

The second story relates to the transport of the marble blocks from the quarries on Mt. Pentelikon to the Acropolis of Athens and is recorded in Plutarch's *Life of Cato the Elder* (5.3):

The Athenians, when they built their Hekatompedon, turned those mules loose to feed freely which they had observed to have done the hardest labor. One of these, they say, came once by itself to offer its service, and ran along with, nay, went before, the team which drew the wagons up to the Acropolis, as if it would incite and encourage them to draw more stoutly; upon which there passed a vote that the creature should be kept at the public charge even till it died.

CHRONOLOGICAL TABLE

B.C.

566–65	Founding of Greater Panathenaia
490	Battle of Marathon
490–80	Pre-Parthenon begun
480–79	Persian sack of the Acropolis; pre-Parthenon destroyed; Greek naval victory at Battle of Salamis
479	Greek land victory at Battle of Plataia
478–77	Founding of the Delian League
ca. 465	Wall painting of the Battle of Marathon in Stoa Poikile
460s	Pheidias working on Athenian dedication at Delphi
ca. 455	Pheidias' colossal bronze Athena on Acropolis
ca. 454	Treasury of Delian League transferred to Athens
447	Parthenon begun
ca. 445–38	Athenian cavalry expanded from 300 to 1,000
ca. 442–38	Parthenon frieze carved
438	Athena Parthenos dedicated at Greater Panathenaia
432	Parthenon completed
426	Major earthquake in Athens

A.D.

ca. 100	Plutarch writes *Life of Perikles*
ca. 160	Pausanias visits Acropolis
267	Herulian sack of Athens; Parthenon burned
6th c.	Parthenon converted to Christian Church
12th c.	Parthenon/church enlarged; central slab of east frieze removed and six windows cut into side friezes
1388	Acciauoli of Florence occupy Acropolis
1436	Cyriacus of Ancona's first visit to Acropolis
1444	Cyriacus of Ancona's second visit to Acropolis

1458	Ottomans take over Acropolis
ca. 1460	Parthenon converted to a mosque
1674	Jacques Carrey draws 57 Parthenon frieze blocks still *in situ*
1687	Parthenon blown up during Venetian siege; large parts of frieze destroyed or damaged
1749	Richard Dalton draws west frieze
1751	James Stuart draws parts of frieze remaining after explosion
1801–1805	Lusieri removes most of remaining frieze blocks and saws off backs
1802	Central east frieze block breaks during loading in Piraeus
1810	Parts of frieze exhibited in Park Lane shed
1816	House of Commons votes to purchase Acropolis marbles from Lord Elgin
1817	Temporary Elgin Room opened to the public
1818	Louvre purchases east frieze VII, originally acquired by Fauvel for Choisseul-Goffier in 1787
1833	Ottomans surrender Acropolis to Greeks
1834	Acropolis declared an archaeological site
1835	Permanent gallery known as "The Elgin Saloon" built for display of Parthenon marbles
1842–44	Restoration work on Parthenon carried out
1871	First comprehensive publication of frieze by Adolf Michaelis
1875	Carl Robert assigns 42 fragments in Acropolis Museum to frieze
1885–90	Excavations on Acropolis uncover more fragments of frieze
1910	West frieze photographed by Boissonnas, published by Collignon
1928	West frieze photographed by Hege
1938–39	Unauthorized cleaning of Parthenon sculptures in British Museum
1946	Discovery by Benjamin D. Merritt of Francis Vernon's manuscript indicating clerestory windows in church
1954	New arrangement of frieze blocks by William B. Dinsmoor
1958	Frieze photographed by Alison Frantz

1960	Maria Brouskari publishes additional fragments of frieze found in Acropolis storerooms
1962	Frieze exhibited in Duveen Gallery of British Museum
1975	Committee for Preservation of the Acropolis Monuments founded
1977	Comprehensive publication of frieze by Frank Brommer
1983	Greek minister of culture Melina Mercouri requests return of Parthenon marbles
1987	Center for Acropolis Studies established in Athens; completion of frieze reconstruction in Skulpturhalle, Basel
1992–93	Removal of last remaining blocks of west and south friezes
1994	Renumbering of north and south frieze blocks by Ian Jenkins
1996	Full documentation on frieze published by Ernst Berger and Madelaine Gisler-Huwiler
1999	"Cleaning the Parthenon Sculptures," Twenty-third British Museum Classical Colloquium

CONCORDANCE

NOTES

INTRODUCTION

1. This photograph (Fig. 1) and others by Robertson of mid–nineteenth century Athens and its antiquities are published in the Benaki Museum exhibition catalogue, Constantinou and Tsigakou, 1998. The Parthenon frieze is reconstituted in plaster casts in the Skulpturhalle, Basel; see Berger and Gisler-Huwiler, 1996. For the distribution and influence of the plaster casts see Chapter 7.

2. Cyriacus of Ancona: Ashmole, 1959; Bodnar, 1970; Mitchell, 1974, with additional bibliography; Brown, 1996, 84–89. A second drawing of the Parthenon facade after Cyriacus of Ancona, preserved in the Barberini Codex and attributed to Giuliano da Sangallo, does depict some of the south metopes, although incorrectly placed, so it can be assumed that Cyriacus' original drawing contained them.

3. Vitruvius: Corso, 1986, 31–50. Marble stelai: *IG* I^3 436–451.

4. Evidence for the Parthenon windows came about with the discovery in 1946 of the long-lost description of the Parthenon written in 1675 by Francis Vernon; see Dinsmoor, 1954. For a reconstruction of the Parthenon with its windows, see Berger and Gisler-Huwiler, 1996, pls. 157 and 160; Korres, Panetsos, and Seki, 1996, 30–31, no. 12; Hurwit, 1999, 296, fig. 238 (M. Korres).

5. For an eyewitness account of the bombing of the Parthenon, see Bruno, 1974, 124–28. A modern reconstruction of the event was created on paper by Manolis Korres; see Korres, Panetsos, and Seki, 1996, 32–33.

6. While at first glance the corner breaks might look to be the work of metal seekers hacking away at the blocks in order to get at the lead-encased clamps holding the architrave together, there are no tool marks on the stones. Dinsmoor (ms.) believed that the corners of the west frieze were split off by the expansion of rusting dowels. Brommer (1977, 210) suggested that the damage was caused either by earthquake or the explosion of 1687 (although some of it is already visible in the Carrey drawings). It is worth noting that some of the damage is symmetrical; e.g. the north corners of East III and East VI, (Brommer, 1977, pl. 165) or West II and XV, V and XII, VI

and XI (Brommer, 1977, pl. 7), suggesting seismic action. I thank John Dobbins and Kirk Martini of the University of Virginia for discussion of this issue.

7. Carrey drawings: Bowie and Thimme, 1971. Later drawings: Berger and Gisler-Huwiler, 1996, 21–23. From his low vantage point Carrey was unable to see the rock beneath the right foot of N47 and so omitted it. His rendering of the drapery is also less detailed.

8. History of the British Museum cast collection: Jenkins, 1990. Casts in the Skulpturhalle in Basel: Berger and Gisler-Huwiler, 1996, vol. 2.

9. Parthenon in Nashville: Wilson, 1937.

10. The publications of the British Museum include: Smith, 1892; Smith, 1910; Ashmole, 1949; Haynes, 1959; Haynes, 1962, rev. ed. 1965; Cook, 1984a, 2nd ed. 1997; Jenkins, 1994a.

11. Brommer, 1977; Berger and Gisler-Huwiler, 1996.

12. Boardman, 1985, 94.

13. Connelly, 1996.

14. Connelly's interpretation has met with a surprising degree of acceptance in the popular literature, as indicated by the latest edition of H. W. Janson's *History of Art* (5th rev. ed. 1997: 149), where the caption for an illustration of the central scene reads "the sacrifice of the daughters of Erechtheus." For further discussion of this theory see Chapter 6.

1. POLIS: THE FRAMEWORK OF RITUAL

1. The phenomenon of religious pilgrims and pilgrimages to sacred sites is surveyed by Dillon, 1997. The early history of the Acropolis, its buildings, and their decoration, is very complex and still unresolved; for a review of the problems see most recently Brouskari, 1997. Essentially there are two basic positions: (1) those who believe that there was a single temple to Athena Polias on the north side of the Acropolis in the sixth century, and (2) those who believe in a "hypothetical but necessary" second sixth-century temple located under the present-day Parthenon, a so-called grandparent or *Urparthenon* known as the Hekatompedon, according to Dinsmoor, 1947, 109–51. Those who support the first position include: Plommer, 1960; Herington, 1963, 61, n. 1; Beyer, 1974; Hurwit, 1985, 236–43 (a good summary of the many problems, inscrip-

tional, architectural, and sculptural); Shapiro, 1989, 21–24. Those who subscribe to the second include Herington, 1955; Travlos, 1971, 258; Dinsmoor, Jr., 1980, 28–29; Rhodes, 1995, 29–53 and 188–89, n. 1. Manolis Korres, the architect in charge of the Parthenon conservation project, believes (following Travlos) in three predecessors to the Parthenon; see Korres, Panetsos, and Seki, 1996, 12. For the appearance of the olive-wood cult statue of *Athena Polias,* see Kroll, 1982. The authenticity of the Oath of Plataia has been questioned both in antiquity and by modern historians; for a summary of the arguments, see Meiggs, 1972, 504–507 and 597.

2. Louvre G 372: *ARV*² 1300, 4. For a perceptive treatment of this vase, see Cromey, 1991. He believes that Athena and the giant are rebuilding the Pandroseion; however, the size and shape of the boulder indicate a fortification rather than a sanctuary wall.

3. Angelitos' Athena (Acropolis 140): Raubitschek, 1949, 26–28, no. 22; Ridgway, 1970, 29–30, fig. 39; Brouskari, 1974, 129–30, fig. 248; Ridgway, 1992, 130, fig. 79. Mourning Athena (Acropolis 695): Ridgway, 1970, 48–49, fig. 69; Brouskari, 1974, 123–24, fig. 237; Meyer, 1989; Ridgway, 1992, 139–40, fig. 94. For the theory that the relief was a victory dedication, see Chamoux, 1957. There of course may have been many other early Classical dedications, now lost. To this list could be added the marble archer (Acropolis 599: Brouskari, 1974, 128–29, fig. 246) and possibly the Kritios and Blond Boys (Acropolis 698 and 689: Hurwit, 1999, 147).

4. Pronapes dedication: *IG* II² 3123; Raubitschek, 1949, 205–207, no. 174; Korres, Panetsos, and Seki, 1996, 28, nos. 10–11. Athena and Marsyas: Ridgway, 1970, 85–86; Stewart, 1990, 147; Hurwit, 1999, 148–49.

5. Bronze Athena of Pheidias: Mattusch, 1988, 168–72; Harrison, 1996b, 28–34; Lundgreen, 1997. In addition to the testimonia cited above, Demosthenes (19. *De falsa legatione* 272) stated that the statue was "dedicated by the Polis as a meed of valor of the war against the barbarians with money given by the Hellenes."

6. The best overview of the history of the Agora is that of Camp, 1986. Kimonian embellishments: Camp, 1986, 68–77; Boersma, 1964. Kimon may have deliberately positioned his new monuments to compete with earlier ones associated with the tyrants; namely, the Stoa Poikile and the herms next to the Altar of the Twelve Gods, the

tholos over Building F, and the aqueduct in competition with the southwest fountain house. Tyrannicides: Ridgway, 1970, 79–83; Mattusch, 1988, 119–27.

7. The early development of the Agora and its function as an area for special religious events are discussed by Camp, 1994. See also Ajootian, 1998, for the inter-relationship of the race track and the statue group of the Tyrannicides. Panathenaic Way: Travlos, 1971, 422–27.

8. The Panathenaia is the subject of the 1992 Hood Museum of Art exhibition catalogue by Neils, 1992a. For more specific studies of elements pertaining to the Panathenaia, see the edited volume of conference papers, Neils, 1996a. Tribal competitions: Neils, 1994. Panathenaic prize amphoras: Bentz, 1998.

9. Panathenaic procession: Neils, 1992b, 1996b. Processional religiosity was also characteristic of European cities during the Middle Ages and Renaissance; for such sacral rituals and processions in Renaissance Florence, see Trexler, 1980. The subtitle of this chapter is adopted from Part I of his book.

10. The political background for the Acropolis building program is considered by Meiggs 1963 and 1972, and Kagan, 1991, 104–105. The authenticity of the so-called Congress Decree has been much debated, but is now generally accepted; see Meiggs, 1972, 512–15, and Bloedow, 1996.

11. Peace of Kallias: Meiggs, 1972, 129–51; Badian, 1987. The more controversial Papyrus Decree authorizing expenditures for the building program is discussed in Meiggs, 1972, 511–18; Kallett-Marx, 1989. Financing of the building program: Samons, 1993; Giovannini, 1997; Pope, 2000 Athens had other sources of revenue, namely, the silver mines of Laurion and war booty. I am grateful to T. Leslie Shear Jr. for discussing these controversial decrees with me.

12. For a recent account over-glorifying Perikles' role in the Acropolis rebuilding, see Kagan, 1991, esp. 151–71. A critical commentary on Plutarch's *Life of Perikles* is that of Stadter, 1989, esp. 157–83. Ameling, 1985, provides a specific analysis of the passage (12–14.2) dealing with the building program and concludes that Plutarch may have been overly influenced by his contemporaries like Trajan. For some skepticism about the Periclean building program, see Robkin, 1979, who concludes (12), "Clearly no tightly structured 'Periklean Building Program'

can be defined on the basis of present evidence. Explicit ancient sources suggest a range of definitions from a broad socio-economic plan for maximum employment of manpower and material that included perhaps all the temples that were begun after 450, to a more limited program of civic beautification, including only five or six projects; and not always are these attributed to Perikles alone. The safest course seems to be to regard the 'building program,' whatever its scope, as the natural outcome of the Athenian desire to avoid post-war economic distress and/or to beautify their city during Perikles' administration." See also Himmelmann, 1977, who makes a case against Perkles' control based on fifth-century inscriptions and the normal procedures of the Athenian democracy, and Podlecki, 1998, 101–109, for the relationship of Perikles and Pheidias.

13. Technical details of Greek temple building: Burford, 1963. Wycherley, 1978, 113, writes: "in some sense the Parthenon must have been the work of a committee. In a very real sense it was the work of the whole Athenian people, not merely because hundreds of them had a hand in building it but because the assembly was ultimately responsible, confirmed appointments and sanctioned and scrutinized the expenditure of every drachma."

14. For a discussion of what constitutes the essential equipment for Greek religious practice, see Burkert, 1988.

15. Pre-Parthenon: Hill, 1912; Dinsmoor, 1947; Dinsmoor, 1950, 149–50; Travlos, 1971, 444. Quarrying of Mt. Pentelikon: Korres, 1995.

16. Plan of the Parthenon: Dinsmoor, 1950, 159–79. For a comparison of temple cellas see Scranton, 1946.

17. For the amount of gold in the Parthenos that was supervised by a board of *epistatai* (one of whom was Perikles) and recorded on marble stelae set up on the Acropolis, see Eddy, 1977. He argues that the source of the gold was the tribute paid by the allies. See also Kallet-Marx, 1989, who argues otherwise. There has been a tendency of late to regard the Parthenon itself as a grand treasury rather than a temple; cf. Hurwit, 1999, 164: "It functioned instead as a treasury, as a votive, and as a symbol. In effect, the Parthenon was the central bank of Greece. . . ." This conclusion is based on the wealth embodied in the statue, the absence of an altar, and the lack of a specific priestess or known cult. The same could be said

for the Temple of Zeus at Olympia (with its equally costly gold-and ivory statue, and the continued use of the old ash altar) whose status as a temple has never, to my knowledge, been challenged. As at Olympia, where Zeus was originally worshipped in the Temple of Hera, it was a common practice to erect an additional, more modern temple to the principal deity (cf. Hera at Paestum) while retaining the old sacrosanct altar and so presumably the same cult personnel. We should take our cue from the ancient Greeks who referred to the Parthenon as *"ho neos,"* i.e., the temple.

18. For recent and thorough discussion of Greek architectural sculpture, see Ridgway, 1999.

2. PARADEIGMA: DESIGNING THE FRIEZE

1. The continuous frieze wrapped around the column of Trajan is approximately the same height as the Parthenon frieze but is 206 m in length; it includes over 2,700 figures. The gigantomachy frieze of the Altar of Zeus at Pergamon is taller (2.30 m) but is only 100 m in total length.

2. According to Stadter, 1989, 166: "We cannot identify P.'s [Plutarch's] sources or know how far he can be trusted, but it is certainly mistaken to take his words at face value and make Phidias Pericles' chief architect, master sculptor, and head of public works." See also Himmelmann, 1977, who discusses the procedures according to which boards of overseers contracted plans and labor for temple building. For the view of Pheidias as the master sculptor see Schweitzer, 1940.

3. For the metopes of the Parthenon see Brommer, 1967a. The latest study of the problematic central south metopes is that of Mantis, 1997. Hurwit, 1999, 174, suggests that "perhaps some of these metopes were originally carved for placement above the *pronaos* and *opisthodomos* and were moved to the south side, where they would be less obvious, after the decision was made to go with an Ionic frieze atop the cella wall instead." However, the dimensions of the porches would not allow for 1.20 m–high metopes.

4. Ionic-Cycladic elements are not unknown in Athenian buildings on the Acropolis previous to the Parthenon. These include terracotta gorgoneion and palmette antefixes of Ionic form (Winter, 1993, 205, 227–32 nos. 14, 16–18, pls. 96, 98–99), the Hymettian marble sima associated with the H-architecture which is currently seen as the grandparent of the Parthenon (Hurwit, 1999, figs. 77–81), a possible Ionic frieze on

the Old Athena Temple (Ridgway, 1993, 395–97), and the Ionic base molding on the antae and walls of the pre-Parthenon (Hill, 1912, 552–53, figs. 18–20). It should also be noted that a bead-and-reel molding runs along the top of the exterior Doric frieze of the Parthenon (Brommer, 1967a, 166) as it earlier graced the top of the tympanum of the Archaic Introduction Pediment (Hurwit, 1999, fig. 85). Thus, there was a long-standing tradition on the Athenian Acropolis of incorporating Ionic elements into Doric architecture.

5. Korres, 1994, 33. This study will not consider the possible frieze over the east doorway, as none of it survives.

6. Development of Greek friezes: Ridgway, 1966. Archaic friezes: Ridgway, 1993, 377–415. Assos frieze: Felten, 1984, 22 no. 17, pl. 6. Influence of Persepolis on the Parthenon: Lawrence,1951: Root, 1985. For further discussion, see Chapter 6. Brommer, 1977, 151–53, has cited as precedents for the subject of the frieze the file of mounted cavalry on the frieze of the seventh-century temple of Prinias in Crete, and the chariots on the Archaic temple friezes of Kyzikos in the Propontis and Mys in Ionia. See also the discussion of other possible prototypes by Kroll, 1979, 349–50; Castriota, 1992, 202–29.

7. Siphnian Treasury frieze: Stewart, 1990, 128–29; Ridgway, 1993, 393–95 and 411–12. Similarities between Siphnian Treasury and Parthenon friezes: Vasić, 1984.

8. For the island marble relief fragments, possibly from an architectural frieze of the late sixth century, see Brouskari, 1974, 60, no. 1343 (Hermes), fig. 107; 68, no. 1342 (charioteer), fig. 127. The suggestion that they pertain to the Old Athena Temple was first made by Schrader, 1905, and is still accepted by Ridgway, 1993, 395–97.

9. Votive relief, Acropolis 581: Brouskari, 1974, 52–53, fig. 94. Interpretation as a family at the Apaturia: Palagia, 1994.

10. Interpretation of the frieze as a votive monument and the relevance of the Delphi monuments to the Parthenon frieze: Kroll, 1979.

11. Kerameikos Museum P 1001: Willemsen, 1963, 105–109, no. 1; Ridgway, 1993, 234, 261, n. 6.43. The leg position of the second rider is not common but can also be seen on the south frieze of the Parthenon (S9, Fig. 69).

12. Hockey-Player Base, Athens National Museum 3477: Willemsen, 1963.

13. These fragmentary plaques by Exekias, which are divided between Berlin and Athens, are now fully published by Mommsen, 1997. Some of the most elaborate processions are those that depict the wedding of Peleus and Thetis painted in the early sixth century, such as on the famous Attic black-figure krater signed by Kleitias and Ergotimos and known as the François Vase.

14. Marathon Painting: Harrison, 1972; Stansbury-O'Donnell, 1999, 142–45. This type of narrative is often referred to as progressive narrative.

15. It is thanks to Jenkins, 1995, that we now have the correct sequence for the eastern end of the south side.

16. Arnheim, 1977, 158. He goes on to say: "It is also a standard device of traditional drama, and is constantly used in music to dam the melodic flow before a new surge of power. Suspense derives from the temporary suspension of action."

17. Fagerström, 1994, who concludes on the basis of the positions of the horses that no actual movement is depicted on the frieze. Cf. also Gauer, 1984, who asserts that the Archon Basileus is inspecting the *peplos* in the Agora.

18. Root, 1985, 105–107.

19. Boardman, 1990, 59.

20. In her recent discussion of narrative in Greek art, Small (1999) suggests that "time in classical antiquity was mistakenly thought to be movement through space and not duration. Hence, to show that time has elapsed, the setting or location of the scene must change." Fehl (1961) has argued for changes of locale on the basis of the variety of rocks depicted throughout the frieze. That temporal progression in a narrative need not involve change of locale is perhaps indicated by the progressive phases of the symposium as depicted on the volute-krater attributed to Euthymides found at Morgantina; see Neils, 1995, 440–41.

21. Fagerström, 1994, 37–40 attempts to show that the horses are in "arrested movement" but fails to explain the fluttering cloaks, certainly a Greek convention for rapid movement.

22. Much of the Street of the Panathenaia, or *dromos* as it was also called, has been brought to light in the Agora excavations, which show that it was approximately 10 m wide and paved with large limestone blocks, presumably in the second century A.C. See Camp, 1986, 45–46. At its upper end beyond the Eleusinion the grade is extremely

steep and so the road consisted of steps from there to the ramp leading to the Propylaia.

23. The only other figure on the frieze posed thus (but without the extended left arm) is the official receiving the procession (E49). He also plays a key role in the narrative. Youths holding out large pieces of drapery are fairly common in Attic red-figure vase-painting of the late sixth and fifth centuries. For a list of some examples see Neils, 1996b, 195–96, n. 25.

24. Divisions of the south frieze: Harrison, 1984, 230–33; Beschi, 1984, 179–80, 192. The division of the south frieze into ten tribal units was recognized by Dinsmoor in 1950 (unpublished ms.).

25. The total count of horsemen on the north frieze is debated. Jenkins (1994a, 99) restores 60, whereas Harrison (1984, 230) states that the total is 61 on the basis of a fragment in the Agora (S1776), which preserves four rear horse legs and could be inserted into slab XXXV, thereby adding an additional rider. If this were the case the third rank (N91–98), according to my reading, would have nine horsemen, whereas all the others have either seven or eight. Ten ranks on north side: Beschi, 1984, 185–86, 194; Jenkins, 1994a, 99, plan.

26. Note especially the gesture of N133, which echoes that of the backward-looking rider W2, or the boy attendant N136, who recalls the standing boy W24.

27. Jenkins, 1994a, 97. Dinsmoor (unpublished ms., 1950) also believed that there were ten phylarchs in the north frieze, distinguished by the fact that they all appear in the foreground plane and are not overlapped by other riders.

28. Parallelism between north and south: Jenkins, 1995.

29. Proportions of this young horse compared to the other mature ones: Markman, 1943, 74. Bugh, 1988, 18, suggests that W22 "may have just crossed him [W23] and his horse from the list of participants."

30. Harrison, 1895, 91.

31. Corbett, 1959, 21–22.

32. Petersen, 1873, 301.

33. Furtwängler, 1893, 183–92.

34. First suggested by Hill, 1894, 225–26. Followed by Lethaby, 1908, 94; Robertson, 1963, 56 (also 1975, 11); and Heinze, 1993, 410. This theory would imply that the old *peplos* did not carry the same religious significance as the new. Given the presence of a *peplotheke* or storage place for *peploi*

on the Acropolis, one can assume that even the old peploi continued to be revered and deemed valuable. *Peplotheke:* Nagy, 1984, 227–32.

35. Nagy, 1978b, 136–41.

36. Connelly, 1996, 67.

37. Smith, 1892, 157. See also Smith, 1910, 51.

38. Ridgway, 1981, 80, refers to each group of gods being seated in a "hemicycle."

39. Smith, 1892, 151.

40. Aphrodite is known in Attica by the epithet Pandemos ("of all the people"). Hermes presided over travelers, the Agora, and the palaistra. As Psychopompos he conducted the souls of the dead to Hades.

41. The Italian Renaissance painter Sandro Botticelli dealt with a similar artistic problem in executing his *Adoration of the Kings* (London, National Gallery, NG 1033). In opting for a centralized composition in a tondo with the Holy Family in the center, he had to devise two processions approaching from the back and fill the foreground with courtly figures standing around in something like a semicircle.

42. Orvieto, Museo Claudio Faina 2748: *ABV,* 144, no. 9. See Shapiro, 1989, pls. 25d, 26a–b. Parenthetically, the young woman seated next to Poseidon but confronting Ares might well be Hebe, since Herakles is present. For discussion of Hebe in relation to the frieze, see Chapter 5.

43. Fagerström, 1994, 43, feels that the gods Hermes and Dionysos are "a bit awkwardly poised, more or less back to back, and yet Dionysos is leaning on Hermes in a way more in accord with a position side by side."

44. London, British Museum E 49: *ARV²* 432, no. 52.

45. Jenkins, 1994a, 81.

46. This reconstruction of the gods seated in a semicircle was first presented by the author in Neils, 1999, 12–15.

47. Such that Wesenberg, 1995, believes that two separate ceremonies are taking place; see Chapter 6. Jenkins, 1994a, pl. III, makes a much more pleasingly symmetrical composition of four figures.

48. Harrison, 1996a, 202. Boardman, 1999, 314, believes that the action is one of receiving on the part of the man, not necessarily folding or unfolding.

49. Van Straten, 1995, 186–92.

50. Ridgway 1981, 16. Although her point relates to carvers, not designers, it does indicate that less

significant parts of temple sculpture were sometimes relegated to less capable artists.

51. Collaboration in Greek sculpture: Goodlett, 1989.

3. TECHNE: CARVING OF THE FRIEZE

1. Relationship of Plutarch's text with the Parthenon building accounts (*IG* I³ 436–51, 453–61): Stadter, 1989, 157–62.

2. Possibly this characteristic of Pentelic marble, its inability to take fine detail, was in part responsible for the development of the more simplified Early Classical style as compared to the often highly finicky ripe Archaic. The latest kore, Acropolis 688 ("Propylaia Kore") of ca. 480, which begins to show characteristics of the Severe style, is of Pentelic marble; see Brouskari, 1974, 128, no. 688, figs. 244–45.

3. Rockwell, 1993, 144.

4. Measurements: Berger and Gisler-Huwiler, 1996, 37, 57, 107, and 147. Many of these are based on the precise measurements of Manolis Korres. In his unpublished ms. Dinsmoor (followed by Korres) noted that East VII and VIII were originally a single block measuring 3.59 m, a fact that seems to have escaped the notice of Coulton, 2000, 71.

5. Coulton, 2000, 71.

6. General discussion of building techniques, including quarry work: Scranton, 1969, 1–34. Quarrying on Mt. Pentelikon: Korres, 1995; Osborne, 1987a, 81–91, and bibliography, 207. Transport of marble: Korres, 1995; Snodgrass, 1983. Costs relating to quarrying and transport: Burford, 1965.

7. According to Dinsmoor (unpublished ms.) the east frieze was fastened by ordinary dowels, whereas the west frieze utilized a more complicated system of blind dowels, suggesting that the east was laid before the west.

8. For measurements and detailed discussion of these cuttings, see Korres, 1988. For a review of the various views concerning where the frieze was carved, see Brommer, 1977, 168–70. The jury is about evenly divided between those who feel that some parts were carved in the workshop (Ashmole, 1972, 126–27, 141–42; Brommer, 1977, 168–70) and those who believe it was carved *in situ* (Dinsmoor, 1954; Korres, 1988, 21–25; Jenkins, 1994a, 19 and 109). Coulton, 2000, 78, surveys the problem and mentions the existence of ceiling beams over the east and west friezes, which would have constricted the space for sculptors. Because of the difference in treatment

of the joints and the existence of ceiling beams he concludes that east and west friezes were carved in a workshop.

9. Rockwell, 1993, 98.

10. Dinsmoor (unpublished ms.) cites additional support for carving *in situ,* namely, the fact that one of the blocks on the south side (XVIII) had to be shortened before placement and yet there is no evidence that the sculpture was amputated. Problems of on-site work space: Rockwell, 1993, 184.

11. Evidence for incised sketches on stone exists for the Archaic period; see Ridgway, 1993, 263, n. 51. Ashmole, 1972, 118, suggests that a small-scale version of the design was first sketched onto whitened boards. Because of repeated patterns in the frieze Younger, 1991, argues that "when planning a length of the frieze the designer(s) of the cavalcade used small cartoons for the placement of the specific heads and legs and occasionally larger cartoons for entire figures; the assistants who cut the stone seem not to have been the ones responsible for the concept or organization of the figures."

12. This observation is made by Jenkins on the audio-tape available in the Parthenon galleries in the British Museum.

13. Detail of point work: Brommer, 1977, pl. 76 = North XVIII. Discussion of point work: Adam, 1966, 16.

14. Adam, 1966, 28.

15. Chisel marks behind Zeus' throne: Adam, 1966, pl. 12b; Brommer, 1977, pl. 175.

16. Adam, 1966, 56. Her discussion of the grave stele from Aegina, Athens National Museum 715, appears on pp. 110–13; it is slightly later (ca. 420) than the frieze and is carved in a similar fashion. See also Chapter 7.

17. Adam, 1966, 49. Adam notes that essentially the same principle was followed to quarry a block.

18. Other examples cited by Adam, 1966, 55, include the right knee of the *apobates* N53, the crest of the helmet of *apobates* N64, the legs of the horse of rider N119, and the edge of the incense burner of E57.

19. Adam, 1966, 56.

20. Adam, 1966, 46.

21. Use of rasp: Adam, 1966, 76.

22. Marble piecing: Adam, 1966, 59.

23. Randall, 1953, 207.

24. Brommer, 1977, 210–11.

25. Erechtheion workmen: Randall, 1953. Wages: Stewart, 1990, 66.

26. Polychromy in Greek sculpture: Dimitriou, 1947; Reuterswärd, 1960. Metal attachments in Greek sculpture: Ridgway, 1990a.
27. Paint on the Parthenon sculptures in the British Museum: Jenkins and Middleton, 1988.
28. Tübingen S./10 1363: *CVA* Tübingen 1 (Germany 36) pl. 49. It is interesting that the other side of the vase shows a nude youth standing before a draped man, and both have their arms raised as if they were intended to be holding something between them (a *peplos?*). A woman stands at the far right.
29. On the symbolism of colors in Greek Archaic sculpture, see Manzelli, 1994.
30. Lethaby, 1908, 93–94; Lethaby, 1929, 11. See also Ridgway, 1999, 117–18.
31. If the designer had wanted to indicate a sharp division between the central scene and the gods he could more easily have used a separate block.
32. Solid horse tails: Brommer, 1977, 226.

4. MIMESIS: THE HIGH CLASSICAL STYLE
1. Recent discussion of the Classical style: Pollitt, 1972; Hallett, 1986; Childs, 1988.
2. The first signs of rejecting Archaic conventions and the emergence of the early Classical or Severe style appear on the Acropolis ca. 480 in the latest *korai* dedicated there, as well as in male figures, the so-called Blond Boy and the Kritios Boy.
3. In the case of the south metopes there is also only one back view – of the centaur on south metope 1 (Brommer, 1967a, pl. 155). It was presumably more difficult to carve a figure in this pose.
4. Jenkins, 1994a, 80, sees a similar "pleasing sequence" in the arm movements of Poseidon, Apollo, and Artemis on the east frieze, culminating in the pointing gesture of Aphrodite.
5. *Doryphoros* of Polykleitos: Moon, 1995. Polykleitos as one of the Parthenon sculptors: Brommer, 1977, 277.
6. Delphi Museum 2161, grave stele from the east necropolis: Boardman, 1985, fig. 57.
7. South metope 27: Brommer, 1967a, pl. 217.
8. The pose is already present in late Archaic (Athens National Museum 39, stele from Orchomenos ca. 490; Boardman, 1978, fig. 244) and early Classical relief sculpture (Vatican stele of an athlete ca. 460). The man leaning on his staff on the Borgia stele of ca. 470 in Naples resembles E44 in his stance; see Boardman, 1985, fig. 50.

9. The backward leaning posed is discussed by Palagia, 1984. It comes to be a pose of women in general (cf. the woman leaning on the marital bed on the epinetron by the Eretria Painter; Oakley and Sinos, 1993, fig. 129) and Aphrodite in particular.
10. Apollo's pose: Harrison, 1979a.
11. Robertson and Frantz, 1975, caption to North X.
12. Venus rings: Ridgway, 1981, 53.
13. Ashmole, 1962, 233: "Some of these beings created by Pheidias and his pupils may sometimes look as if they have little in their heads: perhaps it may be granted that some have much in their hearts."
14. Although many heads are missing, it seems that the marshals are not bearded. The bearded figure W5, sometimes identified as a marshal, should probably not be considered one. See Eckstein, 1984.
15. The hairstyle of W24 closely resembles that of the boy on the Great Eleusinian Relief: Ridgway, 1981, 138–39; Harrison, 1988, 251.
16. Braided hairstyle: Ridgway, 1970, 58–60.
17. For nudity as the default position for Greek males, see Stewart, 1997.
18. Ridgway, 1981, 13.
19. Adam, 1966, 110–11.
20. The selvage appears in the early Classical period on the Nike of Paros (see Ridgway, 1970, 37 and fig. 58) and only appears sporadically after 400. It has been called a hallmark of the period 450–400, and can be seen on other Classical statues such as the Stumbling Niobid in Rome (see Ridgway, 1981, fig. 25). A press-fold has been detected on at least one figure of the frieze (S125; see Brommer, 1977, pl. 156), but they are not common.
21. Harrison, 1989, 48, states that "the *exomis* . . . came to be associated in the iconography of the fifth century with the primitive ways of early times and far-off places." She thus believes that these garments on the frieze indicate an early, i.e. pre-democratic, era for this part of the procession.
22. Sleeved chitons: Miller, 1997, 161.
23. Sandals: Morrow, 1985, 55–56. Boots: Morrow, 1985, 64–66.
24. Deeds of Theseus: Neils, 1987, 147.
25. Shield of *Athena Parthenos:* Harrison, 1981.
26. North metopes 31–32: Brommer, 1967a, pls. 129–36.
27. Anderson, 1961, 15. All translated quotations from Xenophon are from this source.

28. Brommer, 1977, 280. He also relates the pronounced articulation of the abdominal muscles of rider S8 and *apobates* S79.
29. Schuchhardt, 1930.
30. Brommer, 1977, 281, no. 17.
31. Kjellberg, 1926, 53.
32. Brommer, 1977, 281, no. 18.
33. Ashmole, 1972, 125.
34. Brommer, 1977, 282, no. 19.
35. Attributions of West VIII to Pheidias: Brommer, 1977, 277.
36. Attributions of East VI to Alkamenes: Brommer, 1977, 277. On Alkamenes: Ridgway, 1981, 174–78, 190; Boardman, 1985, 206; Stewart, 1990, 267–69.
37. The central slab on the east side (East V) has been attributed to Agorakritos, Alkamenes, Kolotes, and Pheidias. Various attributions: Brommer, 1977, 276–77.

5. ICONOGRAPHIA: IDENTIFYING THE PLAYERS

1. Acropolis 9447: Despinis, 1982, 6–7. Other recent additions to the frieze: Brouskari, 1960; Mantis, 1986, 75, pl. 106.1.
2. Red-figure amphoras of Panathenaic shape: Shapiro, 2001, and list included in volume, 199–202.
3. *LIMC*, vols. I–VIII (1981–1997). These volumes contain individual entries on the Olympian gods and the eponymous heroes, all of which are relevant to the frieze.
4. Niarchos cup: Simon, 1983, pls. 16.2 and 17.2; Himmelmann, 1992; Van Straten, 1995, 14–17, 203, V55, fig. 2.
5. One example is the new inscription from Athens that preserves part of three Panathenaic victor lists; see Tracy, 1991.
6. In spite of his somewhat shorter cloak and longer hair, this figure is a marshal, according to Eckstein, 1984, 218–19, who argues that he acts as a pendant to W1.
7. I had originally thought that the youth might be leading his horse across a stream (the Eridanos?) with the horses behind rearing in excitement at the rushing water. However, thanks to Jack Sulak, who put me in touch with Ray Harm, an artist and horse-trainer, I was informed of the correct interpretation of this pose. For illustrations of this pose in other works of art, see Chapter 7 and Fig. 144.
8. Robertson and Frantz, 1975, pl. 9 with notes.

9. *Dokimasia* on Attic vases: Cahn, 1973 and 1986.
10. *Contra* Robertson a number of scholars believe it impossible for the youth to be holding a tablet or stylus; cf. Brommer, 1977, 19; Eckstein, 1984, 218. Note, however, the extended forefinger of the man with tablet and stylus on the cup by Onesimos, once in Berlin (3139); *ARV²* 321, 23; Boardman, 1975, fig. 235.
11. Bugh, 1988, 18. He argues against the interpretation of Cahn, 1973, who sees these cups as showing the official *dokimasia* of the Athenian cavalry as described in the *Athenaion Politeia* 49.1–2.
12. Munich 2314: *ARV²* 362, 14, attributed to the Triptolemos Painter. A similar scene is depicted on a neck amphora attributed to the Oionokles Painter: Cabinet des Médailles 369, *ARV²* 648, 31.
13. The pose is rare in vase-painting, but a horse with its head down stands before a seated king (?) and a standing youth on a late fifth-century red-figure chous in Providence (Rhode Island School of Design 25.090); Beazley (*ARV²* 1215, 2) called it "tired." Cf. also the red-figure cup by Onesimos, Boston 95.29; *ARV²* 324, 65.
14. *Salpinx:* Paquette, 1984, 74–83. A performer of ancient Greek music, Philip Neuman, suggests that the *salpinx*-player might be giving support to the muscles in the lower back when he had to blow with a great deal of force. W23 is not strictly in this pose, but the relative positions of his arms suggest it.
15. Heralds and trumpeters at Greek festivals: Crowther, 1994.
16. Texts: Lucian, *Nigrinos* 14; Herodotos 6.111. Vases: Valavanis, 1990.
17. Panathenaic prize amphoras with trumpeters: Valavanis, 1990, 350.
18. Athens, National Museum, Acropolis 1025: Graef and Langlotz, 1923, vol. 1, pl. 58.
19. Athens, Acropolis Museum 2568: *LIMC* II, s.v. Athena 600, pl. 763. Athena's voice is associated with the *salpinx* in the *Iliad* (18.219) and there was a sanctuary of Athena Salpinx in the agora of Argos. For further discussion of the relationship of Athena and the *salpinx,* see Serghidou, 2001.
20. For instance, British Museum B 648: Van Straten, 1995, 199, V30.
21. Florence, Museo archeologico 81600: Van Straten, 1995, 219–20, V145, fig. 116; Shapiro,

1989, suppl. 1995, 4–5, pl. 73d–f. Since the tondo depicts Hephaistos, the scenes on the exterior are said to relate to his festival, the Hephaistia, although this need not necessarily be the case, as Shapiro notes.

22. Ancient testimonia: Demosthenes, *Against Meidias* 171; *First Phillipic* 26; Xenophon, *Hipparchikos* 3. For the argument that none of these texts refers specifically to the Panathenaia, see Pollitt, 1997, 52–53.

23. Athenian cavalry: Bugh, 1988. Agora I 7167, *Anthippasia* relief: *Hesperia* 40, 1971: 271–72; Camp, 1998, 28–29.

24. Rome, Villa Giulia 50407: *ARV²* 402, 24 and 1651.

25. Thracians on the frieze: Borchhardt, 1985; Mader, 1996. Thracians in Attic art: Tsiafakis, 1998 and 2000. Athenian cavalry in Thracian garb: Cahn, 1973, 13–15; Lissarrague, 1990, 217–31. Morrow, 1985, 66 summarizes the reasons for Thracian dress on the frieze: ". . . Thracian costume persisted in Athens into the second half of the fifth century, by which time elements of Thracian dress had perhaps become 'native' to Athenians and were commonly worn for their practical appeal – warmth, the reason for which they were invented. . . . Mixtures of elements of national costumes such as those appearing in the Parthenon frieze indicate the fusion of foreign elements into Athenian costume."

26. Given the prominence of this figure, it has been suggested that he serves as a metaphor for Perikles taming the *demos*. See most recently Stewart, 1997, 80.

27. Robertson and Frantz, 1975, 46. Bugh, 1988, 78 n. 134, cautions that these bearded men could also be phylarchs.

28. How and when the cavalry grew from 300 to 1,000 is still debated, but according to inscriptions there were three hipparchs after the Battle of Tanagra in 458–57 and by the time of the Peloponnesian War there were two in charge of a larger cavalry. See Worley, 1994, 68–70.

29. A vase-painting parallel for the corslet with gorgoneion just above the waist can be seen on the mounted Amazon on the Christie Painter's stamnos in London, British Museum 1898.7–15.1; *ARV²* 1048, 35. See Matheson, 1995, 122, pl. 106, 372 no. CHR. 37.

30. Sleeved chiton: Brommer, 1977, 232; Miller, 1997, 161 ("*Barbaroi* have no place in the Panathenaic festival"). Kardara (1964,143)

believed that the costume was worn in the mythical past, whereas Holloway (1966a, 225) considered it a reference to the marble equestrian statues of Persians dedicated on the Archaic Acropolis.

31. Beschi, 1984, 13, counted twelve chariots on the north, but it is clear that there are only eleven; see Gisler-Huwiler, 1988, 15–16.

32. *Apobates:* Reed, 1990; Kyle, 1993, 188–89.

33. Malibu, J. Paul Getty Museum 79.AE.147: Neils, 1992a, 90, fig. 58; Bentz, 1998, 78–79, 175–76, no. 4.080, pls. 117–18. A fourth-century bell krater, Vienna 1049 (*ARV²* 1437, 7), shows an *apobates* dismounted from his chariot, which is led by Hermes; underneath the rearing front legs of the horses are two Panathenaic-shaped amphoras that surely must allude to the Panathenaia. For a list of vases showing the *apobates* contest, see Brommer, 1977, 224. For the possibility that *apobatai* may be represented in the Geometric period, see Reber, 1999.

34. Athens, Agora Museum S 399: Neils, 1992a, 90, fig. 57 and 206, n. 81; Camp, 1998, 27, fig. 40. For a list of reliefs showing the *apobates* contest, see Brommer, 1977, 223.

35. W12, who is not riding but tying his sandal, wears a sword at his waist, as does, apparently W3 who is standing and tying a fillet. Weapons on the frieze: Brommer, 1977, 228–30.

36. The source for this legend (Hyginus, *Astronomica* 2.13) is late, i.e., first century A.C. It has been argued that the *apobates* wearing a long chiton (N62) is the priest of Poseidon-Erechtheus, disguised as the Attic king Erechtheus: d'Ayala Valva, 1996. Perhaps he is simply wearing the *xystis,* or saffron robe, mentioned by Aristophanes as the garb of those who drive chariots to the Acropolis (*Clouds* 68–70).

37. Severe hairstyle: Ridgway, 1970, 57–60.

38. Testimonia on *thallophoroi:* Berger and Gisler-Huwiler, 1996, 196. The earliest reference is in Aristophanes (*Wasps* 540–545).

39. Simon, 1983, 62.

40. Carrey drawing of N31: Berger and Gisler-Huwiler, 1996, pl. 81.9.

41. New York, Metropolitan Museum of Art 20.244: *ARV²* 249, 6, attributed to the Syleus Painter. Another red-figure amphora of Panathenaic shape, newly acquired by the British Museum (GR 1998.1-21.1; Williams, 1998) and attributed to the Aegisthus Painter, shows on the obverse an elaborately garbed *kithara*

player, while on the reverse are two draped, bearded men carrying olive twigs. Cf. another red-figure Panathenaic with *thallophoroi* also by the Aegisthus Painter (*ARV*² 506, 25) formerly in Reading. For the relationship of these red-figure Panathenaics to the festival see Shapiro, 2001.

42. Other, less plausible, identifications have been suggested for these figures, namely, a male chorus (Heinze, 1995, 209–14), eight archons and ten tribal representatives on south only (Beschi, 1984, 182), officials involved in the organization of the sacrifices and games (Jenkins, 1994a, 69), and veterans of the Battle of Marathon (Boardman, 1999, 321–30). Since veterans of the battle could not be marching in the company of those who died in the battle (Boardman, 1977), Boardman (1999, 326, n. 26) retracts his earlier opinion that the frieze represents the Panathenaia of 490.

43. Plaque-bearers: Brommer, 1977, 220. Secretaries: Simon, 1983, 62; Beschi, 1984, 181–82. Kitharists: Harrison, 1979c, 489; Himmelmann, 1988, 213–24; Jenkins, 1995, 456.

44. Simon, 1983, 63, states that these kitharists are also wearing a *peplos* over the chiton with a back-pinned mantle.

45. Berlin, Antikensammlung F 1686; *ABV* 296, 4. See Shapiro, 1992, 54–55, figs. 34 a–b.

46. Berlin, Antikensammlung F 2161, attributed to the Nikoxenos Painter (*ARV*² 221, 7). At least six other red-figure Panathenaics with kitharists/kitharodes are extant; see Shapiro, 2001.

47. Aulos in Athens: Wilson, 1999. Kithara in Athens: Maas and Snyder, 1989, 53–70. Music at religious festivals: Haldane, 1966; Nordquist, 1994. Music at the Panathenaia: Holloway, 1966b; Shapiro, 1992.

48. Jenkins, 1994a, 70 (drawing); Jenkins, 1995, 456.

49. Testimonia on female *hydriaphoroi:* Berger and Gisler-Huwiler, 1996, 195.

50. Simon, 1983, 63–64.

51. Hydrias as vessels for tribute: Wesenberg, 1995, 168–172 and 177. He argues that, because the vessels are carried at an oblique angle, liquid would splash out of them; naturally this depends on how full they are. The hydria carried on the shoulder of an Egyptian on the Pan Painter's pelike in Athens depicting the Bousiris myth is presumably not filled with coin: Van Straten, 1995, 256, V341, fig. 49. A hydria is

depicted among money sacks on a document relief of 426–25 from the Acropolis: *IG* I³ 68; Lawton, 1995, 81, no. 1.

52. *Hydriai* in Parthenon inventories: Harris, 1995, 113–14. Twenty-seven silver *hydriai* of Athena Polias appear in the inventories from 402–21 on; see ibid., 161–62. *Skaphai:* ibid., 114.

53. Testimonia on *skaphephoroi:* Berger and Gisler-Huwiler, 1996, 195–96.

54. *Skaphephoroi:* Brommer, 1977, 214. The trough-like *skaphe* sometimes resembles another sacrificial vessel, the *sphageion,* which is used to collect the blood of a large victim. Sphageion: Van Straten, 1995, 104–105.

55. New York, Metropolitan Museum of Art 20.244: *ARV*² 249, 9. Cf. also Stanford, Cantor Center for the Visual Arts 1970.11, a red-figure amphora of Panathenaic shape attributed to the Eucharides Painter, ca. 470: Münzen und Medaillen 40, no. 95, pl. 39.

56. Agora P 30059: *Hesperia* suppl. XXV (1992), pl. 36, no. 113. Kition inv. no. 4761: Berger, 1984, pl. 15.2.

57. Jenkins, 1994a, 85, identifies N12 as a marshal, since he has turned in the other direction, but it seems more probable that each sheep should have a driver.

58. Animal sacrifice: Burkert, 1985, 55–59; Zaidman and Pantel, 1992, 28–36.

59. Votive reliefs with scenes of sacrifice: Van Straten, 1995, 275–332.

60. Prices of sacrificial victims: Van Straten, 1995, 175–77.

61. Philochoros, *FGrHist* 328 F 10. See Simon, 1983, 61.

62. Uppsala University 352: Melldahl and Flemberg, 1978; Simon, 1983, 61, pl. 16.1; Van Straten, 1995, 202, no. V50, fig. 5.

63. Himmelmann, 1997, 37–44. See also Burkert, 1966, 107, n. 43, for specific references.

64. Other suggestions, such as that of Boardman, 1977, 40, that these girls are carrying a loom for the *peplos,* have not met with acceptance. Although Jenkins (1985a, 123, n. 19) stated that "By default, *thymiateria* seem the only possible explanation," he suggested (1994a, 77) they might instead be "the stands for supporting the spit on which the meat was roasted." In Attic vase painting and on votive reliefs women never handle the roasting equipment; see Van Straten, 1995, *passim.*

65. *Kanoun* held by E49: Schelp, 1975, 55–56.

66. Toledo Museum of Art 72.55: *CVA* Toledo 1 (USA 17), pl. 53.

67. Festival mantle: Roccos, 1995.

68. The *kanephoros* of Attic vase painting should not be confused with the *kistephoros* of votive reliefs; the latter carries a cylindrical basket filled with cakes (and so is analogous to the metic *skaphephoros*) and walks at the end of the family procession on many votive reliefs.

69. Testimonia on *kanephoroi:* Berger and Gisler-Huwiler, 1996, 194–95.

70. There is a mistaken tendency in some of the literature dealing with the frieze to call all these men "elders"; cf. Connelly, 1996, 68, and Fagerström, 1994, 46. Three or four of the ten lacks beards and so are not elderly in Greek terms.

71. Jenkins, 1985a, 123–24. He argues that the man is making a gesture like a marshal, he lacks a stick, and he acts as a transition between the processional and non-processional parts of the frieze.

72. Robertson, 1975, identifies E18–19 as marshals and E47–48 as part of his group of ten standing men. Likewise Rotroff, 1977, 381, n. 14.

73. Raubitschek, 1969, 130.

74. Woodford, 1987, 1–4. She stresses the symmetry between E18–19 and E47–48.

75. Harrison, 1996a, 200.

76. As argued by Woodford, 1987, 4; Nagy, 1992, 59: "there is no discernible difference in scale between these same humans and the supposed 'heroes.'"

77. For a chart showing the different identifications, see Berger and Gisler-Huwiler, 1996, 175. The basic source on the eponymous heroes is Kron, 1976. For the *eponymoi* on the frieze, see Harrison, 1979b; Kron, 1984.

78. Vases: *LIMC* I (1981) s.v. Akamas et Demophon, nos. 6, 25, 26. E44 on frieze as Akamas: Kron, 1976, 212; Kron, 1984, 242–43.

79. Monument of the Eponymous Heroes: Mattusch, 1994.

80. Athenian *Archai:* Hansen, 1980.

81. *Athlothetai* in general: Nagy, 1978a. *Athlothetai* on frieze: Nagy, 1992.

82. Two other extremes have also been proposed: one, that these are simply contemporary spectators arranged in typically Athenian homoerotic pairs (DeVries, 1992), and the other, that they are minor Attic deities (Raubitschek, 1969).

83. DeVries (1992) argues that they are merely mortal spectators grouped together like *erastai* and *eromenoi.* While this interpretation could apply to the pairs on the south side (although E18's head has been missing since before Carrey so it is not certain that he was bearded), it cannot be applied as well to the northern group. I see the difference in the configuration of the two groups as another instance of the more conservative designer (south) versus the more innovative designer (north).

84. On this gesture, see Neumann, 1965, 136–45. Some scholars have taken this figure to be Hekate because of the torch.

85. *Anakalypsis:* Oakley and Sinos, 1993, 30.

86. See Harrison, 1979a.

87. Because of this figure's robust physique, Martin Robertson (1979, 75–78) has argued that he might be Herakles rather than Dionysos. See also the discussion of this identification and a defense of the figure as Dionysos in Carpenter, 1997, 90–92. He is perhaps the first unbearded Dionysos in Greek art.

88. For the relationship of Demeter and Dionysos as a quasi-marriage, see Harrison, 1996a, 206.

89. As done for instance by Mark, 1984, 306, fig. 1.

90. See Brommer, 1977, 114, 259–60; Mark, 1984, 304–12. Boardman, 1985, fig. 94, labels the figure as "Nike (or Iris)."

91. West pediment N: Palagia, 1993, 48–49, figs. 105–107. Cf. the comments regarding Nike of Mark, 1984, 310: "She is a graceful, delicate being, most often floating, weightless. . . ."

92. Iconography of Iris: *LIMC* V, s.v. Iris. The inscribed Iris on a red-figure pyxis of ca. 460–450 from Attica (Berlin Antikenmuseum 3308: *ARV*² 977, 1), for instance, is not winged; see ibid. 747, no. 56.

93. Nike in west pediment (G): Palagia, 1993, 44. East metope IV: Brommer, 1967a, pls. 48–49. In later fifth-century Attic vase painting Nike can be depicted without her wings. Cf. the bell-kraters Leipzig T 958 (see Paul, 1997, 22–24, no. 7), British Museum 98.7–16.6 attributed to the Nikias Painter (*ARV*² 1333, 1), and New York 56.171.49 attributed to the Kekrops Painter (*ARV*² 1347, 3). Nike in fifth-century art: Thöne, 1999.

94. The identification of this figure as Hebe was very common in the nineteenth century; see Michaelis, 1871, 262. A recent study which argues the identification of Hebe is Neils, 1999, 8–11. See also Kardara, 1964, 116–18,131.

95. Iconography of Hebe: *LIMC* IV, s.v. Hebe I, 458–64 (Annie-France Laurens).
96. Neils, 1999, 18–19, n. 29.
97. Toledo, Museum of Art 82.88: *CVA* Toledo 2 (USA 20) 11–13, pls. 84–87 (attributed to the Kleophon Painter). The figure fanning Hera is not identified in the text.
98. Mark, 1984, 312. I would not agree with him when he goes on to say: "Typical mythological characteristics and affiliations have been placed to the side." The emphasis on the societal institutions of marriage and family can be easily effected by accentuating the gods' most characteristic traits and their mythological/familial associations.
99. Athens, National Museum 1629: *ARV²*, 1250, no. 34; Lezzi-Hafter, 1988, 253–62, 347–48, no. 257, pls. 168–69.
100. For the binding of the hair as an emblematic motif with nuptial connotations, see Sabetai, 1997, 319–35, esp. 328–29. See also Oakley and Sinos, 1993, figs. 21, 23, and 24.
101. Hebe with wings: Neils, 1999, 10. Thöne, 1999, 99, claims that Hebe is not depicted winged and identifies the winged libation-pourer on the Sosias cup as Nike.
102. Twelve Gods: Long, 1987; *LIMC* III (1986), 646–58, s.v. Dodekatheoi; Georgoudi, 1996, 43–80.
103. Boardman (1999, 307–13) has discussed the identity and position of these objects at length. Simon (1982, 141) thought the footstool might be an incense box, while Wesenberg (1995, 160) identified it as a torch. The latter also argued that E32 is holding a lamp, rather than a stool leg, in her left hand. The cushions on the stools have occasionally been identified as material or garments: Heinze, 1993, 408–409; Connelly, 1996, 63–64.
104. Brommer, 1977, 266–67.
105. *Arrephoroi*: Parke, 1977, 141–43; Simon, 1983, 39–43, 66–68.
106. The two *arrephoroi* may be represented at their loom on the Amasis Painter's lekythos in New York (1931.33.10); see Neils, 1992a, fig. 66b.
107. Iconography of priests: Mantis, 1990,
108. List of the various interpretations of E35 from 1829 to 1993: Berger and Gisler-Huwiler, 1996, 172–74. Of the thirty-one identifications listed here, only four identify the child positively as a girl (and two of these are by the same scholar).
109. Robertson and Frantz, 1975, 34.
110. The limitation of Venus rings to females has since been disputed by Brommer, 1977, 269. See also Clairmont, 1989; Harrison, 1996a, 204: "These are wrinkles in the tender skin of a well-nourished child."
111. Boardman, 1988, 9–10. He expands his arguments in favor of a girl in Boardman, 1999, 314–21.
112. For example, the Eros looking up at Aphrodite on the Pan Painter's white-ground pyxis of ca. 460 in New York (Metropolitan Museum of Art 07.286.36: *ARV²* 890, 173). One could also cite the prominent curvature of boys' spines and buttocks on non-Attic relief stelai of the fifth century; see Rühfel, 1984, figs. 33 (Kos), 35 (Aegina), and 36 (Ikaria). Rühfel, who has studied representations of children in Greek art, seems to have no doubt that this child is male.
113. Girl with the Doves stele (New York, Metropolitan Museum of Art 27.45): Boardman, 1985, fig. 52. The nude boy on the gravestone from Ikaria figured on the next page (fig. 53) shows the "strong curve above the buttocks" that Boardman says characterizes female anatomy.
114. Jenkins, 1994a, 35.
115. Harrison, 1996a, 203–204. Steinhart, 1997, 475–78, also speaks of a youth wearing a mantle.
116. Boardman (1988, 10) states that "the youth of west frieze 6 has a somewhat nondescript build in the crucial area," but tracings show the curve above the buttocks on all three figures (E35, W6, and N134) to be the same. Jenkins, 1994a, clearly implies that these the figures (E35 and N134) are "brothers" by the juxtaposition of the two images on his pls. III–IV.
117. See Clairmont, 1989. Boardman's response: Boardman, 1991.
118. Brommer, 1977, 269–70; Parke, 1977, 143; Simon, 1983, 66; Neils, forthcoming.

6. ICONOLOGIA: INTERPRETING THE FRIEZE

1. Cf. Lawrence, 1972, 144: "Never before has a contemporary subject been treated on a religious building and no subsequent Greek instance is known, with the doubtful exception of the Erechtheum. The flagrant breach with tradition requires explanation."
2. The reception of Connelly's theory (1996) in the popular press and its immediate inclusion in

such art history texts as Janson's *History of Art,* 5th edition (1997) are surprising, but demonstrate the general public's enthusiasm for new explications of familiar monuments.

3. Lists of omissions: Rotroff, 1977; Boardman, 1977, 42–43; Holloway, 2000, 81–82.

4. Cf. Boardman, 1977, 42, n. 17: "Raised like a sail on a wheeled ship it would have looked ungainly in the frieze. But it may not have been so carried in the mid–fifth century. . . ." On the Panathenaic ship whose only known appearance is on the so-called Calendar Frieze, which is probably Roman in date, see Norman, 1983.

5. Cf. Figueira, 1984, 468: "The 5th-century Panathenaia was a complex socio-religious event which probably evolved in many stages." References to the Panathenaia: Deubner, 1932, 22–34. Many writers take passages from Aristophanes (*Birds* 1550–1552; *Ecclesiazusae* 730–745) that enumerate *kanephoroi, hydriaphoroi, skaphephoroi, thallophoroi,* and *skiaphoroi* to be descriptive of the Panathenia in the late fifth century, but there is no specific reference to this festival; the passages could simply be generic descriptions of religious *pompai.* On these passages, see Rotroff, 1977, 379–80.

6. If Schwab (1994) is correct that north metope 1 represents Athena in her chariot, then the goddess is directly involved in the Trojan war. She appears in the form of a cult statue in north metope 25, possibly also in north metope 27 and south metope 21. Parthenon metopes: Brommer, 1967a. Parthenon sculpture in general: Brommer, 1979; Boardman and Finn, 1985; Delivorrias, 1994.

7. Ridgway, 1999, 144.

8. Athena Parthenos: Leipen, 1971; Lapatin, 2001. Pandora: Berczelly, 1992; Hurwit, 1995.

9. Kardara, 1964, 115–58. For views on Kardara's interpretation, see Brommer, 1977, 149. Kristian Jeppesen (1963) also argued for a similar mythological interpretation, but his identifications of figures on the east frieze are slightly different and even less convincing: E33 = Pandrosos, E34 = Butes, E35 = Erechthonios.

10. Athens, Acropolis Museum 396: Kardara, 1966, 22–24. This vase is also cited by Jenkins, 1994a, 37, fig. 19, although he labels the boy "the legendary Erechtheus."

11. Cleveland Museum of Art 82.142: lekythos with Birth of Erichthonios attributed to the Meidias Painter: *CVA* Cleveland 2 (USA 35) pls. 72–74

[J. Neils]. Autochthony and Attic vase painting: Shapiro, 1998.

12. Panathenaic contests: Neils, 1992b; Kyle, 1993.

13. Boardman, 1984, 210. Cf. Also Boardman, 1977, 43: "The explanation is too obscure and the details of recognition would have eluded even the most skilled observer."

14. For the suggestion that a group sculpture (no. 56) from the north frieze of the Erechtheion might depict the baby Erichthonios being tended by one of the daughters of Kekrops, see Boulter, 1970, 14, n. 37.

15. Connelly, 1996. The first scholarly publication of her interpretation appeared as an abstract in 1993: *AJA* 97: 309–10.

16. Connelly, 1996, 67.

17. Representations of priests in relief sculpture: Mantis, 1990, 82–92; Connelly, 1996, 59, figs. 2–3.

18. Harrison, 1996a, presents compelling arguments for the cloth being folded (202) and the male gender of the child (202–205). Neils, 1999, 12–15, argues that the gods are seated in a semicircle with the *peplos* ceremony in the center. See also *supra,* Chapters 2 and 5.

19. On the peaceful attitude of the gods, see Harrison, 1996a, 206–208. She notes that neither Ares nor Athena, the principal Greek war-gods, have their traditional attributes, shield and helmet, which one would expect if a war with the Eleusinians was imminent, as argued by Connelly, 1996.

20. Bonnechere, 1997. To this study can be added the newly discovered late Archaic marble sarcophagus with the sacrifice of Polyxene from the salvage excavations at Gümüşçay on which gesticulating women mourn the impending death of the Trojan princess; see *Studia Troica* 6 (1996): 251–64.

21. It had earlier been suggested that a marble male torso in a long unbelted garment, and so probably a priest, closely coupled with another figure may be Erechtheus about to sacrifice one of his daughters. The fragment, found on the North Slope (Agora AS 158), almost certainly belongs to the Erechtheion frieze, which was in progress at the time of Euripides' play *Erechtheus.* Boulter, 1970, 18, n. 50, has argued for this identification based on Athena's speech, which establishes the worship of Poseidon-Erechtheus at the end of the play. If it appears at all in architectural sculpture, this theme is obviously more appropriate for the Erechtheion.

22. Boardman, 1977, 43.
23. Nike Temple frieze: Harrison, 1972; Stewart, 1985.
24. Further refutations of Boardman's theory: Spence, 1993, 267–71. Simon, 1983, 59–60, also argues that the mounted riders are ephebes rather than knights, but there is no evidence that ephebes received equestrian training in the Classical period. cf. Holloway, 2000.
25. Holloway, 1966a.
26. Eaverly, 1995.
27. Lawrence, 1951 and 1972, 144. Cf. also Ashmole, 1972, 117: "Whether this choice was intended as a deliberate democratic counterblast to the long lines of tribute-bearers on the great palace of the Persian Kings at Persepolis, carved a generation before this, we cannot say, but Pericles must have known of Persepolis, and may well have had the contrast in mind."
28. Meiggs, 1963.
29. Root, 1985, 113.
30. The Athenians may have used Persian war booty, such as a silver-footed *diphros,* in the Panathenaic ritual, as argued by Thompson, 1956. For the possibility that the throne of Zeus on the frieze quotes a Persian form, see Miller, 1997, 54–55.
31. Pollitt, 1972, 87.
32. Figueira, 1984, 469. He notes that the rhythm of political crises in sixth-century Athens coincides with the quadrennial festival, which provided a critical mass for populist agitation.
33. Pollitt, 1997, 51.
34. Pollitt, 1997, 61.
35. Involvement of knights in religious festivals: Spence, 1993, 186–88.
36. Hurwit, 1999, 228, follows Pollitt in calling the frieze "a distillation of the many processions, athletic and cultural contests, ritual presentations, and sacrifices that characterized Athenian life in the age of Perikles." Harrison, 1984, distinguishes the four sides of the frieze in terms of time: west = mythological past, south = pre-Kleisthenic, north = democratic, east = timeless.
37. Wesenberg, 1995. See also Holloway, 2000, 84–85.
38. Cf. Boardman, 1999, 309 n. 11 and 310–12.
39. Maurizio, 1998, 415, n. 3. The author cites Wohl, 1996, as the inspiration for her approach.
40. Osborne, 1987b, 104.
41. Maurizio, 1998, 301.
42. Maurizio, 1998, 303.
43. Purple robes were given to the Furies at the end of Aeschylus' *Eumenides* as a sign of their accep-

tance into Athens, and ephebes wore purple robes during festivals; see Maurizio, 1998, 305. On the status value of purple garments, see Barber, 1999.
44. Ridgway, 1981, 17, n. 3.
45. On the pre-Parthenon, see Rhodes, 1995, 30–32; Brouskari, 1997, 152–58; Hurwit, 1999, 132–35.
46. This argument follows that presented by Neils, 1999, 11–12.
47. The first to advance this theory was Müller, 1829.
48. Robert, 1919, 21–35.
49. Elderkin, 1936. His method is revealed by the following statements: "The sequence of the five 'Erechtheid' divinities was entirely determined in the frieze by their sequence from east to west on the holiest site of the acropolis" (95), and "Pheidias placed these seven figures in the northern group because their cults were all situated to the north of the Parthenon. . . ." (95).
50. Pemberton, 1976.
51. Linfert, 1979; Mark, 1984. It has also been applied to the gods on the east pediment; see Harrison, 1967, 57–58.
52. These dedications have been summarized in Geagan, 1996.
53. Simon, 1996.
54. See Sappho fr. 5.1 Lobel/Page. For the state shrine of Aphrodite Euploia at the Piraeus, see Garland, 1987, 150. This shrine is likely to be the one dedicated by Themistokles after the Battle of Salamis. For further discussion of the correspondences between Aphrodite's powers and the force of the sea, see Segal, 1965.
55. On these sites, see Stillwell, 1976.
56. It should also be noted that Artemis Agrotera received an annual sacrifice of goats in honor of the land victory at Marathon.
57. The land/sea scheme occurs also in some of the earliest Greek art, engraved Geometric fibulae. I thank Michael Bennett for reminding me that some of them feature ships, fish, and/or sea birds on the opposite side of the central disk from horses and other land creatures. Marine thiasoi coupled with Dionysiac thiasoi in later Greek art illustrate the same phenomenon.
58. Contest as one of priority: Binder, 1984.
59. Binder, 1984, 21–22, in reference to L. H. Jeffery, who first suggested that the west pediment celebrates the founding of the cult of Poseidon on the Acropolis around 475. For another view

regarding the worship of Poseidon on the Acropolis, cf. Shapiro, 1989, 101–11.

60. Athena as horse goddess: Yalouris, 1950.

61. Equestrian statues in Attica: Eaverly, 1995. Her discussion of Poseidon Hippios (56–59) makes the point that Delos was the only Greek island where the god was worshipped in hippic guise (Poseidon Hippogetes) and where equestrian statues are found outside Attica.

62. Poseidon's associations with horses and the sea: Edmunds, 1996, 90–93. Cf. also Shapiro, 1989, 108–11.

63. Policoro, Museo Archeologico Nazionale 35304: Simon, 1980.

64. Further discussion of the relationship of Poseidon Hippios and Athena Hippias can be found in Detienne and Vernant, 1978, 187–213.

65. Athena and Zeus: Neils, 2001.

66. Simon, 1983, 8–12.

67. Luyster, 1965, 149.

68. Zeus in Classical art: Arafat, 1990.

69. Arafat, 1990, 167.

70. On the Panathenaic *peplos* and the possibility that there were two *peploi* (one annual and the other quadrennial) as per Mansfield (1985), see Barber, 1992.

71. See Neils, 1996b, 185, n. 25; Neils, forthcoming.

72. Discussed more fully in Neils, 1996b, 189–93.

73. Or is she protecting the child in front of her from its hideous appearance, as she sometimes does at the birth of Erichthonios, when she slings it over her back? This action of concealing the gorgoneion may serve as further support for the semicircular seating plan of the gods.

74. The dressing theme is discussed more fully in Neils, 1996b, 193, with references.

75. Boardman, 1977, 40–41

76. Agora P10554: *Agora* XXX, 138, no. 22.

77. Jameson, 1994.

78. Jameson, 1994, 36.

79. Jameson, 1994, 41–42.

80. Taylor, 1937.

81. *IG* I³ 324: Harris, 1995, 91–94. The thrones and stools were located in the Parthenon proper which refers to the west chamber of the temple.

82. For a list of where various scholars locate the gods, see Berger and Gisler-Huwiler, 1996, 170. The absence of Hestia would support the fact that the gods are somewhere other than Mt. Olympos for she stays home to tend the hearth.

83. Scenes of sacrifice: Van Straten, 1995.

84. Harrison, 1996a, 208.

85. The other youthful god included on the frieze, Eros, may also resonate with this theme of youth and marriage; in this period he is a frequent attendant of brides in Athenian vase painting. See Oakley and Sinos, 1983, *passim.*

86. Aristotle, *Rhetoric* 1365a 31–32, 1411a 1–4. See Osborne, 1987b, 104; Stewart, 1997, 76–77; Podlecki, 1998, 124. For fifth-century Athens as a youth culture, see Strauss, 1993.

87. A number of scholars see a homoerotic aspect to this emphasis on youth. In particular Stewart, 1997, 80–82, posits a homoerotic relationship between the ideal Athenian male viewer and the youthened *demos* on the frieze which is intensified, he argues, by the paucity of naked youths who thereby call special attention to themselves. See also Younger, 1997, who regards the juxtaposition of males of different ages as evidence of homoerotic themes within the frieze.

7. KLEOS: THE IMPACT OF THE FRIEZE

1. Sparkes, 1999, 5.

2. Oxford, Ashmolean Museum 1916.68, red-figure stamnos attributed to Polygnotos: *ARV²* 1028, 6; Matheson, 1995, 40, pl. 29; 346 no. P5. A similar scene on a slightly earlier (ca. 450) unattributed red-figure amphora in the Ashmolean (1890.22) mentioned by Matheson (1995, 313, n. 38) is illustrated in Vickers, 1978, no. 54.

3. Other examples include: a bell-krater in Karlsruhe (B40) attributed to the Villa Giulia Painter (*ARV²* 619, 15), where the riders move to the left; a column-krater in Faenza (19) attributed to the Academy Painter (*ARV²* 1134, 8 1124, 7), where the raised right arms of the riders recall N131; a column-krater on the London market attributed to the Naples Painter (Christie's 11 July 1984, lot 214), where a third horse is emerging from the frame at left and one of the riders is bearded.

4. Tampa Museum of Art 86.64, red-figure pelike attributed to the Westreenen Painter: *ARV²* 1006, 2; Neils, 1992a, 27 and 180, no. 51. For a similar rider on a pelike attributed to the Achilles Painter on loan to the Ashmolean Museum in Oxford, see Vickers, 1999, 48 no. 36. His *petasos,* however, is slung over his back, as might have been the case with some of the missing riders of the south frieze.

5. Cincinnati Art Museum 1884.231, red-figure kylix in the manner of the Bull Painter: *ARV²*

1351, 9; *The Cincinnati Art Museum Bulletin* 8, 1966, 11–12, figs. 11–14.

6. Berlin, Antikensammlung F 2357, red-figure pelike attributed to the manner of the Washing Painter: *ARV²* 1134, 8; Brommer, 1977, 199 and 201, no. 1; Sparkes, 1999, 4, and 14, fig. 6.

7. See Kleiner, 1992, 50, fig. 31. Kleiner states that the soldier is about to mount his horse (as does Beazley in the case of the Berlin pelike; *ARV²* 1134, 8), but for the "parking up" pose see Chapter 5. This motif is discussed in Hafner, 1972, 108–109.

8. The late black-figure Haimonian lekythoi that are said to show the *apobates* may, in fact, not since the warriors are carrying spears. For the later Attic red-figure examples see Metzger, 1951, 359–60, nos. 32–34; Brommer, 1977, 224, nos. 25–30; Kephalidou, 1996, 239–41, nos. 143–149. To these can be added two column-kraters attributed to the Naples Painter (*ARV²* 1097, 15–16), another in Arezzo (1413), and a calyx-krater in Tarquinia (RC 4195) with Athena (*CVA* Tarquinia 2, pl. 13).

9. It also appears on an undated fourth-century prize Panathenaic fragment in Heidelberg (Univ. 242): Bentz, 1998, 192, no. 4.336, pl. 136.

10. Cambridge, Harvard University Art Museums 1959.129, red-figure chous attributed to the Dinos Painter, ca. 420: Neils, 1992a, 180–81, no. 52.

11. For other vases related to the sacrificial procession of the south frieze, see Brommer, 1977, 201–202, nos. 3–5, 28 The cow of the frieze is often changed to a bull in vase painting.

12. Metairie, Diefenthal collection, red-figure bell-krater in the manner of the Dinos Painter, ca. 420: Shapiro, 1981, 80–81, no. 30 (J. Neils); Matheson, 1995, 394 no. DM 15. Cf. Leipzig, Antikenmuseum der Universität T 958, red-figure bell-krater, ca. 400 with youth leading restive bull to sacrifice: Paul, 1997, 22–24, no. 7.

13. New York, Metropolitan Museum of Art 1925.78.66, red-figure bell-krater attributed to Polion: *ARV²* 1172, 7.

14. Ferrara, Museo Nazionale di Spina T 57 C VP, red-figure volute-krater attributed to the Kleophon Painter: *ARV²* 1143, 1; Robertson, 1992, 224, fig. 31.

15. Robertson, 1992, 223.

16. In regard to a stamnos by Polygnotos in London (E 454), Matheson (1995, 57) makes a perceptive comparison between the frieze and a single row of overlapping symposiasts "riding klinai rather than horses" and the flute-girl posed at the end "like a marshal at left, facing against the direction of the traffic." She claims that "This kind of reversal of direction to stop the action or movement of a procession, typical of the rhythmic variations on the Parthenon frieze, is one of the most lasting effects that the monumental work had on vase painting compositions."

17. Carpenter, 1929, 77.

18. Slabs 3 and 11: see Carpenter, 1929, 18–19 and 66–67.

19. Sandal-binder, slab 12: Carpenter, 1929, 62–63. Nike with foot on boulder, slab 10: Carpenter, 1929, 32–33.

20. One could cite other instances of influence such as the conclave of Olympian gods which makes its appearance on the east friezes of both the Hephaisteion (albeit half the number) and the Temple of Athena Nike.

21. Vatican, Museo Gregoriano Etrusco inv. 1684, marble grave relief ca. 430: Helbig, 1963, no. 871. Cf. also the limestone relief from Tyndaris (Vatican inv. 4092) that depicts a rider in *chlamys* and *petasos* mounted on a rearing horse: Helbig, 1963, no. 471. An Attic marble grave stele of ca. 400 (British Museum 638) showing a man on horseback with his hand to the horse's head is particularly reminiscent of the frieze, where this specific gesture is used (e.g. W8, W19, N117): Clairmont, 1970, 93–95, pl. 12, no. 24.

22. Hanfmann, 1967, 314.

23. Athens, National Museum 715: Ridgway, 1981, 146, 157, fig. 106.

24. Adam, 1966, 110–13. She, like many others, mistakenly refers to this stele as the "Salamis stele."

25. This striking similarity was originally noted by Michaelis (1871, 237), and repeated by others without attribution. See Brommer, 1977, 280, no. 12.

26. Brommer, 1977, 279, no. 6. For the complete relief, but an inferior copy, see Boardman, 1985, fig. 239.3.

27. Harrison, 1986.

28. Could these figures have once belonged to the frieze over the east door of the Parthenon, which is now posited by Korres on the basis of an upper molding (see Fig. 56)? The subject matter, like that of the metopes, would be related to the cult statue that showed Pandora's arrival on its base.

The scale (85 cm), type of marble (Pentelic), and style (attributed to Alkamenes) are all appropriate to the Parthenon. If these figures are a series of deities, as Harrison suggests, they would be most appropriately positioned at the east end of the temple.

29. Harrison, 1986, 114.
30. Lycian sarcophagus in relation to frieze: Vermeule, 1955, 107; Brommer, 1977, 206 no. 4; Ridgway, 1981, 150; Boardman, 1994, 54–57.
31. Adam, 1966, 57.
32. There are four Scythian *gorytoi* with the same decoration. Although they are often said to depict the episode of Achilles at King Lykomedes' court on Skyron, some of the figures seems closer to the myth of Jason, Medea, and Glauke at Kreon's court in Corinth (notably in the upper register).
33. Ridgway, 1981, 99.
34. Rome, Museo Nazionale Romano 8602: see Ridgway, 1990b, 84–87, 103 no. 22.
35. Jason: Ridgway, 1964, has argued that the work is not by Lysippos and is instead a second century eclectic work. Alexander Rondanini: Von den Hoff, 1997.
36. Palagia, 1984. Cf. also the figure of Asklepios on the votive relief in Copenhagen, Ny Carlsberg 197 (I.N. 1430), whose feet are differently posed but whose backward leaning stance is otherwise comparable. See Boardman, 1985, fig. 171.
37. Brommer, 1977, 206, nos. 10–11.
38. Boucher, 1988.
39. For a discussion of this influence as well as other sources for the Augustan altar, see Simon, 1967; Kleiner, 1978.
40. Tellus panel: Simon, 1967; Neils, 1999, 16.
41. *Gemma Augustea:* Pollini, 1993; Neils, 1999, 16–17.
42. It is perhaps worth noting in this context that the figure of Tiberius in the chariot crowned by Nike recalls Berger's reconstruction of Ares and Iris in the east pediment of the Parthenon; see Boardman, 1985, fig. 78.
43. Augustan art and ideology: Zanker, 1988.
44. London, British Museum 2206: Walker and Cameron, 1989, 140. For discussion of this relief in relation to the west frieze, see Moore, 1975, 44.
45. Greenhalgh, 1978, 42.
46. Tanoulas, 1997, 25.
47. Vasari, *Lives* (Penguin edition), 310.
48. On sources for the Raphael fresco, see Fehl,

1961, 14, n. 32. Brommer, 1977, 207, doubts the connection.
49. Cummings, 1964, 325, fig. 12.
50. For the contrasting views of Haydon and Richard Payne Knight, see Ballantyne, 1988. He (p. 156) quotes the otherwise ardent philhellene Knight as saying, "The preserved fragments of the frieze are interesting; but I do not think the workers of them deserve any better Title than common *Stonehewers* of the age of Phidias."
51. Athenaeum frieze: Jenkins, 2000. Parthenon frieze wallpaper: Jenkins, 1994b, 179, fig. 6.
52. Stephanoff: Jenkins, 1985b. Temporary Elgin Room and its visitors: St. Clair, 1998, 261–64.
53. This viewpoint is argued in the dissertation of Aleson, 1993.
54. For the history of cast making on the part of the British Museum, see Jenkins, 1990.
55. See also Connor, 1989.
56. See Gazi, 1998. These casts are now on display in the Acropolis Study Center south of the Acropolis.
57. In modern times a number of forgeries after heads, human and equine, on the frieze have been made in Pentelic marble and are presumably from Athens: Ashmole, 1954; Houser, 1972.
58. Greenough drawings (1826–32): Saunders, 1999, 47–48 no. 5. Rodin drawings (1856): Tournikiotis, 1994, 241, figs. 13–14.
59. Castor and Pollux relief: Saunders, 1999, 77–78, no. 39.
60. Degas and horses: Boggs, 1998.
61. Goodrich, 1982, 236–37.
62. Smith, 1916.
63. See Dorival, 1951, 123; d'Argencourt, 1999, 284.

8. THAUMA: WHOSE HERITAGE?

1. The most authoritative and up-to-date study devoted to Lord Elgin and the Acropolis marbles is that of St. Clair, 1998, a third revised edition of his 1967 monograph. Less reliable is Vrettos, 1997, a more-or-less word-for-word reprint of his 1974 book, *A Shadow of Magnitude: The Acquisition of the Elgin Marbles.* See also Rothenberg, 1977; Cook, 1984b; Hitchens, 1987; Checkland, 1988; Hamilakis, 1999.
2. Merryman, 1985, 1894–95. Repatriation of cultural property: Lowenthal, 1988 and 1996; Greenfield, 1996, esp. 42–90 on the Elgin marble debate.

3. These quotes can be found in St. Clair, 1998, 341. See also Merryman, 1986.

4. The Italian text of the *firman* and an English translation can be found in St. Clair, 1998, 37–41. For Merryman's arguments on the legal issues, see Merryman, 1985.

5. The intricacies of this case are reviewed by Bush, 1996.

6. St. Clair, 1999, 413.

7. St. Clair, 1999, presents an extensive investigation of this cleaning with full source documents. Jenkins, 1999, discusses earlier cleanings of the marbles. Lyons, 2000, reports on the 1999 conference.

EPILOGUE

1. Vassilika, 1998, 96, no. 46.

2. Quoted from St. Clair, 1998, 105–106.

aegis snake-fringed breast plate; armor often worn by Athena but held on her lap on the east frieze (E36)

alopekis animal skin cap usually worn by Thracians; worn by some riders (e.g. W8, W15, N119, N122, S32–37)

anakalypsis ceremonial unveiling of the bride; a wedding gesture performed by Hera (E29)

anathyrosis architectural technique whereby only the edges of blocks were smoothed for close fitting

antilabe leather thong used as a hand grip on the inner left edge of a shield

apobates, apobatai participant in a contest in which armed men leap on and off moving chariots, held in the Athenian Agora (e.g. N47, 50, 53, 55, 60, 64, 68, 71)

archon basileus chief magistrate and overseer of Athenian state religion; man in priest's garb folding the *peplos* on the east frieze (E34)

arete goodness, excellence, virtue

arrephoros, arrephoroi young girl who helped weave the Panathenaic peplos and carried sacred objects

athlothetes, athlothetai one who awards the prize; judge in the games

aulos, auloi musical instrument consisting of double pipes

chiton linen tunic or dress of Ionian origin, buttoned at the shoulders and girdled at the waist, worn by women on the east frieze

chitoniskos short, thigh-length chiton, worn by riders on the frieze

chlamys, chlamydes short cloak, usually pinned at the shoulder; worn by riders on the frieze

deme Attic township

demos people, citizens

diphrophoros, diphrophoroi stool-bearer; young women with stools on their heads at the center of the east frieze (E31–32)

diphros, diphroi four-legged stool

dokimasia examination or inspection

dromos roadway, race track

embades high leather boots, worn by riders on the frieze

ephebe, epheboi a youth, usually between the age of eighteen and twenty, enrolled in Athenian military training

epistates, epistatai supervisor, inspector, or commissioner

eponymoi ten Attic heroes after whom the Kleisthenic tribes are named; often identified as the standing men E18–23, 43–46

exomis short chiton with one shoulder strap, worn by some riders on the west and north friezes (W15, 8, N55, 64)

gorgoneion head of the Gorgon Medusa; decoration on the cuirass of a rider on the north frieze (N11)

hebe youth

hekatomb offering of 100 oxen or, more generally, a great public sacrifice

hekatompedon temple measuring 100 feet

hieropoios, hieropoioi one who manages religious rites; at Athens one of the ten officers who ascertained that the victims were unblemished

himation, himatia woolen cloak, usually worn by older men

hipparch one of two generals of the cavalry at Athens; on the frieze the bearded horsemen W8 and W15

hippeis horsemen or knights

hydria, hydriai three-handled water vessel; carried by youths (N16–19)

hydriaphoros, hydriaphoroi one who carries a hydria; the youths on the frieze N16–19, possibly also on the south frieze

kanephoros, kanephoroi one who carries a basket, specifically, an Athenian girl chosen to carry the basket on her head in a sacrificial procession; possibly E16–17, 50–51, 53–54

kanoun, kana wicker basket, used especially for carrying the sacred barley at sacrifices; probably held by E49

kekryphalos woman's headdress

kerykeion caduceus or herald's staff, attribute of the messenger gods Hermes and Iris

keryx herald, possibly W23

kithara seven-stringed musical instrument with wooden sound box; carried by four youths on the north frieze (N24–27) and probably also on the south frieze

kleos fame, good reputation, glory

metic resident alien

mimesis representation, imitation

oinochoe, oinochoai wine jug; libation vessel held by young women on the east frieze (E7–11, 58–59)

opisthodomos rear room of a temple

pais child, slave

Panathenaia annual festival held on the twenty-eighth of Hekatompedon in honor of Athena; "Greater" held every four years

paradeigma example, model

peplos, peploi article of female dress consisting of a large rectangle of

woolen cloth; cloth held by the priest and child (E34–35) and worn by various women and goddesses on the east frieze

petasos, petasoi broad-brimmed traveler's hat; hat resting on Hermes' lap (E24) and worn by various riders, notably, a group on the south frieze (S50–55)

phiale, phialai shallow bowl with central boss; libation bowl held by various young women of the east frieze (E2–6, 55, 60–63)

phyle, phylai tribe

pinax, pinakes painted plaque

polis, poleis city-state

pompe, pompai solemn procession, usually of a religious nature

Praxiergidai Athenian clan in charge of dressing the cult statue of Athena Polias

pronaos front porch of a temple

quadriga four-horse chariot, such as those used by the *apobatai*, N XI–XXVIII, and S XXV–XXXV

salpinx musical instrument similar to a trumpet, possibly held by W23

skaphe, skaphai offering tray, carried by the youths N13–15 and S119–121

skiaphoros, skiaphoroi umbrella-bearer; metic woman who carries sun shade for *kanephoros*

sophrosyne moderation, discretion, self-control

stemma, stemmata garland, usually of wool, often draped on animals' horns before sacrifice

techne skill, expertise

temenos, temene sanctuary or sacred area, often bounded by a wall

thallophoros, thallophoroi one who carries olive branches, as old men did at the Panathenaia, possibly those elderly men on the frieze N28–43 and S89–106

thauma wonder, marvel

theoxenia reception for a god or gods in which seats and offerings are set out

thymiaterion incense burner on a vertical stand; ritual implement carried by at least one young woman on the east frieze (E57)

zeira decorated Thracian cloak

BIBLIOGRAPHY

Adam, Sheila. 1966. *The Technique of Greek Sculpture in the Archaic and Classical Periods. BSA* suppl. 3. London.

Ajootian, Aileen. 1998. "A Day at the Races: The Tyrannicides in the Fifth-century Agora." In ΣΤΕΦΑΝΟΣ: *Studies in Honor of Brunilde Sismondo Ridgway,* ed. Kim J. Hartswick and Mary C. Sturgeon, 1–13. Philadelphia.

Aleson, Robyn Patricia. 1993. *Classic into Modern: Inspiration of Antiquity in English Painting, 1864–1918.* Yale University diss.

Ameling, W. 1981. "Komödie und Politik zwischen Kratinos und Aristophanes: Das Beispiel Perikles," *Quaderni Catanesi di studi classici e medievali* 3: 338–424.

———. 1985. "Plutarch, Perikles 12–14," *Historia* 34: 47–63.

Anderson, J. K. 1961. *Ancient Greek Horsemanship.* Berkeley and Los Angeles.

Arafat, K. W. 1990. *Classical Zeus: A Study in Art and Literature.* Oxford.

Arnheim, Rudolf. 1977. *The Dynamics of Architectural Form.* Berkeley.

Ashmole, Bernard. 1949. *A Short Guide to the Sculpture of the Parthenon.* London.

———. 1954. "Five Forgeries in the Manner of the Parthenon." In *Neue Beiträge zur klassischen Altertumswissenschaft. Festschrift zum 60. Geburtstag von Bernhard Schweitzer,* ed. Reinhard Lullies, 177–80. Stuttgart.

———. 1959. "Cyriac of Ancona," *Proceedings of the British Academy* 45: 25–41, pls. 1–14.

———. 1962. *Some Nameless Sculptors of the Fifth Century B.C.* London.

———. 1972. *Architect and Sculptor in Classical Greece.* London.

Badian, Ernst. 1987. "The Peace of Callias," *JHS* 107: 1–39.

Ballantyne, Andrew. 1988. "Knight, Haydon and the Elgin Marbles," *Apollo,* September: 155–59.

Barber, Elizabeth J. W. 1992. "The Peplos of Athena." In Neils, 1992a, 103–117.

———. 1999. "Colour in Early Cloth and Clothing," *Cambridge Archaeological Journal* 9: 117–20.

Bentz, Martin. 1998. *Panathenäische Preisamphoren. AntK* Beiheft 18. Basel.

Berczelly, Laszlo. 1992. "Pandora and Panathenaia. The Pandora Myth and the Sculptural Decoration of the Parthenon," *Acta ad archaeologiam et artium historiam pertinentia* 8: 53–86.

Berger, Ernst, ed. 1984. *Der Parthenon-Kongress Basel.* Vols. 1–2. Mainz.

Berger, Ernst, and Madeleine Gisler-Huwiler. 1996. *Der Parthenon in Basel: Dokumentation zum Fries.* Mainz.

Beschi, Luigi. 1984. "Il fregio del Partenone: una proposta di lettura," *Rendiconti dell'Accademia dei Lincei, classe di scienze morali storiche e filologiche* 39: 173–95.

Beyer, I. 1974. "Die Reliefgiebel des alten Athena-Tempels der Akropolis," *AA:* 639–51.

Binder, Judith. 1984. "The West Pediment of the Parthenon: Poseidon." In *Studies Presented to Sterling Dow on his Eightieth Birthday,* ed. Alan L. Boegehold, 15–22. Durham, N.C.

Bloedow, E. F. 1996. "'Olympian' Thoughts: Plutarch on Pericles' Congress Decree," *Opuscula Atheniensia* 21: 7–12.

Blundell, Sue. 1998. "Marriage and the Maiden: Narratives on the Parthenon." In *The Sacred and the Feminine in Ancient Greece,* ed. Sue Blundell and Margaret Williamson, 47–70. London.

Boardman, John. 1975. *Athenian Red-figure Vases: The Archaic Period.* London.

———. 1977. "The Parthenon Frieze – Another View." In *Festschrift für Frank Brommer,* ed. Ursula Höckmann and Antje Krug, 39–49. Mainz.

———. 1978. *Greek Sculpture: The Archaic Period.* London.

———. 1984. "The Parthenon Frieze." In Berger, 1984, 210–15.

———. 1985. *Greek Sculpture: The Classical Period.* London.

———. 1988. "Notes on the Parthenon East Frieze." In *Kanon. Festschrift Ernst Berger, AntK* Beiheft 15, ed. M. Schmidt, 9–14. Basel.

———. 1990. "The Greek Art of Narrative." In ΕΥΜΟΥΣΙΑ, *Ceramic and Iconographic Studies in Honour of Alexander Cambitoglou, Mediterranean Archaeology* suppl. 1, ed. J.-P. Descoeudres, 57–62. Sydney.

———. 1991. "The Naked Truth," *Oxford Journal of Archaeology* 10: 119–21.

———. 1994. *The Diffusion of Classical Art in Antiquity.* Bollingen Series 35. Washington D.C. and Princeton.

———. 1999. "The Parthenon Frieze, A Closer Look," *Revue archéologique* 2/99: 305–30.

Boardman, John, and David Finn 1985. *The Parthenon and Its Sculptures.* Austin.

Bodnar, Edward W. 1970. "Athens in April 1436: Part I," *Archaeology* 23: 96–105.

Boedeker, Deborah, and Kurt A. Raaflaub, ed. 1998. *Democracy, Empire, and the Arts in Fifth-Century Athens.* Cambridge, MA.

Boersma, J. S. 1964. "On the Political Background of the Hephaisteion," *BaBesch* 39: 101–106.

 1970. *Athenian Building Policy from 561/0 to 405/4 B.C.* Groningen.

Boggs, Jean Sutherland. 1998. *Degas at the Races.* Washington D.C.

Bonfante, Larissa. 1989. "Nudity as Costume in Classical Art," *AJA* 93: 543–70.

Bonnechere, Pierre. 1997. "La ΠΟΜΠΗ sacrificielle des victimes humaines en Grèce ancienne," *Revue des Études anciennes* 99: 63–89.

Borchhardt. J. 1985. "Thrakische Reiter im Festzuge des Parthenonfrieses," *Terra Antiqua Balcanica 2, Studi in Honorem Chr. M. Danov.,* ed. M. Tacheva, 60–71. Sophia.

Boucher, Stephanie. 1988. "Une scène de procession sacrificielle sur une plaque de bronze découverte à Templemars (Nord)," *Revue du Nord* 70: 83–97.

Boulter, Patricia N. 1970. "The Frieze of the Erechtheion," *Antike Plastik* 10: 7–28, pls. 1–30.

Bowie, Theodore, and Dieter Thimme, ed. 1971. *The Carrey Drawings of the Parthenon.* Bloomington.

Brommer, Frank. 1967a. *Die Metopen des Parthenon.* Mainz.

 1967b. "Ein Bruchstuck vom Sudfries des Parthenon," *AA:* 196–98.

 1977. *Der Parthenonfries: Katalog und Untersuchung.* Mainz.

 1979. *The Sculptures of the Parthenon.* Trans. M. Whittall. London.

Brouskari, Maria S. 1960. "Parthenon-Fragmente," *AM* 75: 4–8, pls. 2–13.

 1974. *The Acropolis Museum.* Athens.

 1997. *The Monuments of the Acropolis.* Athens.

Brown, Patricia Fortini. 1996. *Venice & Antiquity: The Venetian Sense of the Past.* New Haven and London.

Brulé, Pierre. 1996. "La cité en ses composantes: remarques sur les sacrifices et la procession des Panathénées," *Kernos* 9: 37–63.

Bruno, Vincent J., ed. 1974. *The Parthenon.* New York.

Bugh, Glenn R. 1988. *The Horsemen of Athens.* Princeton.

Buitron-Oliver, Diana, ed. 1997. *The Interpretation of Architectural Sculpture in Greece and Rome.* Studies in the History of Art 49. Washington D.C.

Bundgaard, J. A. 1976. *The Parthenon and the Mycenaean City on the Heights.* Copenhagen.

Burford, Alison. 1963. "The Builders of the Parthenon." In Hooker, 1963, 23–35.

 1965. "The Economics of Greek Temple Building," *Proceedings of the Cambridge Philological Society* 191, n.s. 2: 21–34.

 1972. *Craftsmen in Greek and Roman Society.* London.

Burkert, Walter. 1966. "Greek Tragedy and Sacrificial Ritual," *GRBS* 7: 87–121.

 1985. *Greek Religion.* Trans. J. Raffan. Oxford.

 1988. "The Temple in Classical Greece." In *Temple in Society,* ed. M. V. Fox, 27–47. Winona Lake.

Buschor, Ernst. 1961. *Der Parthenonfries.* Munich.

Bush, Sara E. 1996. "The Protection of British Heritage: Woburn Abbey and *The Three Graces,*" *International Journal of Cultural Property* 5: 269–90.

Cahn, Herbert. 1973. "Dokimasia," *Revue archéologique:* 3–22.

 1986. "Dokimasia II." In *Studien zur Mythologie und Vasenmalerei. Festschrift für K. Schauenburg,* ed. E. Böhr and W. Martini, 91–93.

Camp, John McK. 1986. *The Athenian Agora: Excavations in the Heart of Athens.* London.

 1994. "Before Democracy: Alkmaionidai and Peisistratidai." In Coulson, et al., 1994, 7–12.

 1998. *Horses and Horsemanship in the Athenian Agora.* Agora Picture Book 24. American School of Classical Studies at Athens.

Carpenter, Rhys. 1929. *The Sculpture of the Nike Temple Parapet.* Cambridge, MA.

 1970. *The Architects of the Parthenon.* Baltimore.

Carpenter, Thomas. 1997. *Dionysian Imagery in Fifth-Century Athens.* Oxford.

Castriota, David. 1992. *Myth, Ethos, and Actuality: Official Art in Fifth-Century B.C. Athens.* Madison.

Chamoux, François. 1957. "L'Athéna mélancolique," *BCH* 81: 141–59.

Checkland, Sydney. 1988. *The Elgins 1766–1917: A Tale of Aristocrats, Proconsuls, and Their Wives.* Aberdeen.

Childs, William A. P. 1988. "The Classic as Realism in Greek Art," *Art Journal* 47.1: 10–14.

Clairmont, Cristoph W. 1970. *Gravestone and Epigram.* Mainz.

 1989. "Girl or boy? Parthenon east frieze 35," *AA:* 495–96.

Collignon, M., and F. Boissonas. 1910–1912. *Le*

Parthénon. L'Histoire, l'Architecture et la Sculpture. Paris.

Connelly, Joan B. 1996. "Parthenon and *Parthenoi:* A Mythological Interpretation of the Parthenon Frieze," *AJA* 100: 58–80.

Connor, Peter. 1989. "Cast Collecting in the Nineteenth Century: Scholarship, Aesthetics, Connoisseurship." In *Rediscovering Hellenism: The Hellenic Inheritance and the English Imagination,* ed. G. Clarke, 187–235. Cambridge.

Connor, W. R. 1987. "Tribes, Festivals and Processions: Civic Ceremonial and Political Manipulation in Archaic Greece," *JHS* 107: 40–50.

Constantinou, Fani, and Fani-Maria Tsigakou. 1998. Photogaphs by James Robertson. "Athens and Grecian Antiquities," 1853–1854. Exhib. cat., Benaki Museum. Athens.

Cook, Brian F. 1984a. *The Elgin Marbles.* 2nd ed. 1997. London.

——— 1984b. "Lord Elgin and the Acquisition and Display of the Parthenon Sculptures in the British Museum." In Berger, 1984, 326–328.

Corbett, P. E. 1959. *The Sculpture of the Parthenon.* Harmondsworth.

——— 1970. "Greek Temples and Greek Worshippers: The Literary and Archaeological Evidence," *Bulletin of the Institute of Classical Studies, London* 17: 149–58.

Corso, Antonio. 1986. *Monumenti Periclei. Saggio critico sulla attività edilizia di Pericle.* Memorie: Classe di Scienze, Lettere ed Arti, Istituto Veneto di Scienze, Lettere ed Arti XL, fasc. 1. Venice.

Coulson, W. D. E., O. Palagia, T.L. Shear, Jr., H. A. Shapiro, and F. J. Frost, ed. 1994. *The Archaeology of Athens and Attica under the Democracy,* Oxbow Monograph 37. Oxford.

Coulton, J. J. 1974. "Lifting in Early Greek Architecture," *JHS* 94: 1–19.

——— 1977. *Ancient Greek Architects at Work.* Ithaca.

——— 2000. "Fitting Friezes: Architecture and Sculpture." In *Periplous: Papers on Classical Art and Archaeology Presented to Sir John Boardman,* ed. G. R. Tsetskhladze, A. J. N. Prag, and A. M. Snodgrass, 70–79. London.

Creighton, W. F. 1968. *The Parthenon in Nashville.* Nashville.

Cromey, R. D. 1991. "History and Image: The Penelope Painter's Acropolis (Louvre G372 and 480/79 BC)," *JHS* 111: 165–74.

Crowther, Nigel B. 1994. "The Role of Heralds and Trumpeters at Greek Athletic Festivals," *Nikephoros* 7: 135–55.

Cummings, Frederick. 1964. "Phidias in Bloomsbury: B. R. Haydon's Drawings of the Elgin Marbles," *Burlington Magazine* 106: 323–28.

d'Argencourt, Louise. 1999. *European Paintings of the 19th Century.* Cleveland Museum of Art Catalogue of Paintings. Cleveland.

d'Ayala Valva, Stefano. 1996. "La figura nord 55* del fregio del Partenone," *AntK* 39: 5–13.

Deacy, Susan J., and Alexandra Villing, ed. 2001. *Athena in the Classical World.* Leiden.

Delivorrias, Angelos. 1994. "The Sculptures of the Parthenon." In Tournikiotis, 1994, 98–135.

Demangel, R. 1932. *La frise ionique.* Paris.

Despinis, Giorgos. 1982. Παρθενωνεια. Library of the Athens Archaeological Society no. 97. Athens.

Detienne, Marcel, and Jean-Pierre Vernant. 1978. *Cunning Intelligence in Greek Culture and Society.* Chicago.

Deubner, Ludwig. 1932. *Attische Feste.* Berlin.

Devries, Keith. 1992. "The 'Eponymous Heroes' on the Parthenon Frieze," *AJA* 96: 336 (abstract).

——— 1994. "The Diphrophoroi on the Parthenon Frieze," *AJA* 98: 323 (abstract).

Dillon, M. 1997. *Pilgrims and Pilgrimage in Ancient Greece.* London and New York.

Dimitriou, Penelope. 1947. *The Polychromy of Greek Sculpture to the Beginning of the Hellenistic Period.* Columbia University diss.

Dinsmoor, William B. 1913. "Attic Building Accounts I: The Parthenon," *AJA* 17: 53–80.

——— 1923. "How the Parthenon Was Planned," *Architecture* 47: 177–80, 241–44.

——— 1934. "The Date of the Older Parthenon," *AJA* 38: 408–448.

——— 1947. "The Hekatompedon on the Athenian Acropolis," *AJA* 51: 109–51.

——— 1950. *The Architecture of Ancient Greece.* London.

——— 1954. "New Evidence for the Parthenon Frieze," *AJA* 58: 144–45 (abstract).

Dinsmoor, William B., Jr. 1980. *The Propylaia to the Athenian Acropolis,* vol. 1, *The Predecessors.* Princeton.

Dorival, Bernard. 1951. "Sources of the Art of Gauguin from Java, Egypt and Ancient Greece," *Burlington Magazine,* April: 118–23.

Eaverly, Mary Ann. 1995. *Archaic Greek Equestrian Sculpture.* Ann Arbor.

Eckstein, Felix. 1980. "Die Gruppe der sog. Phylenheroen am Parthenon-Ostfries." In *Stele. Tomos eis Mnemen Nikolaou Kontoleontos,* 607–13. Athens.

——— 1984. "Die Rolle der Festordner im Parthenonfries." In Berger, 1984, 216–19.

Economakis, Richard, ed. 1994. *Acropolis Restoration: The CCAM Interventions.* London.

Eddy, Samuel 1977. "The Gold in the Athena Parthenos," *AJA* 81: 107–11.

Edmunds, Lowell. 1996. *Theatrical Space and Historical Place in Sophocles'* Oedipus at Colonus. Lanham, MD.

Elderkin, George W. 1936. "The Seated Deities of the Parthenon Frieze," *AJA* 40: 92–99.

Fagerström, Kåre. 1994. "All the Virgin's Horses and All the Virgin's Men. On the Choice of Moment in the Parthenon Frieze." In *Opus Mixtum. Essays in Ancient Art and Society,* ed. Tullia Linders, 35–46. Stockholm.

Fehl, Philipp. 1961. "The Rocks on the Parthenon Frieze," *Journal of the Warburg and Courtauld Institute* 24: 1–44. Partially reprinted in Bruno, 1974, 311–21.

Felten, Florens. 1984. *Griechische tektonische Friese archaischer und klassischer Zeit.* Waldsassen-Bayern.

Figueira, Thomas J. 1984. "The Ten *Archontes* of 579/8 at Athens," *Hesperia* 53: 447–73.

Foxall, Lin. 1995. "Monumental Ambitions: The Significance of Posterity in Greece." In *Time, Tradition and Society in Greek Archaeology,* ed. Nigel Spencer, 132–49. London and New York.

Francis, E. D. 1990. *Idea and Image in Fifth-Century Greece: Art and Literature after the Persian Wars.* London and New York.

Frel, Jiří. 1994. "Ancient Repairs of Parthenon Sculptures." In *Studia Varia,* ed. Jiří Frel, 47–62. Rome.

Furtwängler, Adolf. 1893. *Meisterwerke der griechischen Plastik: kunstgeschichtliche Untersuchungen.* Leipzig.

Garland, Robert. 1987. *The Piraeus from the Fifth to the First Century B.C.* Ithaca.

Gauer, W. 1984. "Was geschieht mit dem Peplos?" In Berger, 1984, 220–29.

Gazi, Andromache. 1998. "The Museum of Casts in Athens (1846–1874)," *Journal of the History of Collections* 10: 87–91.

Geagan, Dan. 1996. "Who Was Athena?" In *Religion in the Ancient World: New Themes and Approaches,* ed. Matthew Dillon, 145–64. Amsterdam.

Georgoudi, Stella. 1996. "Les Douze Dieux des Grecs: Variations sur un thème." In *Mythes grecs au figuré de l'antiquité au baroque,* ed. Stella Georgidou and Jean-Pierre Vernant, 43–80. Paris.

Giovannini, Adalberto. 1997. "La participation des alliés au financement du Parthénon: *aparchè* ou tribut," *Historia* 46: 145–57.

Gisler-Huwiler. 1988. "À propos des apobates et de quelques cavaliers de la frise nord du Parthenon." In *KANON: Festschrift Ernst Berger, AntK* Beiheft 15, ed. Margot Schmidt, 15–18. Basel.

Glowacki, Kevin T. 1998. "The Acropolis of Athens Before 566 B.C." In ΣΤΕΦΑΝΟΣ: *Studies in Honor of Brunilde Sismondo Ridgway,* ed. Kim J. Hartswick and Mary C. Sturgeon, 79–88. Philadelphia.

Goldhill, Simon, and Robin Osborne, ed. 1999. *Performance Culture and Athenian Democracy.* Cambridge.

Goodlett, Virginia C. 1989. *Collaboration in Greek Sculpture: The Literary and Epigraphical Evidence.* New York University diss.

Goodrich, Lloyd. 1982. *Thomas Eakins.* Cambridge.

Graef, Botho, and Ernst Langlotz. 1923. *Die antiken Vasen von der Akropolis zu Athen.* Berlin.

Greenfield, Jeanette. 1996. *The Return of Cultural Treasures.* 2nd ed. Cambridge.

Greenhalgh, Michael. 1978. *The Classical Tradition in Art.* New York.

Hafner, German. 1972. "Zwei römische Reliefwerke," *Aachener Kunstblätter* 43: 97–100.

Haldane, J. A. 1966. "Musical Instruments in Greek Worship," *Greece & Rome* 13: 98–107.

Hallett, C. H. 1986. "The Origins of the Classical Style in Sculpture," *JHS* 106: 71–84, pls. 4–6.

Hamilakis, Yannis. 1999. "Stories from Exile: Fragments from the Cultural Biography of the Parthenon (or 'Elgin') Marbles," *World Archaeology* 31: 303–20.

Hanfmann, George M.A. 1967. *Classical Sculpture.* Greenwich, CT.

Hansen, Mogens Herman. 1980. "Seven Hundred *Archai* in Classical Athens," *GRBS* 21: 151–73.

Harris, Diane. 1995. *The Treasures of the Parthenon and Erechtheion.* Oxford.

Harrison, Evelyn B. 1967. "Athena and Athens in the East Pediment of the Parthenon," *AJA* 71: 27–58, pls. 13–22.

1972. "The South Frieze of the Nike Temple and the Marathon Painting in the Painted Stoa," *AJA* 76: 353–78, pls. 73–78.

1979a. "Apollo's Cloak." In *Studies in Classical Art and Archaeology: A Tribute to Peter Heinrich von Blanckenhagen,* ed. Gunter Kopcke and Mary B. Moore, 91–98. Locust Valley.

1979b. "The Iconography of the Eponymous Heroes on the Parthenon and in the Agora." In *Greek Numismatics and Archaeology: Essays in Honor of Margaret Thompson,* ed. Otto Mørk-

holm and Nancy M. Waggoner, 71–85, pls. 5–6. Wetteren.

1979c. Review of Brommer, 1977. In *AJA* 83: 489–91.

1981. "The Motifs of the City-Siege on the Shield of the Athena Parthenos," *AJA* 85: 281–317.

1984. "Time in the Parthenon Frieze." In Berger, 1984, 230–34.

1986. "The Classical High-Relief Frieze from the Athenian Agora." In Kyrieleis, 1986, vol. 2, 110–17, pls. 117–22.

1988. "Greek Sculpted Coiffures and Ritual Haircuts." In *Early Greek Cult Places, Proceedings of the Fifth International Symposium at the Swedish Institute at Athens, 26–29 June, 1986,* ed. Robin Hägg et al., 247–54. Stockholm.

1989. "Hellenic Identity and Athenian Identity in the Fifth Century B.C." In *Cultural Differentiation and Cultural identity in the Visual Arts,* ed. Susan J. Barnes and Walter S. Melion, *Studies in the History of Art* 27: 41–61. Washington D.C.

1996a. "The Web of History: A Conservative Reading of the Parthenon Frieze." In Neils, 1996a,198–214.

1996b. "Pheidias." In *Personal Styles in Greek Sculpture,* ed. Olga Palagia and Jerome J. Pollitt, *Yale Classical Studies* 30, 16–65, figs. 2–26. Cambridge.

Harrison, Jane E. 1895. "Some Points in Dr. Furtwaengler's Theories on the Parthenon and Its Marbles," *Classical Review* 9: 85–92.

Haynes, D. E. L. 1959. *The Parthenon Frieze. London.*

1962. *An Historical Guide to the Sculptures of the Parthenon.* Rev. ed. 1965. London.

Heinze, Helga von. 1993. "Athena Polias am Parthenon als Ergane, Hippia, Parthenos: I. Die Ostseite," *Gymnasium* 100: 385–418, pls. 9–24.

1994. "Athena Polias am Parthenon als Ergane, Hippia, Parthenos: II. Die Westseite. Athena Hippia," *Gymnasium* 101: 289–311, pls. 9–24.

1995. "Athena Polias am Parthenon als Ergane, Hippia, Parthenos: III. Die Nord- und die Südseite. Athena Polias und Athena Parthenos," *Gymnasium* 102: 193–222, pls. 9–22.

Helbig, W. 1963. *Früher durch die öffentlichen Sammlungen klassischer Altertümer in Rom I,* 4th ed. Tübingen.

Herington, C. J. 1955. *Athena Parthenos and Athena Polias.* Manchester.

1963. "Athena in Athenian Literature and Cult." In Hooker, 1963, 61–73.

Hill, B. H. 1912. "The Older Parthenon," *AJA* 16: 535–58.

Hill, G. F. 1894. "The East Frieze of the Parthenon," *Classical Review* 8: 225–26.

Himmelmann, Nikolaus. 1977. "Phidias und die Parthenon-Skulpturen." In *Bonner Festgabe Johannes Straub,* 67–90. Bonn.

1988. "Planung und Verdingung der Parthenon-Skulpturen." In *Bathron. Beiträge zur Architectur und verandten Künsten für Heinrich Drerup,* ed. H. Büsing and F. Hiller, 213–24.

1992. "Der Parthenonfries im kleinen," *Frankfurter Allgemeine Zeitung* 180 (5 August).

1997. *Tieropfer in der griechischen Kunst.* Opladen.

Hitchens, Christopher. 1987. *Imperial Spoils: The Curious Case of the Elgin Marbles.* New York.

Holloway, R. Ross. 1966a. "The Archaic Acropolis and the Parthenon Frieze," *Art Bulletin* 48: 223–26.

1966b. "Music at the Panathenaic Festival," *Archaeology* 19: 112–19.

2000. "The Parthenon Frieze Again," *Quaderni Ticinesi, Numismatica e Antichità classiche* 29: 77–89, pls. 1–6.

Hooker, G. T. W., ed. 1963. *Parthenos and Parthenon. Greece & Rome,* suppl. to vol. X. Oxford

Houser, Caroline. 1972. "Is it from the Parthenon?," *AJA* 76: 127–37.

Howland, Richard H., ed. 2000. *The Destiny of the Parthenon Marbles.* Washington, D.C.

Hurwit, Jeffrey M. 1985. *The Art and Culture of Early Greece, 1100–480 B.C.* Ithaca.

1995. "Beautiful Evil: Pandora and the Athena Parthenos," *AJA* 99: 171–86.

1999. *The Athenian Acropolis: History, Mythology, and Archaeology from the Neolithic Era to the Present.* Cambridge.

Jameson, Michael H. 1994. "Theoxenia." In *Ancient Greek Cult Practice from the Epigraphical Evidence, Proceedings of the Second International Seminar on Ancient Greek Cult, organized by the Swedish Institute at Athens, 22–24 November 1991,* ed. Robin Hägg, 35–57. Stockholm.

1998. "Religion in the Athenian Democracy." In *Democracy 2500? Questions and Challenges,* ed. Ian Morris and Kurt A. Raaflaub, 171–95. Dubuque.

Jenkins, Ian D. 1985a. "The Composition of the so-called Eponymous Heroes on the East Frieze of the Parthenon," *AJA* 89: 121–27.

1985b. "James Stephanoff and the British Museum," *Apollo,* March: 174–81.

1990. "Acquisition and Supply of Casts of the Parthenon Sculptures by the British Museum, 1835–1939," *BSA* 85: 89–114, pls. 10–20.

1994a. *The Parthenon Frieze.* Austin and London.

1994b. "'G. F. Watts' Teachers': George Frederic Watts and the Elgin Marbles," *Apollo,* September: 176–81.

1995. "The South Frieze of the Parthenon: Problems in Arrangement," *AJA* 99: 445–56.

1997. "Documenting the Parthenon Frieze in Basel" (review of Berger and Gisler-Huwiler, 1996), *AJA* 101: 774–75.

1999. "Cleaning the Elgin Marbles," *Minerva* 10: 43–45.

2000. "John Henning's Frieze for the Athenaeum." In *The Athenaeum Collection,* Hugh Tait and Richard Walker, 149–56. London.

Jenkins, Ian D., and A. P. Middleton. 1988. "Paint on the Parthenon Sculptures," *BSA* 83: 183–207.

Jeppesen, Kristian. 1963. "Bild und Mythos an dem Parthenon," *Acta Archaeologica* 34: 1–96.

1990. *The Parthenon Frieze: An Alternative Interpretation.* Washington D.C.

Kagan, Donald. 1991. *Pericles of Athens and the Birth of Democracy.* New York.

Kallet-Marx, Lisa. 1989. "Did Tribute Fund the Parthenon?" *Classical Antiquity* 8: 252–66.

Kardara, Chrysoula. 1964. "Γλαυκῶπις Ο Αρχαῖος Ναὸς καὶ τὸ θέμα τῆς ζωφόρου τοῦ Παρθενῶνος" [Glaukopis – Ho Archaios Naos kai to Thema tes Zophorou tou Parthenonos], *Archaiologike Ephemeris* 1961: 62–158.

1966. "Ἐριχθόνιος Σπενςν" [Erichthonios Spendon]. In *Charisterion eis Athanasion K. Orlandon* II, 22–24. Athens.

Kavoulaki, Athena. 1999. "Processional Performance and the Democratic Polis." In Goldhill and Osborne, 1999, 293–320.

Kenner, Heinrich. 1965. *Die Darstellung der Götterversammlung in der attischen Kunst des VI. u. V. Jahrhunderts v. Chr.* Diss., Freiburg.

Kephalidou, Euridike. 1996. Νικητης. Thessalonki.

Kjellberg, E. 1926. *Studien zu den attischen Reliefs des V. Jahrhunderts v. Chr.* Uppsala diss.

Kleiner, Diana E. E. 1978. "The Great Friezes of the Ara Pacis Augustae. Greek Sources, Roman Derivatives, and Augustan Social Policy," *Mélanges de l'École française de Rome, Antiquité* 90: 753–85.

1992. *Roman Sculpture.* New Haven and London.

Knell, Heiner. 1968. "Zur Götterversammlung am Parthenon-Ostfries," *Antaios* 10: 38–54.

1990. *Mythos und Polis: Bildprogramme griechischer Bauskulptur.* Darmstadt.

Korres, Manolis. 1988. "Überzählige Werkstücke des Parthenonfrieses." In *Kanon: Festschrift Ernst Berger,* ed. Margot Schmidt, 19–27. Basel.

1994. "The Sculptural Adornment of the Parthenon." In Economakis, 1994, 29–33.

1995. *From Pentelicon to the Parthenon.* Athens.

Korres, M., G. A. Panetsos, and T. Seki, ed. 1996. *The Parthenon: Architecture and Conservation.* Exhib. cat. Osaka Museum. Athens.

Koufopoulos, Petros. 1994. *Study of the Restoration of the Parthenon.* Vol. 3A. *Restoration Project of the Opisthodomos and the Ceiling of the West Colonnade Aisle.* In Greek, English summary 109–16. Athens.

Kroll, John H. 1979. "The Parthenon Frieze as a Votive Relief," *AJA* 83: 349–52.

1982. "The Ancient Image of the Athena Polias." In *Studies in Athenian Architecture, Sculpture and Topography presented to Homer A. Thompson, Hesperia* supplement 20, 65–76, pl. 11. Princeton.

Kron, Uta. 1976. *Die zehn attischen Phylenheroen. Geschichte, Mythos, Kult und Darstellungen, AM* Beiheft 5. Berlin.

1984. "Die Phylenheroen am Parthenonfries." In Berger, 1984, 235–44, 418–21, pls. 17–19.

Kyle, Donald G. 1993. *Athletics in Ancient Athens.* 2nd rev. ed. Leiden.

Kyrieleis, Helmut, ed. 1986. *Archaische und klassische griechische Plastik: Akten des Internationalen Kolloquiums vom 22.–25. April 1985 in Athen.* Mainz.

Lagerlöf, Margaretha R. 2000. *The Sculptures of the Parthenon.* New Haven.

Lapatin, Kenneth D. S. 2001. *Chryselephantine Statuary in the Ancient Mediterranean World.* Oxford.

Lawrence, A. W. 1951. "The Acropolis and Persepolis," *JHS* 71: 116–19.

1972. *Greek and Roman Sculpture.* London.

Lawton, Carol L. 1995. *Attic Document Reliefs: Art and Politics in Ancient Athens.* Oxford.

Leipen, Neda. 1971. *Athena Parthenos: A Reconstruction.* Toronto.

Lethaby, W. R. 1908. *Greek Buildings Represented By Fragments in the British Museum.* London.

1929. "The Central Part of the Eastern Frieze of the Parthenon," *JHS* 49: 7–13.

Lezzi-Hafter, Adrienne. 1988. *Der Eretria-maler, Kerameus* 6. Mainz.

Linfert, A. 1979. "Die Götterversammlung im Parthenon-Ostfries und das attische Kultsystem unter Perikles," *AM* 94: 41–47.

Lissarrague, François. 1990. *L'autre guerrier: Archers, peltastes, cavaliers dans l'imagerie attique.* Paris.

Long, Charlotte. 1987. *The Twelve Gods of Greece and Rome.* Leiden.

Loraux, Nicole. 1993. *The Children of Athena.* Trans. C. Levine. Princeton.

Lowenthal, David. 1988. "Classical Antiquities as National and Global Heritage," *Antiquity* 62: 726–35.

 1996. *Possessed By the Past: The Heritage Crusade and the Spoils of History.* New York.

Lullies, Reinhard, and Max Hirmer. 1960. *Greek Sculpture.* New York.

Lundgreen, B. 1997. "A Methodological Inquiry: The Great Bronze Athena by Pheidias," *JHS* 97: 190–97.

Luyster, Robert. 1965. "Symbolic Elements in the Cult of Athena," *History of Religions* 5: 133–63.

Lyons, Claire L. 2000. "Cleaning the Parthenon Sculptures," *International Journal of Cultural Property* 9: 180–84.

Maas, Martha, and Jane M. Snyder. 1989. *Stringed Instruments of Ancient Greece.* New Haven.

Mader, Ingrid. 1996. "Thrakische Reiter auf dem Fries des Parthenon?" In *Fremde Zeiten. Festschrift für Jürgen Borchhardt,* ed. Fritz Balkolmer et al., vol. 2, 59–64.

Mansfield, John Magruder. 1985. *The Robe of Athena and the Panathenaic "Peplos."* University of California, Berkeley diss.

Mantis, Alexander. 1986. "Neue Fragmente von Parthenonskulpturen." In Kyrieleis, 1986, vol. 2, 71–76.

 1990. Προβλήματα της Εικονογραφίας των Ιερειών και των Ιερέων στην αρχαία ελληνική Τέχνη. (Problems Concerning the Iconography of Priestesses and Priests in Ancient Greek Art). Athens.

 1997. "Parthenon Central South Metopes: New Evidence." In Buitron-Oliver, 1997, 67–81.

Manzelli, Valentina. 1994. *La policromia nella statuaria greca arcaica.* Rome.

Mark, Ira. 1984. "The Gods on the East Frieze of the Parthenon," *Hesperia* 53: 289–342.

Markman, Sidney D. 1943. *The Horse in Greek Art.* Baltimore.

Matheson, Susan B. 1995. *Polygnotos and Vase Painting in Classical Athens.* Madison.

Mattusch, Carol C. 1988. *Greek Bronze Statuary from the Beginnings Through the Fifth Century B.C.* Ithaca and London.

 1994. "The Eponymous Heroes: The Idea of Sculptural Groups." In Coulson et al., 1994, 73–81.

Maurizio, Lisa. 1998. "The Panathenaic Procession: Athens' Participatory Democracy on Display?" In Boedeker and Raaflaub, 1998, 297–317.

Meiggs, Russell. 1963. "The Political Implications of the Parthenon." In Hooker, 1963, 36–45. Reprinted in Bruno, 1974, 101–11.

 1972. *The Athenian Empire.* Oxford.

Melldahl, C., and J. Flemberg. 1978. "Eine Hydria des Theseus-Malers mit einer Opferdarstellung," *Boreas Uppsala* 9: 57–79.

Merryman, John H. 1985. "Thinking About the Elgin Marbles," *Michigan Law Review* 83.8: 1880–1923.

 1986. "Who Owns the Elgin Marbles?" *Art News* (Sept.): 100–109.

Metzger, Henri. 1951. *Les représentations dans la céramique attique du IVᵉ siècle.* Paris.

Meyer, Marion. 1989. "Zur 'Sinnenden' Athena." In *Festschrift für Nikolaus Himmelmann, Bonner Jahrbuch* Beiheft 47, ed. Hans-Ulrich Cain et al., 161–68. Mainz.

Michaelis, Adolf. 1871. *Der Parthenon.* Leipzig.

Miller, Margaret C. 1992. "The Parasol: an Oriental Status-Symbol in Late Archaic and Classical Athens," *JHS* 102: 91–105.

 1997. *Athens and Persia in the Fifth Century B.C.* Cambridge.

Mitchell, Charles. 1974. "Ciriaco d'Ancona: Fifteenth-Century Drawings and Descriptions of the Parthenon." In Bruno, 1974, 111–23.

Mommsen, Heide. 1997. *Exekias I: Die Grabtafeln. Kerameus* 11. Mainz.

Moon, Warren G., ed. 1995. *Polykleitos, the Doryphoros, and Tradition.* Madison.

Moore, Mary. 1975. "The Cottenham Relief," *The J. Paul Getty Museum Journal* 2: 37–50.

Morrow, Kaherine Dohan. 1985. *Greek Footwear and the Dating of Sculpture.* Madison.

Müller, C. O. 1829. "De opere sculpto in zophoro cellae Parthenonis," *Annali dell'Istituto di corrispondenza archeologica* 1: 221–26.

Murray, A. S. 1903. *The Sculptures of the Parthenon.* London.

Nagy, Blaise. 1978a. "The Athenian Athlothetai," *GRBS* 19: 307–13.

 1978b. "The Ritual in Slab V-East on the Parthenon Frieze," *Classical Philology* 73: 136–41.

 1984. "The *Peplotheke:* What Was It?" In *Studies Presented to Sterling Dow on his Eightieth Birthday,* ed. Alan L. Boegehold, 227–32. Durham, N.C.

 1992. "Athenian Officials on the Parthenon Frieze," *AJA* 96: 62–69.

Neils, Jenifer. 1987. *The Youthful Deeds of Theseus.* Rome.

 ed. 1992a. *Goddess and Polis: The Panathenaic Festival in Ancient Athens.* Exhib. cat. Hanover, N.H.

1992b. "The Panathenaia: An Introduction." In Neils, 1992a, 13–27.

1994. "The Panathenaia and Kleisthenic Ideology." In Coulson et al., 1994, 151–60.

1995. "The Euthymides Krater from Morgantina," *AJA* 99: 427–44.

ed. 1996a. *Worshipping Athena: Panathenaia and Parthenon.* Madison.

1996b. "Pride, Pomp, and Circumstance: The Iconography of Procession." In Neils, 1996a, 177–97.

1999. "Reconfiguring the Gods on the Parthenon Frieze," *Art Bulletin* 81: 6–20.

2001. "Athena, Alter Ego of Zeus." In Deacy and Villing, 2001, 217–30.

Forthcoming. "Priest and *Pais.*" In *The Child in Greek Cult, Proceedings of the Seventh International Seminar on Ancient Greek Cult,* ed. Robin Hägg.

Neumann, Gerhard. 1965. *Gesten und Gebärden in der griechischen Kunst.* Berlin.

Nordquist, Gullög C. 1994. "Some Notes on Musicians in Greek Cult." In *Ancient Greek Cult Practice from the Epigraphical Evidence, Proceedings of the Second International Seminar on Ancient Greek Cult,* ed. Robin Hägg, 81–93. Stockholm.

Norman, Naomi J. 1983. "The Panathenaic Ship," *Archaeological News* 12: 41–49.

Oakley, John H., and Rebecca H. Sinos. 1993. *The Wedding in Ancient Athens.* Madison.

Osborne, Robin. 1987a. *Classical Landscape with Figures: The Ancient Greek City and its Countryside.* London.

1987b. "The Viewing and Obscuring of the Parthenon Frieze," *JHS* 107: 98–105.

1994. "Democracy and Imperialism in the Panathenaic Procession: The Parthenon Frieze in Its Context." In Coulson et al., 1994, 143–50.

Palagia, Olga. 1984. "Transformations of a Parthenon Motif." In Berger, 1984, 245–46, 421–22, pl. 18, 1.

1993. *The Pediments of the Parthenon.* Leiden. 2nd ed. 1998.

1994. "Akropolis Museum 581: A Family at the Apaturia?" *Hesperia* 64: 493–501, pls. 114–16.

Paquette, Daniel. 1984. *L'instrument de musique dans la céramique de la Grèce antique.* Paris.

Parke, H. W. 1977. *Festivals of the Athenians.* Ithaca, N.Y.

Parker, Robert. 1996. *Athenian Religion: A History.* Oxford.

Paul, Eberhard. 1997. *Attisch rotfigurige Vasen.* Leipzig.

Pemberton, Elizabeth. 1976. "The Gods of the East Frieze of the Parthenon," *AJA* 80: 113–24.

Petersen, Eugen A. F. 1873. *Die Kunst des Pheidias am Parthenon zu Olympia.* Berlin.

Plommer, W. H. 1960. "The Archaic Acropolis: Some Problems," *JHS* 80: 127–59.

Podlecki, Anthony J. 1998. *Perikles and His Circle.* London and New York.

Pollini, John. 1993. "The Gemma Augustea: Ideology, Rhetorical Imagery, and the Creation of a Dynastic Narrative." In *Narrative and Event in Ancient Art,* ed. Peter J. Holliday, 258–98. Cambridge.

Pollitt, Jerome J. 1972. *Art and Experience in Classical Greece.* Cambridge.

1997. "The Meaning of the Parthenon Frieze." In Buitron-Oliver, 1997, 51–65.

Pope, Spencer A. 2000. "Financing and Design: The Development of the Parthenon Program and the Parthenon Building Accounts," *Miscellanea Mediterranea,* Archaeologia Transatlantica 18, ed. R. Ross Holloway, 61–69. Providence.

Posch, Walter. 1994. "Skenographie und Parthenon," *AntK* 37: 21–30.

Powell, Anton. 1995. "Athens' Pretty Face: Anti-feminine Rhetoric and Fifth-century Controversy over the Parthenon." In *The Greek World,* ed. Anton Powell, 245–70. London.

Randall, Richard H., Jr. 1953. "The Erechtheum Workmen," *AJA* 57: 199–210.

Raubitschek, Antony E. 1949. *Dedications from the Athenian Acropolis.* Cambridge, MA.

1969. "Die attischen Zwölfgötter." In *Opus Nobile. Festschrift zum 60. Geburtstag von Ulf Jantzen,* ed. P. Zazoff, 129–30. Wiesbaden.

Reber, Karl. 1999. "Apobaten auf einem geometrischen Amphorenhals," *AntK* 42: 126–141, pl. 21.

Reed, Nancy B. 1990. "A Chariot Race for Athens' Finest: The *Apobates* Contest Re-Examined," *Journal of Sport History* 19: 306–17.

Reuterswärd, Patrik. 1960. *Studien zur Polychromie der Plastik. Griechenland und Rom.* Stockholm.

Rhodes, Robin. 1995. *Architecture and Meaning on the Athenian Acropolis.* Cambridge.

Ridgway, Brunilde S. 1964. "The Date of the So-called Lysippean Jason," *AJA* 68: 114–28, pls. 37–38.

1966. "Notes on the Development of the Greek Frieze," *Hesperia* 35: 188–204, pls. 59–60.

1970. *The Severe Style in Greek Sculpture.* Princeton.

1981. *Fifth Century Styles in Greek Sculpture.* Princeton.

1990a. "Metal Attachments in Greek Marble Sculpture." In True and Podany, 1990, 185–206.

1990b. *Hellenistic Sculpture I: The Styles of ca. 331–200 B.C.* Madison.

1992. "Images of Athena on the Akropolis." In Neils, 1992a, 119–42.

1993. *The Archaic Style in Greek Sculpture.* 2nd ed. Chicago.

1999. *Prayers in Stone: Greek Architectural Sculpture (c. 600–100 B.C.E.).* Sather Classical Lectures 63. Berkeley.

Robert, Carl. 1919. *Archaeologische Hermeneutik.* Berlin.

Robertson, Martin. 1963. "The Sculptures of the Parthenon." In Hooker, 1963, 46–60.

1975. *A History of Greek Art.* Cambridge.

1979. "Two Questions on the Parthenon." In *Studies in Classical Art and Archaeology: A Tribute to Peter Heinrich von Blanckenhagen,* ed. Gunter Kopcke and Mary B. Moore, 75–87. Locust Valley.

1992. *The Art of Vase-painting in Classical Athens.* Cambridge.

Robertson, Martin, and Alison Frantz. 1975. *The Parthenon Frieze.* London.

Robkin, A. L. H. 1979. "The Odeion of Perikles: The Date of its Construction and the Periklean Building Program," *Ancient World* 2: 3–12.

Roccos, Linda Jones. 1995. "The Kanephoros and her Festival Mantle in Greek Art," *AJA:* 99: 641–66.

Rockwell, Peter. 1993. *The Art of Stoneworking: A Reference Guide.* Cambridge.

Roebuck, Carl, ed. 1969. *The Greek Muses at Work: Arts, Crafts, and Professions in Ancient Greece and Rome.* Cambridge, MA, and London.

Rolley, Claude. 1999. *La Sculpture grecque. II.* Paris.

Root, Margaret C. 1985. "The Parthenon Frieze and the Apadana Reliefs: Reassessing a Programmatic Relationship," *AJA* 89: 103–20.

Rothenberg, Jacob. 1977. *"Descensus ad Terram" The Acquisition and Reception of the Elgin Marbles.* New York University diss.

Rotroff, Susan I. 1977. "The Parthenon Frieze and the Sacrifice to Athena," *AJA:* 379–82.

Rühfel, Heide. 1984. *Das Kind in der griechischen Kunst.* Mainz.

Sabetai, Victoria. 1997. "Aspects of Nuptial and Genre Imagery in Fifth-Century Athens: Issues of Interpretation and Methodology." In *Athenian Potters and Painters,* ed. John H, Oakley, William D. E. Coulson, and Olga Palagia, 319–35. Oxford.

St. Clair, William. 1998. *Lord Elgin and the Marbles.* 3rd rev. ed. Oxford.

1999. "The Elgin Marbles: Questions of Stewardship and Accountability," *International Journal of Cultural Property* 8: 397–521.

Samons, Loren J., II. 1993. "Athenian Finance and the Treasury of Athena," *Historia* 42: 129–38.

Saunders, Richard H. 1999. *Horatio Greenough: An American Sculptor's Drawings.* Middlebury, VT.

Schäfer, Thomas. 1987. "Diphroi und Peplos auf dem Ostfries des Parthenon: zur Kultpraxis bei den Panathenäen in klassischer Zeit," *AM* 102: 185–212.

Schelp, Jochen. 1975. *Das Kanoun. Der griechische Opferkorb.* Würzburg.

Schrader, Hans. 1905. "Der Cellafries des alten Athenatempels," *AM* 30: 305–22.

Schuchhardt, W. H. 1930. "Die Entstehung des Parthenonfrieses," *JdI* 45: 218–80.

Schwab, Katherine A. 1994. "The Charioteer in Parthenon North Metope I," *Archaeological News* 19: 7–10.

Schweitzer, Bernhard. 1940. "Phidias der Parthenonmeister," *JdI* 55: 170–241.

Scranton, Robert L. 1946. "Interior Design of Greek Temples," *AJA* 50: 39–51.

1969. "Greek Building." In Roebuck, 1969, 2–34.

Segal, Charles P. 1965. "The Tragedy of the *Hippolytus:* The Waters of Ocean and the Untouched Meadow," *Harvard Studies in Classical Philology* 70:118–69.

Serghidou, Anastasia. 2001. "Athena *Salpinx* and the Ethics of Music." In Deacy and Villing, 2001, 57–74.

Shapiro, H. Alan, ed. 1981. *Greek Vases from Southern Collections.* New Orleans.

1989. *Art and Cult under the Tyrants in Athens.* Mainz.

1992. "*Musikoi Agones:* Music and Poetry at the Panathenaia." In Neils, 1992a, 53–75.

1995. Supplement to *Art and Cult under the Tyrants in Athens.*

1996. "Democracy and Imperialism: The Panathenaia in the Age of Perikles." In Neils, 1996a, 215–25.

1998. "Autochthony and the Visual Arts in Fifth-Century Athens." In Boedeker and Raaflaub, 1998, 127–151, 376–84.

2001. "Red-figure Panathenaic Amphoras: Some Iconographical Problems." In *Panathenaika,* ed. Martin Bentz and Norbert Eschbach, 119–24.

Simon, Erika. 1967. *Ara Pacis Augustae.* Tübingen.

1980. "Die Mittelgruppe in Westgiebel des

Parthenon." In *Tainia: Roland Hampe zum 70. Geburtstag,* ed. Herbert H. Cahn and Erika Simon, 239–55. Mainz.

1982. "Die Mittelszene im Ostfries des Parthenon," *AM* 97: 127–44, pls. 23–28.

1983. *Festivals of Attica: An Archaeological Commentary.* Madison.

1996. "Theseus and Athenian Festivals." In Neils, 1996a, 9–26.

Small, Jocelyn Penny. 1999. "Time *in* Space: Narrative in Classical Art," *Art Bulletin* 81: 562–75.

Smith, A. H. 1892. *A Catalogue of Sculpture in the Department of Greek and Roman Antiquities, British Museum* I. London.

1910. *The Sculptures of the Parthenon.* London.

1916. "Lord Elgin and His Collection," *JHS* 36, 163–372.

Snodgrass, A. M. 1983. "Heavy Freight in Archaic Greece." In *Trade in the Ancient Economy,* ed. P. Garnsey, K. Hopkins, and C. R. Whittaker, 16–26 and 182–83. Berkeley.

Sparkes, Brian A. 1999. "The Parthenon and Athenian Vase-painting." In *Classicism to Neo-classicism: Essays Dedicated to Gertrud Seidmann,* ed. Martin Henig and Dimitris Plantzos, BAR International Series 793: 3–17.

Spence, I. G. 1993. *The Cavalry of Classical Greece.* Oxford.

Stadter, Philip A. 1989. *A Commentary on Plutarch's Pericles.* Chapel Hill.

Stanier, R. S. 1953. "The Cost of the Parthenon," *JHS* 73: 68–76.

Stansbury-O'Donnell, Mark. D. 1999. *Pictorial Narrative in Ancient Greek Art.* Cambridge.

Steinhart, Matthias. 1997. "Die Darstellung der Praxiergidai im Ostfries des Parthenon," *AA,* Heft 4: 475–78.

Stewart, Andrew F. 1985. "History, Myth, and Allegory in the Program of the Temple of Athena Nike, Athens." In *Pictorial Narrative in Antiquity and the Middle Ages,* Studies in the History of Art 16, ed. Herbert L. Kessler and Marianna S. Simpson, 53–73. Washington D.C.

1990. *Greek Sculpture: An Exploration.* New Haven.

1997. *Art, Desire, and the Body in Ancient Greece.* Cambridge.

Stillwell, Richard. 1969. "The Panathenaic Frieze: Optical Relations," *Hesperia* 38: 231–41.

, ed. 1976. *The Princeton Encyclopedia of Classical Sites.* Princeton.

Strauss, Barry S. 1993. *Fathers and Sons in Athens: Ideology and Society in the Era of the Peloponnesian War.* Princeton.

Tanoulas, Tassos. 1997. "Through the Broken Looking Glass: The Acciaiuoli Palace in the Propylaea Reflected in the Villa of Lorenzo Il Magnifico at Poggio a Caiano," *Bolletino d'arte* 100: 1–32.

Taplin, Oliver. 1989. *Greek Fire.* New York.

Taylor, Lily Ross. 1937. "A Sellisternium on the Parthenon Frieze?" In *Quantulacumque: Studies Presented to Kirsopp Lake,* ed. Robert P. Casey, Silva Lake, and Agnes K. Lake, 253–64. London.

Thompson, Dorothy B. 1956. "Persian Spoils in Athens." In *The Aegean and the Near East: Studies Presented to Hetty Goldman,* ed. S.S. Weinberg, 281–91. Locust Valley, NY.

Thöne, Cornelia. 1999. *Ikonographische Studien zu Nike im 5. Jahrhundert v. Chr.* Heidelberg.

Tiverios, Michalis A. 1989. Περικλεια Παναθηναια. (Periklean Panathenaia. A Krater by the Painter of Munich 2335). Thessaloniki.

Tournikiotis, Panayotis, ed. 1994. *The Parthenon and Its Impact in Modern Times.* Athens.

Tracy, Stephen V. 1991. "The Panathenaic Festival and Games: An Epigraphic Inquiry," *Nikephoros* 4: 133–53.

Travlos, John. 1971. *Pictorial Dictionary of Ancient Athens.* New York.

Trexler, Richard C. 1980. *Public Life in Renaissance Florence.* Ithaca and London.

True, Marion, and Jerry Podany, ed. 1990. *Marble: Art Historical and Scientific Perspectives on Ancient Sculpture.* Malibu.

Tsiafakis, Despoina. 1998. Η θρακη ςτην Αττικη Εικονογραφια. (The Thracian in Attic Iconography.) Komotini.

2000. "The Allure and Repulsion of Thracians in the Art of Classical Greece." In *Not the Classical Ideal: Athens and the Construction of the Other in Greek Art,* ed. Beth Cohen, 364–89. Leiden.

Valavanis, Panos. 1990. "La Proclamation des vainqueurs aux Panathénées," *BCH* 114: 325–59.

Van Straten, F. T. 1995. *Hierà kalá: Images of Animal Sacrifice in Archaic and Classical Greece.* Leiden.

Vasić, Rastko. 1984. "The Parthenon Frieze and the Siphnian Frieze." In Berger, 1984, 307–11.

Vassilika, Eleni. 1998. *Greek and Roman Art.* Fitzwilliam Museum Handbook. Cambridge.

Vermeule, Cornelius C. III. 1955. "Chariot Groups in Fifth-century Greek Sculpture," *JHS* 75: 104–13.

Vickers, Michael. 1978. *Greek Vases.* Oxford.

1999. *Ancient Greek Pottery.* Oxford.

Von den Hoff, Ralf. 1997. "Der 'Alexander Rondanini': Mythischer Heros oder heroischer Herrscher?" *Münchner Jahrbuch der bildenden Kunst* 48: 7–28.

Vrettos, Theodore. 1974. *A Shadow of Magnitude: The Acquisition of the Elgin Marbles*. New York. Reprinted as *The Elgin Affair: The Abduction of Antiquity's Greatest Treasures and the Passions It Aroused,* New York, 1997.

Walker, Susan, and Avril Cameron, eds. 1989. *The Greek Renaissance in the Roman Empire*. BICS 55. London.

Waywell, G. B. 1984. "The Treatment of Landscape Elements in the Sculptures of the Parthenon." In Berger, 1984, 312–16, 448–49, pls. 53–55.

Wesenberg, B. 1995. "Panathenäische Peplosdedikation und Arrephorie," *JdI* 110: 149–78.

Williams, Dyfri. 1998. "An Athenian Amphora and the Panathenaic Festival," *British Museum Magazine* 31: 26.

Willemsen, Franz. 1963. "Archaische Grabmalbasen aus der Athener Stadtmauer," *AM* 78: 104–53, pls. 54–74.

Wilson, Benjamin Franklin, III. 1937. *The Parthenon of Pericles and Its Reproduction in America*. Nashville.

Wilson, Peter. 1999. "The *Aulos* in Athens." In Goldhill and Osborne, 1999, 58–95.

Winter, Nancy A. 1993. *Greek Architectural Terracottas from the Prehistoric to the End of the Archaic Period*. Oxford.

Wohl, Victoria. 1996. "εὐσεβείας ἕνεκα καὶ φιλοτιμίας: Hegemony and Democracy at the Panathenaia," *Classica et mediaevalia* 47: 25–88.

Woodford, Susan. 1987. "*Eponymoi* or *Anonymoi?*" Source. Notes in the History of Art 6: 1–5.

Worley, Leslie J. 1994. *Hippeis. The Cavalry of Ancient Greece*. Boulder.

Wycherley, R. E. 1978. *The Stones of Athens*. Princeton.

Yalouris. Nikolaus. 1950. "Athena als Herrin der Pferde," *Museum Helveticum* 7: 19–101.

Yeroulanou, Maria. 1998. "Metopes and Architecture: The Hephaisteion and the Parthenon," *BSA* 93: 401–25.

Younger, John G. 1991. "Evidence for Planning the Parthenon Frieze," *AJA* 95: 295 (abstract).

1993. "The Periklean Building Program as Public Works Project," *AJA* 97: 309 (abstract).

1997. "Gender and Sexuality in the Parthenon Frieze." In *Naked Truths,* ed. Anna Olga Koloski-Ostrow and Claire L. Lyons, 120–53. London and New York.

Zaidman, Louise Bruit, and Pauline Schmitt Pantel. 1992. *Religion in the Ancient Greek City.* Trans. Paul Cartledge. Cambridge.

Zanker, Paul. 1988. *The Power of Images in the Age of Augustus*. Trans. Alan Shapiro. Ann Arbor.

Ziehen, L. 1949. "Panathenaia." In *Paulys Real-Encyclopädie der classischen Altertumswissenschaft* 36: 457–93.

All locations are Athens unless otherwise specified.